THE SHANGHAI MUSEUM OF ART

The Shanghai Museum of Art

Edited by Shen Zhiyu

Harry N. Abrams, Inc., Publishers, New York

Preface by Shen Zhiyu. Texts by Huang Xuanpei, Wang Qingzheng, Chen Peifen, Zheng Wei, and Zhu Shuyi
Translations by Yang Yongxing, Zhao Ling, Dai Lijin and Yang Aiwen
Picture credits: Cultural Relics Publishing House, Beijing
Photography by Kong Lihang and Zhang Ping

Edited by Han Zhongmin and Miroslav Kutanjac
Designed by Ivan Picelj

Library of Congress Cataloging in Publication Data

Main entry under title:

The Shanghai Museum of art.

 Translation from an unpublished manuscript.
 1. Shang-hai po wu kuan. I. Shen, Zhiyu.
 II. Shang-hai po wu kuan.
N3750.S45S46 1983 709'.51'0740951132 83–3692
ISBN 0–8109–1646–0

Printed and bound in Yugoslavia

CONTENTS

Preface

by Shen Zhiyu

The Shanghai Museum of Art was established in December 1952 and charged with the task of collecting, excavating, and preserving Chinese cultural relics and promoting their study. We mount exhibitions and compile and publish albums to propagate state policies on the preservation of cultural relics and to bring to the public's attention outstanding items of China's cultural and art heritage. The museum at present has an exhibition of three sections: Chinese bronzes, Chinese ceramics, and Chinese paintings. We also regularly organize small displays of cultural relics on specific topics to teach patriotism and to improve the scientific and cultural levels of the whole nation.

The Shanghai Museum has built up a collection of over 100,000 relics, obtained by purchase, through donation, or from diggings carried out by our museum. Some have been contributed by other museums.

In this volume are some two hundred of the more remarkable objects in the Shanghai Museum. They are set under five divisions: (1) Archaeological Work in the Shanghai Region, (2) Ceramics, (3) Bronzes, (4) Paintings and Calligraphy, and (5) Carvings and Other Handicrafts. The brief introductions preceding each section are written by experts of the museum.

Following is a general introduction to archaeological work in the Shanghai region and to the other specific subjects included in the book.

1. *Archaeological Work in the Shanghai Region.* Archaeological work is one of the main preoccupations of the Shanghai Museum of Art. Before 1949 only one ancient site had been discovered in the Shanghai area. Today, we have uncovered twenty-four sites, dating from the Neolithic Period to the periods of the Spring and Autumn Annals (722–481 B.C.) and the Warring States (403–221 B.C.). We have also excavated over two hundred tombs of the period from the late Neolithic through the Ming Dynasty and recovered more than three thousand articles. They have provided invaluable material for our research into the formation of the civilization of the Shanghai region and the politics, economy, and culture of the area during the various dynasties.

In 1960 we discovered an ancient site in the central section of Shanghai on a piece of high ground called "Zhugang" which was on the former coastline. We named it the Maqiao site. The culture at its lower stratum belonged to the Liangzhu Culture of the late Neolithic Period. The following pieces of pottery were unearthed: *ding* (cauldron) with T-shaped legs, *hu* (wine vessel) with a pair of ear-handles, *dou* (stemmed bowl) in the shape of a bamboo joint, *gui* (water-heating vessel) with pouched legs (Fig. 8), and *he* (vessel for heating wine) with three legs (Fig. 10). Carbon 14 analyses of the shells making up this high ground gave a reading of 5,680 ± 180 years, showing that Zhugang, the high ground, was formed 5,000 years earlier and that the early members of the Liangzhu Culture lived on this ground over 4,000 years ago. This also indicates that the area west of the site was formed some 5,000 to 6,000 years ago by alluvial deposition. But the relics unearthed at the Maqiao site are not from the oldest culture found yet in Shanghai. The earliest ones are from the Songze site in Qingpu County, to the west of Zhugang. This site contains three strata of ancient cultures. The articles unearthed from its lower stratum—characterized by the perforated tongue-shaped stone ax, the *fu* (cooking vessel) with a broad ring and square handles (Fig. 1), and the red pottery goblet—have the distinctive characteristics of the Majiabin type found in the Taihu Lake area of the Neolithic Period. Carbon 14 analyses of charcoal unearthed from the same stratum gave a date of 5,980 ± 140 years.

Archaeological work enables us to identify the various ancient cultures in the Shanghai area in this order: Majiabin type; Songze type; Liangzhu Culture; Maqiao type; and Qijiadun type (in the periods of the Spring and Autumn Annals and Warring States, 8th–3rd century B.C.).

2. *Ceramics*. Chinese ceramic art, which goes back a long time, is an important adjunct of a flourishing agriculture and handicraft industry. According to recent archaeological finds in China, pottery vessels earlier than the Yangshao Culture and dating back some 6,000 years have been unearthed in both the Huanghe (Yellow) and Changjiang (Yangtze) River valleys. In the slave society of the Shang Dynasty, there was beautiful white pottery made of kaolin and proto-porcelain covered with artificial glaze. By the Han Dynasty, as the level of production improved and the feudal system developed, lead, black, and white glazes were invented and successfully applied. By about 400 B.C., the luster of the glaze attained was quite remarkable, particularly in the celadons in the southeastern areas. About midway through the Tang Dynasty, Chinese porcelain was shipped in quantity abroad and "china" gradually became synonymous in the world with porcelain.

Mostly celadon, white, and polychrome porcelain were produced, and celadon attained perfection in the Tang Dynasty, with that of the Yue kilns being the most famous. The most outstanding white porcelain was from the Xing kilns (in today's Qi Village, Lingcheng, Hebei Province). The art developed tremendously in the Song and Yuan Dynasties. There were well-known kilns all over northern China and in eastern and southern China. The articles introduced in this book—the Ge porcelain vase with nipple-like studs and cylindrical ears (Fig. 41), the Ding porcelain dish with impressed clouds-and-dragon design (Fig. 43), and the Jun porcelain basin in the shape of a begonia (Fig. 42)—were from these famous kilns. Their bodies, glazes, and designs reached unprecedented standards. The reduction-firing Ding kilns and "flambé" Jun kilns were huge advances in the art of firing. At the same time, ordinary utility porcelain ware from the Cizhou kilns in northern China began to have carved designs on colored clay, endowing them with an earthy freshness. In the Yuan Dynasty, underglaze porcelain came into its own, and the skill of firing the blue-and-white porcelain and the introduction of underglaze red marked great advances in porcelain making.

The Ming and Qing Dynasties were an Augustan age of Chinese pottery. The emergence of polychrome porcelain, contrasting colors, and monochrome glaze in the Ming Dynasty and of famille rose and enamel in the Qing made Chinese porcelain extraordinarily attractive. The potter's art in Jingdezhen was, at one stage, justifiably world famous.

3. *Bronzes*. China is one of the earliest civilizations in the world, with a recorded history of over 4,000 years. Ancient Chinese bronzes are considered a major milestone in Chinese civilization and they possess characteristics peculiar to China and to a period of history. But bronze ware was an extraordinary invention of slaves and the fruit of joint efforts of the laboring people of *all* nationalities in ancient times.

China's bronze age covered the Shang Dynasty, Western Zhou Dynasty, and the Spring and Autumn Annals and Warring States Periods. Cooking vessels, food, wine, and water containers, musical instruments, tools, weapons, ornaments for chariots and horses, as well as other objects, were made of this metal.

An important early Shang Dynasty site was discovered at Erlitou, Yanshi County, Henan Province, where bronze knives, dagger-axes with a curved tang, wine goblets, and bells were unearthed. The cultural layers of the Erlitou site and the articles found date from the time of the Xia Dynasty, and from later than the Longshan Culture in Henan Province but earlier than the Erligang Culture at Zhengzhou, Henan Province. The finds are important to the study of the source of the cultures of the Shang and Xia Dynasties. The bronzes were unearthed in the third phase. No consensus has been reached among Chinese scholars as to which culture they belong to, the Xia Culture or the early Shang Culture. It can be said with certainty, however, that the bronzes of the Erligang Culture (1600–1400 B.C.) were earlier than the Yinxu Culture at Xiaodun, Anyang. The mid- and late Shang Dynasty and early Western Zhou Dynasty were at their zenith in the art of bronze cast-

ing by the slave society. The bronzes were very numerous, in a great variety, meticulously made, and profusely decorated. The chief motifs were animal mask, dragon and phoenix, and geometrical. Inscriptions were short and few. From mid- and late Western Zhou to the early Spring and Autumn Annals Period (8th to late 6th century B.C.), the style of bronzes became simpler and more straightforward, with more and longer inscriptions. More bronzes were found cast for dukes and princes than for the imperial court, a reflection to some extent of the political situation at the time; *i.e.,* the power of the imperial court was on the wane while the principalities' was growing.

The mid- and late Spring and Autumn Annals Period to the Warring States Period (403–221 B.C.) was the transitional period from slave society to feudal society. During this time, bronzes were no longer cast solely for the slave owners and other aristocrats, but increasingly also for the emergent landlord class. With the expansion of production and exchange, cities arose in the states ruled by dukes and princes. The casting of bronzes revived and reached new heights. They were superbly cast, elegant in form, and in a great variety. The decorations were lively, with animal and complicated geometrical motifs; some depicted hunting scenes, or battles, or banquets. Some bronzes had gold and silver, red copper, and jade inlaid.

By the time of the Qin and Han Dynasties, bronzes were no longer status symbols or symbols of power. Lacquerware, porcelain, and iron increasingly replaced bronze. As a whole, bronze casting began to decline in Central China, but in the border areas it continued to develop. Casting techniques continued to make progress everywhere in China. For example, fine gold- and silver-inlaid and gilded bronzes appeared early in the Western Han Dynasty. In particular, bronze mirrors, which lacquer could not replace, developed on a nationwide scale. Mirror making in the Han and Tang Dynasties was noted for fine workmanship and superb designs. The bronze mirrors of the Han and Tang were unrivaled masterpieces and we end the section on bronzes with them.

4. *Paintings and Calligraphy.* Chinese painting has a long history. Among paintings unearthed, the oldest is a painting done on silk found in a Chu tomb at Changsha of the Warring States Period. Figure painting was well developed even then. Apart from this Chu painting, others—murals— have been found painted on the walls in tombs of the Western and Eastern Han Dynasties. These were in contrasting colors and in smooth, flowing lines. The rise of Daoism and Buddhism in China was accompanied by the development of religious painting. Landscape painting was just emerging in the Wei and Jin Periods. By the Tang Dynasty, the division into figure, landscape, and flower-and-bird painting was clearly demarcated and many professional artists of great talent emerged.

After the Wei and Jin Periods, Chinese painting theory became more systematized and coherent and exerted a tremendous influence on painting in the later generations. In the Song Dynasty, with the setting up of an Academy of Painting in the imperial court, a strictly academic style of painting arose which turned out meticulously rendered flower-and-bird drawings of extreme delicacy. In both the Song and Yuan Dynasties the School of Scholar-Painters, characterized by free ink-sketches, grew increasingly popular. These scholar-painters shunned social reality, holding the "spirit" and "works painted at leisure" to be the ultimate in painting. Much stress was placed on literary knowledge and on portraying ideas which were to be simple and elegant, while brushstrokes were to be both plain and precise. This enriched traditional Chinese painting; and since then Academy Painting, Scholar-Painting, traditional realistic painting (*gongbi*), and ink painting (*xieyi*) have vied constantly with each other to produce ever better works.

Following the introduction of elements of capitalist economy in the Ming and Qing Dynasties, painters were attracted to live and work in major centers of the handicraft industry and commerce. This led to sharply divergent styles of brushwork and schools of painting. Among these schools, some followed tradition in depicting the natural features of the locality they lived in; some stressed individuality; some faithfully copied ancient masters. The assorted local schools and individual styles produced in the Ming and Qing Dynasties a huge proliferation of diverse types of painting based on traditional skills. Since 1840, painters with a concept of nationality and patriotic ideas have explored and experimented with the best in national art to blaze new paths. They paid atten-

tion to painting from life (*xiesheng*) and incorporated the strokes used in calligraphy to offset languid effeminateness and give dignity and strength. The brushwork of the School of Scholar-Painting benefited by this, and new advances were made.

A few items of calligraphy are contained in this volume, far from enough to reflect the development of the art of Chinese calligraphy; they have been included to illustrate two scripts, the rustic and the cursive, in order to give readers a glimpse of the stylistic scope of Chinese calligraphy.

5. *Carvings and Other Handicrafts*. The first group of items included in this section are from the Northern Wei Dynasty (A.D. 386–534) to the Five Dynasties Period (A.D. 907–960), most of them carvings with a Buddhist theme.

Bronzes and ceramics, presented earlier, constitute separate categories; the remainder of Chinese artworks are generally placed in the category of arts and crafts, and the items shown include carvings in jade, stone, bamboo, wood, lacquerware, and ivory and rhinoceros horn, as well as enamelware, tapestry, and embroidery.

As section five is preceded by an explanatory introduction, I will only add a few words about a "ducks in a lotus pond" tapestry (Fig. 196) made in the last year of the Northern Song Dynasty by Zhu Kerou of Yunjian (today's Songjiang County). On the top and lower left corner of the tapestry are marks of cutting and mending. The density of the weave is 27 silk threads in warp and 36 to 64 in weft per square centimeter. The densest part is in the duck's head. Two lines in clerical script are woven on the blue stone. In the picture is a white egret among red lotus and a kingfisher among green duckweed. Two pairs of ducks are swimming and dragonflies and other insects are also seen. This is strictly in the style of Academy Painting. The artist-craftsman's consummate skill as a weaver and an artist of no mean talent is vividly demonstrated and is typical of the best of Song tapestry.

This volume was compiled at the suggestion and with the help of China's Wen Wu Publishing House in Beijing and Yugoslavia's Mladost Publishing House in Zagreb with the aim of contributing to friendship and mutual understanding between the peoples of China and Yugoslavia.

June 23, 1981

Archaeological Work
in the Shanghai Region

上海地區出土文物

ONE

Archaeological Work in the Shanghai Region

Introduction by Huang Xuanpei

The Shanghai region is on the coastal part of the Changjiang (Yangtze) River delta. Ancient cultural sites and remains discovered along the area's ancient coastline show that its western section was formed by silt deposits some 5,000 to 6,000 years ago while the central section (the Shanghai city area) was formed over 1,300 years ago and the eastern section over 900 years ago. Therefore, the earliest sites and finds in the area are in the western section.

Archaeological investigations in the area have so far revealed twenty-four ancient cultural sites. They are located mostly on hillsides, hillocks, and other high ground along the ancient coast. This shows that thousands of years ago after rising from the sea, the land here was still marshes and swamps and people had to make their dwellings on high ground.

Excavation and trial diggings on twelve separate occasions at nine of the ancient sites—Maqiao in Shanghai County; Songze, Siqiancun, Guoyuancun, and Fuquanshan in Qingpu County; Guangfulin in Songjiang County; and Qijiadun, Chashan and Tinglin in Jinshan County—and the sorting out of 220 tombs of various periods, have produced a large quantity of ancient artifacts. The more representative of these have been included here as a reference for understanding and studying the ancient cultures in the Shanghai region.

Majiabang Culture. The several pieces from the Majiabang Culture shown in this volume's first illustrations are the earliest examples of Neolithic Culture in the Shanghai area. The discovery of a hoard of cultivated long-grained and round-grained nonglutinous rice grains in an abandoned underground storage at the lowest stratum of the Songze site showed that paddy rice was cultivated in this area as far back as the Neolithic Period.

The implements unearthed were mostly made of stone or bone. Stone axes were used for felling trees and stone adzes for digging and tilling the land. The stone implements were fashioned by grinding instead of chipping and the people knew how to drill holes in stone for binding the implements onto wooden handles. The large quantity of bone arrowheads, deer antlers, ox bones, fish bones, and turtle shells uncovered show that fishing and hunting still played a big role in the economy.

From the discovery of skeletons of pigs, and after studying their jawbones and teeth, it was found that the pig had already been domesticated.

Vessels of daily use were mainly of earthenware and they often had a prominent broad ring around their shoulders and small square handles. The red pottery *fu* with a broad ring is a typical vessel of this culture, though some of them have ox-muzzle- or cockscomb-shaped handles on their bellies.

Jade ware mainly consisted of the *jue* (penannular jade ring), which was often found near the area of the ears of female skeletons. It is evident that the *jue* was a form of ornament much like

today's earrings. This shows that the people in those times were able to a certain extent to create aesthetic objects.

Carbon 14 analysis of the finds shows that the Majiabang Culture dates back some 5,940 to 6,700 years, to about the same time as the Banpo type of Yangshao Culture in China's Central Plain region.

Songze Culture. Shown in Figures 2 through 6 are several pieces of Songze Culture. This culture developed from the Majiabang Culture with the rise in the level of productive forces. The stone ax's cheeks grew thinner and the head of the stone adze was fashioned to have a protruding ridge to facilitate fastening onto a wooden handle.

Pottery making had advanced from the simple method of coiling lengths of clay to using a slow-turning potter's wheel to smooth out the walls and give vessels a smooth evenness. The art of firing in an enclosed kiln was mastered so that the heat of the flames was fully utilized and, in the reduced atmosphere, the smoke smudged the vessels. Therefore, apart from food vessels, most pottery was of gray or black earthenware. There was also a greater variety of vessels, with a wider range of shapes and sizes. The main form of cooking vessel was the *ding;* the beautiful red pottery *ding* with flat legs and incised design shown here was a vessel used in those days. The increase in the number of new vessels of daily use, such as the vase and jar, cup, *gu* (vessel for drinking wine), *yi* (ewer), and colander, indicates a big improvement in the economic life.

The decorations on the pottery vessels show the power of observation and expression of the people of that period. The interlinked designs, often found either impressed or painted on the belly or handles of the vessels, are related to the art of cane and bamboo weaving in those days. Some designs engraved with holes in the shape of circles or triangles with curved sides probably represent the flowers and fruits of swamp plants.

In the middle stratum of the Songze site's communal burial grounds of the clans, ninety-seven tombs have been found and they can be divided into five groups. The dead were generally buried individually. The body was placed supine on the ground and was covered with earth. However, two tombs have been found in which a child was buried together with a woman.

The amount of funerary objects differs but, on an average, a woman's grave has seven objects while a man's has five, females having a little more than males. From the groups of tombs, it was found that blood ties among the members of the clans were still very tight and when children died they were buried with their mother's group, for it was still the period of matrilineal society. Carbon 14 analysis of the skeletons shows that they date back some 5,180 to 5,860 years, to roughly about the time of the Miaodigou period of Yangshao Culture in China's Central Plain region.

Liangzhu Culture. Several pieces of Liangzhu Culture (Figs. 7, 8, 9, and 10) are included. During this period, production had advanced to a new level with the appearance of the plow and the stone stepped adze, as well as a special implement for harvesting: the stone sickle.

In pottery making, the potter's wheel was extensively used and a quantity of gray-based black pottery vessels with thin, even walls were produced. The *ding* with T-shaped legs, *hu* (wine vessel) with a pair of ear handles and a lid, wide-handled goblet, *gui* (water-heating vessel) with pouched legs, and the toad-shaped *he* (vessel for heating wine) are typical vessels of this period.

The two tombs at the Guangfulin site indicate that in tombs of this period a man's has a pottery dish and jar at the head, a stone ax by the right arm, three stone arrowheads by the lower limbs, and a skeleton of a dog on the right; while a woman's tomb has an earthenware jar at the head, a jar, *he, ding,* dish, and distaff at the feet, as well as a skeleton of a pig. This shows that the men now played the dominant role in social production, engaging in farming, fishing, and hunting, while the women did the household work of cooking, spinning, weaving, and feeding the domesticated livestock. It is evident that with the development of the productive forces, the social structure had entered patrilineal society.

Carbon 14 analysis places this period at 4,200 to 4,710 years ago, about the time of the Longshan Culture in China's Central Plain region.

Impressed Geometric Design Pottery Culture. The three pieces seen as Figures 11, 12, and 13 are examples of this culture in the Shanghai area after it had entered the stage of class society. The unearthed tools and implements belonging to the early part of this period are of stone but there are also small pieces of bronzes. Typical of these are the stone ax, triangular stone knife, semicircular stone knife, and small bronze shovel and chisel. In the latter part of this period, stone implements gave way to those of iron.

The pottery vessels of this period were decorated with geometric designs produced by impressing them on the vessels, and these often took the form of basket- and mat-weaving patterns, or other geometric designs such as rhomboids, squares, diagonally crossed crosses, and thunder-and-lightning patterns.

The main kinds of vessels in the early part of this period were the *ding, fou* (amphora), goblet, bowl, and *hu,* while in the latter part of the period they were chiefly the *pou* (large wine vessel), *lei* (urn-shaped wine vessel), *zhong* (goblet), and jar. In the Shanghai region, this culture appeared some 2,400 to 3,600 years ago.

From the time of the Tang and Song Dynasties, the Shanghai area gradually became a foreign trade port. During the reign of Xian Chun (A.D. 1265–1274) in the Southern Song Dynasty, the town of Shanghai was set up on the west bank of the Huangpu River and the name Shanghai became established. In the twenty-ninth year of the reign of Zhi Yuan of the Yuan Dynasty (A.D. 1292), with its political, economic, and cultural development the town became a county and more and more wealthy and powerful families came to settle there. Their tombs contained some exquisite works of art of the times. These finds, too, have been well looked after since their unearthing and a few of them have been included here (Figs. 14 through 23) for the benefit of those interested in studying and admiring them.

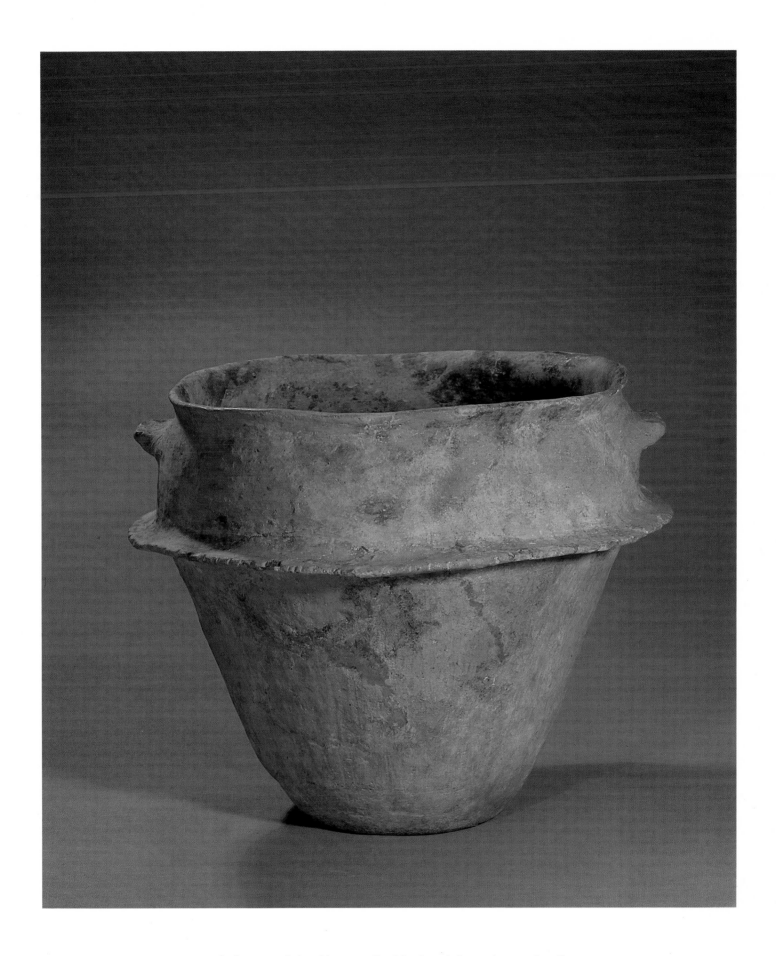

1 Red pottery *fu* (cooking vessel) with a broad ring and square handles.
Neolithic Period

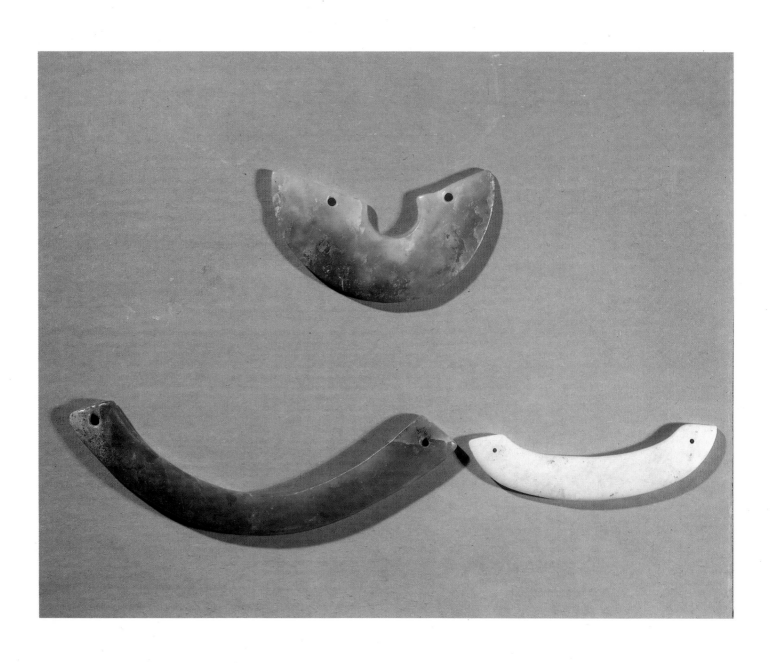

2 Jade *huang* (pendants).
Neolithic Period

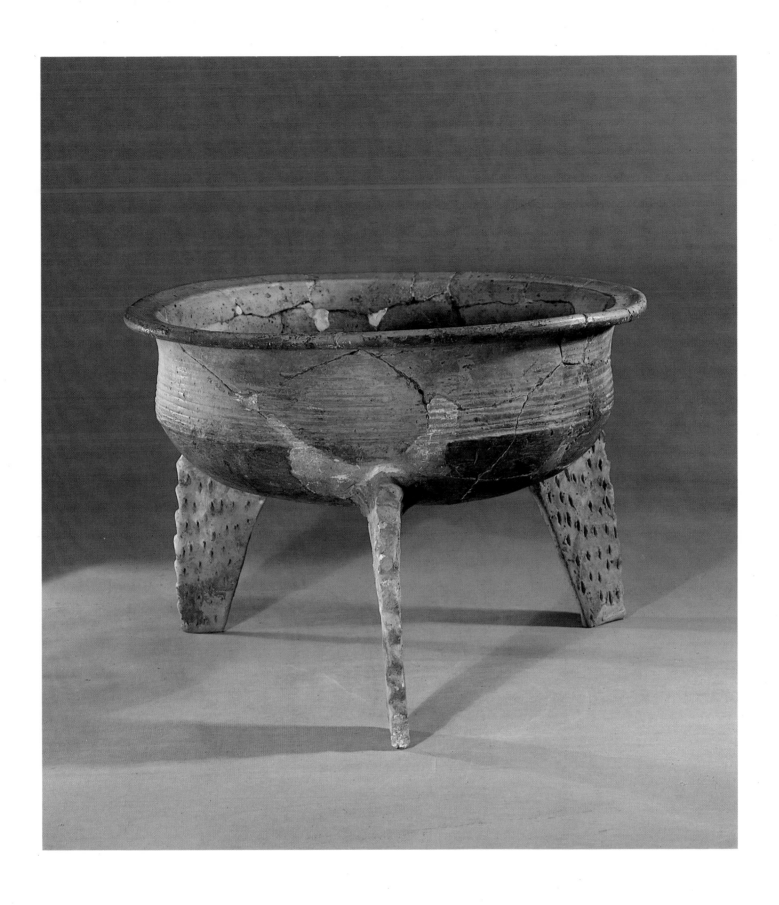

3 Red pottery *ding* (cooking vessel) with flat legs and incised designs.
Neolithic Period

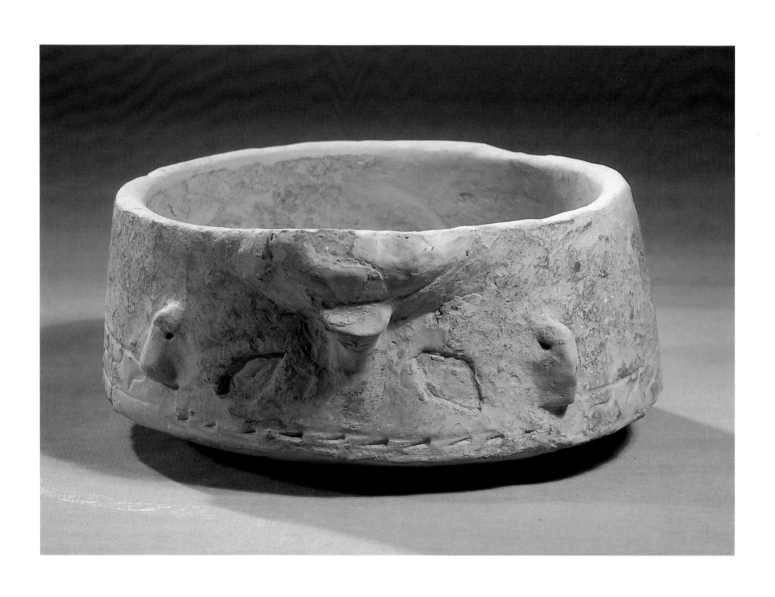

4/5　Pig-shaped gray pottery *yi* (ewer).
Neolithic Period

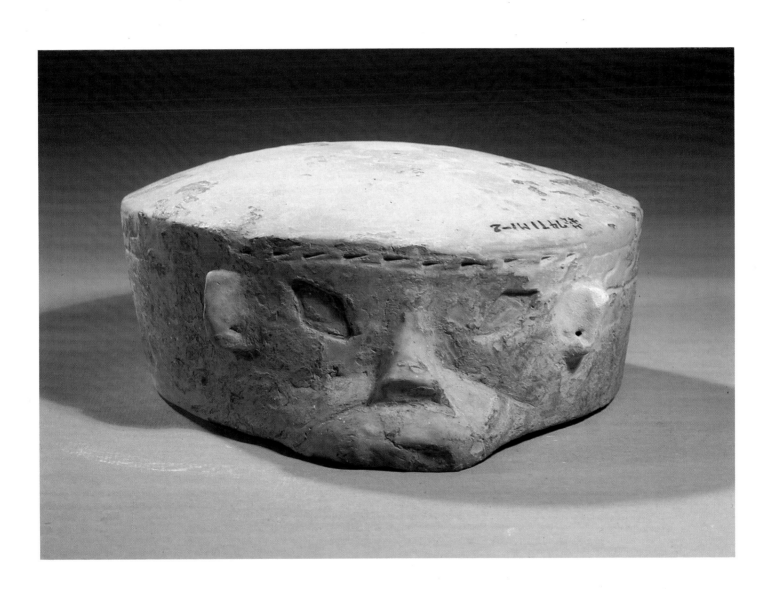

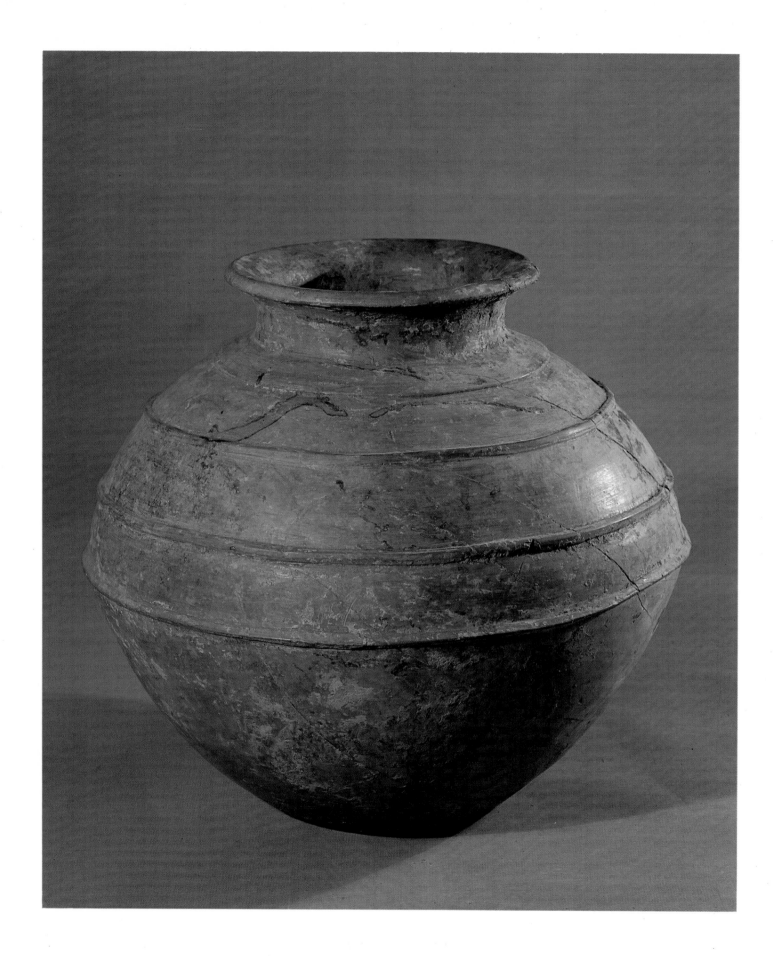

6 Painted black pottery jar.
Neolithic Period

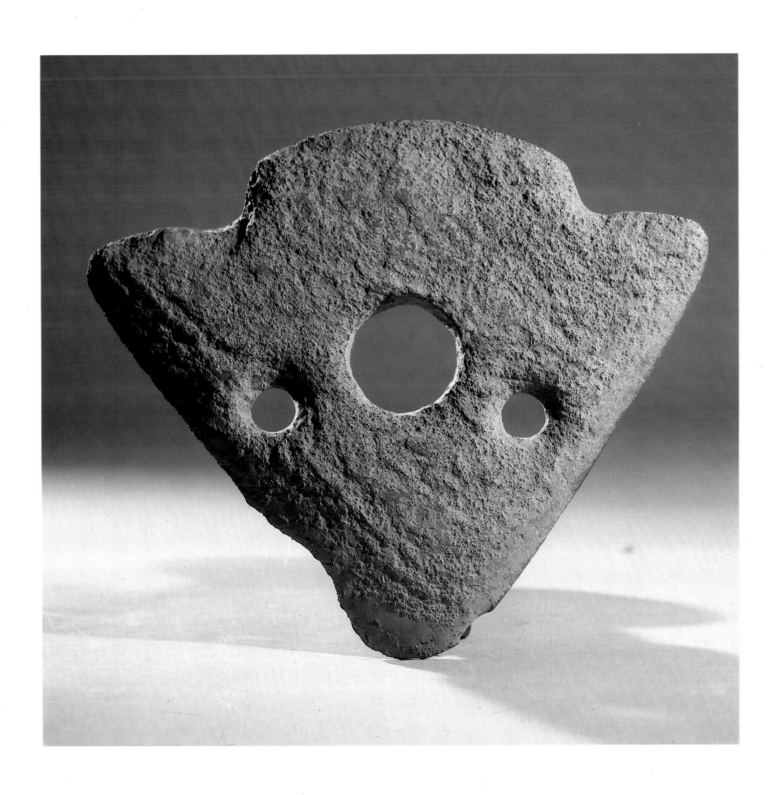

7 Stone plow.
Neolithic Period

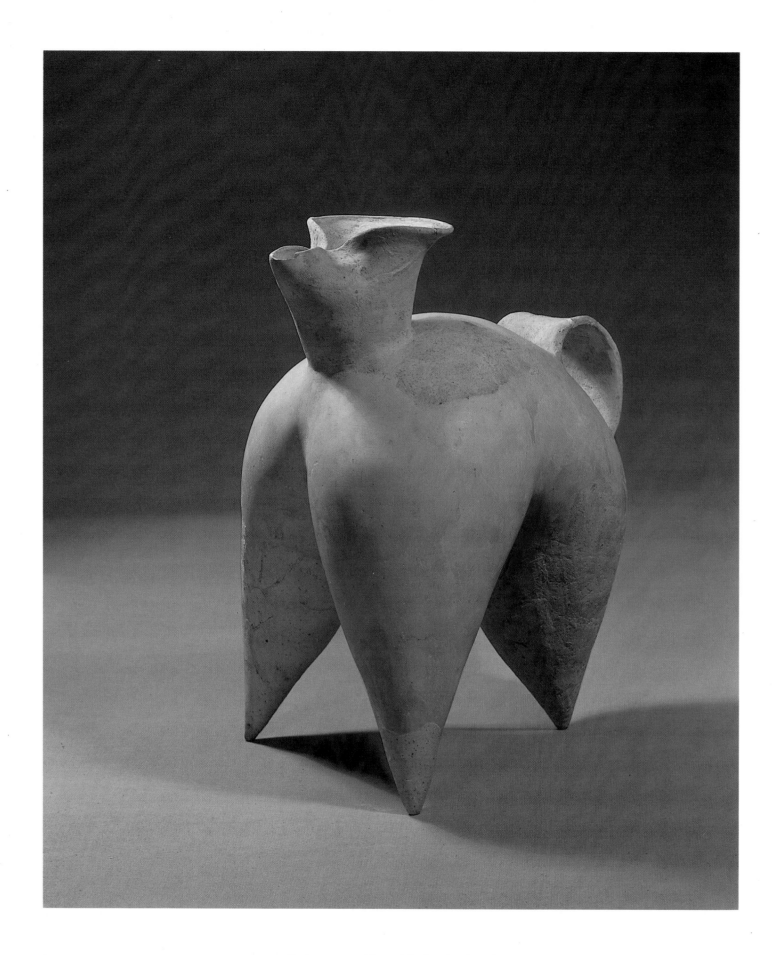

8 Red pottery *gui* (vessel for heating liquids).
Neolithic Period

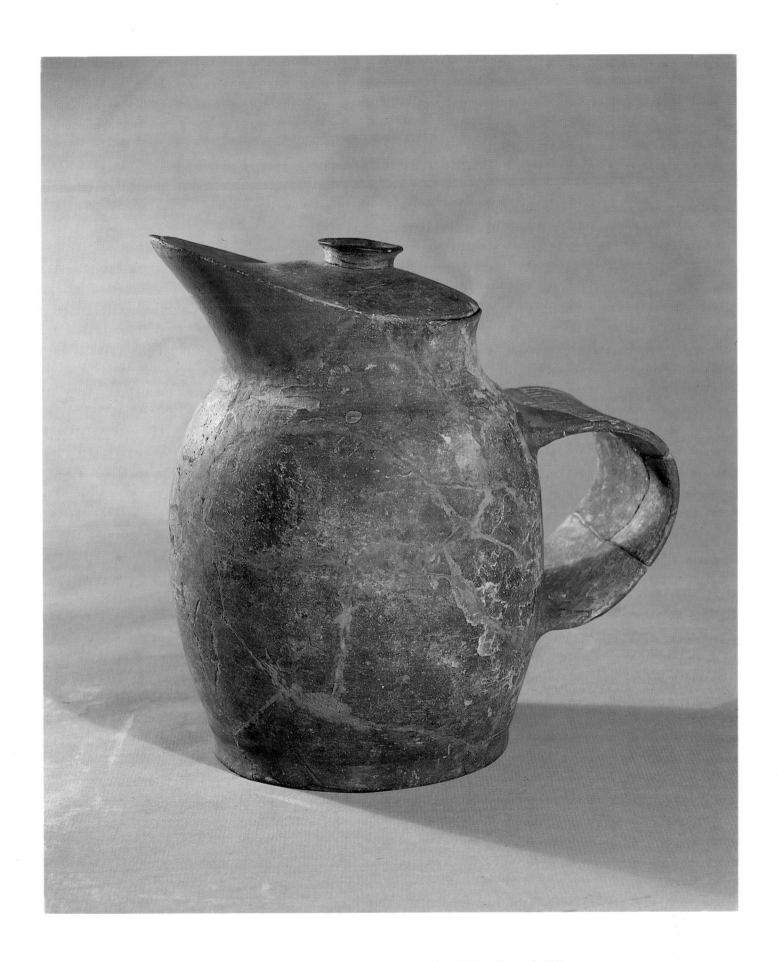

9 Black pottery *hu* (drinking vessel) with wide handles and a lid.
Neolithic Period

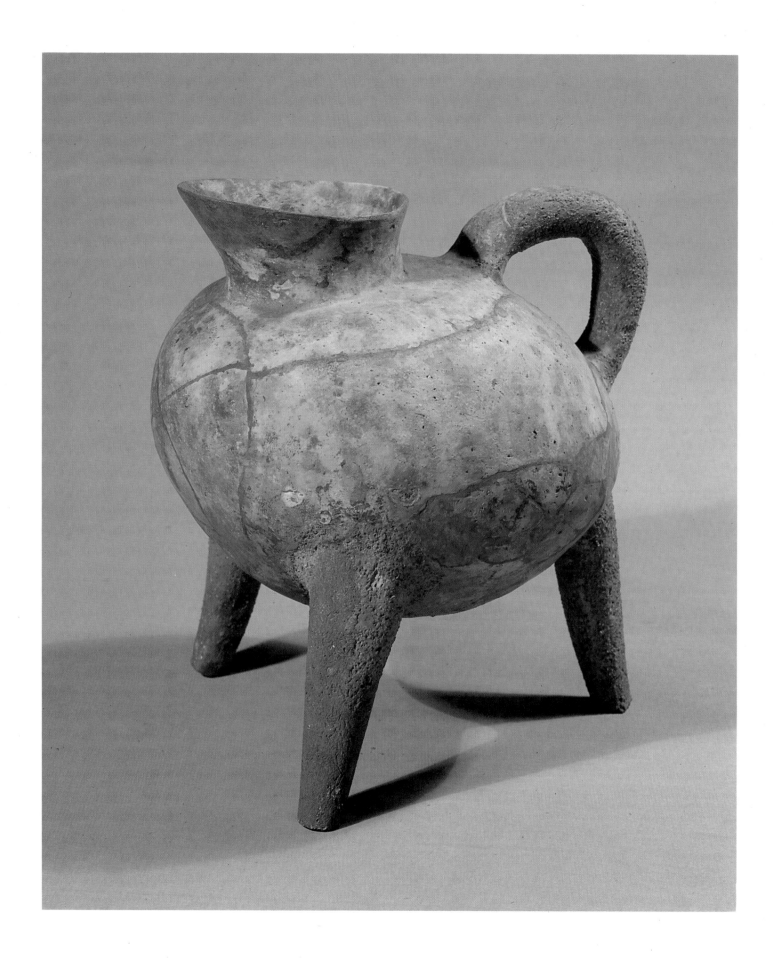

10 Black pottery *he* (vessel for heating liquids).
Neolithic Period

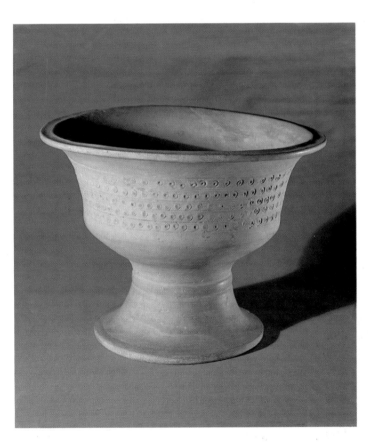

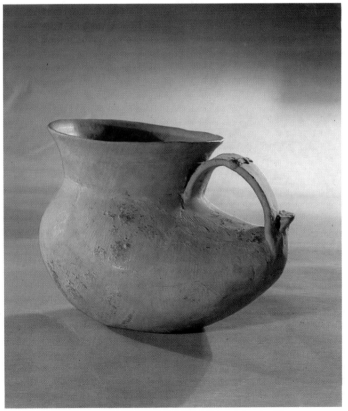

11 Gray pottery *gui* (food vessel) with circle-and-dot design.
Shang Dynasty

12 Impressed geometric-design pottery *hu* (wine vessel)
in the shape of a duck.
Shang Dynasty

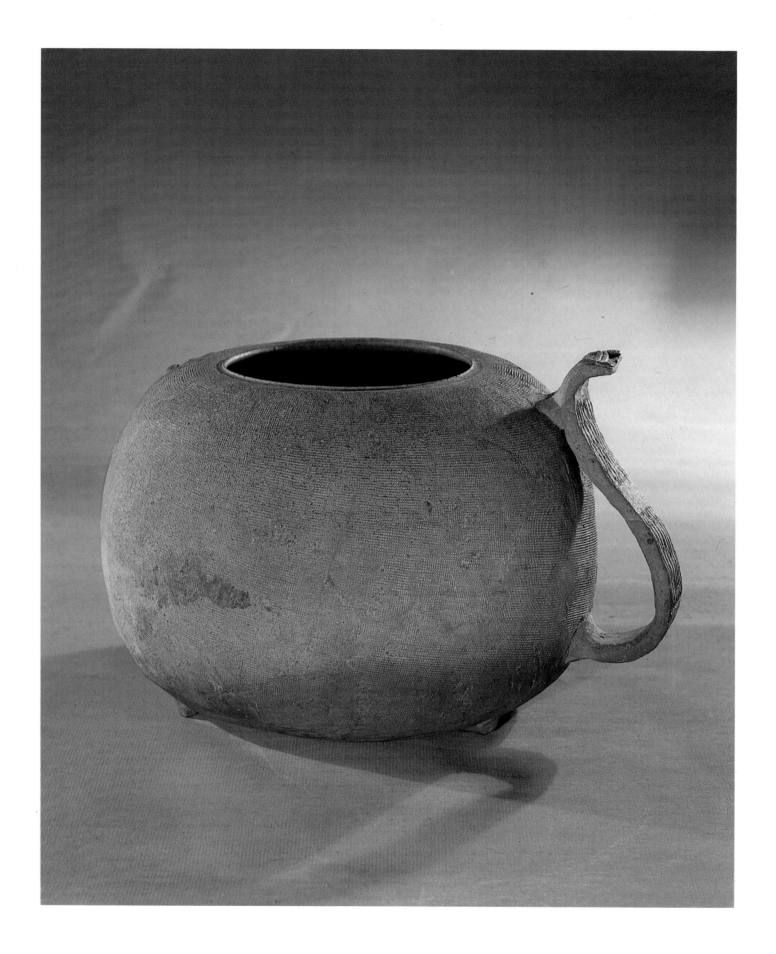

13 Impressed-design pottery *guan* (jar) with handle and stud feet.
Warring States Period

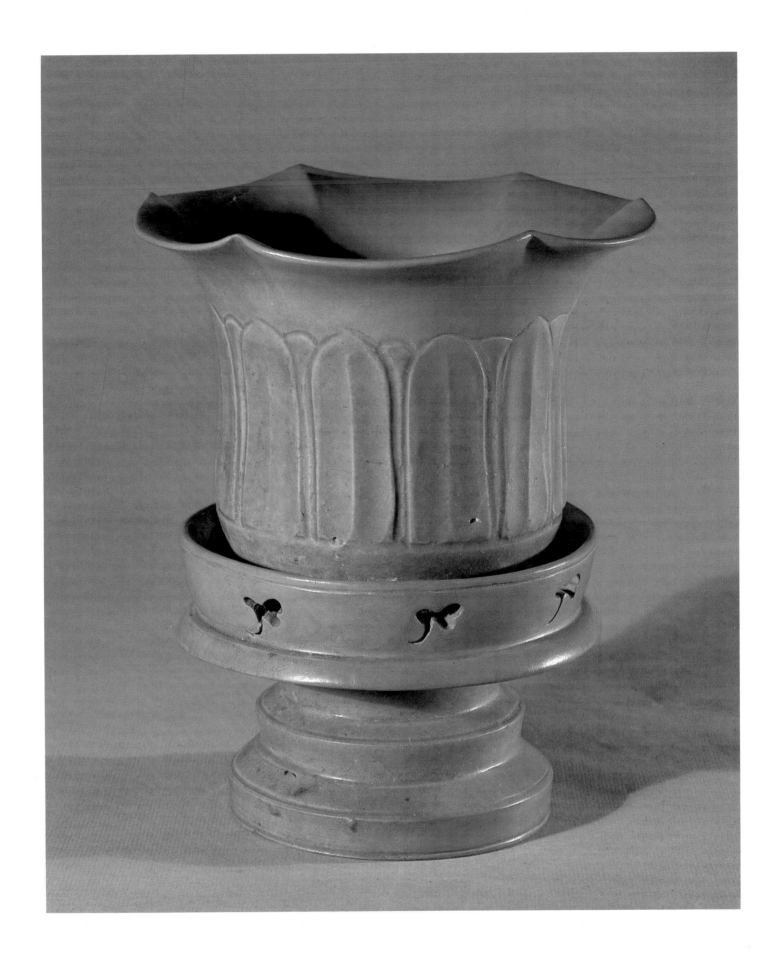

14 Yue ware lotus-flower porcelain *guan* (jar).
Five Dynasties Period

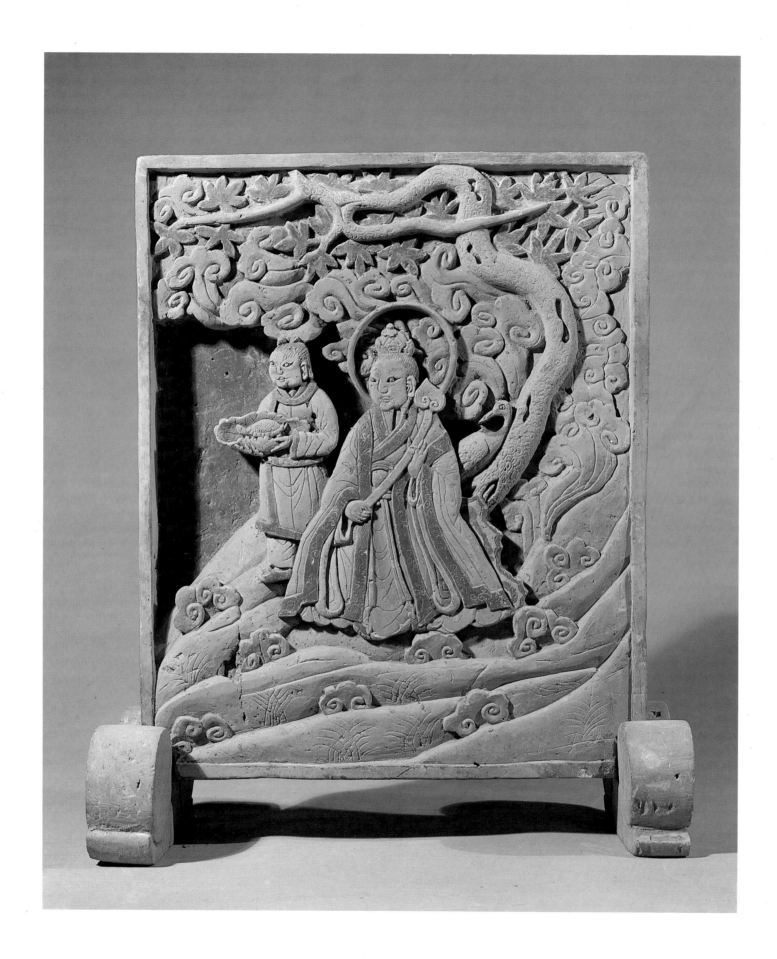

15 Brick screen panel carved with figures.
Song Dynasty

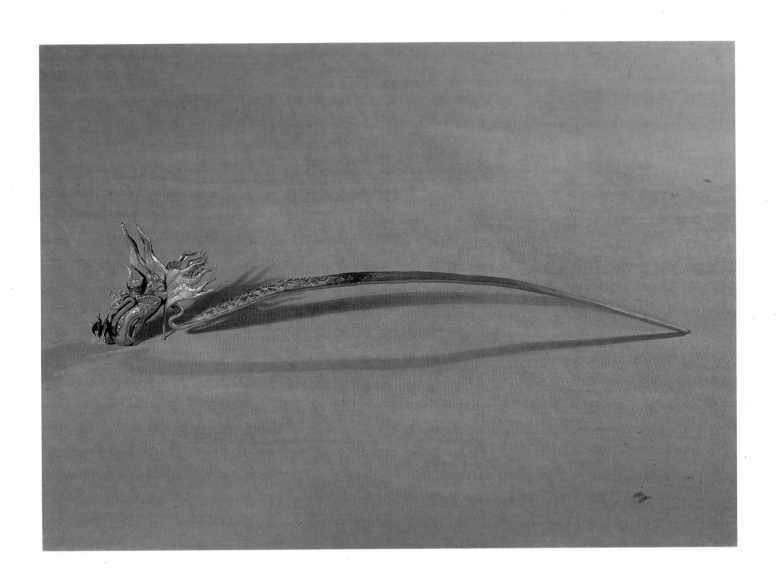

16 Gold phoenix hairpin.
Song Dynasty
17 through 23 Carved wooden ceremonial figurines.
Ming Dynasty

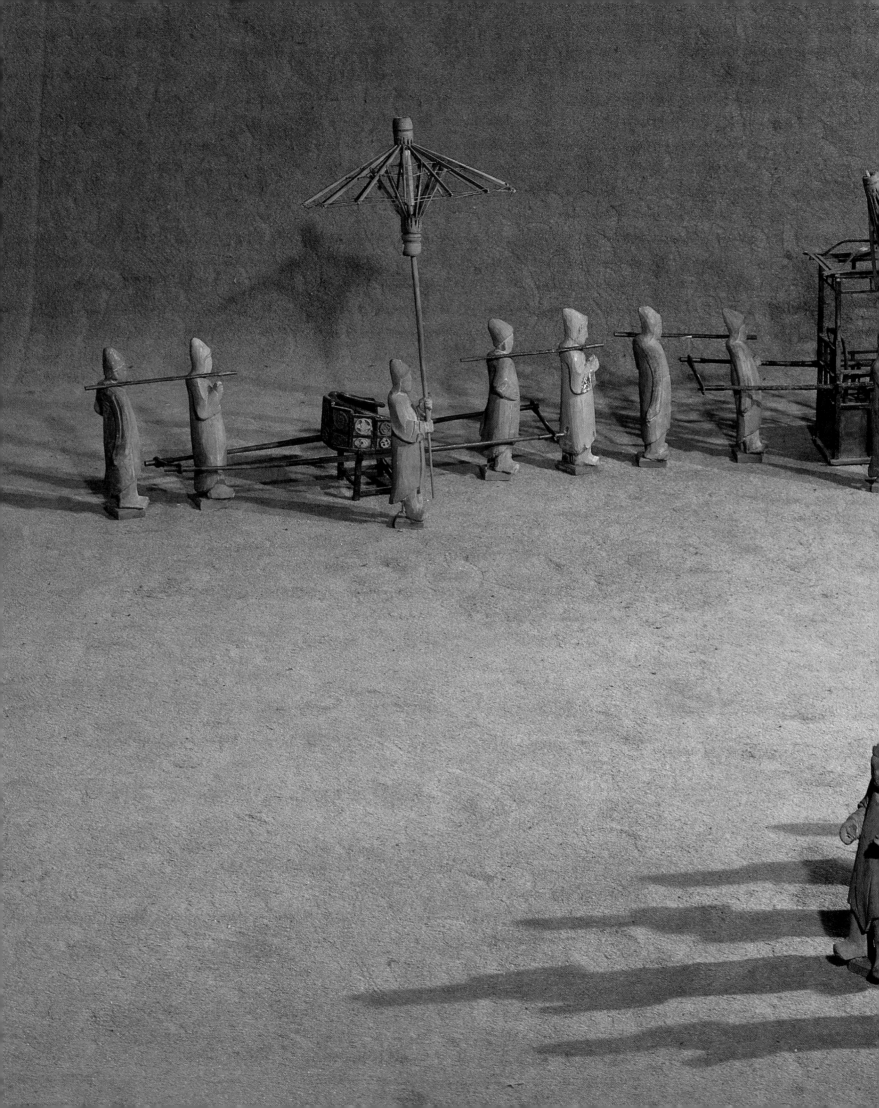

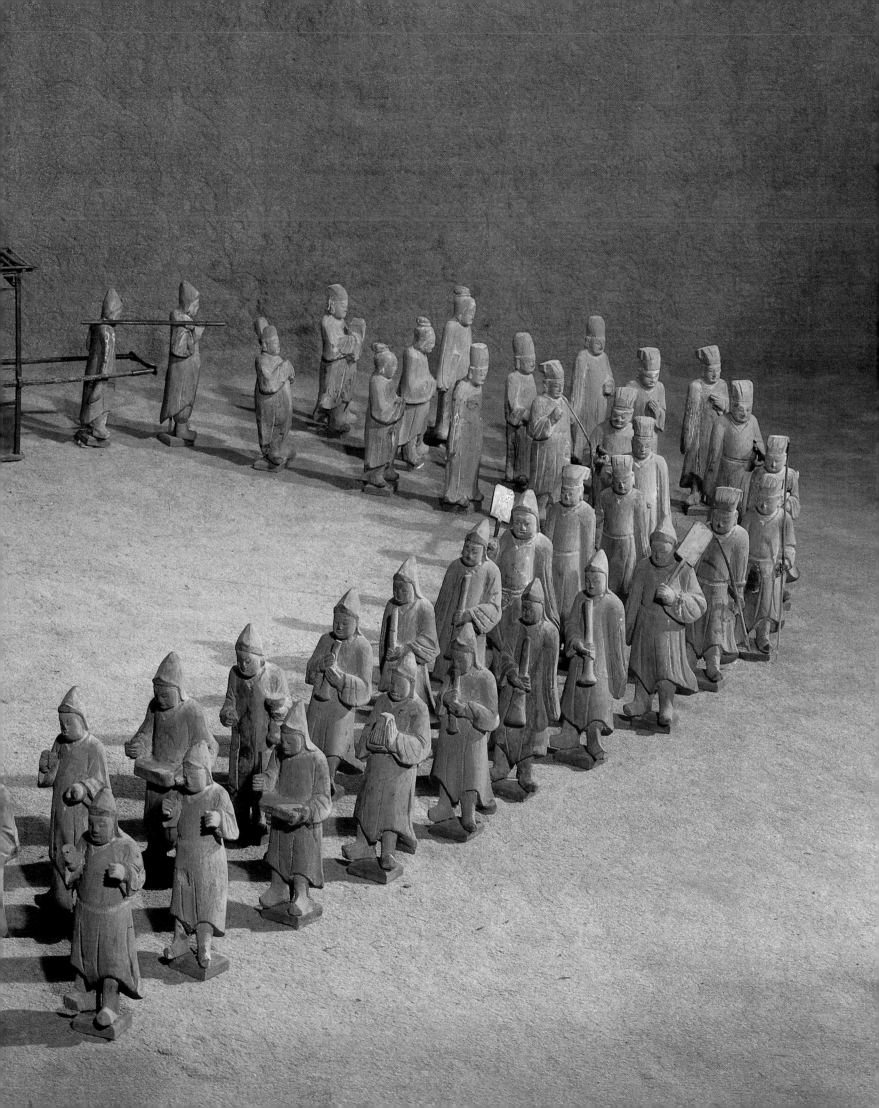

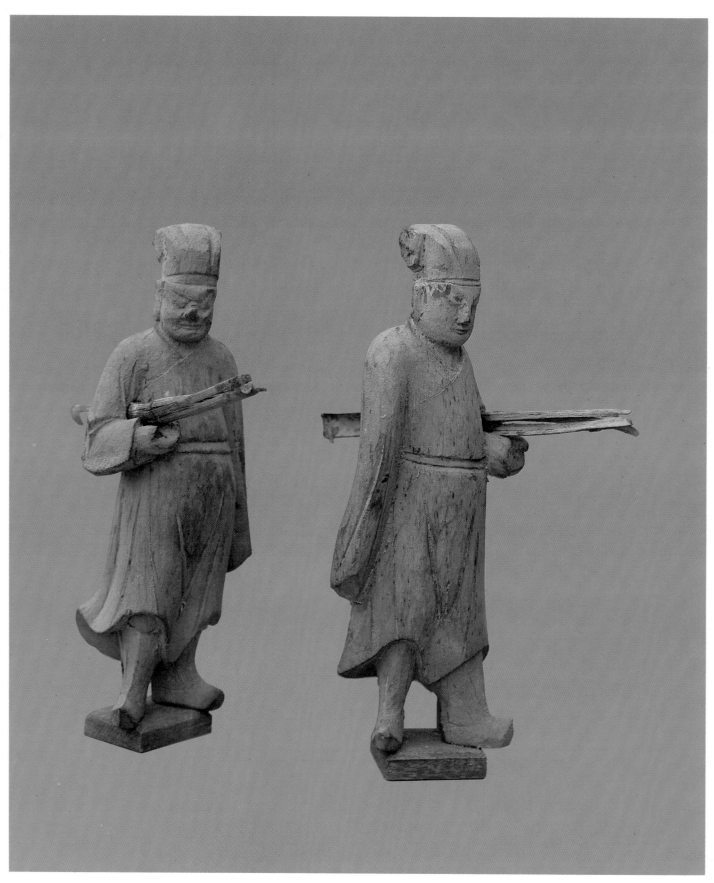

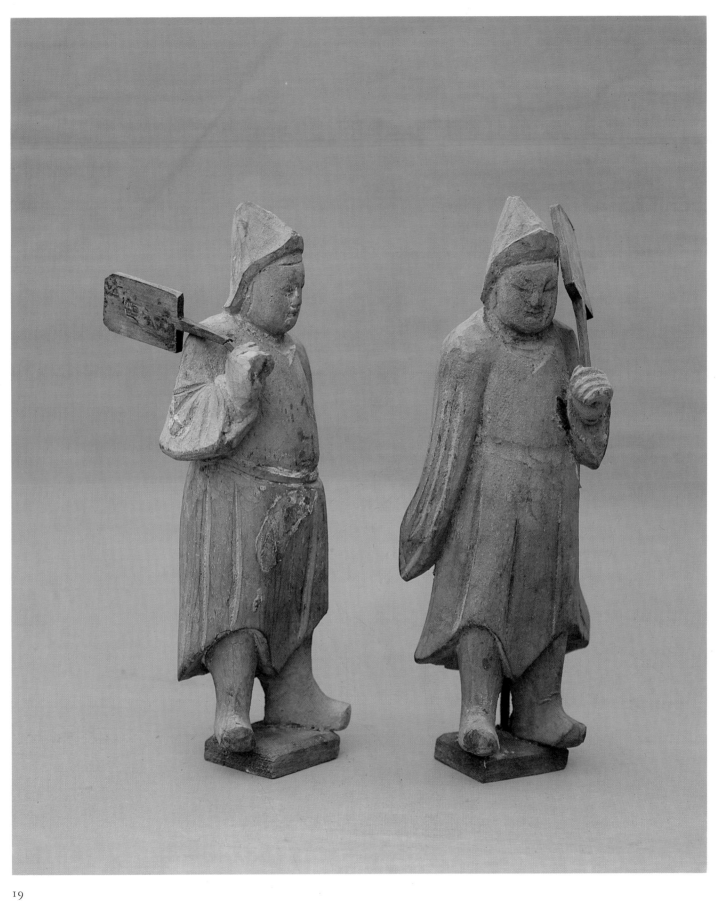

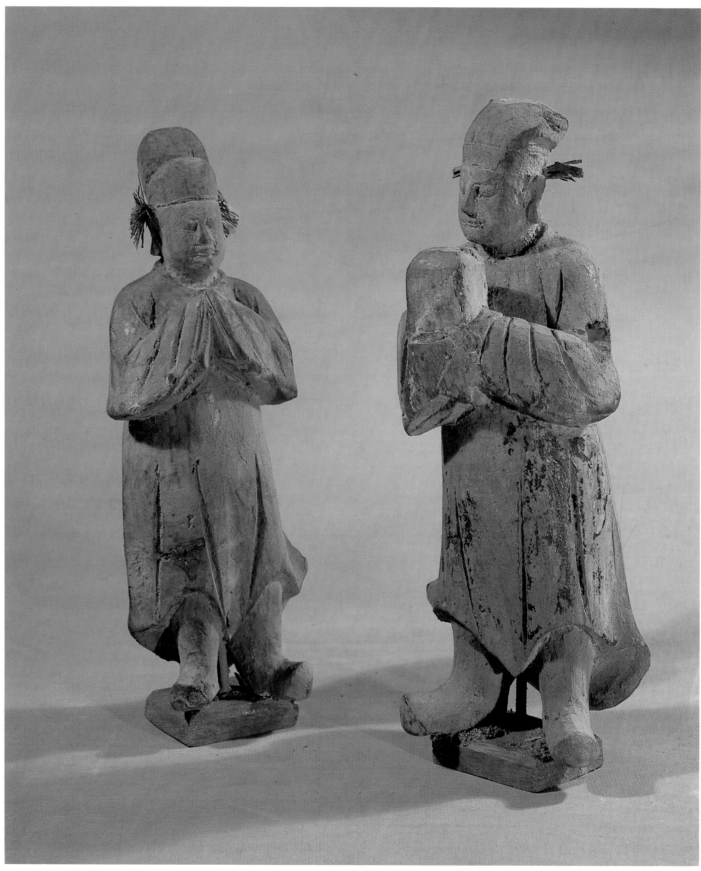

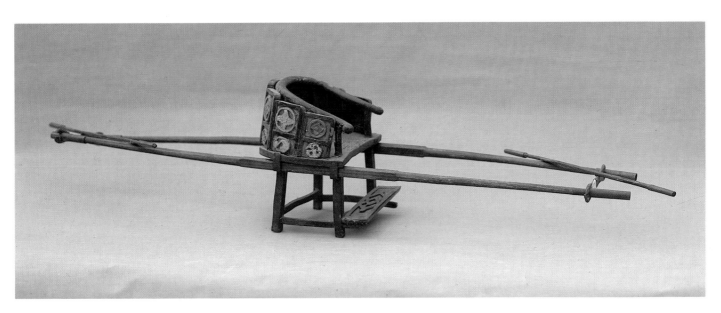

21

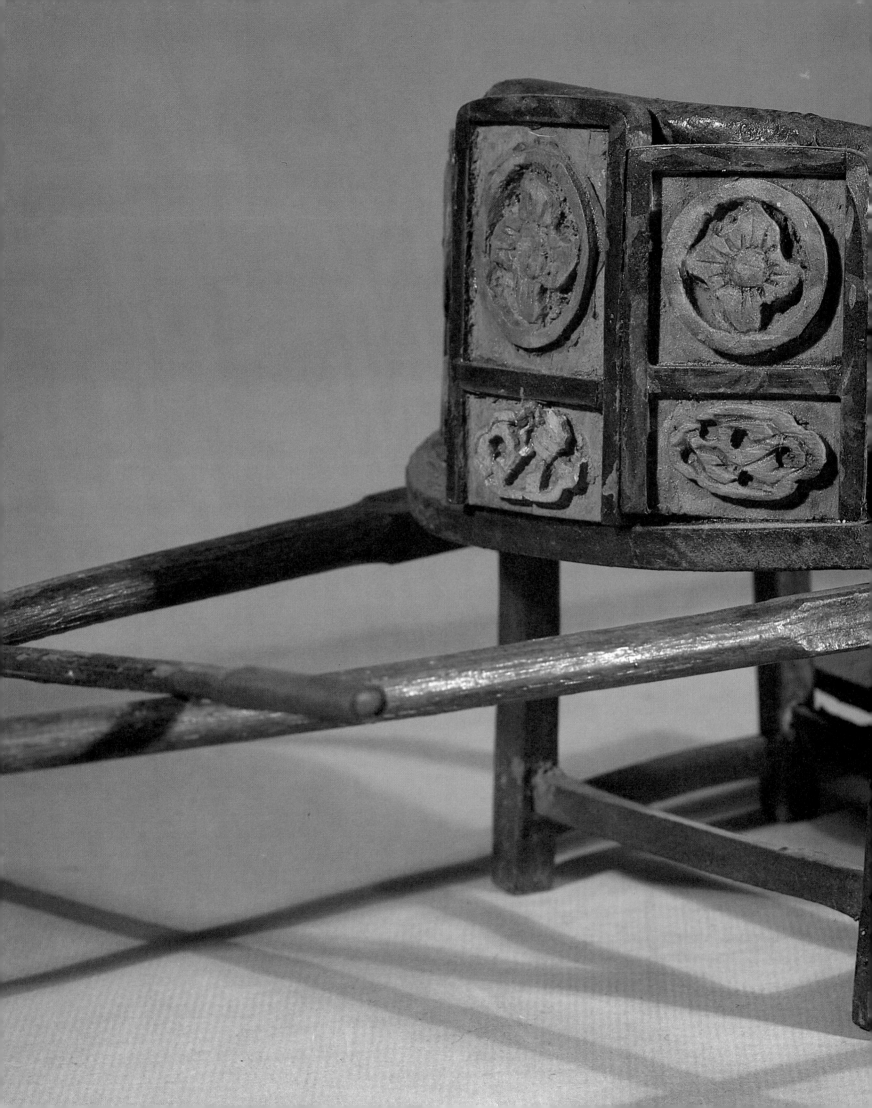

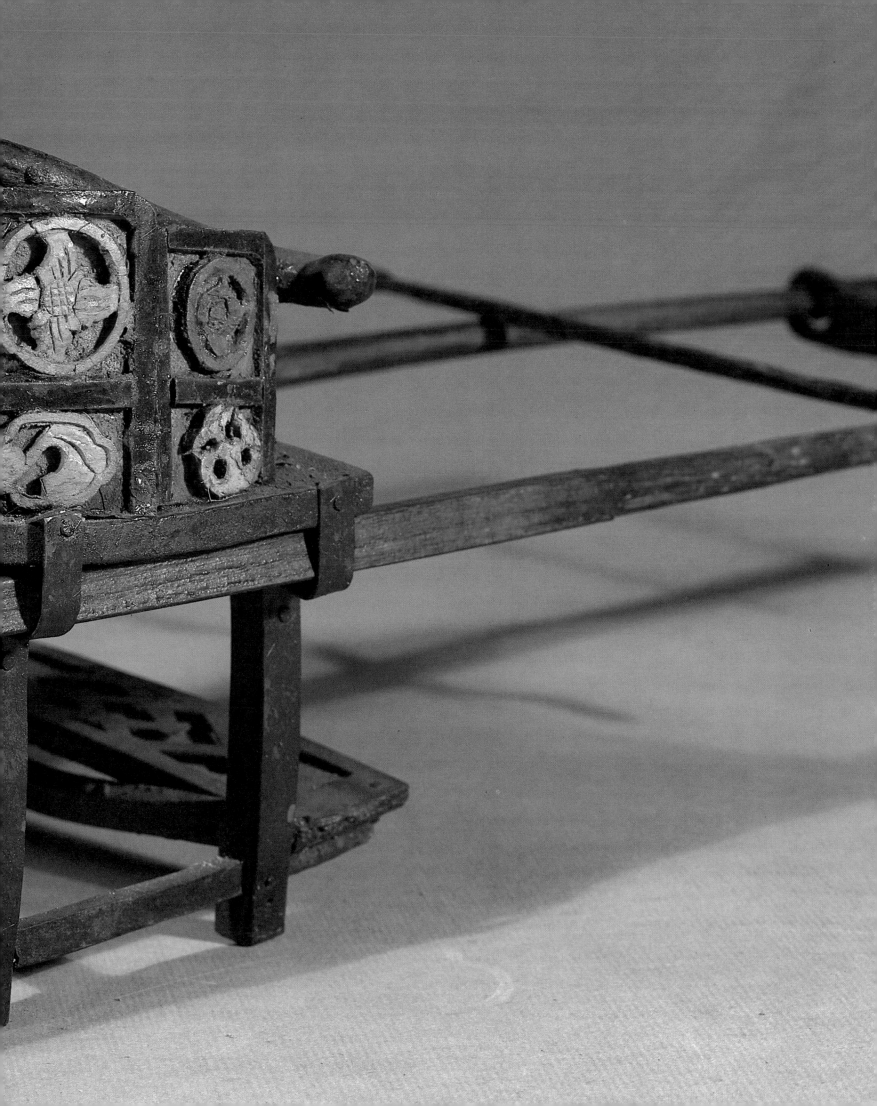

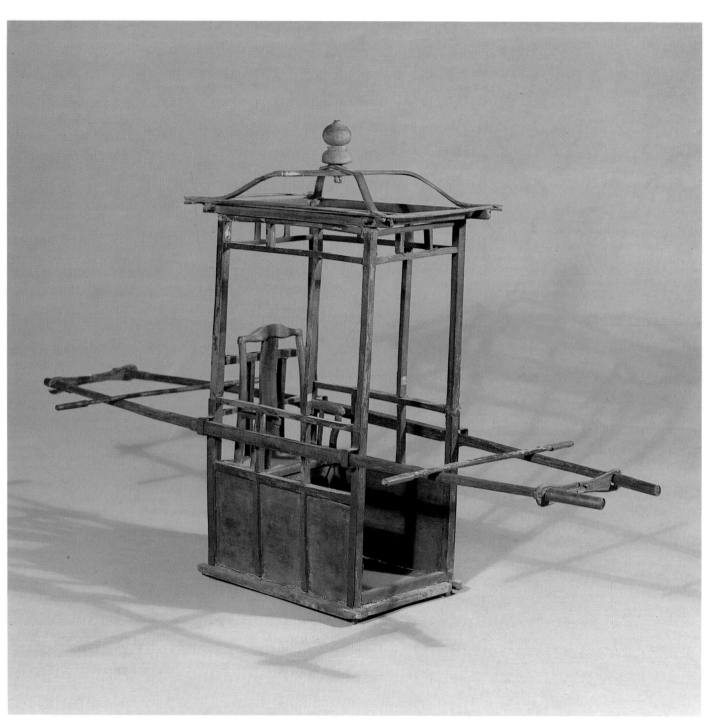

23

I

Red pottery *fu* (cooking vessel) with a broad ring and square handles.
Height: 24.5 cm. Diameter of mouth: 25.9 cm. Neolithic Period

The *fu* was a cooking vessel of China's early Neolithic Period. This *fu* was unearthed in 1974 from the lower stratum of Majiabang Culture at the Songze site in Shanghai's Qingpu County. The vessel is made of clay mixed with sand to prevent it from cracking when used in cooking. It was made by the method of coiling and its inner surface still shows traces of the coiled clay length. Its outer surface has been smoothed over and coated with a layer of reddish-brown clay. It has a pair of square handles at its neck and a broad ring encircling its shoulders for placing it over a cooking fire. This is a distinctive characteristic of vessels of this culture. Carbon 14 analysis of charcoal unearthed from the same stratum shows that this *fu* dates back 5,985 ± 140 years.

2

Jade *huang* (pendants).
Lengths: 7.9 cm., 13.7 cm., and 8.6 cm. Neolithic Period

The *huang* first appeared in the southeastern part of China and was worn as an ornament around the neck by women clan members in primitive society. In the Shang and Zhou Dynasties, it became an ornament worn by nobles. It gradually disappeared after the Western and Eastern Han Dynasties. The three *huang* shown here were unearthed in 1974 from the tombs of females in the middle stratum of Majiabang Culture at the Songze site in Shanghai's Qingpu County. They were found with the necks of the skeletons. Two of them are bow-shaped and the other is in the shape of a three-quarter moon. Both ends of the *huang* have a small hole with a worn-down groove caused by the attached cord. Carbon 14 analysis of the skeletons' bones reveals that they date back 5,180 ± 140 years.

3

Red pottery *ding* (cooking vessel) with flat legs and incised designs.
Height: 21.8 cm. Diameter of mouth: 31 cm. Neolithic Period

The pottery *ding* was a cooking vessel in the eastern part of China during the late Neolithic Period. It developed from the *fu,* which in very early times had to be placed on three stones when used for cooking. Later, a three-legged pottery stand replaced the often uneven stones. Finally, three legs were permanently attached to the *fu*'s bottom, to give rise to the *ding*. Unearthed in 1961 from a tomb in the middle stratum of the Songze site in Shanghai's Qingpu County, this *ding* belongs to the Majiabang Culture of the Songze Period. It is a beautiful vessel with a shallow belly, flared mouth, and three flat legs whose outer edges have wavelike serrations and their two sides incised with wedge-shaped patterns.

4 5

Pig-shaped gray pottery *yi* (ewer).
Height: 6.7 cm. Diameter of mouth: 12.5 cm. Neolithic Period

The pottery *yi* was a water container. Unearthed in 1974 from the middle stratum of the Songze site in Shanghai's Qingpu County, this *yi* is solidly made with a mouth, straight vertical walls, and slightly rounded bottom. On one side of the

mouth is a spout and near the bottom is a band of impressed prostrate S-shaped designs. When lying upside down, the *yi* looks like a fat pig, its spout serving as the animal's snout. The part reinforcing the spout's junction with the body of the vessel forms a long nose with eyes and ears on either side.

Highly imaginative in form, this vessel is an artifact of primitive society over 5,000 years ago and shows that the pig had already been domesticated.

6

Painted black pottery jar.
Height: 22.5 cm. Diameter of mouth: 11.7 cm. Neolithic Period

The earthenware jar was used in ancient times for storing grain. At the same time the art of painted pottery flourished in the Huanghe (Yellow) River valley in Neolithic China, another form of painted pottery prospered in the area by Taihu Lake. The latter differed from the former in that instead of painting the decoration onto the vessels before firing, the designs were painted on after firing. As such decorations were easily rubbed off, very few such painted designs have been preserved. This jar was unearthed in 1974 from a Songze Period Majiabang Culture tomb at the Songze site in Shanghai's Qingpu County. It has a turned-down rim, round belly, and slightly rounded bottom. Four upraised rings divide the upper part of the belly into four segments. The neck and the second and fourth segments are painted a reddish-brown color to give the whole vessel a balanced red-and-black color scheme which is most striking.

7

Stone plow.
Length: 15 cm. Width: 17.6 cm. Neolithic Period

The stone plow was used in farming by people of the Neolithic Period. This plow was unearthed in 1975 from the Guangfulin site in Songjiang County. Made by grinding down a piece of slate, it is triangular in shape with three holes for attaching it onto a wooden base. Except for the stone plow found in Qiucheng, Zhejiang Province, this is the oldest stone plow yet found in China and it is in excellent condition. It proves that over 4,000 years ago, during the Liangzhu Culture period, the plow was used in farming in the Taihu Lake area and it is an important piece of material for studying agricultural development in ancient China.

8

Red pottery *gui* (vessel for heating liquids).
Height: 24 cm. Neolithic Period

The pottery *gui* was a vessel for heating liquids; it was used in eastern China during the late Neolithic Period. This *gui* was unearthed in 1972 from the lower stratum of the Tinglin site in Shanghai's Jinshan County. It has a spout, formed by squeezing together two sides of the mouth, and three pouched legs which communicate with the body cavity and a loop-handle on the back of the belly. It is made of a mixture of clay and fine sand and is of an unusual shape. It developed from those strange *gui* with two pouched legs which were unearthed from the Hemudu site in Zhejiang Province. Carbon 14 analysis of charcoal from the same stratum shows that it dates back 4,200 ± 145 years.

9

Black pottery *hu* (drinking vessel) with wide handles and a lid.
Height: 15.4 cm. Neolithic Period

Four thousand years ago, in Neolithic times, the pottery *hu* served as a drinking vessel. This *hu* was unearthed in 1966 from a Laingzhu Culture tomb at the Maqiao site in Shanghai County. It was found near the neck of the skeleton. It has an oval mouth with one portion turned up to form a spout; its belly is barrel-shaped with a flat, wide handle on one side; its lid and handle each have two small holes so that they could be tied to each other. The vessel looks like a waterfowl standing erect and is charming in its simplicity.

10

Black pottery *he* (vessel for heating liquids).
Height: 18.2 cm. Neolithic Period

The pottery *he* was a vessel for heating liquids. This *he* is a typical vessel of the Neolithic Period's Liangzhu Culture and was unearthed in 1972 from the lower stratum of the Tinglin site in Shanghai's Jinshan County. The walls of this *he* are thin and even, only 0.13 centimeters thick. The upper part of the vessel is made of clay while the bottom half is of a mixture of clay and sand in a proportion which ensures the vessel would not crack on heating. The oval-shaped body has an oval mouth. It is simple and pleasing of appearance with a ring-shaped handle and columnlike legs.

11

Gray pottery *gui* (food vessel) with circle-and-dot design.
Height: 14.5 cm. Diameter of mouth: 19.5 cm. Shang Dynasty

The *gui* is a food vessel. This *gui* was unearthed in 1966 from the Impressed Geometric Design Pottery Culture stratum at the Siqiancun site in Shanghai's Qingpu County. It has a flat rim and deep belly and a trumpet-shaped foot rim. The belly is decorated with five bands of dotted circles. In shape and fabrication it is very much like the *gui* of the late Shang Dynasty which have been unearthed in China's Central Plain region. Dating back over 3,000 years, its discovery in the Shanghai area is evidence of mutual influence between Shang Culture and Impressed Geometric Design Pottery Culture.

12

Impressed geometric-design pottery *hu* (wine vessel) in the shape of a duck.
Height: 12 cm. Diameter of mouth: 5.6 cm. Shang Dynasty

Geometric design pottery gained fame for having all kinds of these designs stamped on the vessels; it is one category of earthenware in South China during the Shang and Zhou Dynasties. This *hu* was unearthed in 1960 from the middle stratum of the Maqiao site in Shanghai County. It is of unique form: a flaring mouth, a duck-shaped belly with a flat handle from the base of the neck to the tail, an elliptical base, and the whole vessel decorated with impressed basket-weave patterns. Its exquisite shape makes it look like a fat duck idly swimming. It is a typical example of early impressed geometric design pottery in China and depicts water animal life in the area of Taihu Lake. According to thermoluminescence tests of pottery shards from the same stratum, it dates back 3,250 \pm 10% years.

13

Impressed-design pottery *guan* (jar) with handle and stud feet.
Height: 11.6 cm. Diameter of mouth: 8 cm. Warring States Period

This jar was unearthed in 1964 from a Warring States Period tomb at the Qijiadun site in Shanghai's Jinshan County. It has a constricted mouth, a flat drum-shaped belly, and a flat base which has three stud feet. An exquisite wide belt-handle joins its shoulder and belly. The upper part of the handle is decorated with an animal-mask design while the body is covered with impressions of a small rhombic design. As it was fired at a fairly high temperature, the pottery is very hard and rings resonantly when struck lightly, so this kind of pottery was known as "hard pottery."

14

Yue ware lotus-flower porcelain *guan* (jar).
Height: 10.2 cm. Diameter of mouth: 6.5 cm. Five Dynasties Period

The Yue ware kilns were in the area of Shaoxing and Yuyao in Zhejiang Province and typical of them was the kiln at Shanglinhu in Yuyao. Yue ware are of fine clay and have rich, glossy glazes which give off various greenish-yellow or emerald-green hues. "With the descent of autumn winds and dew, Yue wares capture the emerald of a thousand peaks," was how the ancients praised the magnificence of Yue ware. The lotus-flower celadon jar was unearthed in 1974 during construction work at the No. 2 Middle School of Chengxiang Town in Shanghai's Songjiang County. The jar's mouth is introverted and the belly very ample. Its body is decorated with lotus patterns and the foot rim flares out. Well made and fired, the jar has a rich emerald-green color, making it look like a lotus flower floating on water—a refined and stately feeling. It is a masterpiece of Yue ware celadon of the Five Dynasties Period.

15

Brick screen panel carved with figures.
Height: 30 cm. Width: 22.7 cm. Song Dynasty

Brick carving has a time-honored history in Chinese sculpturing and carving. Themes are usually taken from opera stories and from paintings of birds and flowers.

This screen was unearthed in 1958 from the Song Dynasty tomb of a person named Zhang Wei who died in 1213 at Zhuxing Town in Shanghai County. The carving shows a Daoist (a traditional Chinese theme) dressed in a wide-sleeved Daoist robe and seated on a hillside looking very kindly. He has a *"ru-yi"* ("as you wish") in his hand with the usual Daoist halo framing his head. Beside him stands a Daoist boy-attendant holding a magic bowl with a tortoise in it symbolizing "longevity." Behind the Daoist is an evergreen pine tree with a crane standing by it. The picture is intended to convey a sense of quietness, tranquillity, and longevity. Six characters meaning "Should rocks crumble, men would replace them" are carved on the reverse side of the brick. This artifact is an example of Daoist art.

16

Gold phoenix hairpin.
Length: 17.5 cm. Song Dynasty

The hairpin was an ornament worn by women in ancient China. The phoenix was a mythical bird representing good fortune. This gold phoenix hairpin was unearthed in 1972 from the Song Dynasty tomb of a woman named Zou who died in 1224 and who was the wife of a man named Tan Sidao. The tomb was found in Yuepu Commune in Shanghai's Baoshan County. At the top of this long hairpin is a phoenix head and between its beak and comb is a beautiful peony. The long, slim feathers at the bird's neck are ruffled. The handle of the hairpin is decorated with an exquisite design of interlocked flowers. This is a masterpiece of gold ornaments by goldsmiths of the early thirteenth century.

17 18 19 20 21 22 23

Carved wooden ceremonial figurines.
Heights: 20–21 cm. Ming Dynasty

These carved wooden figurines were excavated in 1960 from the Ming Dynasty tomb of Pan Yuncheng, who died in 1589. He had held the post of an official of the sixth category, in charge of oil, salt, and other ingredients for the imperial kitchen. His tomb was found in Shanghai Municipality's Luwan District. Altogether 45 wooden figurines were found in his tomb. They consisted of 14 musicians, 4 ceremonial figures, 14 slaves, 2 attendant officials, 3 boy attendants, 8 sedan-chair porters, and both an open sedan chair and an enclosed sedan chair.

 This group of wooden ceremonial figurines presents a most awe-inspiring picture. Each character has a different expression and posture. Some are engrossed in blowing or striking their musical instruments as they clear the way for the official. Some are haughtily holding the signs "Silence" and "Get Out of the Way" or carrying bastinadoes. Some are attendants wearing official hats and carrying the official's seals. Some are sedan-chair porters with one hand supporting a pole on their shoulders while their other arm is hanging down. Seeing them, it is easy to imagine the pageantry of a Ming official setting out on a journey. Carved out of China fir, the knife strokes are clean and simple and show great masterliness. The features and dress of the figurines are remarkably duplicated, showing the creases and folds clearly. They are so realistic that they form a rare set of Ming Dynasty wood carvings.

Ceramics

TWO

Ceramics

Introduction by Wang Qingzheng

Chinese ceramic art has a long history. Pottery vessels dating back 7,000 to 8,000 years have been discovered in both the Huanghe (Yellow) and Changjiang (Yangtze) River valleys. Toward the end of primitive society in China, the art of pottery making was already highly developed and this led to the discovery of porcelain making.

The presence of pottery vessels in a region is generally an indication that mankind had reached the Neolithic Age there; but pottery making did not lead to the making of porcelain in all parts of the world. Porcelain making was the discovery of ancient China. Proto-porcelain was already made back in the Shang Dynasty (16th–11th century B.C.). In the Tang Dynasty (A.D. 618–907), if not earlier, with the improvement of production techniques and the increase of friendly contacts between the people of China and foreign countries, Chinese porcelain was shipped and sold overseas and China gradually became known in the world as "the home of porcelain."

Celadon was the main type of porcelain in ancient China. It used a small amount of iron oxide in the glaze for pigmentation so that when it was fired in a reduction kiln, the porcelain took on a beautiful green tint.

The proto-porcelain of the Shang and Western Zhou Dynasties and the Spring and Autumn Annals and Warring States Periods had a greenish-yellow glaze, because the skill in controlling the temperature in the reduction kiln had not been fully mastered and the body materials were not as fine as those in later periods. Figure 26 shows a Shang Dynasty green-glaze *zun* (wine vessel) with raised-line decoration. The earliness of its age, its perfect shape, and even the application of its glaze make it a highly prized piece of proto-porcelain.

During the period from the Han Dynasty to the Western and Eastern Jin and the Southern and Northern Dynasties, the production of celadon made great progress, especially in the area of what is now Zhejiang Province. The celadon ware of this period was stable in color and of lustrous beauty. The green-glaze tiger shown in this chapter is a typical example of proto-porcelain of the Western Jin Dynasty.

The Tang Dynasty, which lasted almost 300 years, was the heyday of feudal society in China. In this period, the ceramic wares produced were rich and variegated. Besides the highly esteemed celadon of the Yue kilns (the sites are in present-day Yuyao County and other areas in Zhejiang Province), which has been poetically described as having captured "the emerald of a thousand peaks," the white porcelain of the Xing kilns (the sites are in today's Handan City in Hebei Province), which has been praised as being "as white as silvery snow," and the painted porcelain of the Tongguan kilns (the sites are in today's Changsha City in Hunan Province), which initiated the technique of underglaze decorations, even more outstanding is the world-renowned "tricolored pottery" of the Tang Dynasty, a brilliant color-glaze pottery produced at low temperature which had developed from the lead-glaze pottery of the Han. A great number of examples of Tang Dynasty tricolored pottery can now be found in various countries in Europe and America, but some of them are replicas. The six pieces of Tang Dynasty tricolored pottery of different forms presented are photos of genuine works.

In the Song Dynasty, the art of porcelain making flourished as never before, with "a hundred flowers blossoming." The products of the Guan, Ge, Ru, Ding, and Jun kilns, long familiar to European scholars, are representative of the heights reached. The Ge ware porcelain vase with nipple-like studs and cylindrical ears shown in this chapter appears completely fragmented with what is known as "crackling." This decorative effect is deliberately obtained by making use of the difference in the coefficient of expansion of the glaze and the clay body in the course of firing. The Ding kilns in what is now Quyang County, Hebei Province, which greatly influenced the products of other kilns during the Song Dynasty, produced white porcelain Ding ware noted for its thinness, soft glaze, and perfection of shape. The white porcelain dish with impressed clouds-and-dragon design and with a silver-mounted rim, seen as Figure 43, is a prized item in the Shanghai Museum's Ding ware collection. The main achievement of the Jun kilns (in present-day Yu Xian County, Henan Province) was the use of copper oxide as pigmentation to produce a lustrous red glaze when fired in a reduction kiln. The Jun wares were the earliest examples in China of high-temperature copper-red glaze, and of using both copper and iron as pigmentation. Such wares often show a beautiful blue color tinged with red, so-called flambé, which was not easy for man to control.

Apart from the five famous large kiln groups, folk kilns were found in all parts of northern and southern China in the Song Dynasty. Of these, the Longquan kilns (in today's Longquan County, Zhejiang Province) were famous for making celadon. The glaze on Longquan ware of the Southern Song Dynasty has a luster like that of jade and a plum-green color. The products of the Cizhou kilns, the sites of which were found in Handan, Hebei Province, were typical of the folk kilns in northern China in the Song Dynasty. Their lively black decorations on a white-glaze ground were the main trend of folk kilns in northern China. The Bacun ware vase with black decorations on a white-glaze ground, Figure 45, was a product of the Cizhou kilns located in Yu-xian County, Henan Province.

The Yuan Dynasty occupies a prominent place in the history of Chinese porcelain. The blue-and-white wares of Jingdezhen heralded a new age in the annals of ceramics. Although there were underglaze and overglaze porcelains in China before the Yuan Dynasty, the bulk of them were of green, white, and black glaze. It was only from the time of the Yuan that polychrome porcelain became the main trend in Chinese porcelain.

The blue decoration on blue-and-white porcelain was obtained by painting the raw body with cobalt oxide, then applying a coat of clear glaze before a single firing at an approximate temperature of 1,300° C. Since the decoration was painted on before glazing, the products were known as underglaze porcelain.

Polychrome porcelain was obtained by painting with various colors on white-glaze porcelain and then firing for a second time at a low temperature of 800° to 900° C. Since the colors were on the glaze, the product of this process was known as overglaze porcelain. The combination of blue-and-white underglaze and polychrome overglaze was known as *dou cai* (contrasting colors).

Blue-and-white porcelain was the main product of Jingdezhen during the Ming and Qing Dynasties. The most outstanding pieces were made in the early Ming Dynasty during the reigns of Yong Le (A.D. 1403–1424) and Xuan De (A.D. 1426–1435).

In the Ming Dynasty, very few polychrome overglaze porcelains were produced but there were many of polychrome overglaze combined with blue-and-white underglaze—what are generally termed *dou cai*, or contrasting colors. The most famous Ming Dynasty *dou cai* were made in the reign of Cheng Hua (A.D. 1465–1487).

In the Qing Dynasty the art of ceramics reached another glorious age during the reigns of Kang Xi (A.D. 1662–1722), Yong Zheng (A.D. 1723–1735), and Qian Long (A.D. 1736–1795).

In the Kang Xi period, the skill in making monochrome glazes, such as copper-red and cobalt-blue, at high temperature was improved and the making of overglaze polychrome—red, yellow, blue, green, and purple—saw even greater advances with the use of overglaze blue instead of underglaze blue-and-white. Toward the end of the reign of Kang Xi, the Jingdezhen potters invented famille rose, so-called "glass-white glaze," by adding arsenic to the lead-based vitrified petuntse

to produce a delightfully soft color tone. Famille-rose porcelain of the Yong Zheng period is quite famous and was a notable Qing Dynasty achievement in overglaze decoration.

Jingdezhen porcelains in the Ming and Qing Dynasties were not only for the domestic market. They were also sold to other Asian and European countries. In collections in Iran, Turkey, Japan, and countries in Europe and America, the blue-and-white, polychrome, *dou cai,* famille-rose, and other painted glaze porcelains of the Yuan, Ming, and Qing Dynasties are mainly products of Jingdezhen. Since the 14th century, Jingdezhen has been hailed as China's "porcelain capital."

In modern China, porcelain is made in all provinces throughout the country. The kilns of Liling in Hunan Province, Tangshan and Handan in Hebei Province, Liubo in Shandong Province, Yixing in Jiangsu Province, Shiwan in Guangdong Province, and Dehua in Fujian Province are particularly famous. But, as shown herein, the Jingdezhen porcelain, with its very thin body, pureness of glaze, and exquisite workmanship, has enabled Jingdezhen to retain its honor of being China's porcelain capital.

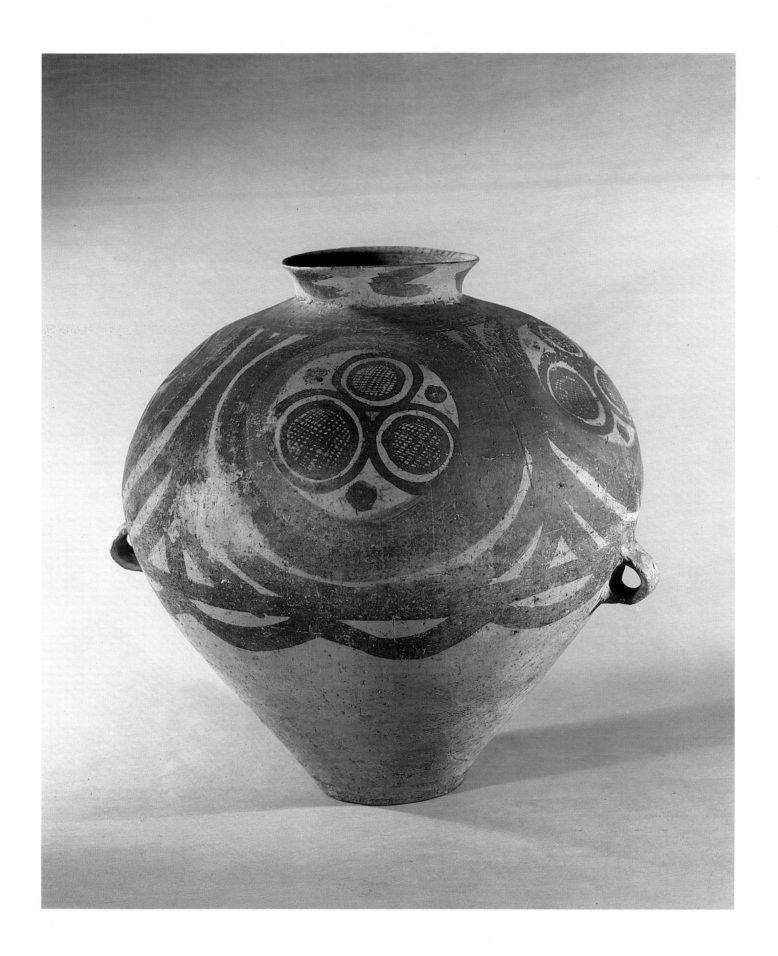

24 Painted pottery pot with four circles of netlike designs.
Neolithic Period

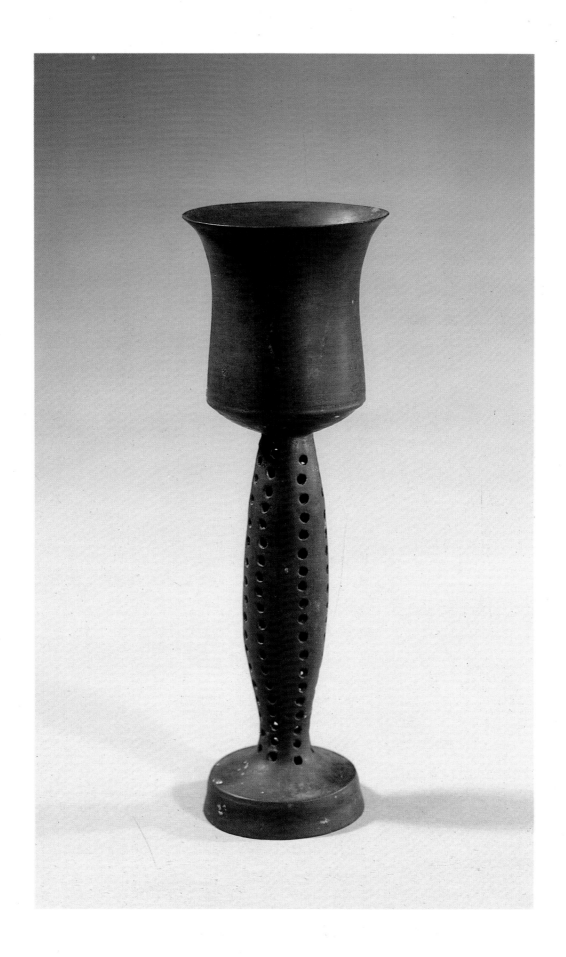

25 Black pottery cup with openwork high stem.
Neolithic Period

26 Green-glaze proto-porcelain *zun* (wine vessel) with raised-line decoration.
Shang Dynasty

27　Green-glaze proto-porcelain *ding* (cooking vessel) decorated with a dragon head.
Warring States Period

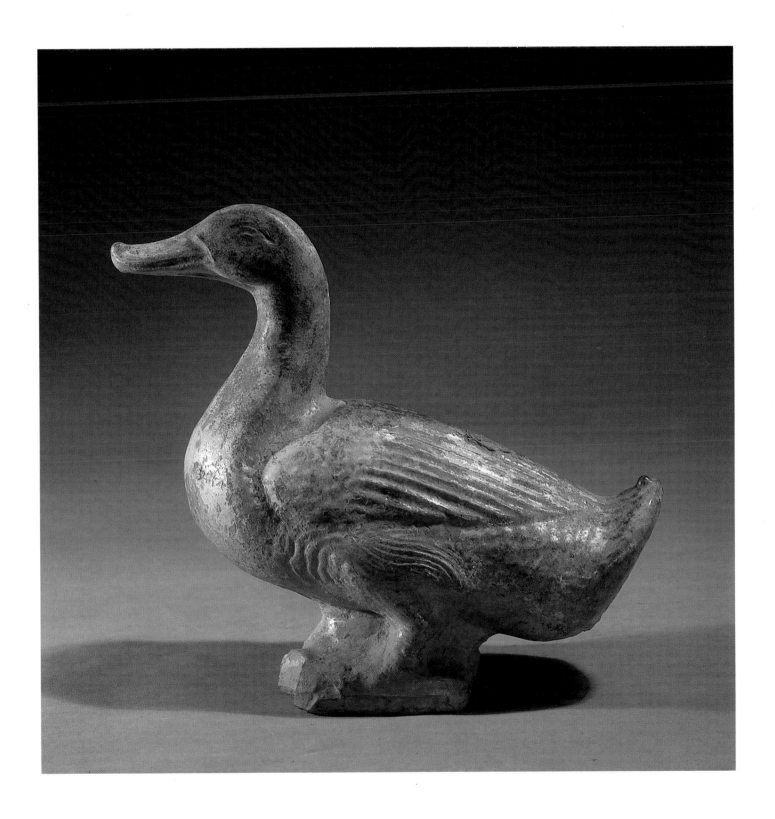

28 Green-glaze pottery duck.
Han Dynasty

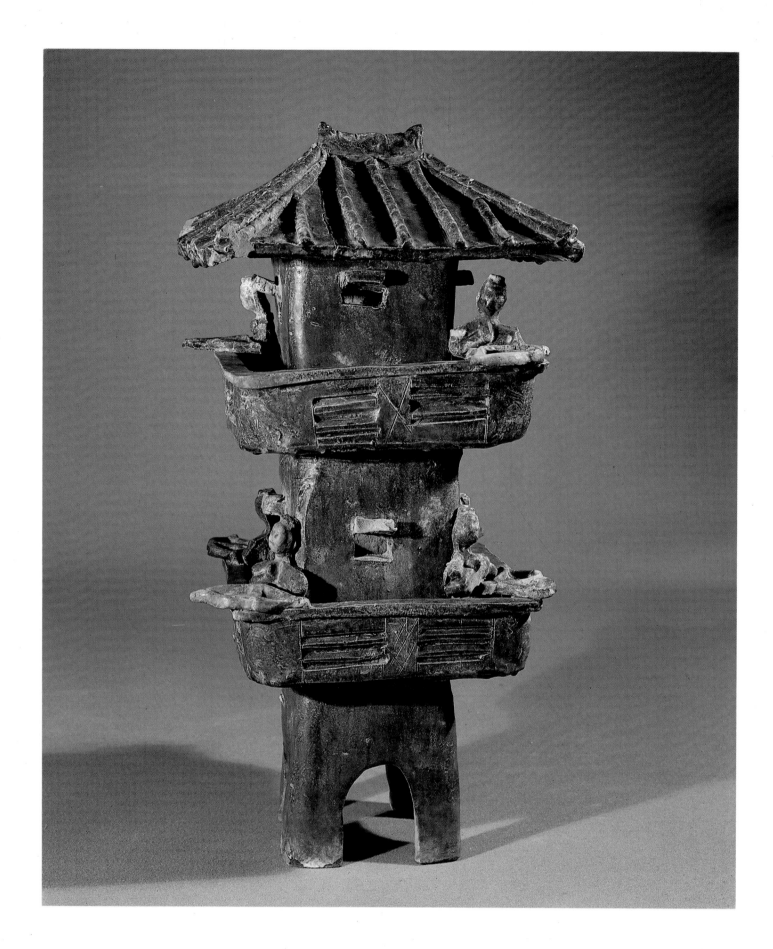

29 Green-glaze pottery watchtower.
Han Dynasty

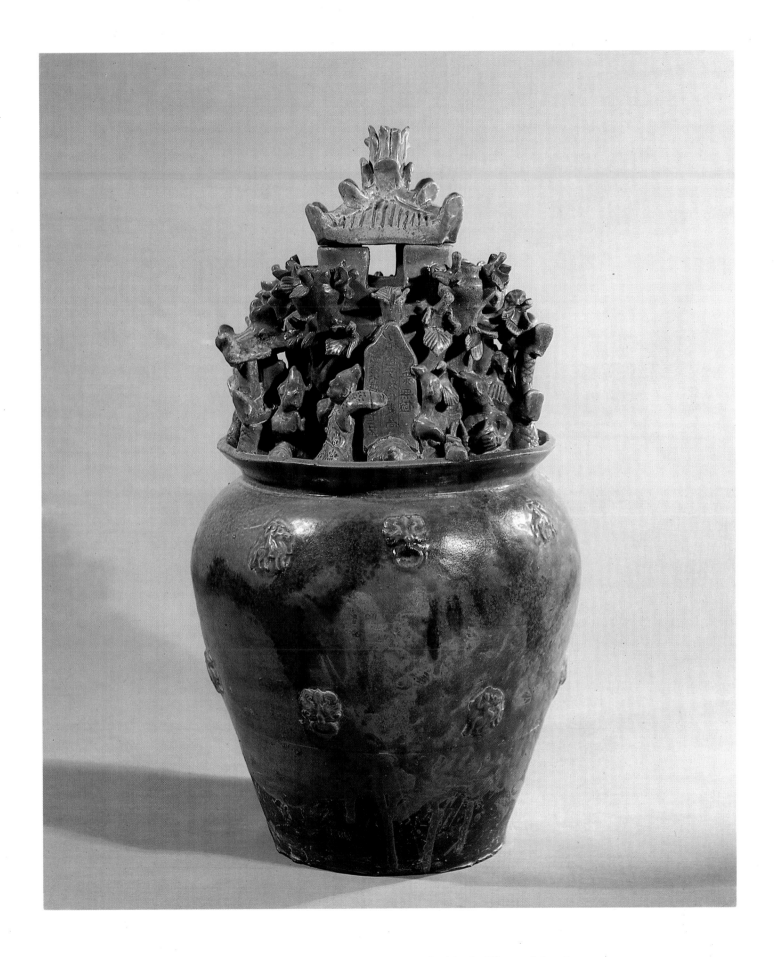

30 Green-glaze proto-porcelain jar crowned with a building and figurines.
Western Jin Dynasty

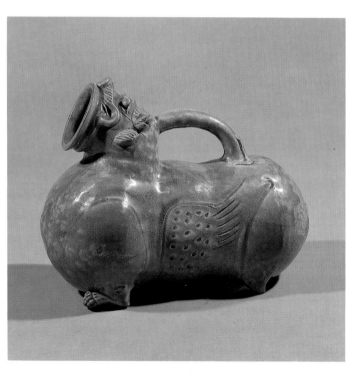

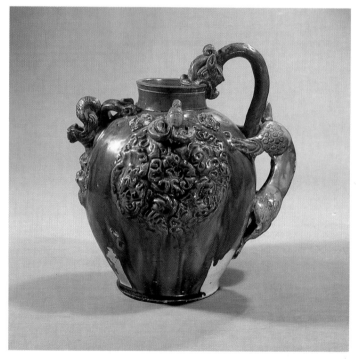

31 Green-glaze proto-porcelain tiger.
Western Jin Dynasty

32 Color-glaze pottery *hu* (wine vessel) decorated with
embossed floral patterns and dragon heads.
Tang Dynasty

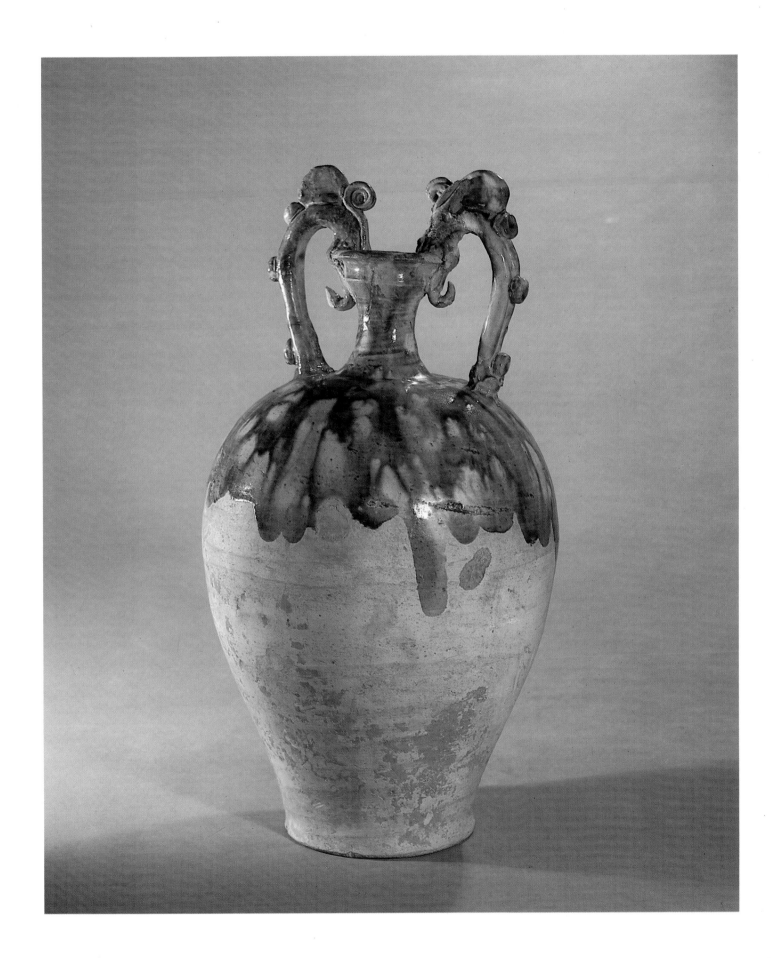

33 Tricolored pottery *zun* (wine vessel) decorated with two dragons.
Tang Dynasty

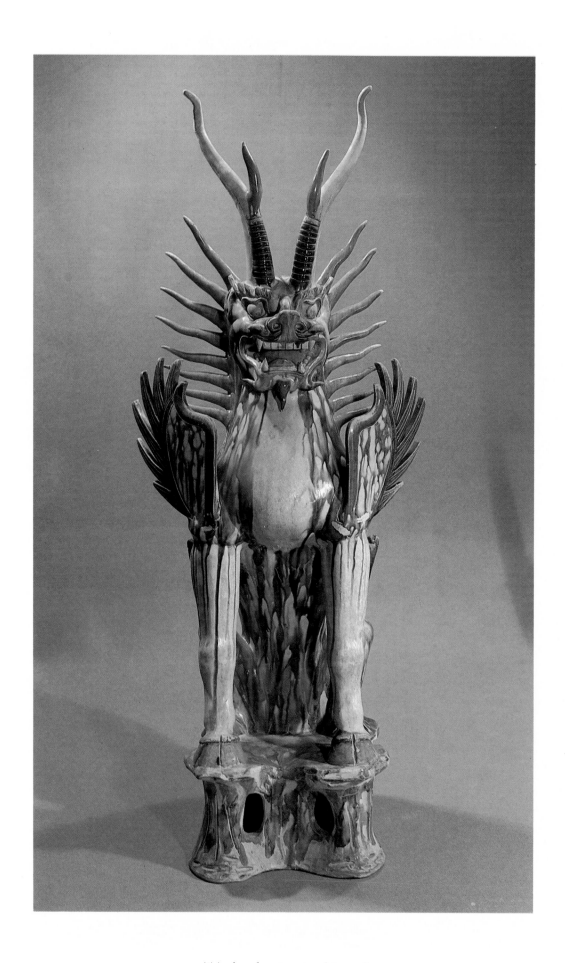

34 Tricolored pottery tomb-guardian.
Tang Dynasty

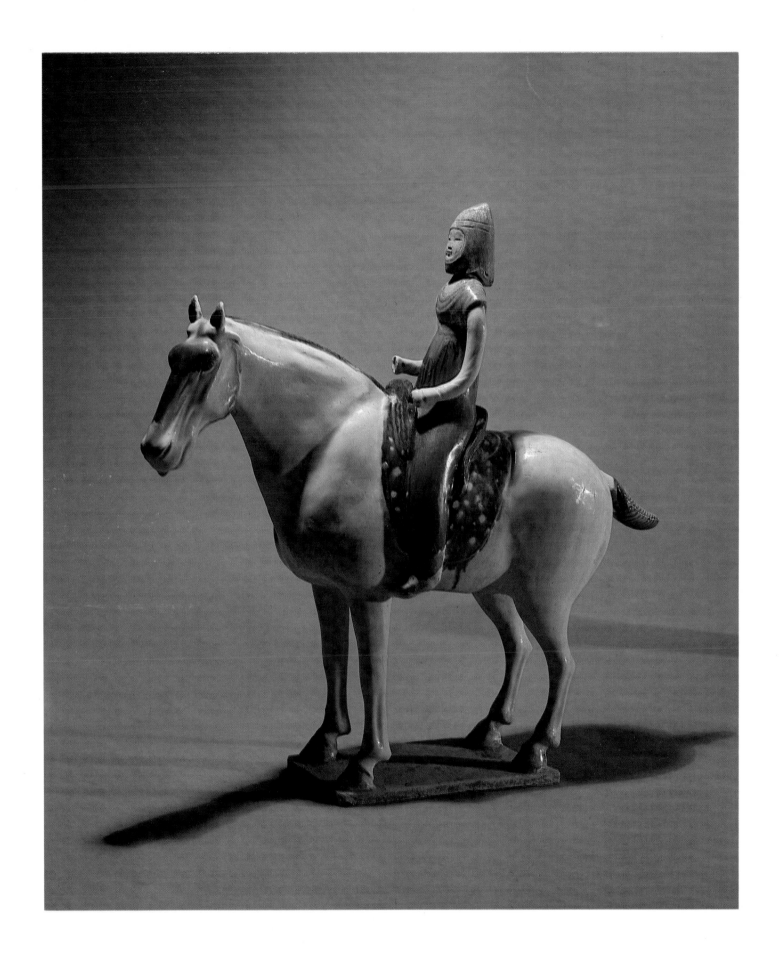

35 Tricolored pottery figurine of a mounted woman.
Tang Dynasty

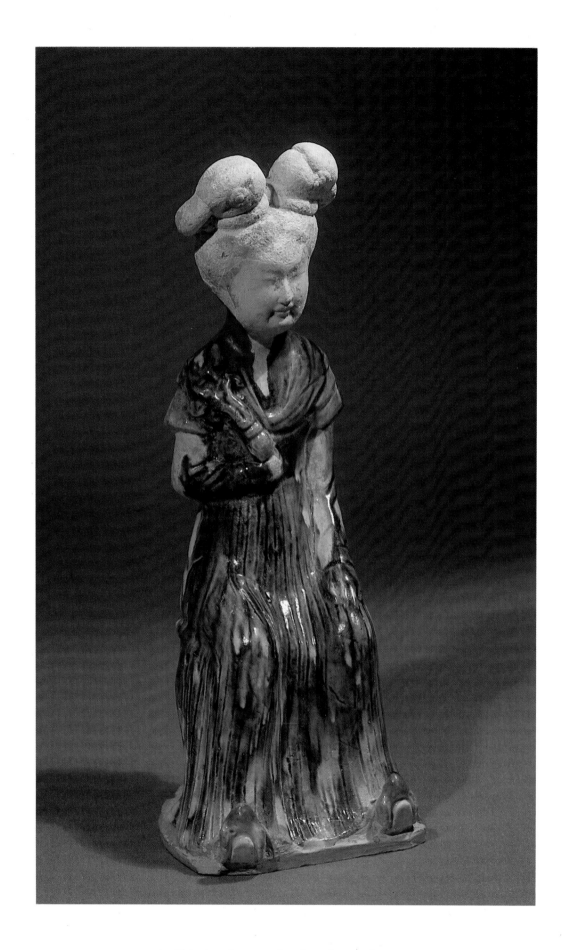

36 Tricolored pottery figurine of a seated woman.
Tang Dynasty

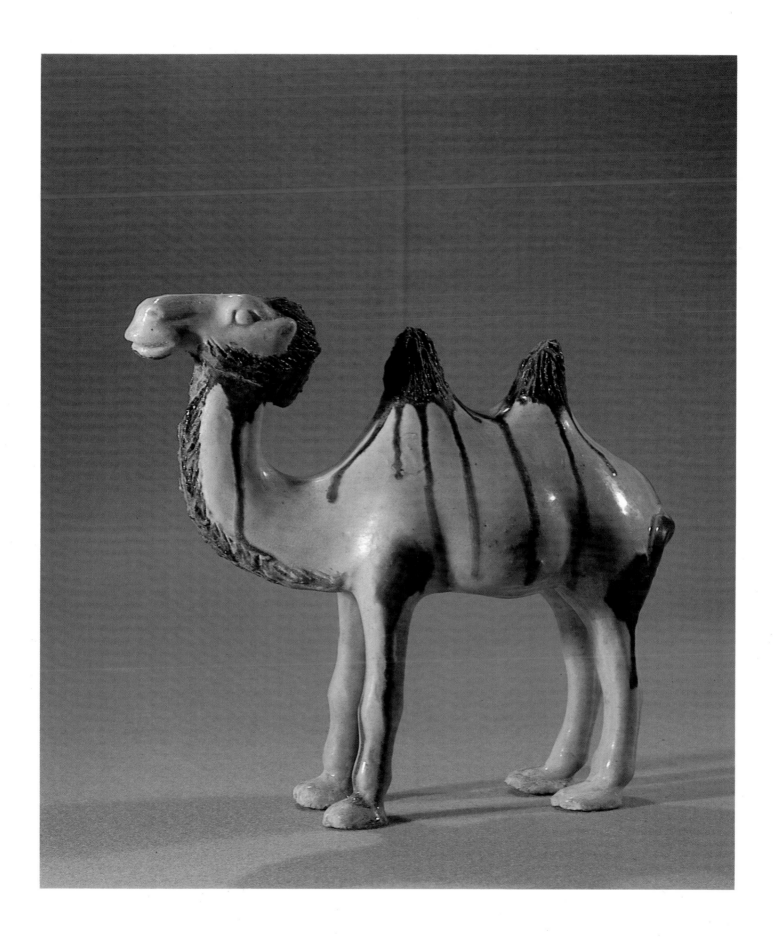

37 Tricolored pottery camel.
Tang Dynasty

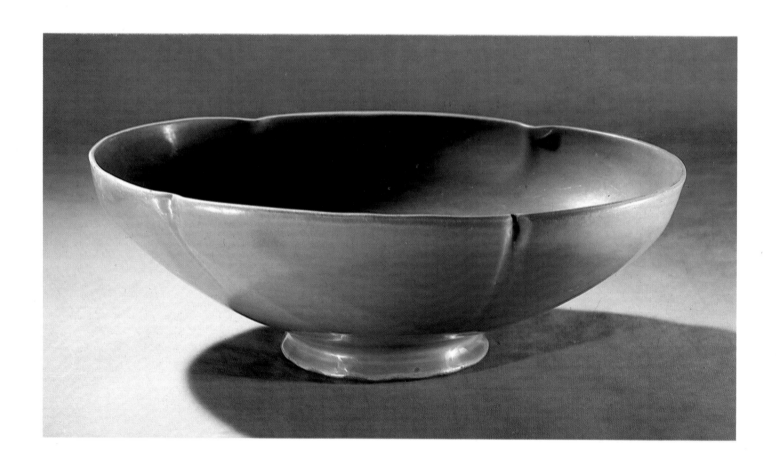

38 Yue ware begonia-shaped porcelain bowl.
Tang Dynasty

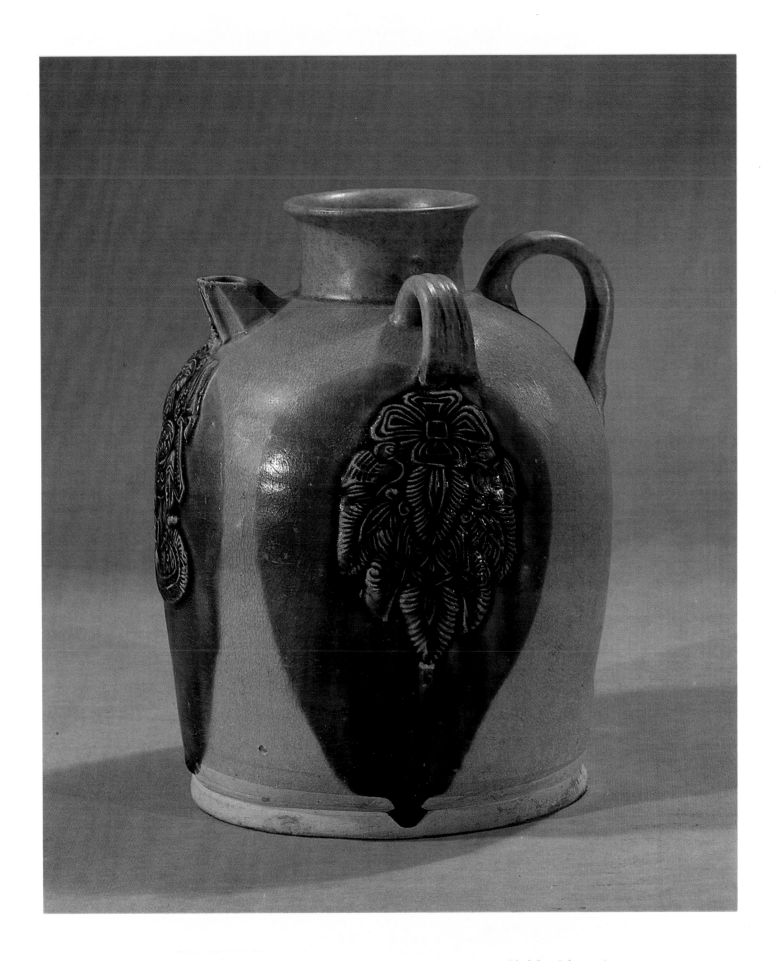

39 Changsha ware brown-green glaze porcelain *hu* (ewer) with molded floral decoration.
Tang Dynasty

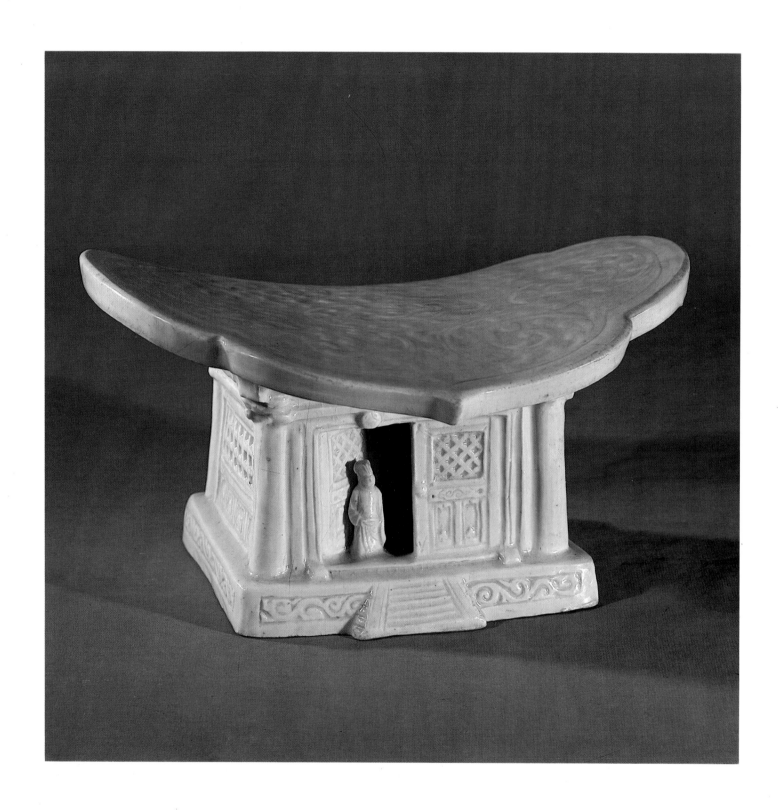

40 White porcelain pillow with openwork hall-building and figurine.
Five Dynasties Period

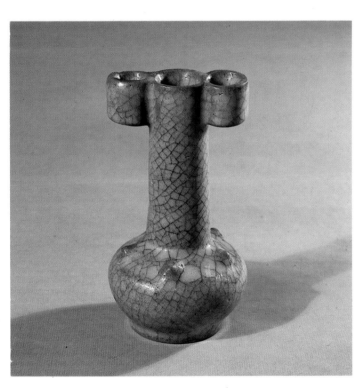

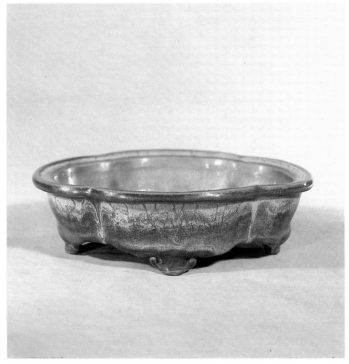

41 Ge ware porcelain vase with nipple-like studs
and cylindrical ears.
Song Dynasty

42 Jun ware porcelain basin in the shape of a begonia.
Song Dynasty

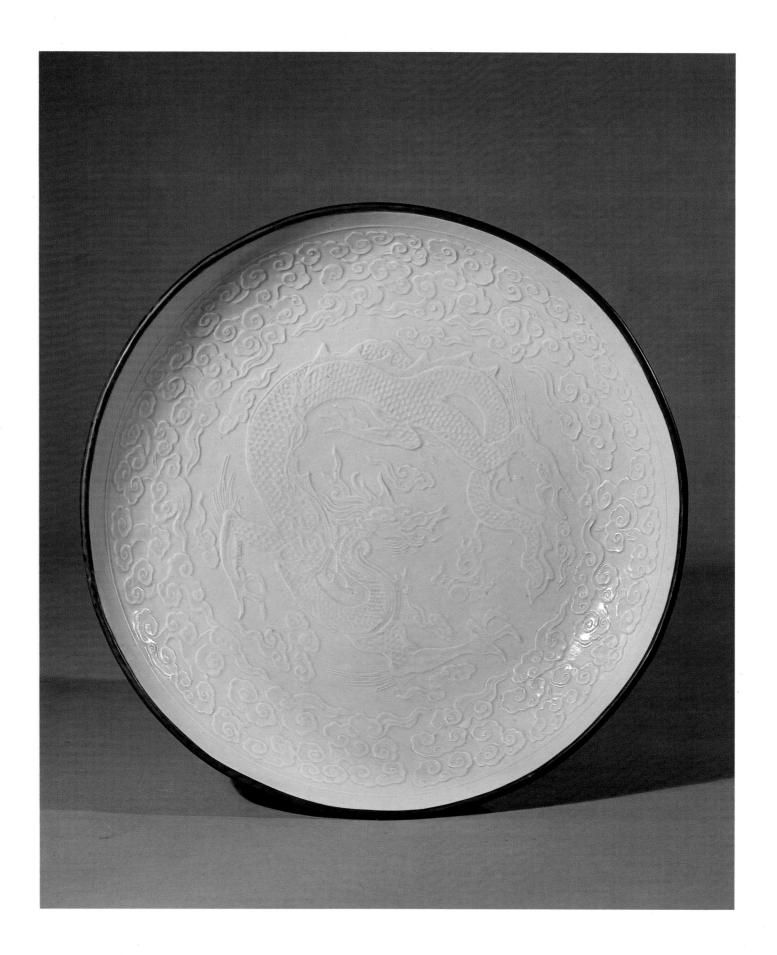

43 Ding ware porcelain dish with impressed clouds-and-dragon design and a silver-mounted rim.
Song Dynasty

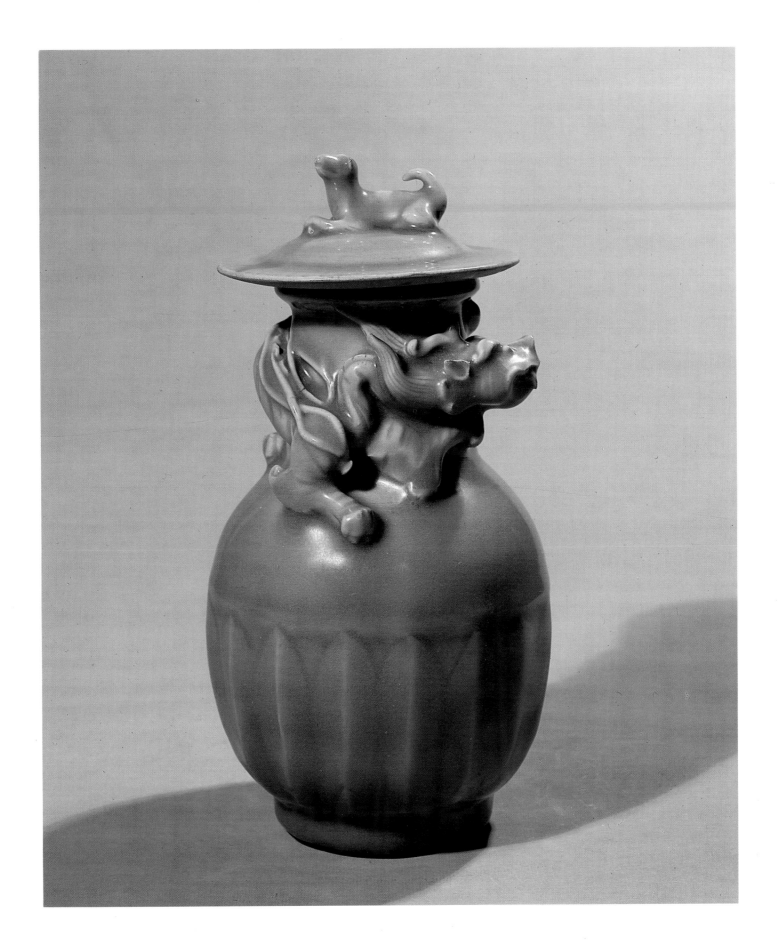

44 Longquan ware covered jar in the shape of a lotus flower with molded coiled dragon.
Southern Song Dynasty

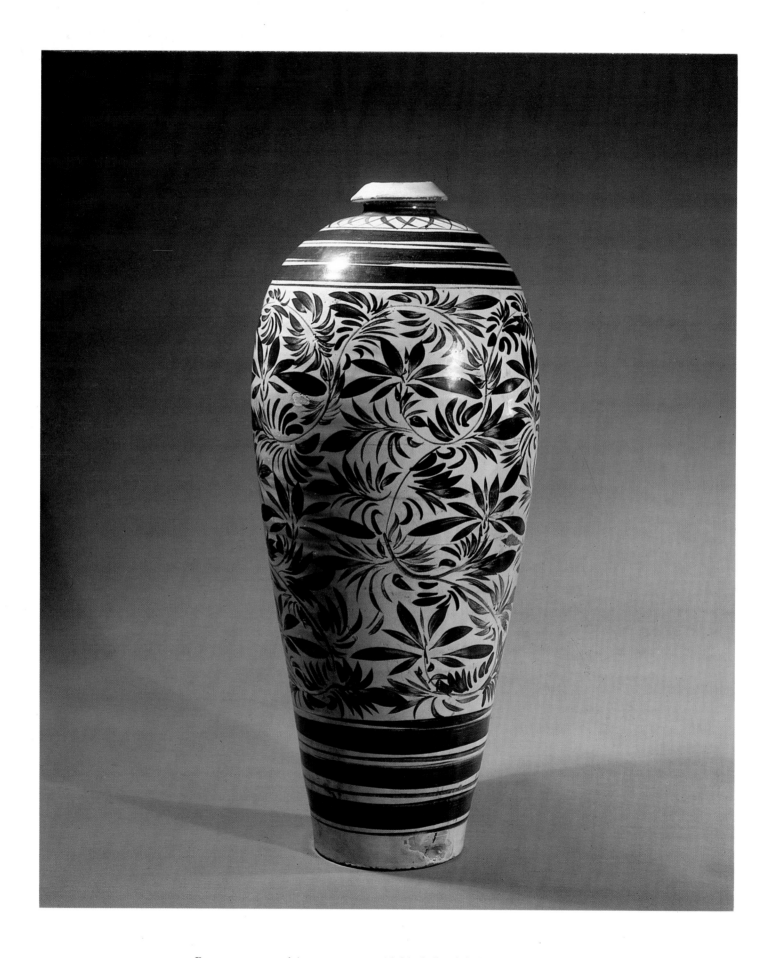

45 Bacun ware porcelain prunus vase with black floral designs on a white ground.
Song Dynasty

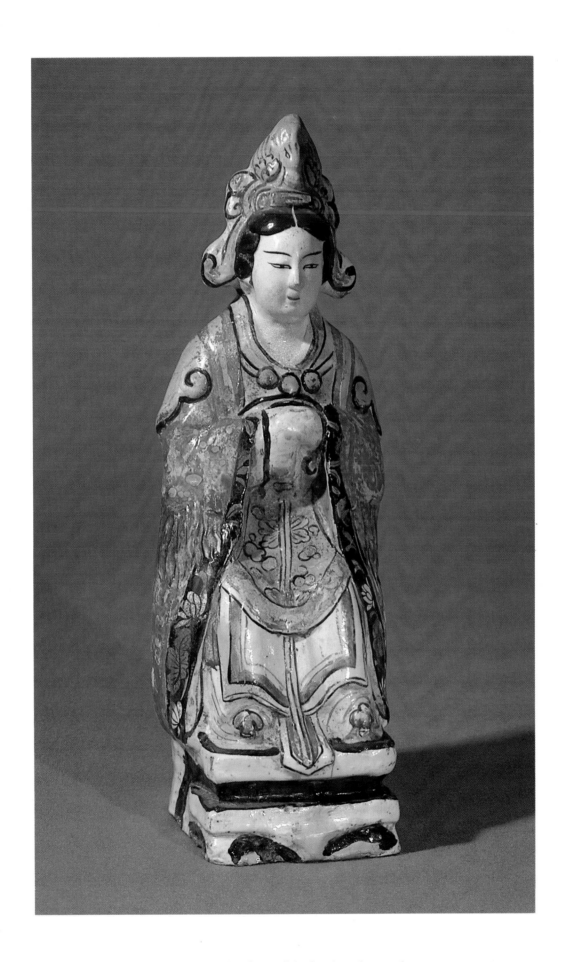

46 Bacun ware painted porcelain figurine of a seated woman.
Song Dynasty

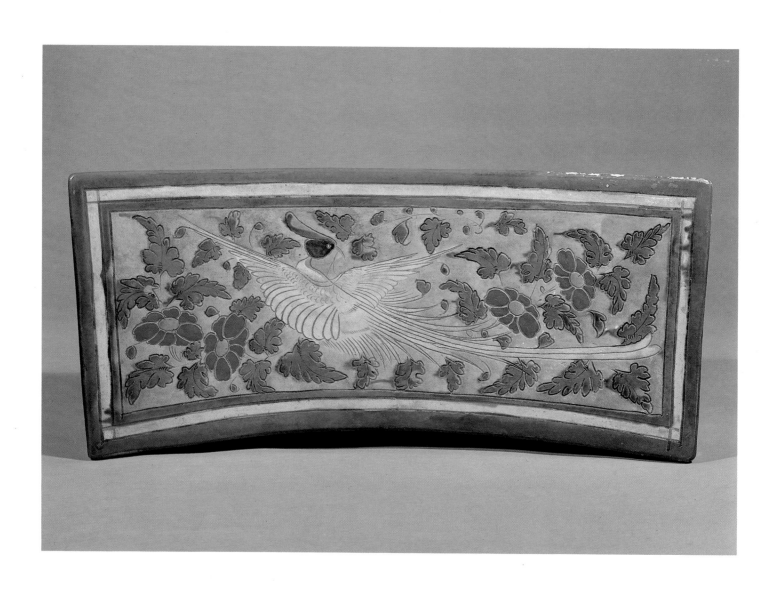

47 Color-glaze porcelain pillow engraved with flower-and-bird design.
Song Dynasty

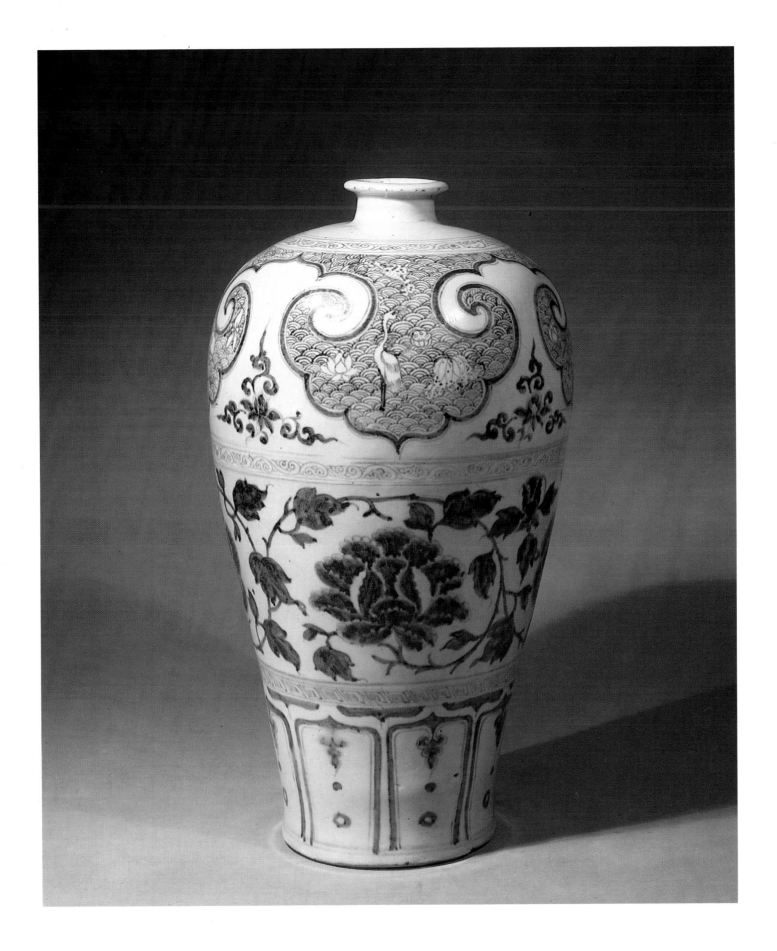

48 Jingde ware blue-and-white porcelain vase decorated with interlaced sprigs of peonies.
Yuan Dynasty

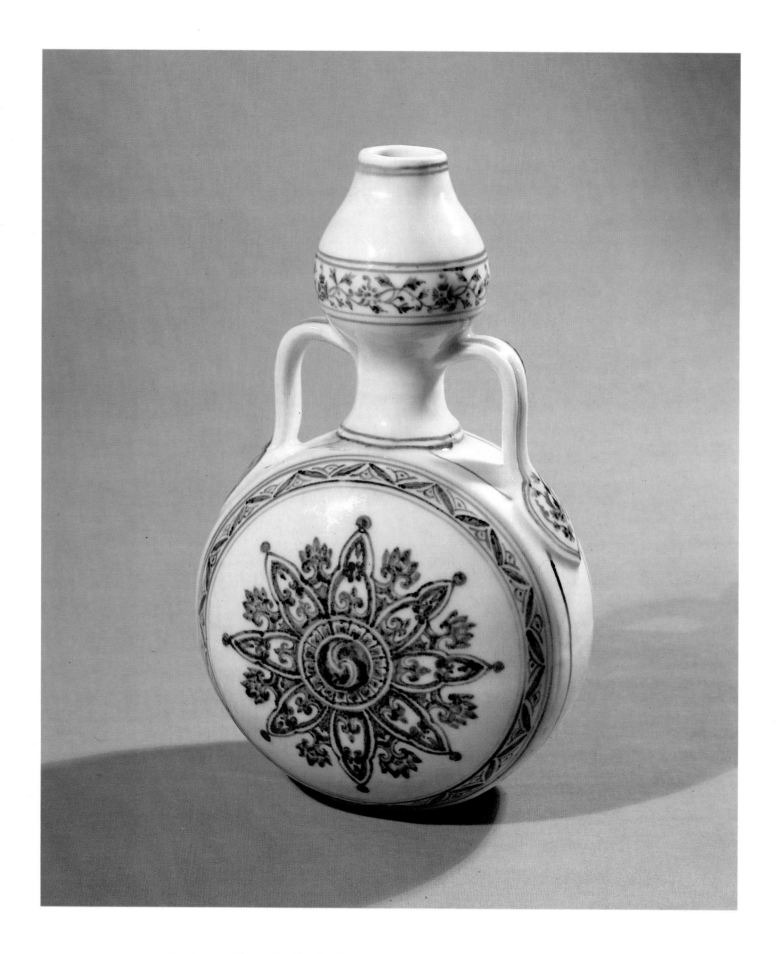

49 Jingde ware blue-and-white flat flask with two ears and decorated with Indian lotus motif.
Ming Dynasty

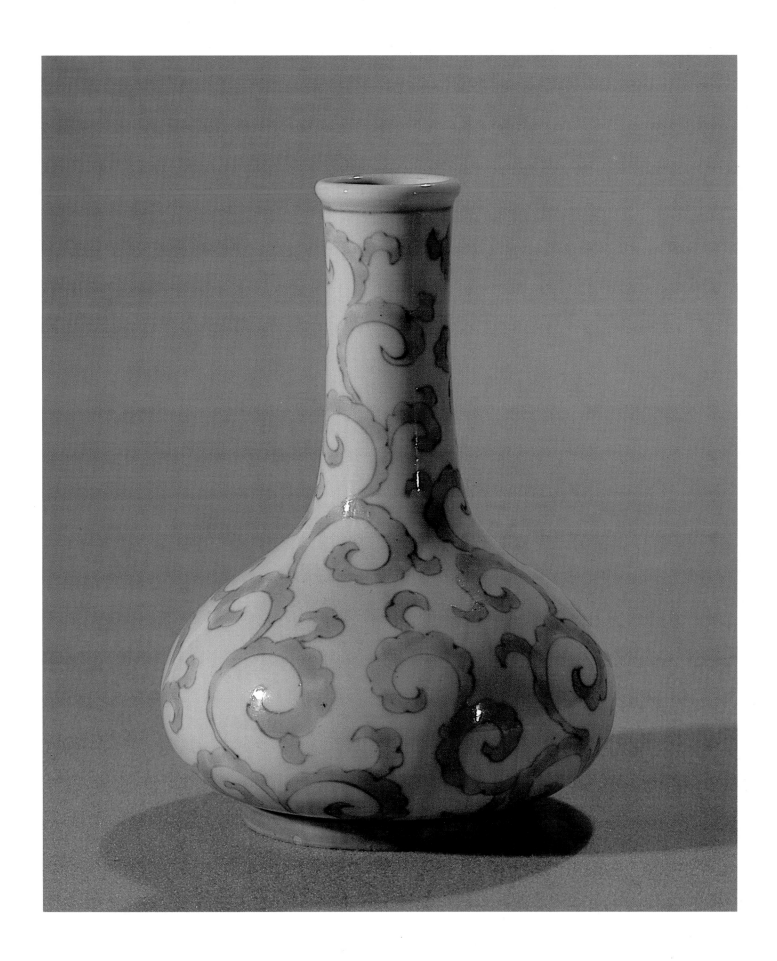

50 Jingde ware porcelain flask with contrasting-color designs of plant tendrils.
Ming Dynasty

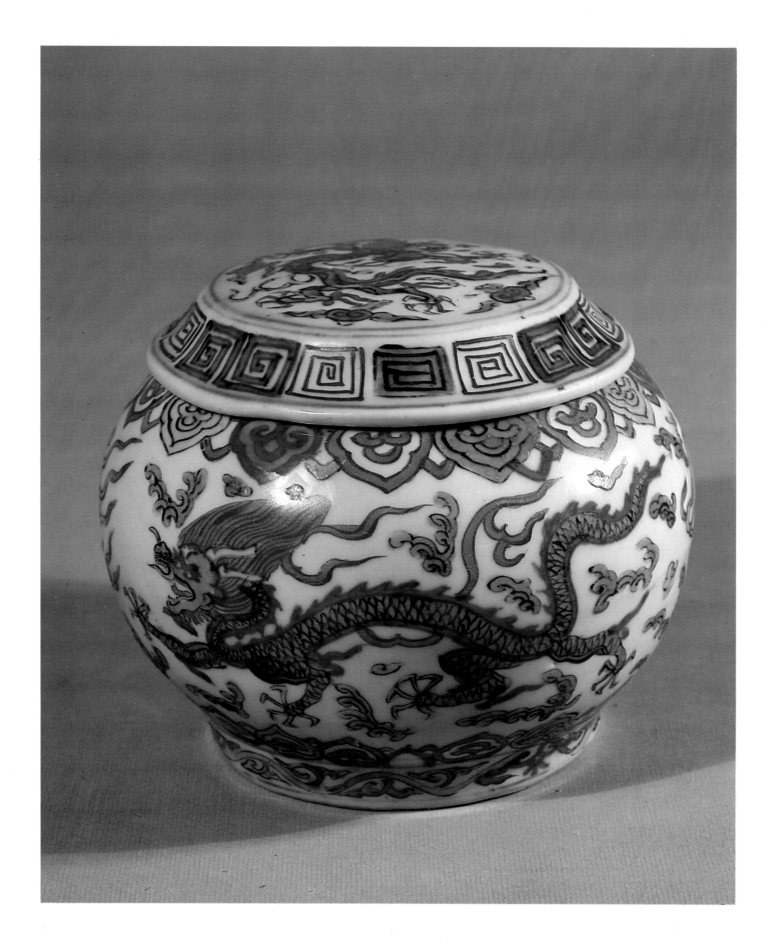

51　Jingde ware polychrome covered porcelain jar with clouds-and-dragon designs.
Ming Dynasty

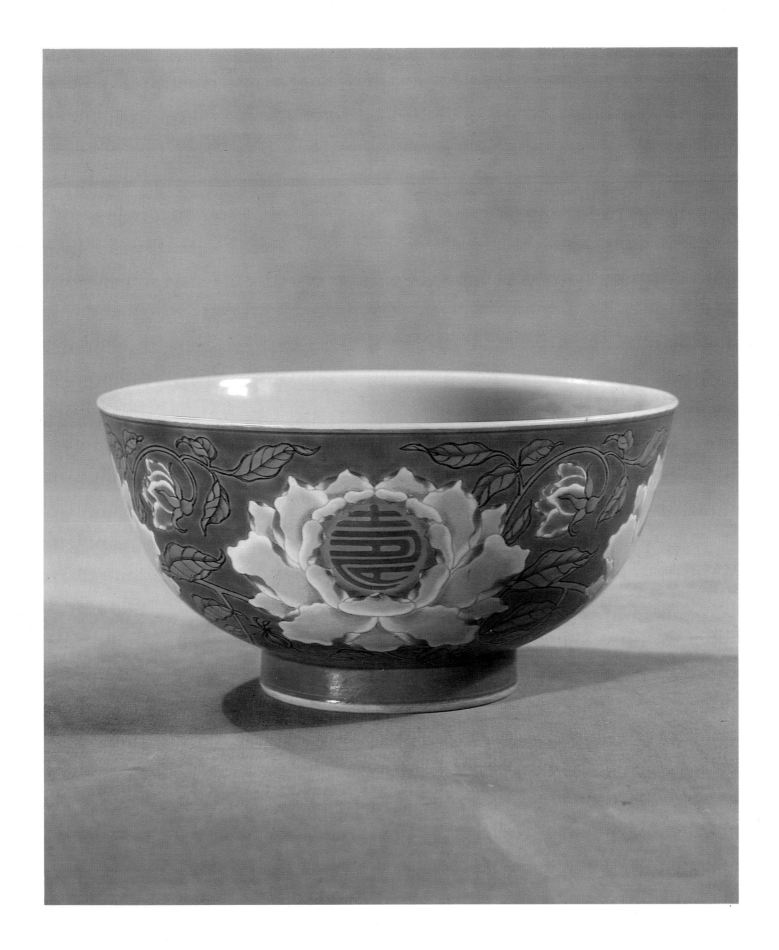

52 Painted-enamel porcelain bowl decorated with interlaced sprigs of peony.
Qing Dynasty

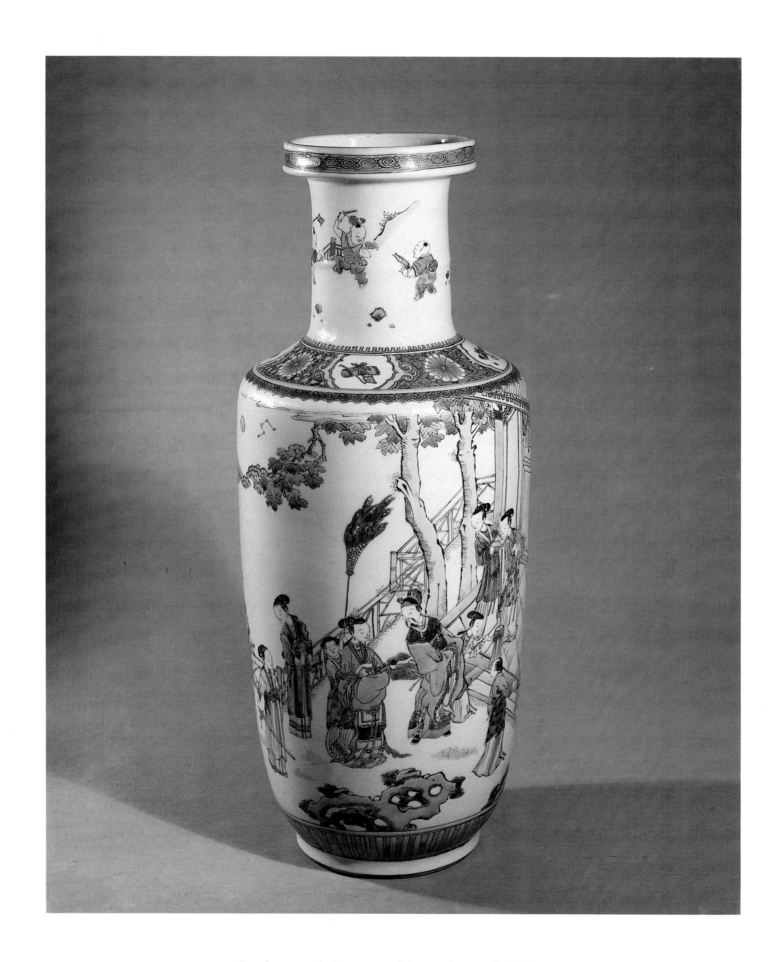

53 Jingde ware polychrome porcelain vase decorated with figures.
Qing Dynasty

54 Jingde ware lobed porcelain vase decorated with famille-rose flowers and birds.
Qing Dynasty

55 Porcelain vase with enamel-color figurines.
Qing Dynasty

56 Coral-red porcelain vase with two ears
decorated with designs in gold.
Qing Dynasty

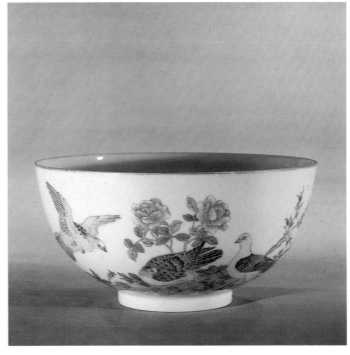

57 Thin-wall porcelain vase decorated with
famille-rose flowers.
Modern Period

58 Thin-wall porcelain bowl decorated with
famille-rose flowers and birds.
Modern Period

59 Porcelain jar painted with underglaze colors.
Modern Period

24

Painted pottery pot with four circles of netlike designs.
Height: 50.5 cm. Diameter of mouth: 14 cm. Neolithic Period

The earliest Chinese painted pottery of the Neolithic Period so far discovered belongs to the Yangshao Culture on the middle reaches of the Huanghe River. Carbon 14 tests date it back some 6,500 years. The painted pottery of this culture in the Shanghai Museum collection is of the types produced by the kilns of Majia, Banshan, and Machang, the last dating back some 4,100 years.

Machang painted pottery is characterized by being red in color with mainly black decoration, though there are some with red decor. This pot has a small mouth, drumlike belly, and flat bottom with two symmetrical loop-handles on the belly. The inside of its mouth is painted and its neck is painted with arrowhead patterns. The shoulders and belly are decorated with four big red and black concentric circles of equal sizes. Inside these circles are dots and small circles filled in with a netlike pattern. Beneath the big circles is a wavy line encircling the whole girth of the belly. The pot's shape is well formed. Its decoration is simple and vigorous and its colors are succinct and generalized. It is a typical Machang-type vessel used for holding water.

25

Black pottery cup with openwork high stem.
Height: 21.75 cm. Diameter of mouth: 7.25 cm. Neolithic Period

Dawenkou Culture is a primitive culture on the lower reaches of the Huanghe River which was discovered after the founding of the New China. It is represented by the Dawenkou site at Taian County, Shandong Province. The latter period of this culture dates back about 4,300 years.

The color of the pottery of Dawenkou Culture is quite complicated. Some of the pieces are painted pottery vessels of a variety of shapes. This cup belongs to the late Dawenkou Culture period. It is black in color with a flared mouth, a high stem, and a foot rim. There are six rows of pearllike openwork decorations on the high stem. The vessel is carefully made. Its walls are of an even thickness and as thin as an eggshell. Its shape is uniform and regular with simple and tasteful openwork. All this shows that pottery making and openwork technique had reached a relatively mature level.

26

Green-glaze proto-porcelain *zun* (wine vessel) with raised-line decoration.
Height: 18 cm. Diameter of mouth: 19.65 cm. Shang Dynasty

This is one of the earliest proto-porcelain vessels found in China. The discovery of proto-porcelain is a major achievement of archaeological work in ceramics since the founding of the New China. Proto-porcelains of the Shang Dynasty have been unearthed in Zhengzhou, Henan Province; Yidu County, Shangdong Province; and Wucheng in Qingjiang County, Jiangxi Province. The facts that the paste of such proto-porcelain contained less than 3 percent iron, the kiln temperature was about 1,200° C.; and glaze was applied to the surfaces basically meet the definition of what could be classified as proto-porcelain. Therefore, these are the first ancestors of Chinese porcelain.

This *zun* has a flared mouth, constricted waist, slightly protruding belly, and an everted foot rim. It is decorated with eight groups of raised lines and impressed small check patterns on the lower part of the belly. There is a thin layer of greenish-yellow glaze on it. This flared-mouth *zun* bears the distinct characteristics of the Shang Dynasty, and is basically the same as those big flared-mouth pottery *zun* unearthed from the Yin Ruins in Anyang, Henan Province.

27

Green-glaze proto-porcelain *ding* (cooking vessel) decorated with a dragon head.
Height: 14.9 cm. Diameter of belly: 13.8 cm. Warring States Period

Proto-porcelain kiln sites of the Warring States Period have been found in South China's Zhejiang Province at Fusheng in Shaoxing County and Jinhua District in Xiaoshan County. The characteristics of these wares are: their bodies are strong and hard with a thin layer of glaze and they mostly show traces of throwing on a potter's wheel.

This *ding* has upright handles and three hoofed legs. At the front of this *ding* is a dragon-head design patterned after those on bronzes while at the back is a small three-dimensional animal. There are two bands of cord designs encircling its belly over a pattern of "S" designs. The body of the vessel is light gray and is coated with a thin and uneven layer of greenish-yellow glaze which gives it a mottled appearance. This is a rare piece of proto-porcelain of the Warring States Period.

28

Green-glaze pottery duck.
Height: 21.7 cm. Length: 26 cm. Han Dynasty

This green-glaze pottery duck emits a silvery glitter. Chinese potters in the Western Han Dynasty had already mastered the technique of using lead glaze, which is a low-temperature glaze using lead as catalyst, to obtain green glaze when copper oxide is used as pigmentation and yellowish-brown glaze when iron oxide is used. Yellow and green glazes were the only two colors in those days. Since lead-glaze pottery forms were fired at a low temperature, they were brittle and easily broken. Furthermore, because lead is poisonous, such vessels could only be used as funerary objects.

After being buried underground for a long time, this green lead-glaze object became saturated with water and underwent a certain chemical reaction so that a layer of new substance was gradually formed over its surface, which gives off a silvery glitter when light is refracted from it. Therefore, the once green-glaze duck has been turned into a silvery one.

29

Green-glaze pottery watchtower.
Height: 51 cm. Han Dynasty

A portion of the lead-glaze burial accessories of the Han Dynasty were pottery buildings, such as houses, water pavilions, forts, and mills—which in a way reflected actual life in society at the time.

This pottery watchtower is a model of a fort or gate-tower used by the deceased in his lifetime for self-defense. It has two stories. On the lower story four guards armed with bows stand watch at each corner, while on the top story two guards holding bows stand at diagonally opposite corners on the lookout against a surprise attack from afar. Such models of buildings provide us with excellent material for studying the architecture of that period.

It was a custom in the Han Dynasty also to bury models of buildings as funerary objects.

30

Green-glaze proto-porcelain jar crowned with a building and figurines.
Height: 46.7 cm. Western Jin Dynasty

Jars crowned with buildings and figurines have been unearthed from tombs belonging to the period from the Three Kingdoms to the Western Jin Dynasty. They symbolize the grain barns which the dead had owned in his life.

Decorating the shoulders of the jar is a complicated scene of a building and figurines and birds in various poses and expressions. On the ground floor, there are two doors on opposite sides of the building, while on each of the other two sides is an oblong stone tablet with a triangular top resting on the back of a stone turtle. The characters on the tablet say that this burial accessory will bring official posts and promotions to this person's descendants. Around the building are servants and musicians. The upper floor of the building has four openwork squares and there are four small round-bellied jars with square mouths standing at the four corners. The roof of the building is the vessel's lid. On the vessel's belly are incised patterns and twelve designs spaced alternately between two rows of animal masks in relief and horsemen.

31

Green-glaze proto-porcelain tiger.
Height: 20.9 cm. Length: 26.6 cm. Western Jin Dynasty

The sites of Western Jin Dynasty kilns producing green proto-porcelain have so far mostly been found in the area of Zhejiang Province. Because the potters had already mastered the right proportion of iron oxide to be used and the right temperature for the muffled kilns, they were able to produce a stable green-glaze which was iridescent.

This water vessel shaped like a crouching tiger has a pair of wings engraved at the sides of its belly, a handle formed by a tail which curls up to the back of its head, and a wide-open mouth which forms a tubular spout. Such stylized vessels of practical use were quite common in the Wei, Jin, and Northern and Southern Dynasties Periods and they are a very prominent feature of the times.

32

Color-glaze pottery *hu* (wine vessel) decorated with embossed floral patterns and dragon heads.
Height: 26.9 cm. Tang Dynasty. *Donated by Tang Hao*

This type of dragon-head *hu* was common in the Sui and Tang Dynasties (A.D. 581–907). Apart from dragon heads, there were also chicken heads and elephant heads. They had developed from the chicken-head proto-porcelain *hu* of the Jin Dynasty.

The open mouth of a dragon serves as this vessel's spout while a dragon rearing up, then stooping down to the vessel's mouth on the opposite side, serves as a handle. Molded on the vessel's two sides is a figure of an attendant with the palms of his hands joined together in homage. Below the spout is a fierce animal mask. Yellow and green glazes flow naturally down the body of the *hu*. This is a color-glaze vessel of the late Tang Dynasty (A.D. 824–907).

33

Tricolored pottery *zun* (wine vessel) decorated with two dragons.
Height: 33 cm. Diameter of mouth: 5.5 cm. Tang Dynasty

On the basis of the Han Dynasty's use of the lead-glaze technique, the potters of the Tang Dynasty learned to use many kinds of metallic oxides for pigmentation and created the world-famous "tricolored pottery of the Tang Dynasty."

"Tricolored pottery" is that ware which used many different kinds of colored glazes, of which there were yellow, green, brown, blue, and white. So actually it would be more accurate to call them "color-glaze pottery of the Tang Dynasty." However, as large amounts of color-glaze pottery of the Tang Dynasty are mainly in yellow, green, and white, and in order to distinguish them from the tricolored pottery of the Song and Liao Dynasties, the term "Tang Dynasty tricolored pottery" has become the generally accepted designation of Tang color-glaze pottery.

The shape of this *zun* has obviously been influenced by the Persian style. The two symmetrical dragons look as if they are drinking water. While serving as decorations they are at the same time handles. The bright color glazes on their ears and the upper part of the vessel drip naturally down in harmonious tones to contrast sharply with the lower part of the vessel's body.

34

Tricolored pottery tomb guardian.
Height: 97 cm. Tang Dynasty

It was the practice in the Tang Dynasty to bury the dead with a rich assortment of funerary objects. In those days, an official proclamation governing funerary objects laid it down that the higher the deceased's official post, the more funerary objects must be used. Therefore, the beautiful color-glaze pottery products were mainly funerary objects. This tomb guardian was meant to subdue demons and ward off evil, and its likes have often been unearthed from the tombs of Tang Dynasty nobles.

This tomb guardian has a pair of antlers, hoofed feet, and a pair of wings. It is squatting with fangs bared, eyes glaring, and hair bristling; its fierce features and bellicose stance are enough to fill evil spirits with fear.

This tomb guardian is tall and its antlers and spikey mane radiate out in a bristling manner. It must have been difficult to make and to preserve. Its whole body is decorated with brown, green, and white glazes which run into each other to produce a beautiful variety of colors. It is a typical tricolored glaze pottery of the zenith of the Tang Dynasty (A.D. 684–756).

35

Tricolored pottery figurine of a mounted woman.
Height: 39.2 cm. Length: 38.7 cm. Tang Dynasty

As horse riding was a favorite activity of the people in the Tang Dynasty, they liked to bury funerary objects of figurines on horseback with their dead.

There are two types of such mounted figurines. The painted pottery mounted figurines were produced by painting the colors on the figurines after they had been made and fired, whereas the renowned tricolored pottery mounted figurines had been made by applying various low-temperature color glazes on the objects after they had been fired for the first time, and then refiring them.

This mounted figurine is an exquisite piece of sculpture. The horse's body is coated with white glaze while the horse's tail, hooves, and saddlecloth, and the figurine's neckerchief, dress, and skirt are coated with either yellow, green, or white glaze. The saddle and the figurine's headdress and its facial features are painted with black glaze. The colors of the mounted figurine are elegant and at the same time convey a soft appearance.

The horse is sturdy and powerful with its four feet standing on the ground. Its ears are pricked up and it is looking

to the left in an alert pose. The woman is relaxed and is seated calmly on the horse. Her hands are in the pose of reining in the horse. The horse and rider have both expression and form and are full of life.

36

Tricolored pottery figurine of a seated woman.
Height: 33.8 cm. Tang Dynasty

Beautiful and highly expressive color-glaze pottery female figurines are successful works of Tang tricolored pottery which are often found.

This seated woman has her hair done up in two high buns. Her facial features are painted on. The eyebrows are finely drawn and the eyes sparkle with life. She is dressed in a narrow-sleeved blouse, whose green, white, and yellow colors intermingle, and a pleated skirt. A green mantle is draped over her shoulders and hangs down in front over her low-cut blouse. From the hem of her skirt peep a pair of white-soled, yellow *"ru-yi"* ("as you wish") shoes. The woman's right hand is holding a bunch of flowers at her breast and her left hand is resting on her knee. Her eyes are looking downward and she is seated on a narrow-waisted, drum-shaped stool.

Before the Sui and Tang Dynasties people used to sit on mats on the ground. The practice of sitting on stools became fashionable in Sui and Tang times, so large quantities of seated figurines, which were rarely found before, have been unearthed from Tang tombs.

37

Tricolored pottery camel.
Height: 19.1 cm. Length: 21.4 cm. Tang Dynasty

Camels and horses are often the themes of Tang tricolored pottery.

As the people of China and western Asia in the time of the Tang Dynasty relied on horses and camels for transportation in their economic and cultural exchanges, the potters of the period were able to have ample opportunities to carefully observe the various postures of these animals and their anatomical structures and make them lifelike—whether they are galloping, walking, neighing, or bawling with heads thrown back, or just standing still and idly staring, or drinking with heads down.

This tricolored pottery camel is standing still with head held high and eyes full of spirit. It is strictly made according to the animal's proportions and its body is mainly coated with white glaze while the humps and thick hair on its neck are coated with brown glaze. In the course of firing, the brown glaze had dripped naturally down so that the resultant runs present a mixed brown-and-white color which makes the camel appear particularly exquisite.

38

Yue ware begonia-shaped porcelain bowl.
Height: 10.8 cm. Size of mouth: 32.2 × 23.3 cm. Tang Dynasty

The Yue kilns were in the Shaoxing County–Yuyao County–Yinxian County area in present-day Zhejiang Province. The production of Yue ware began in the Tang Dynasty on the basis of the production of celadon ware in the Western and Eastern Jin Dynasties.

Yue ware are noted for their fine paste, lustrous glaze, and exquisitely engraved decorations. Their fame in the past and present was due especially to their being olive-green vessels, which Qian Liuju sent as tribute to the imperial palace.

The glaze over this whole bowl is of a soft luster and is as fine as jade. The vessel is fairly large and is of a fairly regular shape. It is a typical piece of Tang Dynasty Yue ware.

39

Changsha ware brown-green glaze porcelain *hu* (ewer) with molded floral decoration.
Height: 21.8 cm. Diameter of mouth: 6 cm. Tang Dynasty

The Changsha kilns were in Tongguanzhen in Changsha City, Hunan Province. These kilns broke from the monotonous green-glaze color of the time and successfully produced brown and green green-glaze porcelain. They also initiated the new technique of underglaze painting, so that the surface of the glaze was smooth and the painted colors remained permanent. Furthermore, they also employed such decorative techniques as impressed and molded patterns.

This Changsha ware ewer is in the standard form of ewers in the Tang Dynasty. The molded figures, flowers, and birds beneath two loops and a short spout on this ewer have big brown patches over them. As the methods of decoration at the Changsha kilns were richer and more varied than at other kilns of the time, their wares were greatly liked and their products found a ready market at home and abroad.

40

White porcelain pillow with openwork hall-building and figurine.
Height: 13.6 cm. Length: 22.9 cm. Width: 18.4 cm. Five Dynasties Period

The making of white porcelain in the Five Dynasties Period had reached a very high level both at the Ding kilns in northern China and the Jingdezhen kilns in southern China. This pillow is a fine specimen of white porcelain of the Five Dynasties Period but its actual place of manufacture still remains to be determined.

The pillow's paste is pure white and refined. It is covered all over with clear glaze which has a greenish-blue tinge where it is thick. The pillow's structural design is exquisite and imaginative. Its top surface is in the shape of a *"ru-yi"* ("as you wish") and is engraved and incised with interlaced floral patterns. The pillow's trunk takes the form of an openwork hall-building with its right-hand door closed and its left-hand door ajar with a figurine standing with his back leaning against it. The hall-building is like the interior structure of the two Tang Dynasty mausoleums of Li Sheng and Li Jing.* The appearance, clothes and ornaments of the figurine leaning against the door are similar to those of pottery figurines unearthed from the mausoleums.

*Nanjing Museum, *Report on the Excavation Work on Two Southern Tang Dynasty Mausoleums,* Wen Wu Press edition, 1957.

41

Ge ware porcelain vase with nipple-like studs and cylindrical ears.
Height: 12.8 cm. Diameter of mouth: 2.3 cm. Song Dynasty

The Ge kilns were one of the five famous kiln groups in the Song Dynasty. It is said that in the area of Longquan County, in today's Zhejiang Province, there were two brothers in the Song Dynasty who were both famous porcelain makers. The products of the elder brother, Zhang Shengyi, were called "Ge ware" and those by the younger brother, Zhang Shenger, were called "Di ware." The plum-green glaze porcelain produced by the Longquan kilns of the Southern Song Dynasty represented the products of the so-called Di kilns, while the porcelains covered with crackling were those of the Ge kilns and made by Zhang Shengyi. However, to this day, no shards of Ge ware have been found in the Longquan area.

The paste of the Ge ware is thick and heavy and the bodies of the pieces are regularly thrown. Their glaze colors were mainly powder greenish-blue, light greenish-blue, and millet-yellow. The vessels are covered with big and small crackling. The large pieces are a deep gray while the tiny pieces are a millet-yellow. The lines of crackling between the pieces are like a web of fine iron wire or gold thread and are in fact known as "gold threads and iron wires."

This vase has a long neck and a small mouth with a pair of symmetrical cylindrical ears level with the rim. Five nipple-like studs protrude upward on its round belly. It is a rare Ge ware vessel, which has been handed down from generation to generation.

42

Jun ware porcelain basin in the shape of a begonia.
Height: 5.4 cm. Size of mouth: 14 × 17.8 cm. Song Dynasty

The Jun kilns were one of the five famous kiln groups of the Song period and were in today's Shengouzhen in Henan Province's Yuxian County. Their glazes were notable for flambés on a blue ground, the chief colors being moon-white, sky-blue, and rose-purple, the latter being the first successful use by Chinese craftsmen of copper oxide as pigmentation to obtain a color glaze by firing in the reduced atmosphere of a kiln. This was the chief achievement of the Jun kilns in the Song Dynasty and it paved the way for the development of copper-red glaze in the Yuan and Ming Dynasties.

This begonia-shaped porcelain basin is exquisitely made. It is sky-blue on the inside and rose-purple on the outside. The bottom is covered with a dark reddish-brown glaze with the character "ㄨ" engraved on it. It was a vessel used at the imperial palace toward the end of the Northern Song Dynasty, in the time of Emperor Wei Zong.

43

Ding ware porcelain dish with impressed clouds-and-dragon design and a silver-mounted rim.
Height: 4.7 cm. Diameter of mouth: 23.4 cm. Song Dynasty

The Ding kilns were one of the five famous kiln groups in the Song Dynasty and were located in today's Quyang County, Hebei Province. While producing mainly white porcelain, they also produced green, purple, and black. Ding ware vessels have thin walls, soft glaze, and regular shapes. Impressed, engraved, and incised motifs were the decorative methods used on Ding ware.

As the Ding kilns widely practiced the art of refiring—which had the drawback of the vessels' mouths being rough, due to not being fully glazed—the rims of their mouths were often mounted with either a gold, silver, or copper rim.

This dish has a silver rim and its inside surface has an impressed clouds-and-dragon design. It was specially produced for the imperial palace and the lines of the design are strikingly clear-cut, showing the high level of skill attained in engraving molds and making thin-walled vessels at the time.

44

Longquan ware covered jar in the shape of a lotus flower with molded coiled dragon.
Height: 22.6 cm. Diameter of mouth: 6.5 cm. Southern Song Dynasty

The Longquan kilns, situated in today's Longquan County, Zhejiang Province, were the producers of the famous celadon ware of southern China in the Song Dynasty. This Southern Song celadon had particularly thick glazes, which appear soft and glossy. The light greenish-blue and plum-green celadon were representative types of Longquan ware, the verdant plum-green celadon being considered the best. As the glazes on Longquan ware in the Southern Song Dynasty were

thick and opaque, the highly popular decorative methods of engraving and incising in the Northern Song Dynasty were no longer suitable and, under such circumstances, the decorative methods of molding and relief sculptures grew in popularity.

This plum-green glaze jar has a coiled dragon molded around its neck and elongated lotus petals engraved and stamped around the lower part of the belly. On its cover is a crouching dog, which serves as the knob. The covers of such jars are generally decorated with a knob in the form of a bird, tiger, or other animal. This is a valuable piece of Longquan celadon.

45

Bacun ware porcelain prunus vase with black floral designs on a white ground.
Height: 44.3 cm. Diameter of mouth: 4.1 cm. Song Dynasty

The Bacun kilns were in what is today's Yuxian County, Henan Province. They were folk kilns of the Song Dynasty in northern China and mainly produced porcelain ware with black floral patterns on a white ground. However, they also turned out large quantities of Song tricolored porcelain and Song painted porcelain.

Porcelain ware with black floral patterns on a white base resulted from the integration of traditional Chinese painting skills with the art of porcelain making. These porcelains were made by first coating the paste with slip and then using a brush to paint on the pictures. Finally, a coating of transparent glaze was applied on the vessels, which were then fired. The black and white colors contrast sharply and the designs are distinct and lively.

This vase is covered with stylized black all-season chrysanthemums on a white ground. They are closely arranged and skillfully drawn in flowing lines. The mouth of the vase is small. It has round, sloping shoulders and a tall, elongated body. The whole vessel presents the graceful appearance of an upright piece of jade and is in the standard shape of prunus vases of the Song Dynasty.

46

Bacun ware painted porcelain figurine of a seated woman.
Height: 32.9 cm. Song Dynasty

The Bacun kilns were folk kilns of the Song Dynasty which produced porcelain ware with black floral designs on a white ground. They also painted porcelain ware.

The main colors of painted porcelain ware in the Song Dynasty were red, yellow, and green. On some painted porcelain figurines, underglaze black lines were used to outline the dress, eyebrows, eyes, hair, and beards and mustaches; these were later filled in by overglaze red, yellow, and green colors. This integration of overglaze and underglaze colors paved the way for great developments in painted porcelain making in the Ming Dynasty.

Underglaze black lines were used to outline the features of this seated figurine; they were later filled in with overglaze red, yellow, and green. The figurine wears a phoenix headdress and a long, wide-sleeved robe. Her hands are clasped together. Her stately poise, fine eyebrows, and clear, bright eyes successfully portray a woman by painting on porcelain.

47

Color-glaze porcelain pillow engraved with flower-and-bird design.
Height: 13 cm. Length: 49.1 cm. Width: 21.9 cm. Song Dynasty

On the basis of the traditional tricolored pottery of the Tang Dynasty, the color-glaze porcelain of the Song Dynasty developed red and black glazes in which the red was of a magnificent hue and the black was of a deep pitch-black. The use of black, in particular, was in those days extremely rare.

This color-glaze porcelain pillow has red, green, yellow, white, and black glazes. On its top surface are engraved and incised flying phoenixes and peony designs on a light yellow ground. The phoenixes have white feathers and black heads, and the peonies are painted with red flowers and green leaves. The elegant colors are lovely in this successful product of the folk kilns of northern China.

48

Jingde ware blue-and-white porcelain vase decorated with interlaced sprigs of peonies.
Height: 40.1 cm. Diameter of mouth: 6.1 cm. Yuan Dynasty

Blue-and-white ware is a kind of underglaze painted porcelain which was produced by first painting on the shaped paste with cobalt, then applying a layer of transparent glaze and completing the process by a single firing at a high temperature. An important achievement of the ceramic art in the Yuan Dynasty was bringing the technique of producing blue-and-white porcelain to maturity.

Yuan Dynasty blue-and-white porcelain generally has a thick, heavy paste, a variety of closely drawn designs, and a rich blue-and-white coloration.

The mouth of this vase has a thickened rim extending outward. It has full, rounded shoulders and a narrowish lower body. Its shape is simple and stately—a typical blue-and-white porcelain vessel of the Yuan Dynasty. The decorations on the vase are three groups of winding tendrils and scroll patterns. The first group consists of four patterns in the shape of "*ru-yi*" ("as you wish"), with blue-and-white ripples as the ground inside the patterns where white spaces have been left in the forms of lotuses, mandarin ducks, and egrets. The second group, which is the main theme design on the vessel, is composed of pictures of interlaced peonies. The third group is made up of six panels of lotus-petal designs, closely packed but not in confusion.

49

Jingde ware blue-and-white flat flask with two ears and decorated with Indian lotus motif.
Height: 25.8 cm. Ming Dynasty, reign of Xuan De (A.D. 1426–1435)

The blue-and-white porcelain produced in the reigns of Yong Le and Xuan De had a rich deep blue color because of the use of imported cobalt. As this imported material contained a high ratio of iron, the wares showed naturally formed dark splashes—a feature of the blue-and-white porcelain of these periods.

This calabash-shaped flask is round at the top and flat at the bottom. Such vessels were never seen before the Ming Dynasty, so obviously they were the result of foreign influences perhaps related to Cheng He's many voyages to the Western Seas.

Such flasks all have the characters for "Made in the Reign of Xuan De of the Great Ming Empire" on their rims, so there is no doubt that they are products of this period whether judged from their paste, glaze color, design style, or the pigmentation material used to produce the blue-and-white.

50

Jingde ware porcelain flask with contrasting-color designs of plant tendrils.
Height: 18.1 cm. Diameter of mouth: 4.2 cm. Ming Dynasty, reign of Cheng Hua (A.D. 1465–1487)

The famous contrasting-color wares of the reign of Cheng Hua are those porcelains which integrate underglaze blue-and-white decoration with overglaze polychrome colors that rival each other in beauty.

This flask was first lightly painted with the outline of scrolls with blue pigmentation on its shaped raw body and then glazed and fired at a high temperature, before the outlined patterns were filled in with green glaze and it was then refired in a low-temperature kiln. The coiling, flowing tendril scrolls are elegant and distinct. This type of Cheng Hua Period painted porcelain has the unique style of contrasting-color porcelain of the Ming Dynasty.

51

Jingde ware polychrome covered porcelain jar with clouds-and-dragon designs.
Height: 11.1 cm. Diameter of mouth: 8.7 cm. Ming Dynasty, reign of Wan Li (A.D. 1573–1620)

This polychrome covered porcelain jar decorated with clouds-and-dragon designs was made in the reign of Wan Li and is a typical piece of polychrome porcelain ware of the Ming Dynasty.

Polychrome porcelain refers to the white-glaze porcelain made by firing at a high temperature and later painted with various colors and then refired in a low-temperature kiln. As overglaze blue was not yet discovered in the Ming Dynasty, the method of blue-and-white porcelain was employed where the color blue was required; and an integration of underglaze blue-and-white and overglaze polychrome was the mainstream of Ming Dynasty painted porcelain ware.

The cover and the vessel itself are decorated with blue-and-white and polychrome clouds and dragons, and with rectangular spirals, *"ru-yi"* ("as you wish"), and interlaced floral sprig patterns. The many and varied designs and rich colors make this an exquisite polychrome porcelain vessel.

52

Painted-enamel porcelain bowl decorated with interlaced sprigs of peony.
Height: 7.5 cm. Diameter of mouth: 14.7 cm. Qing Dynasty, reign of Kang Xi (A.D. 1662–1722)

Painted-enamel porcelain was created during the reign of Kang Xi on the basis of the enameling of inlaid bronzes in the Ming Dynasty. This kind of porcelain was usually made by having white porcelain ware made by the Jingdezhen kilns brought to Beijing, where painters-in-attendance at the imperial palace workshops painted them and refired them in low-temperature kilns. Such porcelain was for the use and pleasure of the emperor and his consorts.

The painted-enamel porcelain of the Kang Xi Period usually has a red, yellow, blue, pea-green, or dark purple ground on which are painted interesting floral designs.

This bowl has a blue ground on which are painted interlaced sprigs of peony with the characters for "ten thousand," "longevity," "long," and "spring" written in the seal script at the centers of the four large flowers. At the bottom is a vermilion seal saying that the vessel was made for the use of Emperor Kang Xi, which shows that it is a valuable vessel made to celebrate the emperor's birthday.

53

Jingde ware polychrome porcelain vase decorated with figures.

Height: 44.8 cm. Diameter of mouth: 11.5 cm. Qing Dynasty, reign of Kang Xi (A.D. 1662–1722)

Kang Xi Period porcelain is also known as classic-color and strong-color porcelain ware. As overglaze blue was discovered in the reign of Kang Xi in the Qing Dynasty, simple overglaze polychrome replaced the Ming Dynasty's blue-and-white integration with polychrome as the main body of painted porcelain ware.

Both the imperial kilns and folk kilns in the reign of Kang Xi produced polychrome porcelain ware. The wares of the imperial kilns had refined paste, exquisitely painted decoration, small and dainty forms, and their prime decorative themes were dragons and phoenixes, phoenixes and Chinese parasol trees, and other motifs representing longevity, prosperity, good fortune, etc. The decorative themes on porcelain produced by the folk kilns had a far richer and wider variety of subject matter than that of the imperial kilns. The paintings were done with a natural effluence and often showed birds, flowers, scenes from stage stories, sabers, horses, and people. Most large vases and jars that have been handed down from generation to generation were products of the folk kilns.

This vase is a representative work of the folk kilns during the reign of Kang Xi. Its mouth has a frieze of cloud patterns and its neck is decorated with pictures of playing children. The shoulder is decorated with motifs of stringed musical instruments, chessmen, books, and paintings on a brocade ground. The belly is adorned with a picture of the Warring States Period story about Lui Bei, the king of the State of Shu, who in his early years married the sister of the ruler of the State of Eastern Wu. The painting is meticulously done and shows the busy scene of the wedding ceremony.

54

Jingde ware lobed porcelain vase decorated with famille-rose flowers and birds.

Height: 45 cm. Diameter of mouth: 12.4 cm. Qing Dynasty, reign of Yong Zheng (A.D. 1723–1735)

Famille rose was a new kind of overglaze painted porcelain created on the foundations of the polychrome porcelain of the Kang Xi Period. Toward the end of the reign of Kang Xi, the potters of Jingdezhen added arsenic to the lead-based vitrified petuntse and created a soft-looking famille-rose decoration. In the reign of Yong Zheng, the progress in making white glaze further promoted the development of famille-rose decorations.

This famille-rose bird-and-flower vase is in the shape of an olive, a form peculiar to the Yong Zheng Period, and the lobes around the vase make it appear most elegant and charming. The four groups of flowers and birds, representing the four seasons, painted on the pure white plain porcelain surface in famille rose and set off with gold-edged famille noire, enhance the vessel's elegance and soft beauty. It is a highly successful product of the Jingdezhen folk kilns.

55

Porcelain vase with enamel-color figurines.

Height: 18.8 cm. Diameter of mouth: 4.25 cm. Qing Dynasty, reign of Qian Long (A.D. 1736–1795)

During the reigns of Yong Zheng and Qian Long the enamel colors on porcelain made great headway. Apart from a few that retained the same colored grounds as in the reign of Kang Xi, most porcelains were decorated with meticulous paintings in various enamel colors on their snow-white surfaces. These paintings were often accompanied by a few lines of impromptu verse. At the beginning and at the end of the lines of verse were vermilion script and white script on a red ground—colophons or vermilion seal marks which were often related to the painting and verse.

Although this vase has no lines of verse, colophon, or seal mark, its decoration is exquisite and neat. On its neck is a famille-rose picture of a dragon swimming in the sea, on a yellow ground; and on the shoulder is painted in enamel colors a picture from a story. The use of famille-rose and enamel colors to decorate a single porcelain vessel was an innovation of the Qian Long Period. The picture depicts the story of Zhang Liang meeting Huang Shigong toward

the end of the Qin Dynasty and receiving from the latter the book *Taigong's Art of War*. The story goes that Zhang Liang became well versed in the art of war and later used his knowledge in the service of Liu Bang to plan victories that were fought a thousand miles away, and so performed meritorious services for the setting up of Western Han Dynasty rule.

56

Coral-red porcelain vase with two ears decorated with designs in gold (belonging to the House of Shende).
Height: 27.5 cm. Diameter of mouth: 7.9 cm. Qing Dynasty, reign of Dao Guang (A.D. 1821–1851)

This two-eared vase decorated with designs in gold on a coral-red ground has the style of Qian Long Period porcelain vessels in the Qing Dynasty. The use of simple gold color to paint various auspicious signs and motifs all over the vessel's low-temperature iron-red glaze body produces a feeling of happiness and prosperity.

In China's feudal society, it was the custom to use homonyms to express auspicious thoughts. For instance, here among the painted Indian lotus designs are the symbols representing "ten thousand" and *"ru-yi"* ("as you wish"), which pair up to mean "everything to turn out as you wish"; two fishes, which represent "boundless luck"; bats, to symbolize "vast happiness equal to heaven"; and peaches, to mean "longevity," etc.

This kind of jar is common in the Dao Guang Period. The inner side of the foot rim bears the red seal mark "Made for the Use of the House of Shende."

57

Thin-wall porcelain vase decorated with famille-rose flowers.
Height: 17 cm. Diameter of mouth: 4 cm. Modern Period

This thin-wall vase was made in the 1970s. It is as light as an eggshell and when the light shines through it, it casts almost no shadow. It has attained the level of the porcelains praised by an ancient poet who described them as "afraid the wind will blow it away and worried that the sun will melt it." It has a gold-rimmed mouth and on its belly are painted wild camellias, narcissus, plum blossoms, fish pelargonium, and other flowers. The neck, shoulder, and foot rim are decorated with cloud scrolls, interlaced floral sprays, *"ru-yi"* ("as you wish") patterns, and broadleaf plants painted in gold on a black ground. At the bottom is an imitation rectangular red seal script mark on a gold ground saying that it was "Made in the Reign of Qian Long." On the body are red inscription seal marks, on a gold ground, which say "Treasure for Qiang Long's Pleasure" and "Hall of Three Rarities," and a seal mark with a gold inscription on a red ground which says "Delightful to Sons and Grandsons."

This vase is of a firm and stable shape. Its main and subsidiary decorations are neatly arranged. They are of vivid realistic appearance and the brushwork is neat and refined. The colors are elegant and neat. The sprays interlink neatly in different poses; some are drooping, some are erect. The whole picture is uncomplicated and appears like a fragrant garden in spring. This eggshell porcelain vase makes full use of the softness and luster of famille rose and shows the high skill and artistic level of Jingdezhen porcelain.

58

Thin-wall porcelain bowl decorated with famille-rose flowers and birds.
Height: 8 cm. Diameter of mouth: 16.3 cm. Modern Period

The porcelain of the Jingdezhen kilns in Jiangxi Province are famous throughout the world, particularly one of their traditional products, the eggshell porcelain, which requires special skill and technique. This eggshell porcelain is a special handicraft product, light and dainty, extremely exquisite, and completely translucent. The finest products of this ware are only 0.5 millimeters thick and really live up to the praise of being as "light as a cloud and thin as a cicada's wing." The manufacture of eggshell porcelain demands a very high level of skill and technique, from choosing the raw material and making the paste to shaping and firing. The designs painted on such thin, translucent porcelain appear very charming when held up to the light. This kind of porcelain is therefore highly treasured.

This thin-wall porcelain bowl was made in the 1970s. It has a deep belly and a foot rim. It is completely round and smooth, with a gold rim, and is decorated with three pigeons painted on the outside—one on the wing and the other two looking around among the flowers. They seem to be calling to each other and appear quite lifelike. Chinese roses, peach blossoms, irises, and other flowers are subsidiary decorations. The main and subsidiary designs are clearly defined and the paintings are finely done. The colors are lightly and elegantly applied and are in the traditional style of Chinese paintings.

59

Porcelain jar painted with underglaze colors.
Height: 21.1 cm. Diameter of mouth: 11.5 cm. Modern Period

Liling County in Hunan Province is an important porcelain-making area. Its underglaze-painted porcelain vessels are famous and are liked and sought after by people at home and abroad. The craftsmen's specialty is to paint with various pigmentations on the raw body of the vessel, then apply over these a smooth and even coating of transparent glaze before firing once in a high-temperature kiln. The pictures obtained are smooth and glossy, glowing with iridescence.

The colors are light but not scant. As the colors are placed below the glaze, they are neither poisonous nor harmful and can resist acids and alkalis. They, therefore, last forever and suit all places. Their form of presentation and the techniques used have a distinctive national flavor.

This jar was made in the 1970s. It has a round belly, a short neck, a slightly everted foot rim, and a cover. From the cover to its foot rim are seven decorated segments—rose-and-purple geometric patterns of whorls and broken lines on a black ground. The jar is sturdily made and the decoration is an imitation of the style on the lacquerware unearthed from the Mawangdui Han Dynasty tomb in Changsha City, Hunan Province.* The colors are elegant and are well set off by the smooth white porcelain covered with transparent glaze to give an artistic effect of harmonious unity.

*Hunan Provincial Museum and the Archaeological Institute of the Chinese Academy of Sciences, *The Changsha Mawangdui No. 1 Han Dynasty Tomb,* Wen Wu Press edition, 1973.

Bronzes

THREE

Bronzes

Introduction by Chen Peifen

China entered the Bronze Age in about the 20th century B.C., when slave society culture began. According to historical documents, Yu, the first king of Xia, China's earliest dynasty, had nine *ding* (cauldrons) cast out of the bronze presented to him as tribute by the nine provinces—to symbolize his power over the whole of China. This shows that the skill of bronze casting had already been mastered at the time.

Recent archaeological excavations have revealed large-scale palace sites and a group of bronze *jue* (wine vessels) and weapons at Erlitou, Yanshi County, Henan Province. Chemical analysis of the bronze *jue* proves that the bronze consisted of 92 percent copper and 7 percent tin, a typical tin–bronze composition. The area in the western part of Henan had been the ruling center of the Xia Dynasty; carbon 14 tests of the sites of Erlitou Culture give their dates as 1900 to 1600 B.C. within the period of the Xia, and testify to the coincidence of the facts of bronze-casting history in China with the ancient records.

In the 16th century B.C., the Xia Dynasty was replaced by the Shang Dynasty, whose early sites have been found in many areas, the most well known being the palace sites, tombs, and a group of early Shang bronzes at Erligang, Zhengzhou City, Henan Province, in 1952. Therefore, archaeologists take Erligang Culture as representative of early Shang Culture. In addition, similar bronzes have been found in Henan Province's Liulige, Huixian County, and People's Park at Baijiazhuang, Zhengzhou City, as well as in Jiangxi Province's Wucheng in Qingjiang County. In 1974, not only city wall vestiges and palace sites but also a number of bronze and jade ware were found at Panlongcheng, Huangpi, Hubei Province. From the early Shang Dynasty bronzes unearthed at different areas, we find that cooking vessels and food containers, such as *ding, li,* and *gui,* and goblets and wine and water containers, such as *jue, jia, gu, zun, hu,* and *pan,* had been cast. The chief features of Erligang Culture bronzes are that the vessels have thin, even walls, thickened mouth rims, hollow legs opening into the belly of the tripod *ding,* and big square or cruciform perforations on their foot rims. The decorations on the bronzes are mainly animal masks and thunder-and-cloud patterns. The vessels are often decorated with intaglio and relievo patterns in bold or fine lines. The ability to cast huge, one-meter-high rectangular *ding* indicates that casting technique had attained a remarkable level.

The late Shang Dynasty had built its capital at present-day Yinxu, Anyang City, Henan Province, and ruled there for 273 years. Years of excavation at the Yin Ruins prove that it is the site of a highly civilized metropolis with huge palace and necropolis areas the size of which had never been seen before. From its tombs a large number of burial accessories of very high craftsmanship were unearthed. Bronze casting had reached its zenith and Shang nobles made great use of the metal for their ritual vessels as well as for some vessels for daily use. All of them were splendidly cast and elaborately decorated. Yinxu Period bronzes can be divided according to their features into three categories, *i.e.,* the products of early, middle, and late phases of Yinxu. The findings up to the present are mostly of the middle or late phases; only a few belong to the early phase.

In early Yinxu, large-sized wine vessels, such as *lei* and *pou,* had already appeared, while goblets

such as *jue* and *gu* were widely used by the nobles. Remains of the early Yinxu Period have also been found in Henan, Shaanxi, Shanxi, Hubei, Anhui, and Jiangxi Provinces. The bronzes of this period are heavier and grander than those cast earlier. Their decorations are mostly two-dimensional animal masks. Bronzes, especially wine vessels of the middle and late Yinxu Period, however, are of many different kinds and forms. This is probably due to the general indulgence of heavy drinking among the Shang nobles. The bronze *lei* decorated with four ram heads (Figs. 63 and 64), bronze *zun* inscribed "Jia Fu Gui" (Fig. 66), bronze *you* inscribed "Gu Fu Ji" (Figs. 67 and 68), and bronze *gong* inscribed "Fu Yi" (Figs. 69 and 70) are all exquisite wine vessels made at the time. The decorations of this period are chiefly animal masks or phoenix designs. The animal mask can be identified from its horns as dragon, ox, deer, or ram; or it may be a tiger or some unknown animal. The dragon is a mythical snake-bodied monster with legs and giraffe horns and the phoenix is a legendary bird of prey with a magnificent feather comb and long tail. Decorations of the Yinxu Period are mostly relief patterns against a background of fine and dense *lei wen* (spirals), though some are on a plain ground, simple but graceful, such as the bronze *gong* inscribed "Fu Yi" and the bronze *you* container inscribed "Gu Fu Ji."

On the whole, Shang bronzes are usually decorated with forceful, magnificent patterns. Sometimes dozens of different patterns are used to decorate one single vessel. Most of the patterns have deep religious connotations. In bronze patterns we find all sorts of mythical monsters, such as the dragon, representing the water deity, and the phoenix, representing the wind deity. These evidence that the people of the time worshiped the elements.

Inscriptions started to appear on bronzes in the middle Yinxu Period, most being only the nobles' clan names and posthumous titles of their ancestors, to whom the sacrifices were offered. Brief narrative inscriptions began in the late Yinxu Period, but lengthy inscriptions are very rare during the Shang Dynasty.

Toward the end of the 11th century B.C., the Zhou Dynasty replaced the Shang when King Wu of Zhou overthrew the Shang and built his capital first at Feng and then at Hao (present-day Huxian County and Changan County in Shaanxi Province). The bronzes of the early Western Zhou Dynasty are somewhat similar to those of the late Yinxu Period in form and decoration but have their own characteristics. Owing to the ban on heavy wine drinking at that time, wine vessels greatly diminished in number and variety while food containers and cooking vessels greatly increased in both respects. There appeared the *gui* (food container) with either a high foot rim or square pedestal and two or four handles. During the middle Western Zhou Dynasty appeared the bronze oval *xu* with lid, the rectangular *fu* with sharply angled shoulders and a cover of similar shape, and the bronze *dou* with a high stem and shallow bowl. According to their ranks, and so to embody the severe hierarchic system, the nobility of the time were permitted to use only a certain number of bronzes.

In addition to ritual bronzes and food and wine vessels, there also appeared bronze chime bells, which were arranged in a scale according to their sizes and tones. The chime bells were usually flat in form, enabling each bell to produce in the lower center and the lower right two different notes when struck, the note produced from the lower right being a major third or a minor third. By such device, a set of chime bells could be used to play complicated tunes.

The early Western Zhou bronze casters carried on the Shang Period's decorative patterns of animal masks and phoenixes—the phoenixes, of various types, enjoying the greater popularity. From the middle Western Zhou Period on, the decorations on bronzes underwent greater changes: the structure of animal masks became simplified and stylized, some animal masks disintegrated into isolated parts. In the late Western Zhou Period, the broad and plain wave patterns and stylized animal patterns took the place of the animal masks which had once been so highly popular. The wave patterns decorating the large bronze *ding* inscribed "Ke" (Figs. 81 and 82) and the bronze *gui* inscribed "Hu" (Fig. 85) are typical decorations for bronzes of the time.

The bronze inscriptions are of great importance and they vary in content. They consist of the conferments of titles of prince and marquis, bestowals of land and slaves, the heredity of nobles,

the appointment of officials, the battle deeds of generals, etc.—such as those of the bronze *ding* inscribed "Ke," the bronze *gui* (Fig. 83) inscribed "Shi Huan," and the bronze *yi* (Figs. 79 and 80) inscribed "Shi Ju." They are valuable material for studying the political, economic, and military decrees and systems of ancient times.

By studying the large amount of bronzes of the Shang and Western Zhou Dynasties and the unearthed pottery molds, we find that the casting of bronzes in those days usually went through the following processes: First, a solid clay model of the object to be cast was made. The decorative designs were then engraved on the model, over which a layer of clay was spread. This clay cover was then cut into sections and fired and later reassembled as pottery molds. The model itself could again be used as the inner mold or core by scraping off a layer of clay to provide space between the mold and the core. Molten bronze was then poured into the space between. After a certain time for cooling, the molds were removed and a bronze object would be obtained.

During the Spring and Autumn Annals Period, as the royal house of Zhou declined, the powerful principalities contended for hegemony and there was great economic development in the various principalities. As a result, the (aboveground) bronzes of this period handed down to posterity belonged mostly to princes, marquises, and high-ranking officials—very few to the royal house. The system restricting the number of bronzes to be used by nobles according to their ranks gradually broke down and locally cast new-fashion bronzes both of wine vessels and food containers increased. These bronzes took on local features such as the styles of the tripartite State of Jin, the State of Qi in the east, the State of Chu in the south, and the State of Wuyue in the southeast. The bronzes produced by the various states, therefore, had both common national style and local features. A group of bronzes of the late Spring and Autumn Annals Period belonging to the State of Jin was unearthed in 1923 at Liyu Village, Hunyuan County, Shanxi Province. Among this group, the bronze *zun* in the shape of an ox (Figs. 91, 92, and 93) and the bronze *hu* decorated with bird, animal, and dragon patterns (Fig. 94) are the most splendid. The bronze *ding* decorated with three oxen (Fig. 97) is attributed to the State of Chu because of its tall legs, a feature of the State of Chu; it is called a *jiao ding*.

Owing to the widespread use of iron tools and the development of feudal productivity between the Spring and Autumn Annals Period and the Warring States Period, production was greatly improved and the bronze industry enhanced. New bronze-casting techniques were invented. The substitution of the painstaking hand engraving on models by the new method of stamping designs on the model by means of a die, as well as the widespread use of the method of separate casting of subordinate parts, fixed on the main body afterward, greatly increased the production of bronze articles. From the many bronze vessels unearthed in 1978 from the tomb of the king of the State of Zheng in Suixian County, Hubei Province, we can see that both lost-wax and composite-mold casting methods had been used. The lost-wax casting method enabled complicated articles to be cast and enhanced the quality of the articles. The decorations on bronzes tended to be elaborate. Sometimes hundreds of fine entwining and interlacing dragons were found horizontally on one single piece. It made the vessel's surface look like brocade. The bronze inscriptions during this period were mostly brief records of important events.

Because of the increasing of production and the demands of the ruling class, many bronze articles of daily use were cast in the Warring States Period, such as measures, lamps, and belt hooks in addition to food and wine containers. During the Shang Dynasty, there had already been inlays used in the decoration of bronzes, but in the Warring States Period the inlaying technique developed more fully. Gold, silver, turquoise, and copper were all used as inlays on bronzes. They made the inlaid bronzes luxurious and splendid. In this period some bronzes were decorated with hair-thin lines incised with a stylus, to depict the life of the nobility, such as feasting, hunting, dancing, archery, and fighting on both land and on water. Such decor was actually a sort of Chinese painting. Significant inscriptions on bronzes gradually lost their popularity, however, and instead there appeared inscriptions of the name of the supervisor or the craftsman. These indicate that the craftsmen were responsible for the articles they made.

In the early Han Dynasty, bronze technology still retained the traditions of the Warring States Period, but the techniques of gilding and of silver-plating began. The bronze tiger seen in Figure 102 is gilded all over. From the tiger we can see the attempt at pictorial art. The bronze *hu* in the shape of a fish (Fig. 99) and the bronze lamp in the shape of a ram (Figs. 100 and 101) are skillfully cast to portray animals. During the Han Dynasty, the biggest development was the casting of bronze mirrors. The decorations on the reverse sides of the mirrors are incomparably exquisite in design and variegated in theme. In the Sui and Tang Dynasties, with the development of communications, Western art influences affected bronze mirror decoration and there appeared rich, flowing lines and high-relief motifs which enabled the Han and Tang Periods to see a golden age for bronze mirrors.

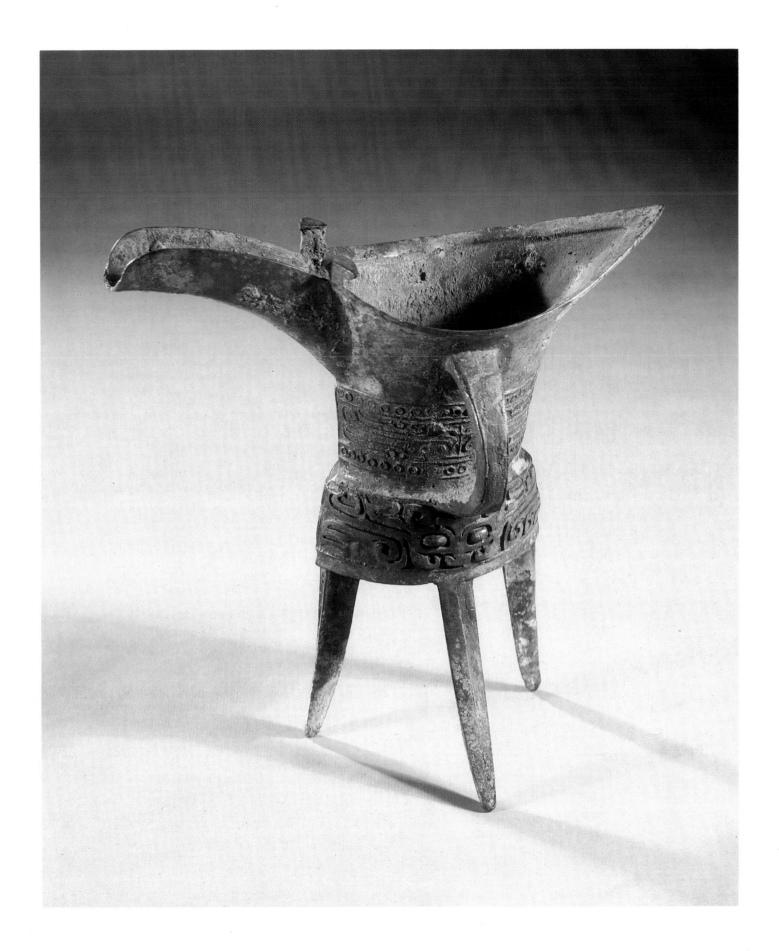

60 Bronze *jue* (wine goblet) with animal-mask design.
Shang Dynasty

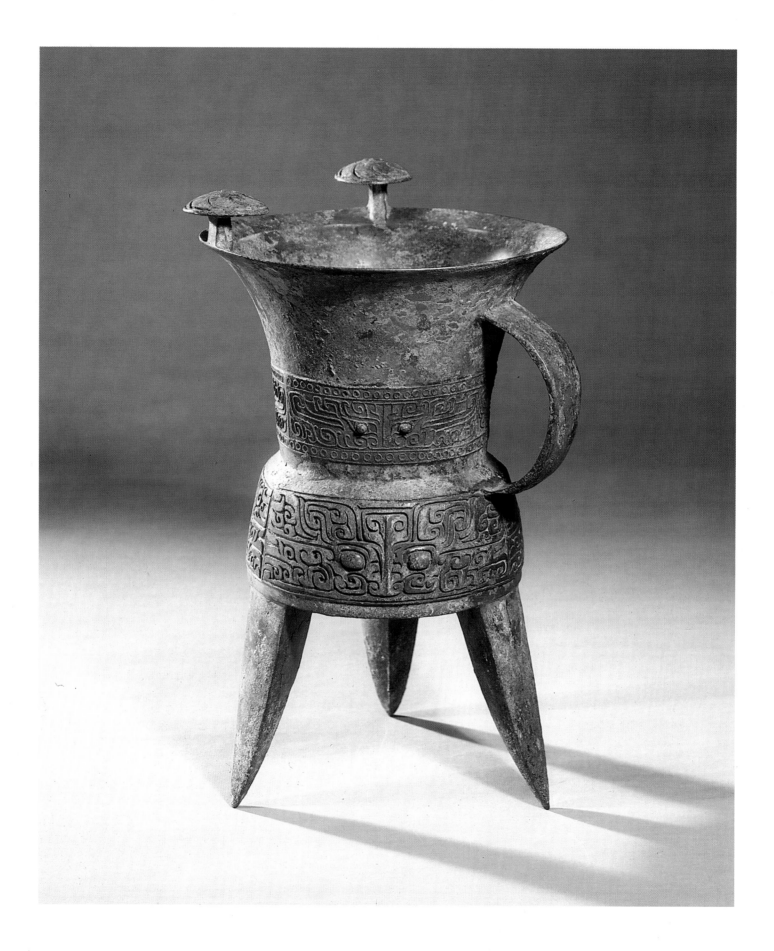

61 Bronze *jia* (wine container and warmer) with animal-mask design.
Shang Dynasty

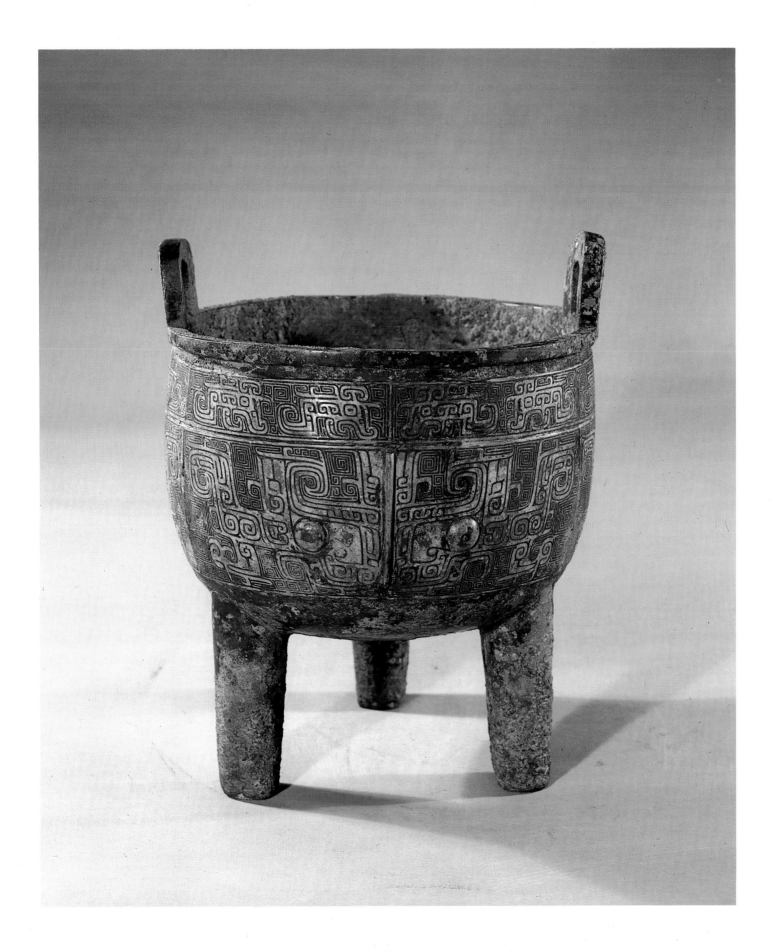

62 Bronze *ding* (food container) with animal-mask design.
Shang Dynasty

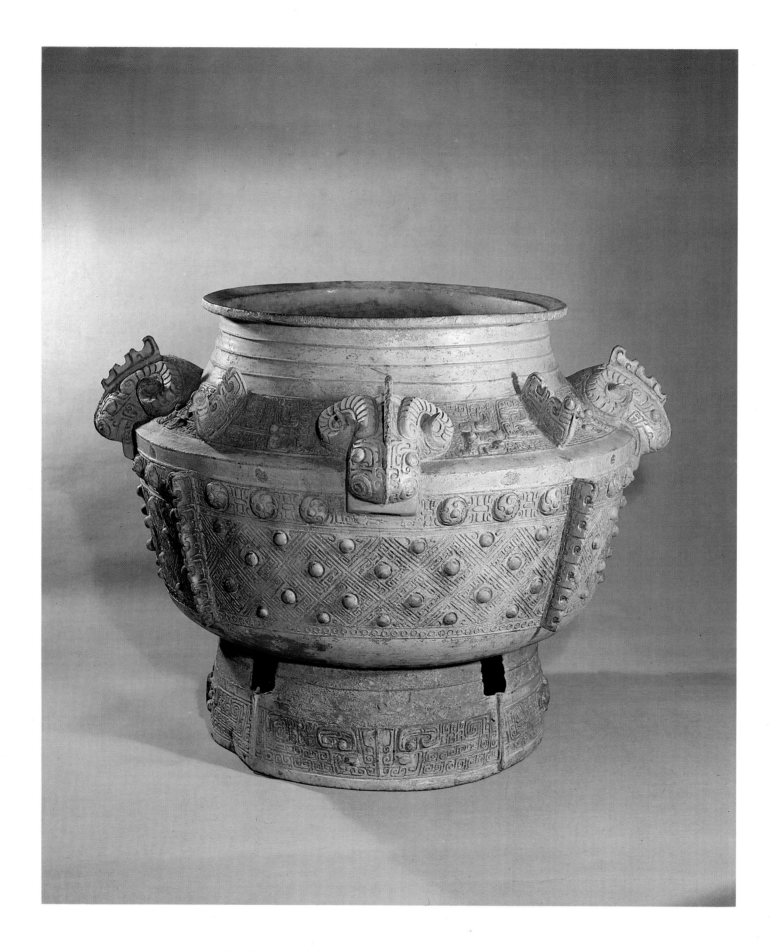

63/64 Bronze *lei* (wine container) ornamented with four ram heads.
Shang Dynasty

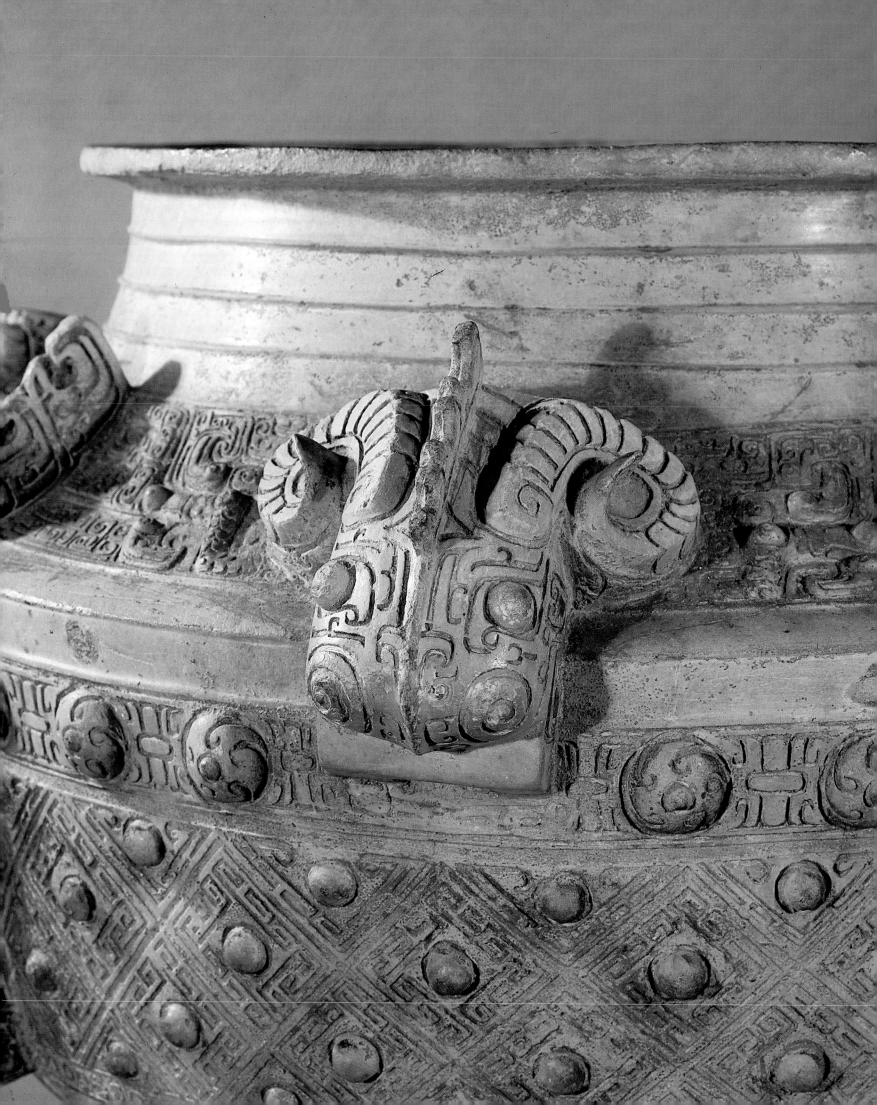

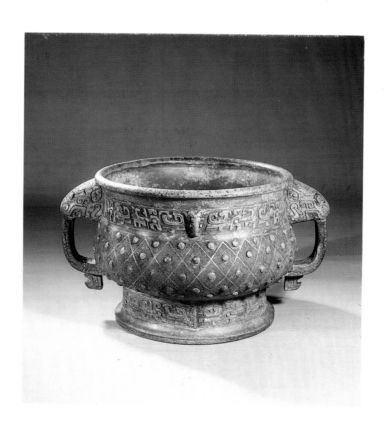

65　Bronze *gui* (food vessel) inscribed "You Fu Kui."
Shang Dynasty

66 Bronze *zun* (wine container) inscribed "Jia Fu Kui."
Shang Dynasty

67/68 Bronze *you* (sacrificial wine container) inscribed "Gu Fu Ji."
Shang Dynasty

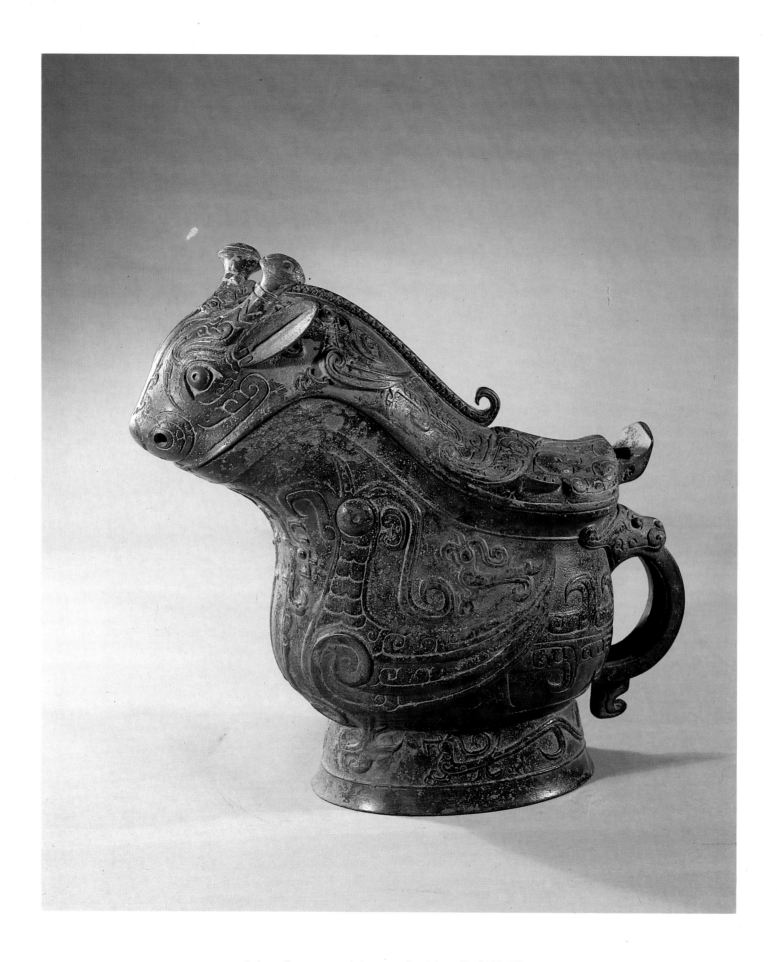

69/70　Bronze *gong* (wine container) inscribed "Fu Yi."
Shang Dynasty

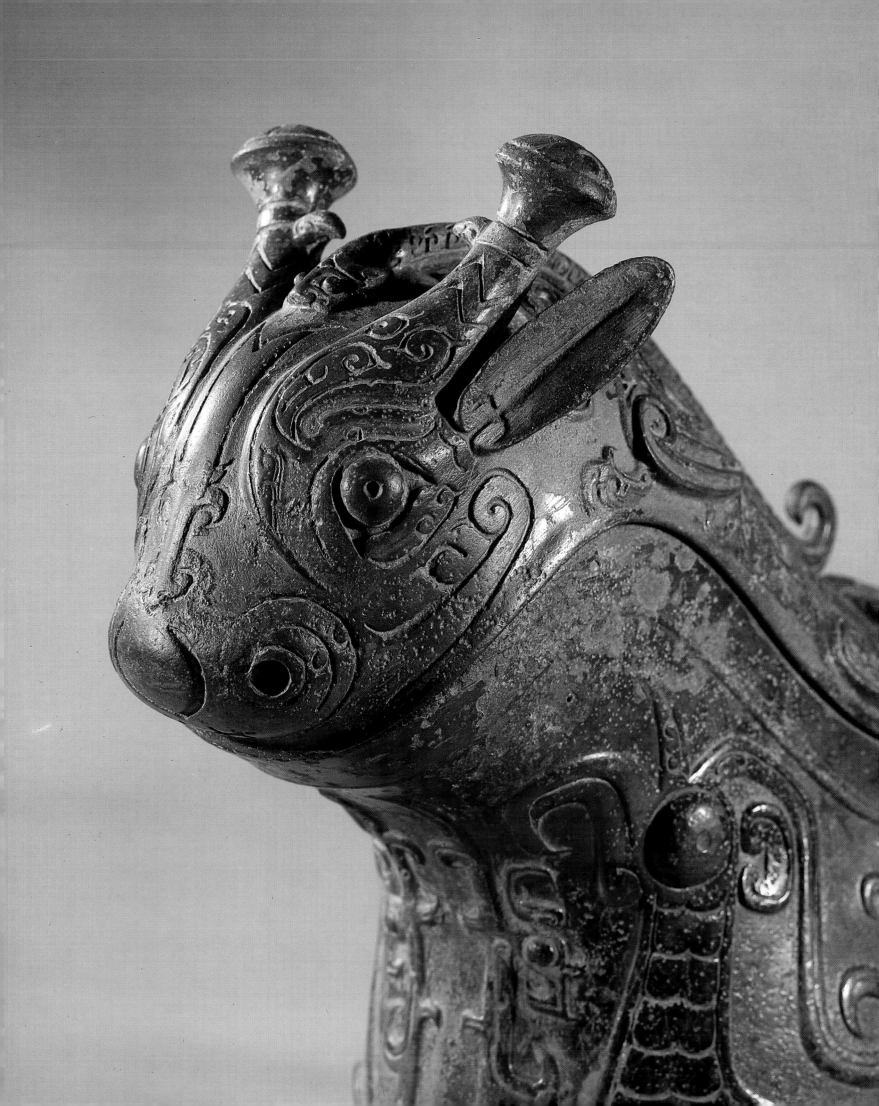

71 Bronze rectangular *ding* (sacrificial vessel) inscribed "Tian Gao Fu Ding."
Western Zhou Dynasty

72 Bronze *ding* (sacrificial vessel) inscribed "Jiao."
Western Zhou Dynasty

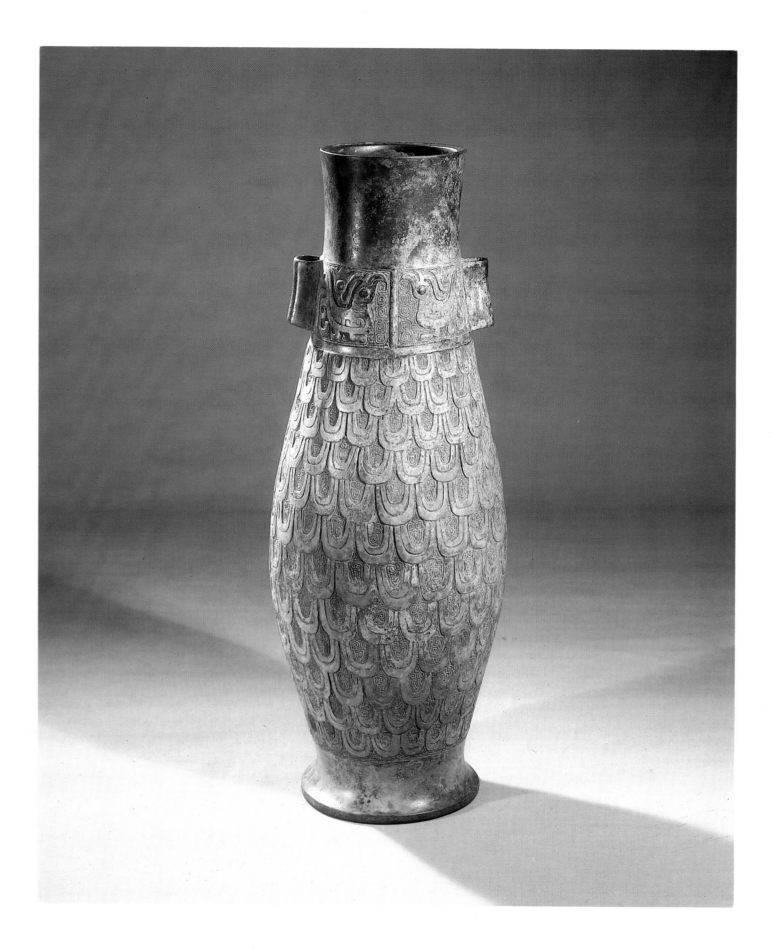

73 Bronze *hu* (wine container) inscribed "Chu Fu Geng."
Western Zhou Dynasty

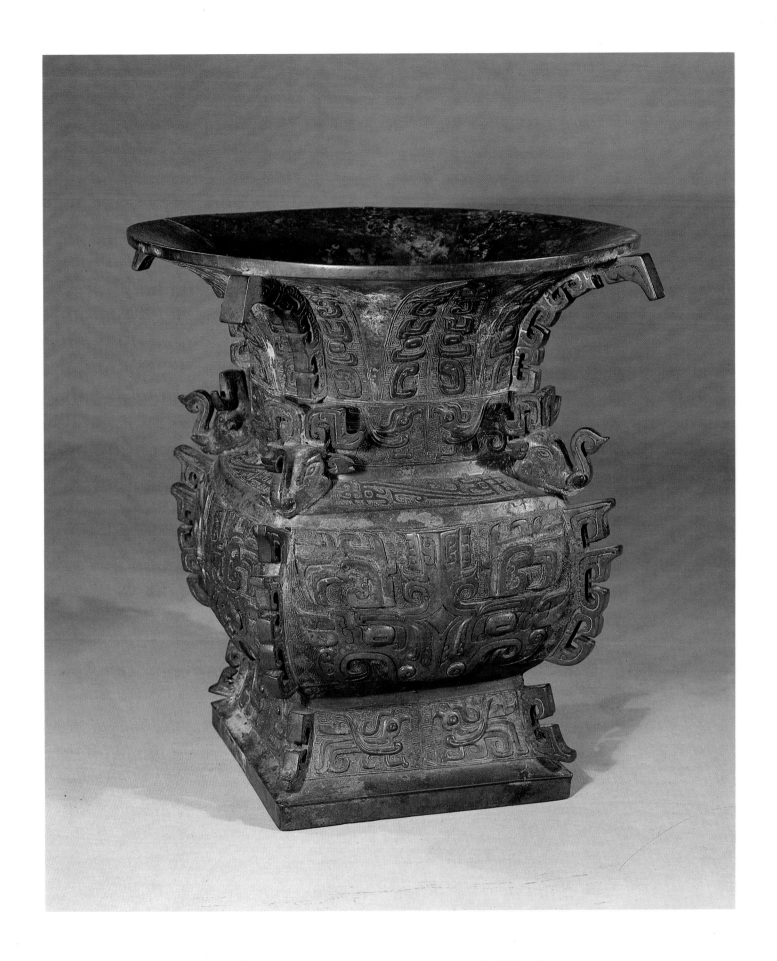

74 Bronze rectangular *zun* (wine container) inscribed "Kuei Gu."
Western Zhou Dynasty

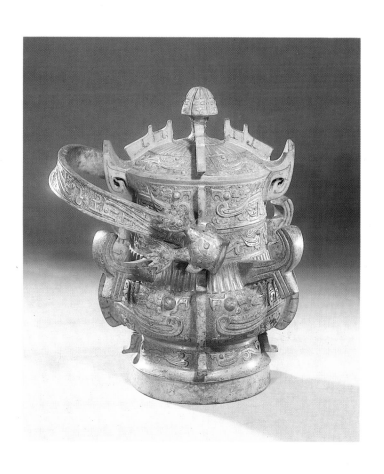

75 Bronze *you* (sacrificial wine container) decorated with phoenixes.
Western Zhou Dynasty

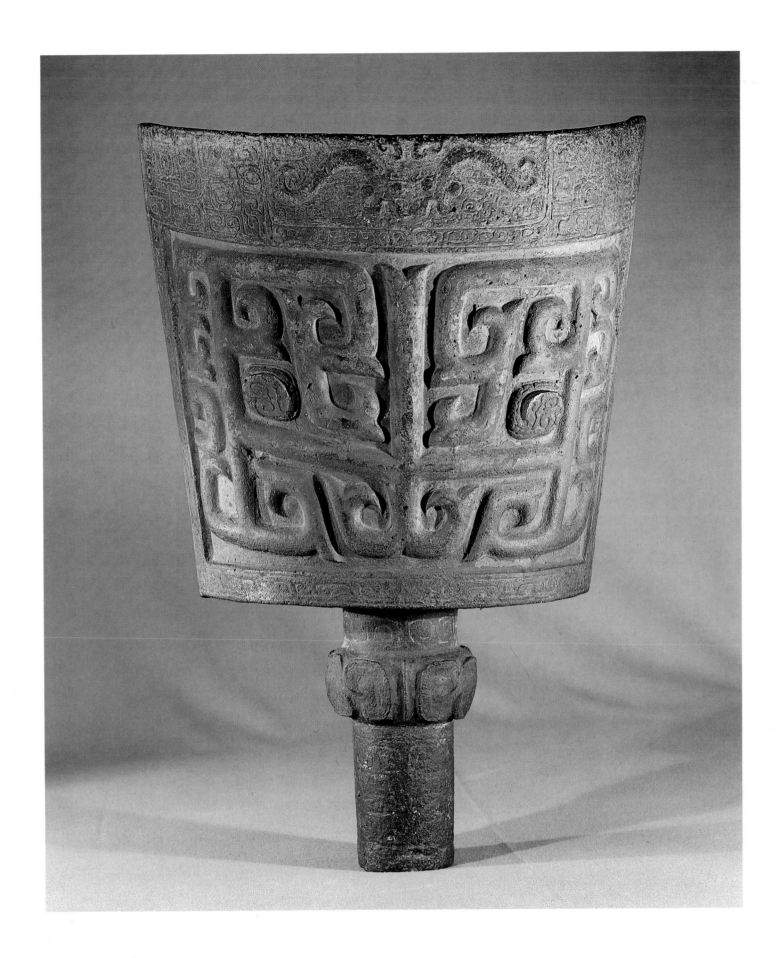

76 Bronze *zheng* (percussion musical instrument) decorated with animal masks.
Western Zhou Dynasty

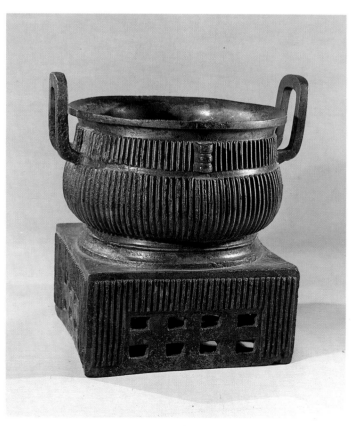

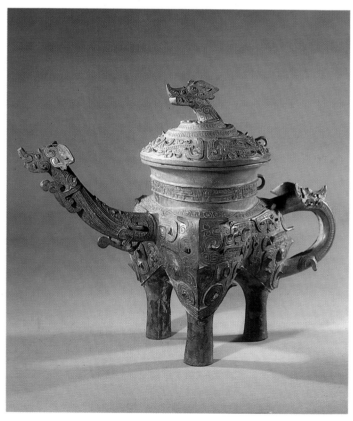

77 Bronze *gui* (food container) inscribed "Shi Lai."
Western Zhou Dynasty

78 Bronze *he* (wine-diluting or -warming vessel)
decorated with animal masks and a dragon-shaped spout.
Western Zhou Dynasty

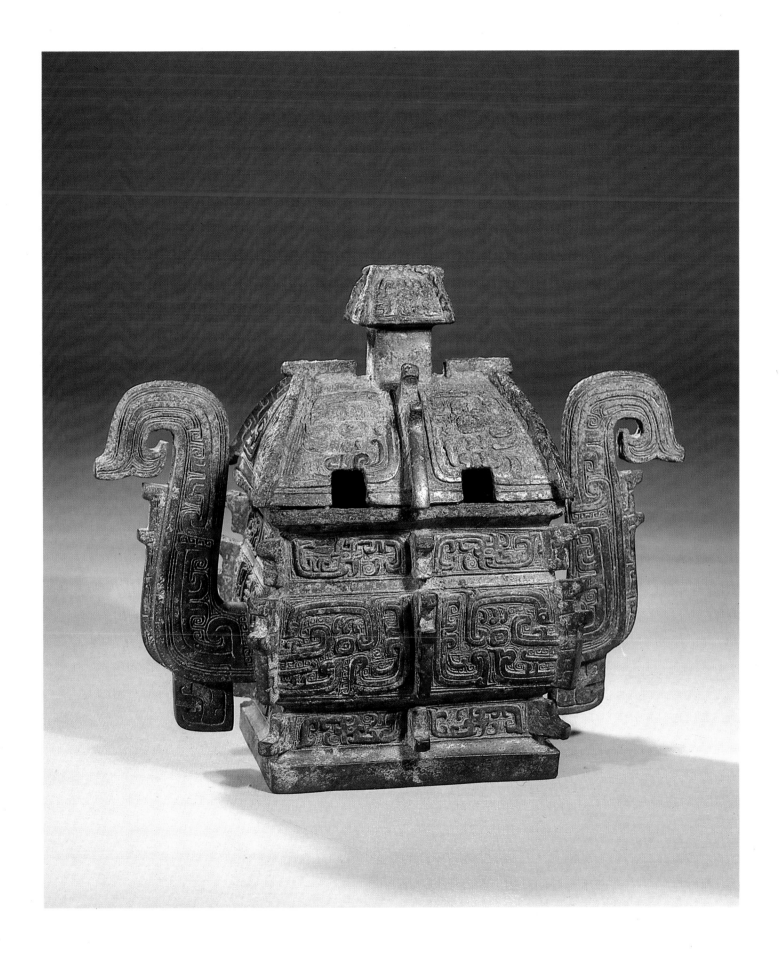

79/80 Bronze rectangular *yi* (wine container) inscribed "Shi Jiu."
Western Zhou Dynasty

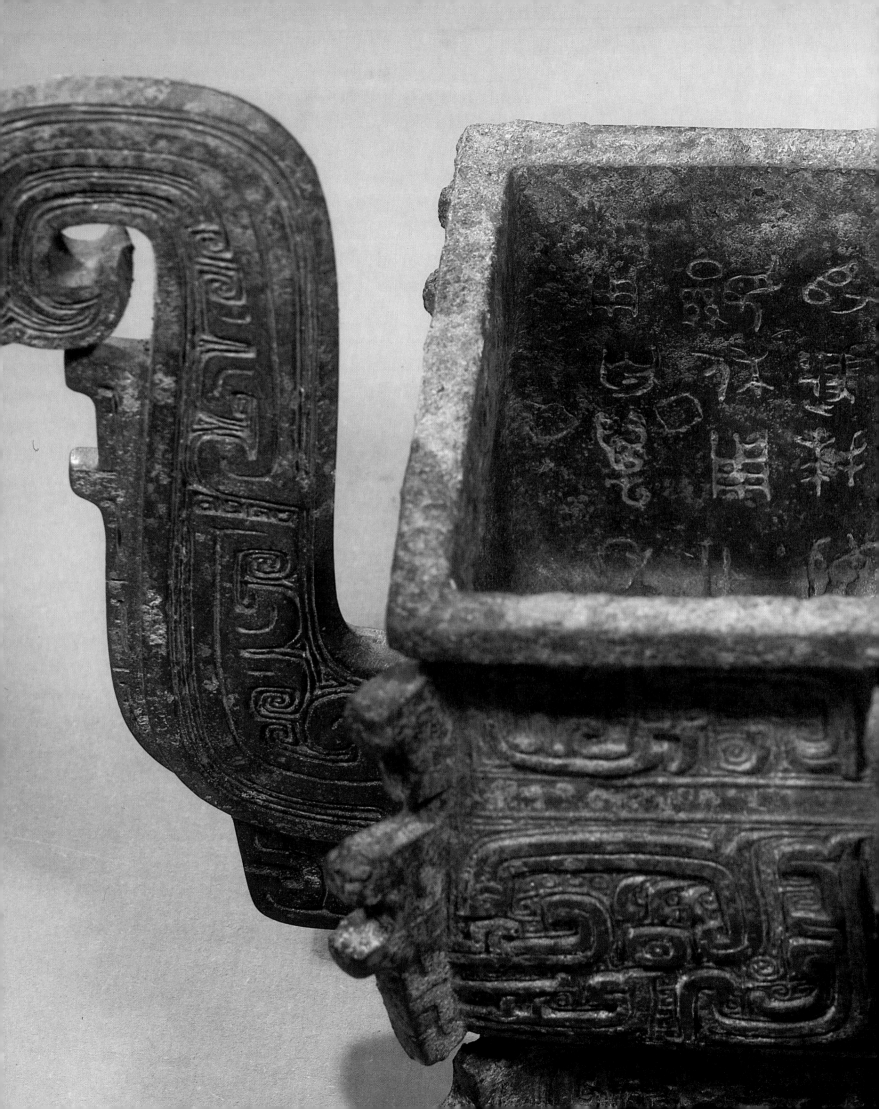

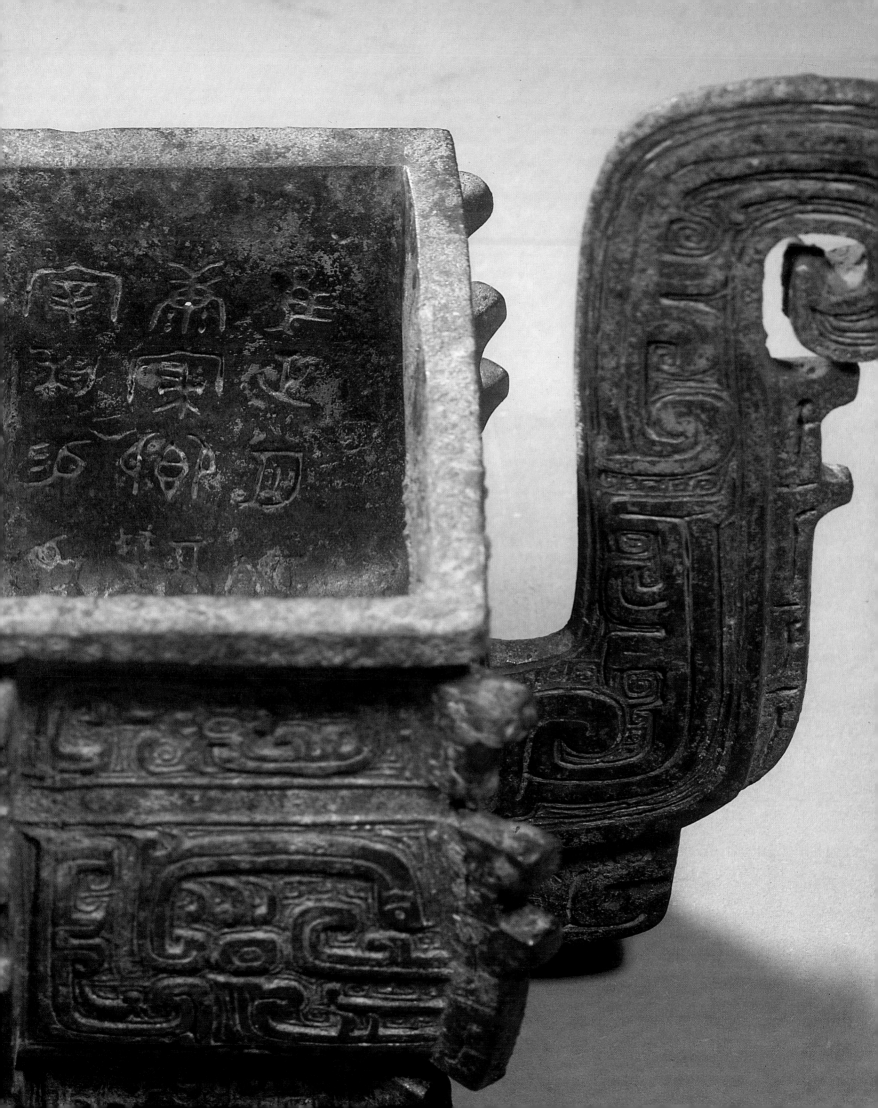

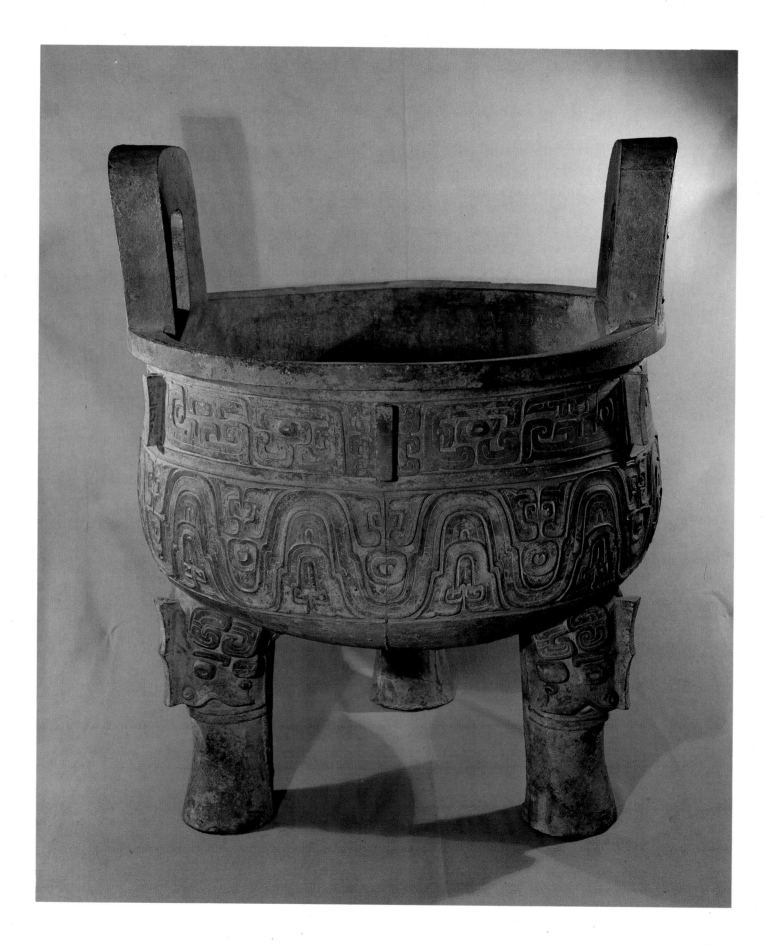

81/82 Large bronze tripod *ding* (sacrificial vessel) inscribed "Ke."
Western Zhou Dynasty

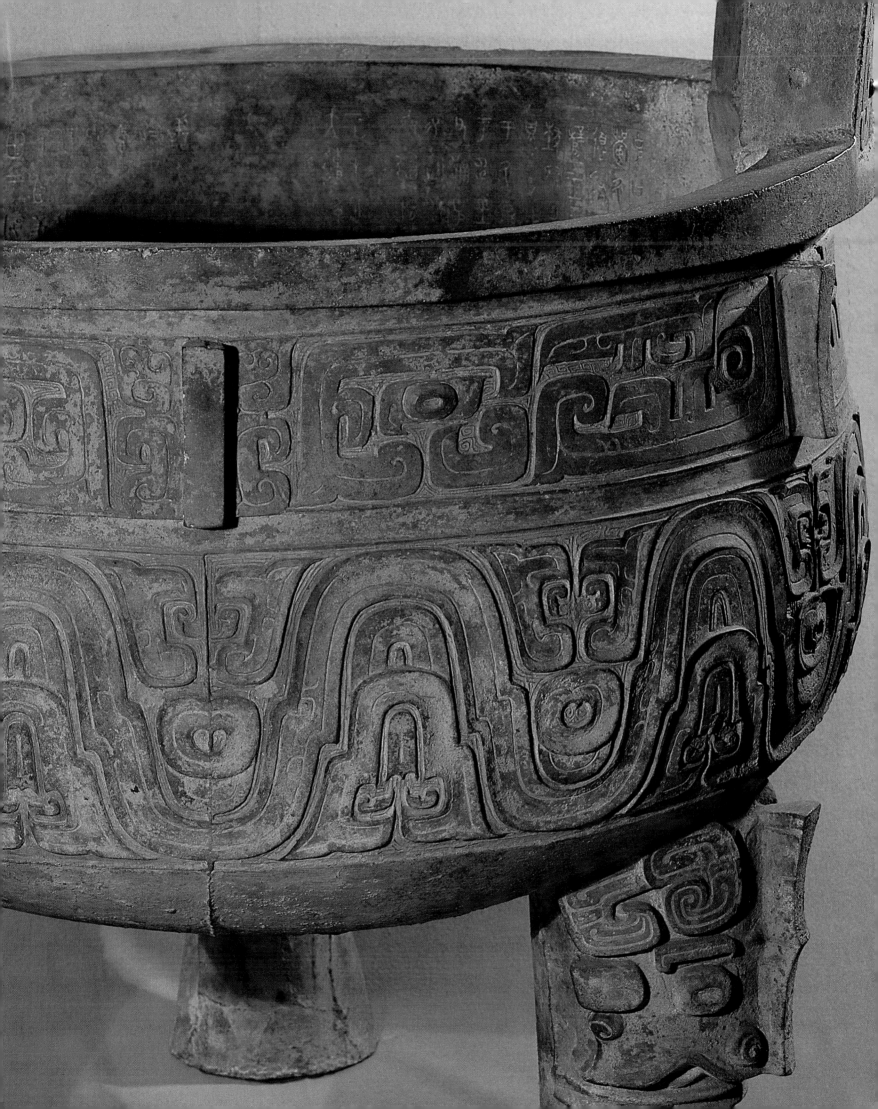

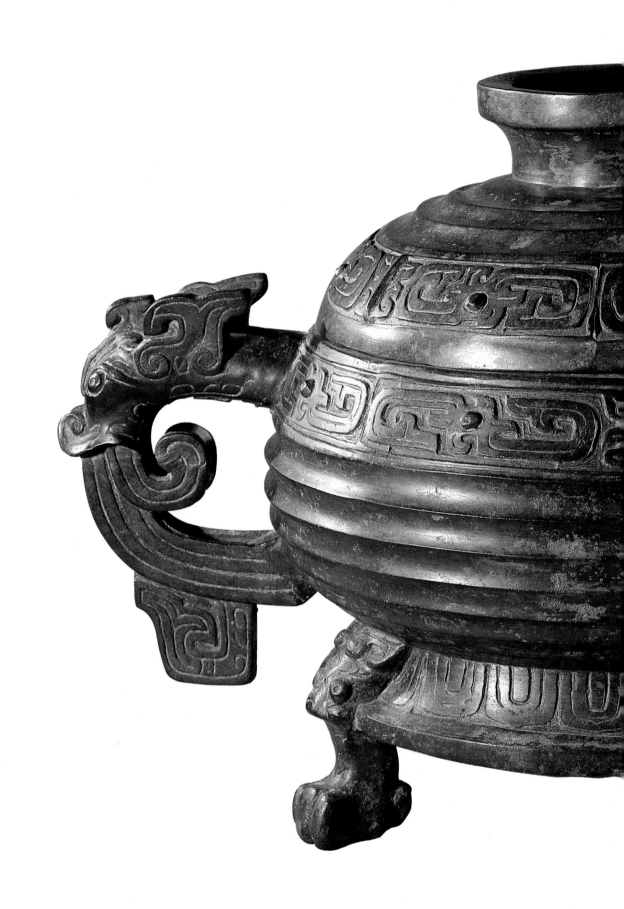

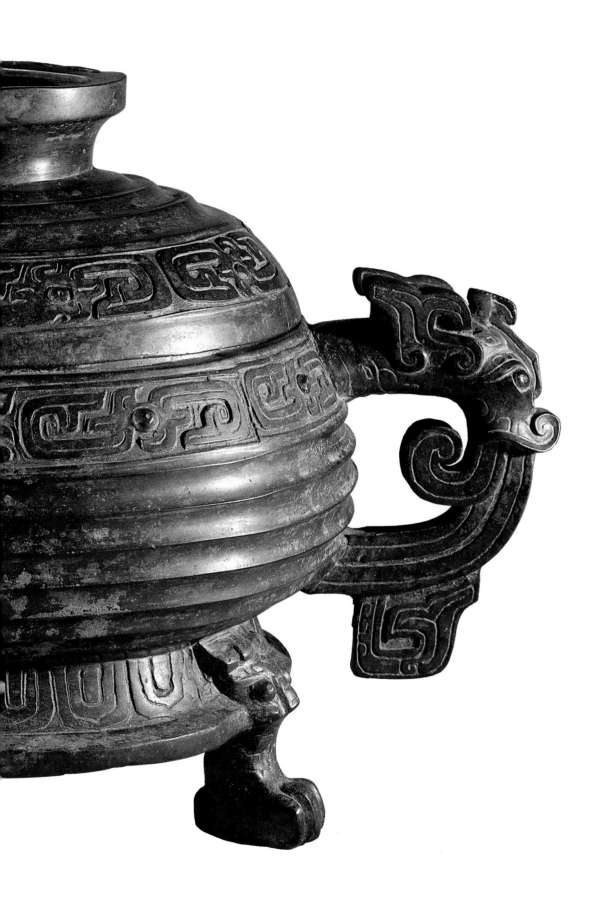

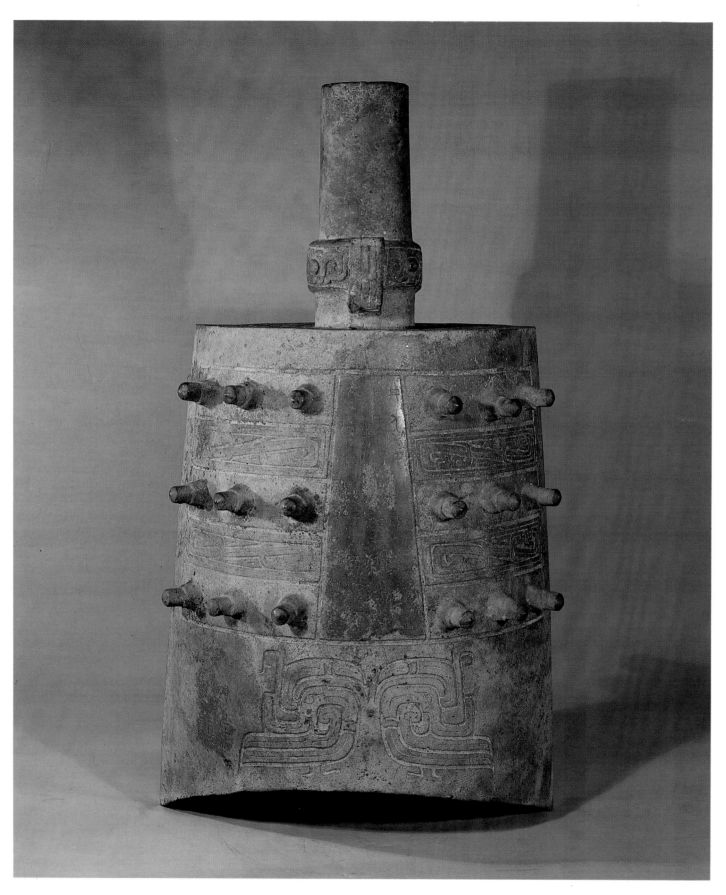

83 Bronze *gui* (food container) inscribed "Shi Huan."
Western Zhou Dynasty
84 Bronze *zhong* (percussion musical instrument) inscribed "Xing Ren."
Western Zhou Dynasty

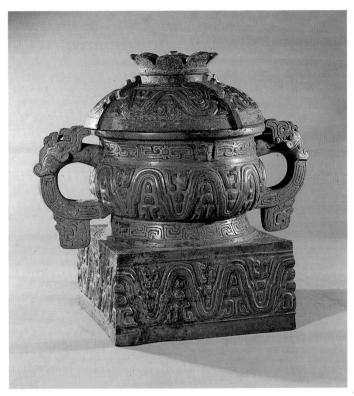

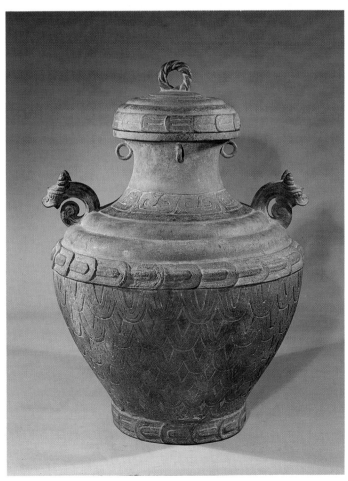

85 Bronze *gui* (food container) inscribed "Hu."
Western Zhou Dynasty
86 Bronze *ling* (wine vessel) inscribed "Zhong Yi Fu."
Western Zhou Dynasty

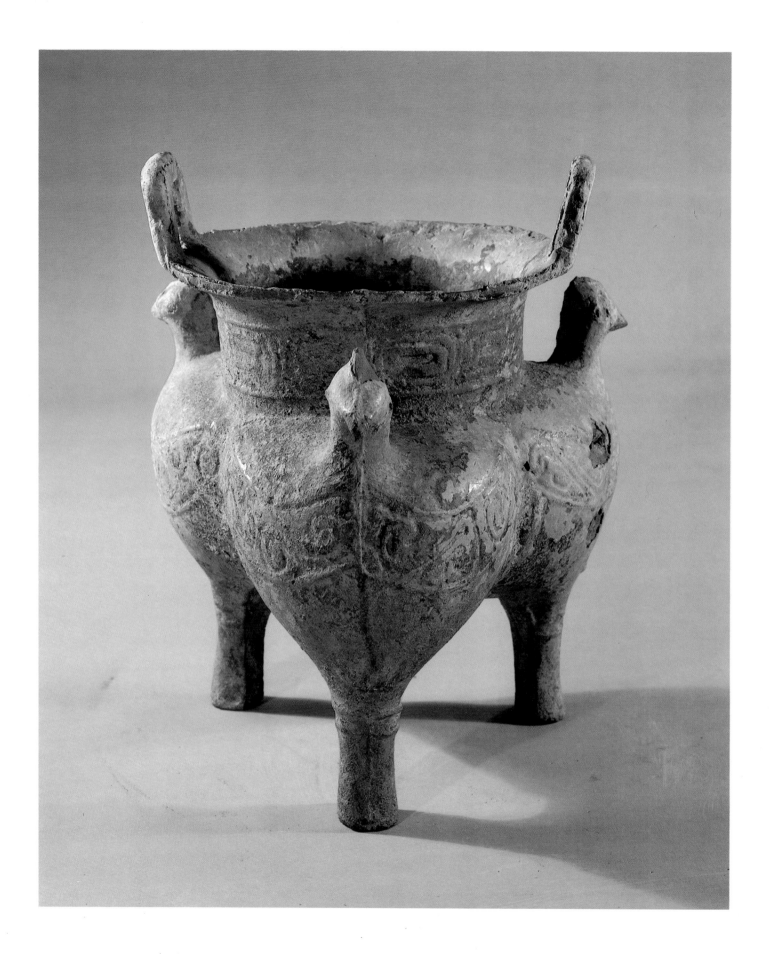

87/88 Bronze *li* (cooking vessel and food container) in the form of three turtledoves.
Western Zhou Dynasty

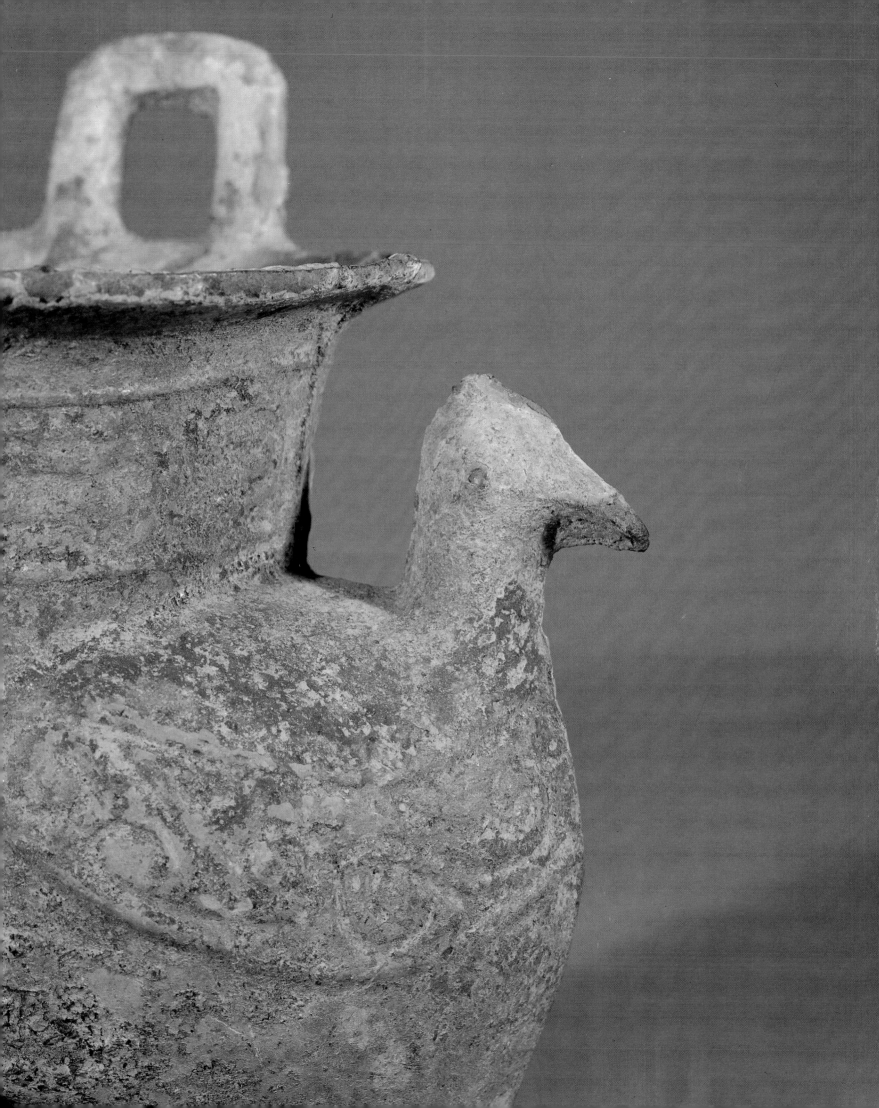

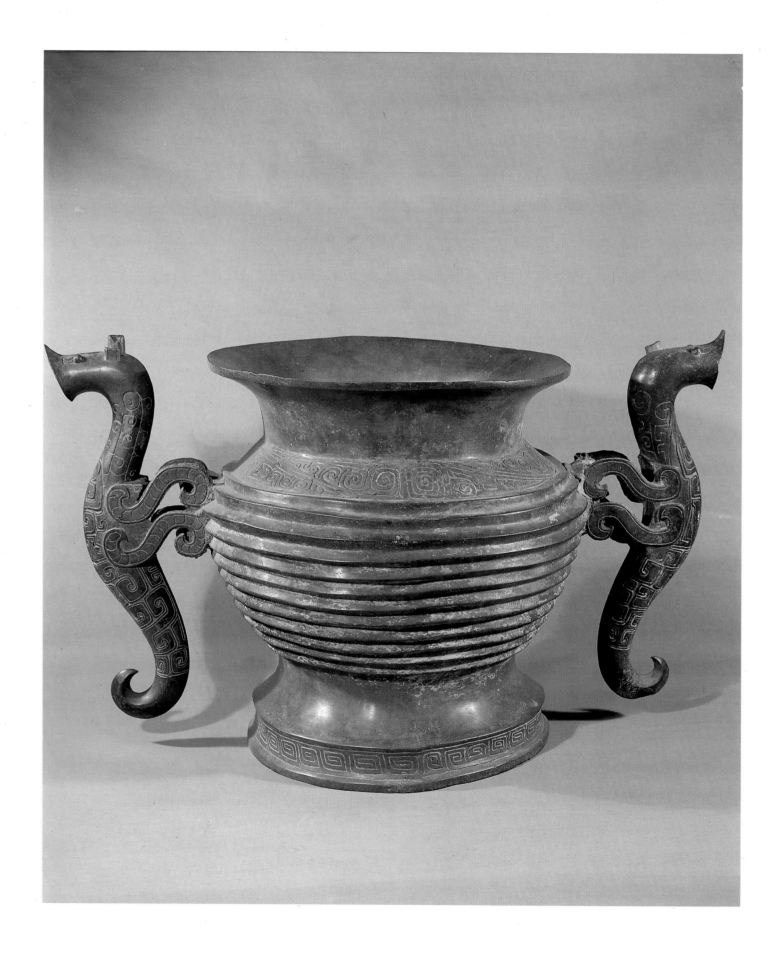

89/90 Bronze *zun* (wine vessel) with dragon-shaped handles.
Western Zhou Dynasty

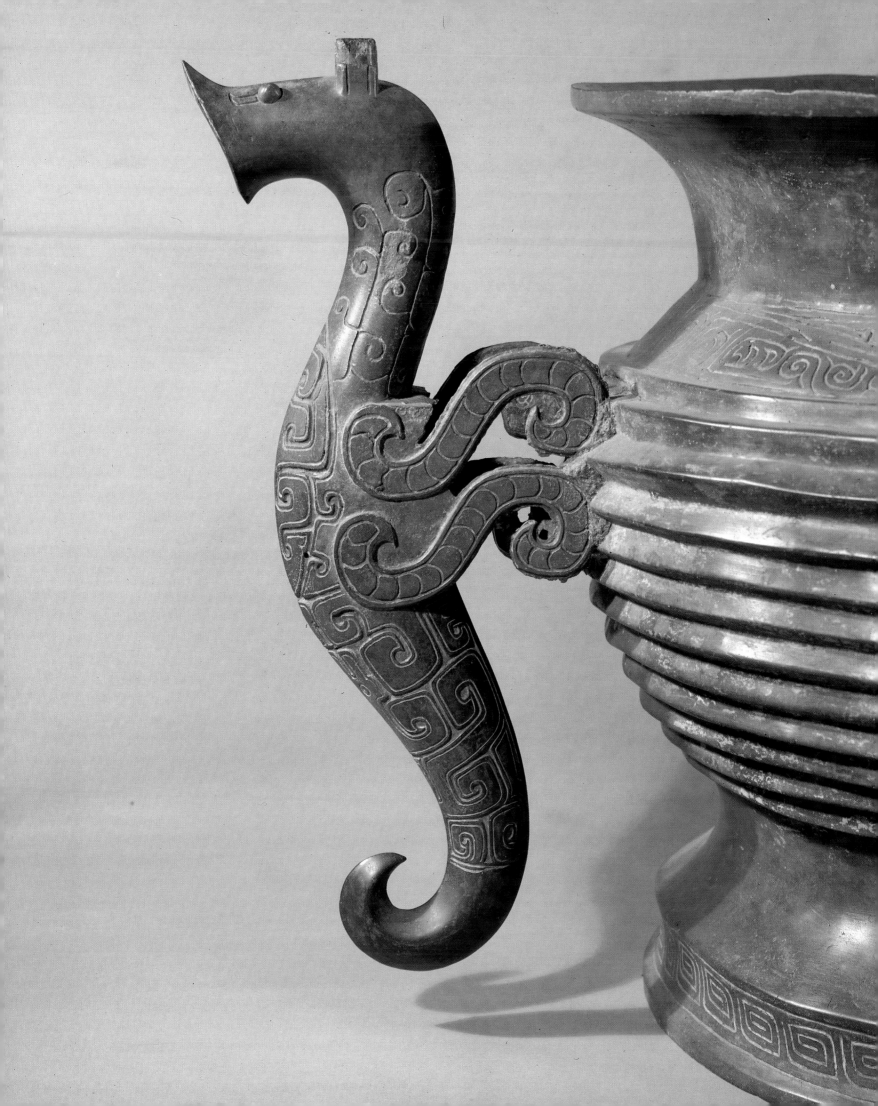

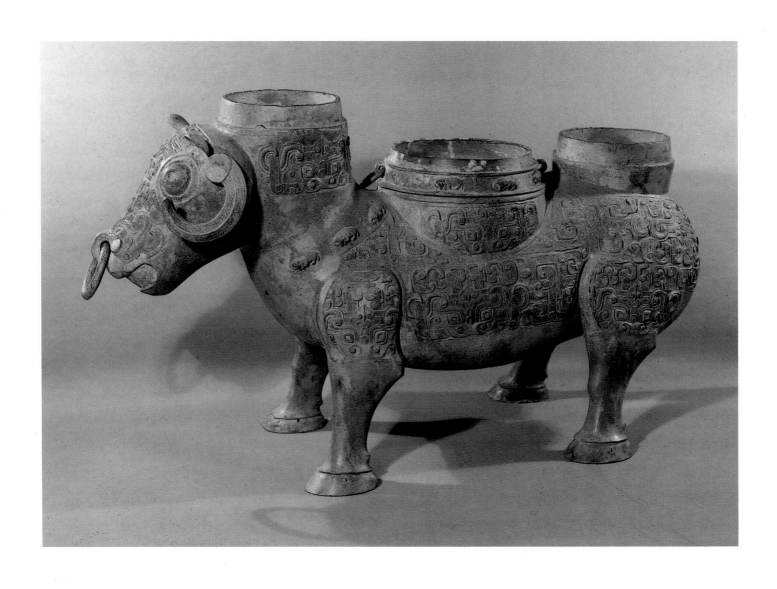

91 through 93 Bronze *zun* (wine vessel) in the shape of an ox.
Spring and Autumn Annals Period

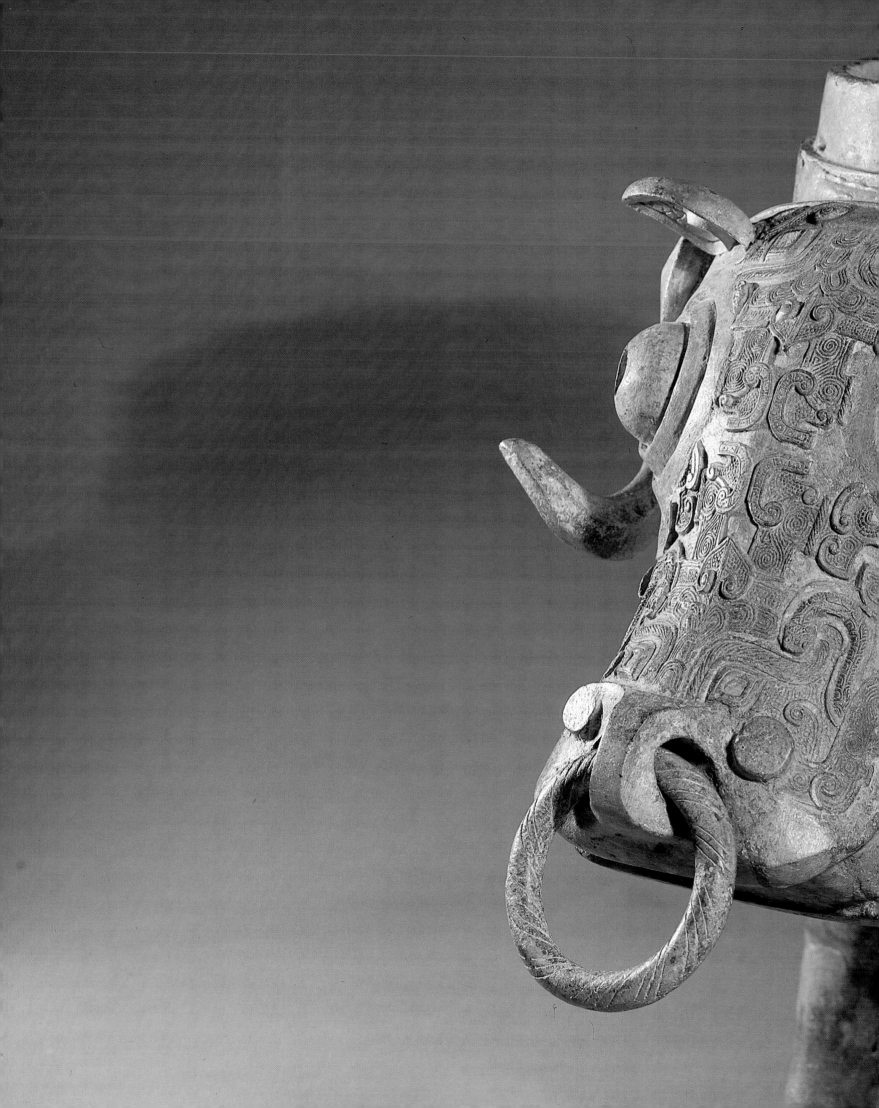

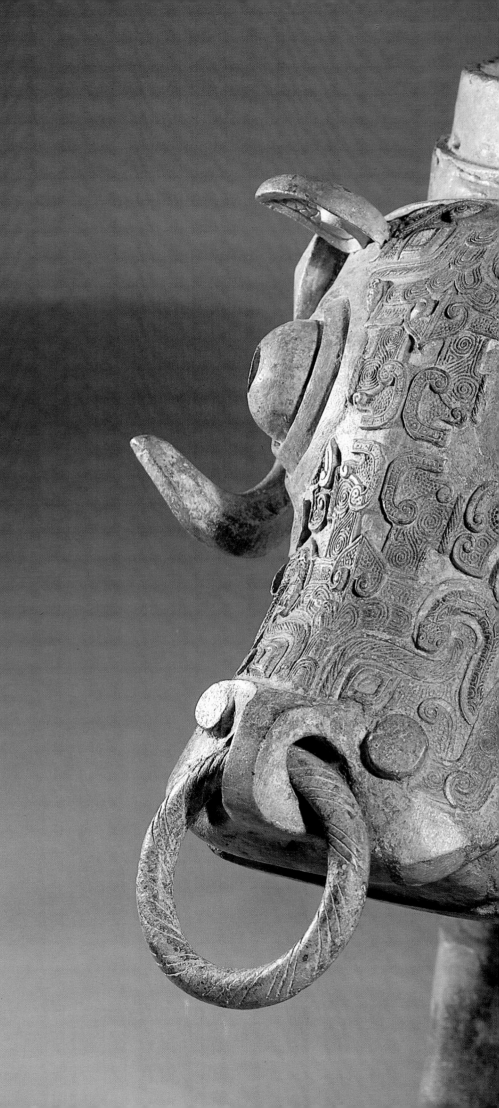

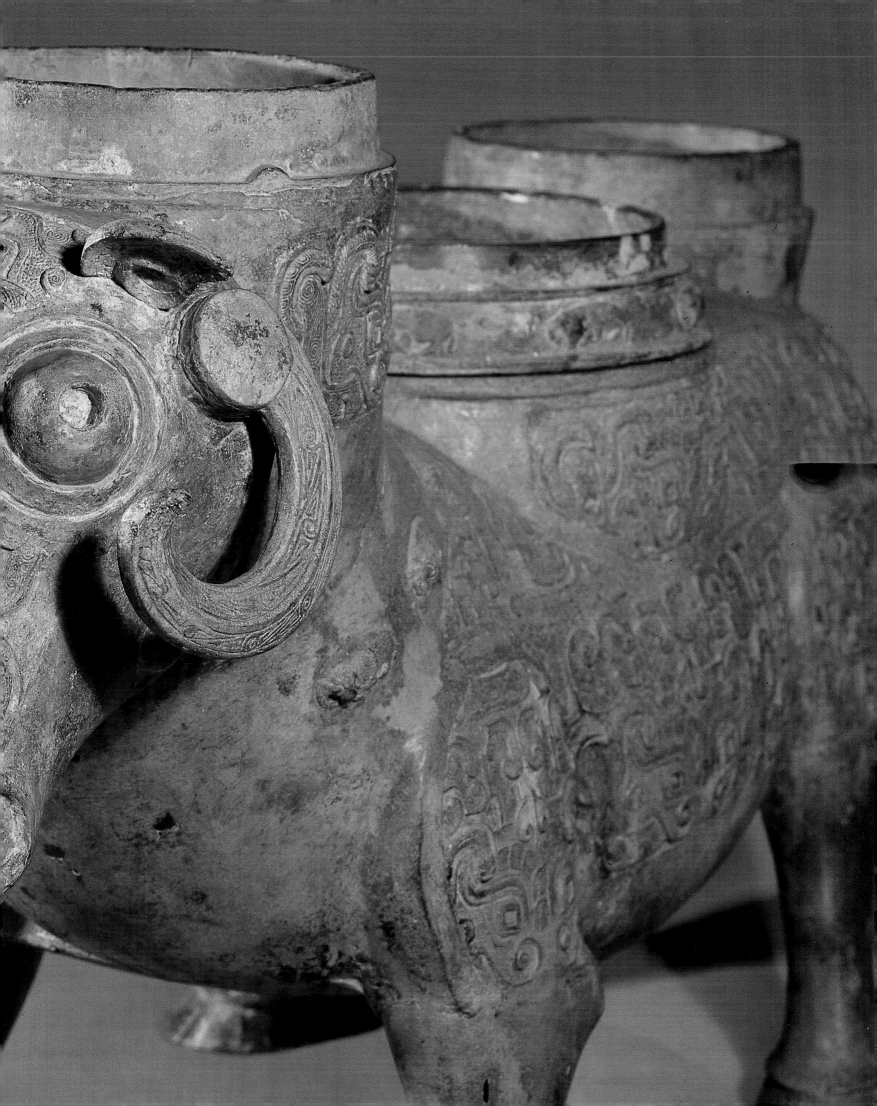

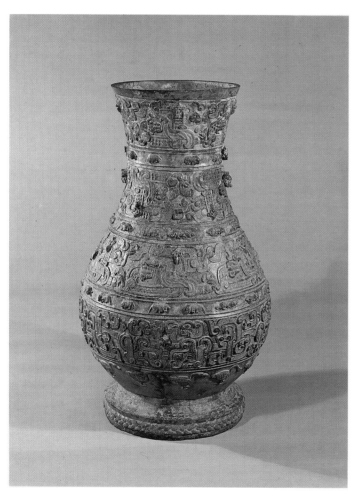

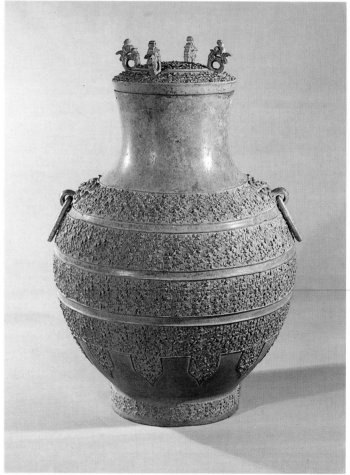

94 Bronze *hu* (wine vessel)
decorated with bird, animal, and dragon patterns.
Spring and Autumn Annals Period

95 Bronze *hu* (wine vessel)
decorated with feather patterns.
Spring and Autumn Annals Period

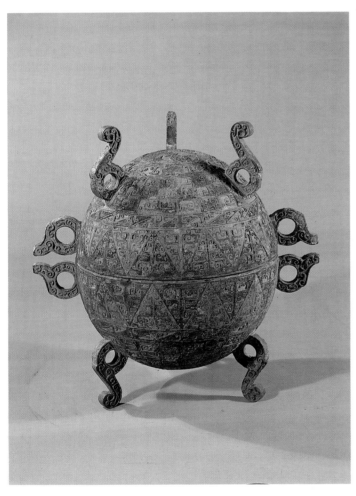

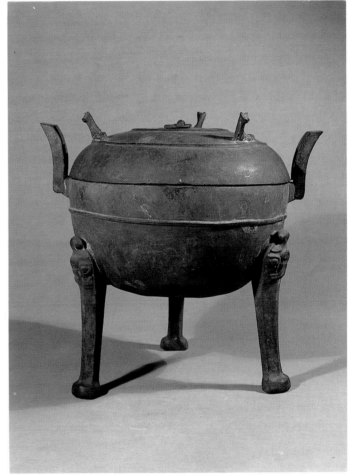

96 Bronze *dui* (food container)
inlaid with geometric patterns.
Warring States Period

97 Bronze *ding* (sacrificial vessel)
decorated with three ox forms.
Warring States Period

98 Bronze mirror decorated with a four-tiger design.
Warring States Period

99 Bronze *hu* (wine vessel) in the shape of a fish.
Western Han Dynasty

100/101 Bronze lamp in the shape of a ram.
Western Han Dynasty

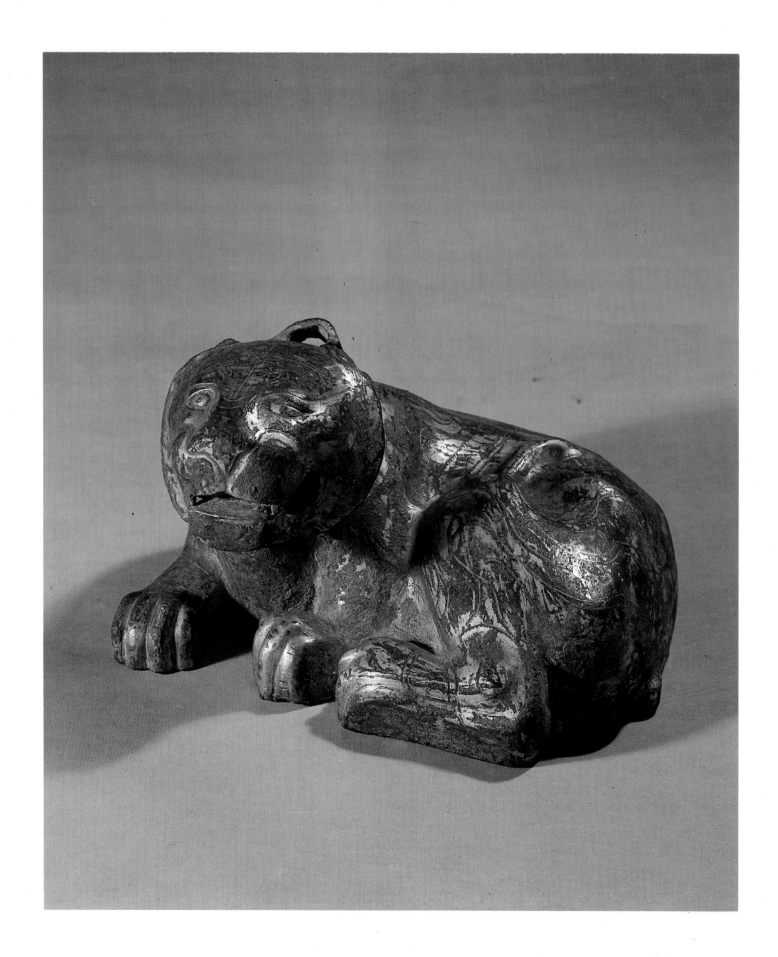

102 Gilt bronze tiger.
Western Han Dynasty

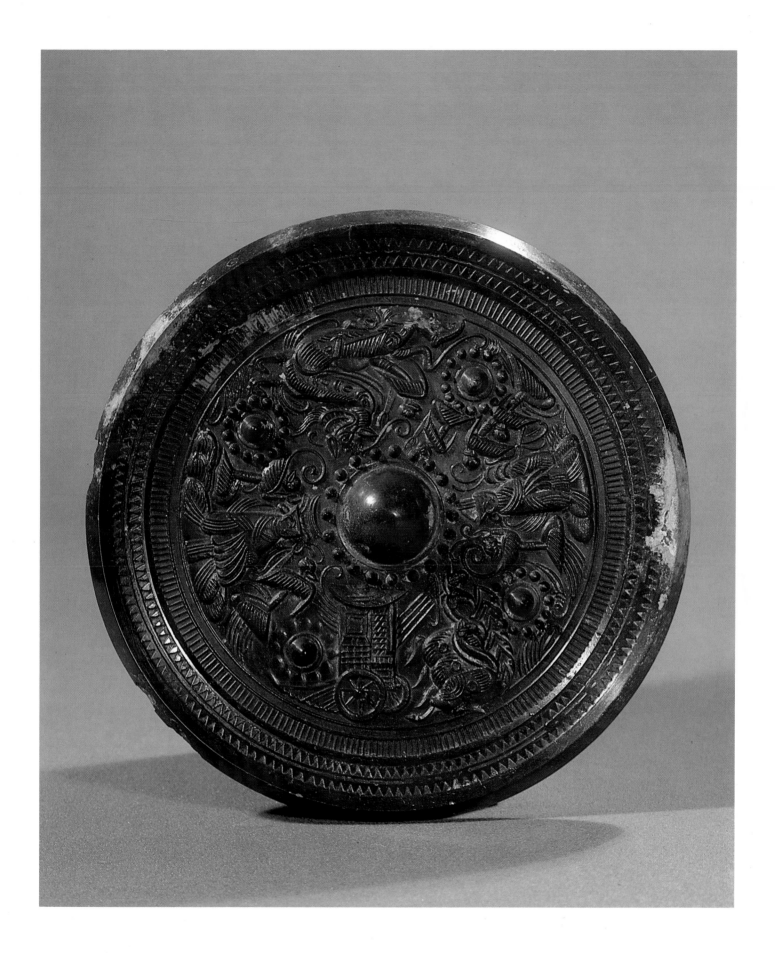

103 Bronze mirror decorated with figures of deities.
Eastern Han Dynasty

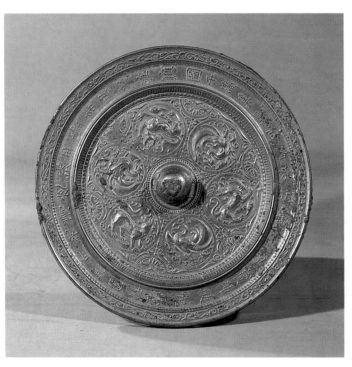 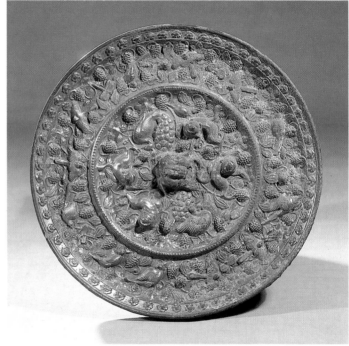

104　Bronze mirror inscribed "Lin Shan Yun Bao."　　　105　Bronze mirror decorated with peacocks and grapes.
Sui Dynasty　　　　　　　　　　　　　　　　　　　　　Tang Dynasty

60

Bronze *jue* (wine goblet) with animal-mask design.
Height: 18.6 cm. Length of mouth: 18 cm. Shang Dynasty

This wine goblet, with three legs below the belly, can also be used as a wine warmer. The upper part projects far outward on both sides, forming a long, narrow spout on one side and a pointed tip on the other. It has a flat body and deep belly. Both the neck and belly are decorated with animal-mask designs. The designs on the neck are of fine but forceful lines while those on the belly are of bold threads. To use dissimilar lines to decorate the same vessel is typical of the Erligang Culture (16th–14th century B.C.) of the Shang Dynasty. This kind of flat-bodied *jue* is one of the earliest of its kind.

61

Bronze *jia* (wine container and warmer) with animal-mask design.
Height: 26.7 cm. Diameter of mouth: 15.6 cm. Shang Dynasty

This *jia* was used both as a wine container and a wine warmer. It has a flared mouth and thickened mouth rim, on top of which are two mushroomlike knobs. A loop-handle on the body joins the neck and the belly. The vessel is decorated with superposed zones of ornaments; each zone has an animal mask. Below the flat bottom are three hollow legs which communicate with the belly. It was so cast because people had not yet found a way to seal off the clay core into the legs. This is another remarkable characteristic of the bronzes of the Shang Dynasty's Erligang Period (16th–14th century B.C.).

62

Bronze *ding* (food container) with animal-mask design.
Height: 20.2 cm. Diameter of mouth: 16 cm. Shang Dynasty

A *ding* was generally used as a food container and sometimes as a cooking vessel. Most magnificently decorated *ding* were used only as food containers for they couldn't stand a strong fire. This *ding* has rather small upright handles, a deep belly, and column-shaped legs. The area below the mouth rim is decorated by a band in dragon design, while the belly is decorated with large, spacious animal masks with horns curling inward and protruding eyes. The spaces on the face are all decorated with spirals. The form and patterns indicate that this is a vessel of the middle Yinxu Period (c. 12th century B.C.).

63 64

Bronze *lei* (wine container) ornamented with four ram heads.
Height: 38.8 cm. Diameter of mouth: 31.6 cm. Shang Dynasty

The *lei* shown here is a magnificent wine container. It has a wide mouth, a thick mouth rim, and a broad shoulder ornamented with four ram heads with curved horns and studded with birds against a background of dragon patterns. On the neck are three bands of raised lines. The belly is ornamented with thunder patterns and sparse nipple-like studs. The tall foot rim with four square openings is decorated with animal masks.

This massive vessel was cast in two stages. The body was first cast leaving apertures in proper places on the shoulder; then the pottery molds for casting the ram heads were placed on the apertures for pouring. The squat form and wide belly are salient features of bronzes of the middle Yinxu Period (c. 12th century B.C.). This *lei* has been attributed to the western part of Hunan Province.

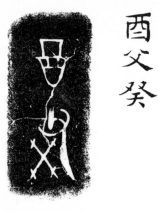

65

Bronze *gui* (food vessel) inscribed "You Fu Kui."
Height: 17.4 cm. Diameter of mouth: 23.5 cm. Shang Dynasty. *Donated by Wu Qinyi*

The *gui* was a food vessel chiefly used for holding cooked millet, rice, and sorghum. This *gui*'s belly is decorated with thunder and nipple-like patterns; the neck and the foot rim are decorated with a dragon with an elongated trunklike motif. Such designs are usually seen on bronzes of the period toward the end of the Shang Dynasty and the beginning of the Western Zhou. Two animal-mask-shaped handles with appendages are on opposite sides of the belly. Inside the belly are inscribed three characters—"You Fu Kui." A noble man named You had this vessel made for offering sacrifices to his father, Kui, in the late Yinxu Period (c. 11th century B.C.).

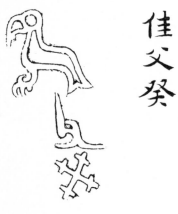

66

Bronze *zun* (wine container) inscribed "Jia Fu Kui."
Height: 31.3 cm. Diameter of mouth: 23.8 cm. Shang Dynasty

The *zun* was a wine container. This vessel is covered all over with spiral patterns on which are finely executed animal masks of different forms—on neck, belly, and foot rim. The animal-mask patterns are incomparably exquisite.

The flanges on four sides extend beyond the mouth rim and make the vessel look even more balanced and solemn, a feature typical of the bronzes of the late Yinxu Period (c. 11th century B.C.). On the inside of the foot rim is inscribed "Jia Fu Kui." The three characters have double hooks and are upright and graceful. The nobleman Jia had this vessel made for offering sacrifices to his father, Kui.

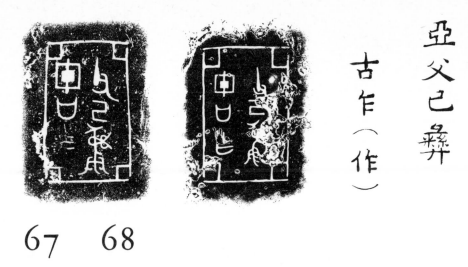

67　68

Bronze *you* (sacrificial wine container) inscribed "Gu Fu Ji."
Height: 33.2 cm. Diameter of mouth: 15.7 cm. Shang Dynasty

The *you* was a sophisticated container for offering fragrant sacrificial wine to deities and ancestors. Only distinguished noblemen were allowed to use such superior wine containers.

The entire body of this *you* is in the form of a barrel. Its form is rather unusual. The neck and the foot rim are decorated with *kui* dragon design. Both the lid and the belly are decorated with large ox heads, their upright horns projecting from the surface and their eyes big and staring. This gives the *you* an air of awe and mystery. The vessel and lid are both inscribed with six characters indicating that the nobleman Gu had this vessel made for his father, Ji, in the late Yinxu Period (c. 11th century B.C.).

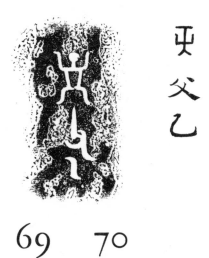

69　70

Bronze *gong* (wine container) inscribed "Fu Yi."
Height: 29.5 cm. Length: 31.5 cm. Shang Dynasty

On the front part of the lid of this *gong,* or wine container, is a giraffe-horned animal head with a small dragon between the two horns and phoenixes on the sides. The rear part of the lid is in the form of an ox head. The whole body is covered with phoenix patterns. The two chief phoenixes are larger than the others, which have long curled tails. All the birds are in different postures. At the front of the vessel is a spout for pouring wine and in the rear, a handle.

Most wine vessels of this type belong to the Shang and early Western Zhou Periods. The style of the animal head on the lid, the inverted tips of the ox horns, and the large flat handle are features of the late Yinxu Period (c. 11th century B.C.). Both the lid and the body are inscribed "Fu Yi."

田告父丁

71

Bronze rectangular *ding* (sacrificial vessel) inscribed "Tian Gao Fu Ding."
Height: 24.3 cm. Mouth: 14.6 × 19.5 cm. Western Zhou Dynasty

Rectangular *ding* are rather rare. This vessel with upright handles, shallow belly, and four column-shaped legs belongs to the early Western Zhou period (11th–10th century B.C.). Below the mouth rim are interlocking animal-eye designs. On the belly are large animal masks with inwardly curled horns, while the bodies spread to the sides. On the legs are plantain-leaf designs. Flanges decorate the four corners and the four sides. On the inner wall of the vessel are inscribed the four characters indicating that this sacrificial vessel was dedicated by Tian Gao to his father, Ding.

交從鄙速臥，王
易（錫）貝用乍（作）寶彝。

72

Bronze *ding* (sacrificial vessel) inscribed "Jiao."
Height: 27.6 cm. Diameter of mouth: 23.3 cm. Western Zhou Dynasty

This vessel belongs to the early Western Zhou Dynasty (11th–10th century B.C.). It has vertical handles, constricted mouth, inflated belly, and column-shaped legs. A band of spirals and studs decorates the part below the mouth rim, large animal masks with open mouths and big fangs decorate the belly, and phoenixes with high crests decorate the sides. All the spaces are studded with spirals. The three legs are decorated with plantain leaves. On the inner wall of the belly are twelve characters saying that a man by the name of Jiao had this vessel made on the occasion when he received a reward for his merits.

73

Bronze *hu* (wine container) inscribed "Chu Fu Geng."
Height: 38.1 cm. Diameter of mouth: 8.4 cm. Western Zhou Dynasty. *Donated by Gu Kaishi and Cheng Yanjia*

This *hu* wine container has a long neck, deep belly, ring-foot, and cylinder-handles on both sides of the neck—which is decorated with two confronting phoenixes with multipronged crests and long, broad, drooping tails. The belly is decorated with overlapped scales. The multipronged crest is rarely seen in phoenix patterns.

Both the form and the patterns on this vessel belong to the early Western Zhou Dynasty (11th–10th century B.C.). Inside the mouth rim are five characters saying that this vessel was dedicated by a man named Chu to his father, Geng. The lid is missing.

74

Bronze rectangular *zun* (wine container) inscribed "Kuei Gu."
Height: 21.8 cm. Diameter of mouth: 20.1 cm. Western Zhou Dynasty

This bronze vessel belongs to the early Western Zhou Period (11th–10th century B.C.). It has sloping shoulders, a rectangular body, and a round mouth. Beneath the mouth rim are plantain leaves formed by animal masks. The neck and the foot rim are decorated with birds whose crests are ribbonlike. On top of the shoulders are dragons with double heads looking at each other, and on the belly are large animal-mask designs. The decorations are quite magnificent. Each of the four corners of the shoulders is decorated with an animal with elephant's trunk and protruding, curved horns; this part of the design was cast separately with smaller molds. Four flanges extending beyond the mouth decorate the corners. This *zun* is not large but it was cast in the style of a massive vessel. The inscription inside of its belly shows that the vessel was for use in traveling.

75

Bronze *you* (sacrificial wine container) decorated with phoenixes.
Height: 27.6 cm. Mouth: 8.8 × 10.8 cm. Western Zhou Dynasty

This wine container has a six-lobed knob above its lid. On each of the lobes is a cicada pattern. The edge of the lid, the neck, the belly, and the foot rim of the bronze are all decorated in symmetry with dissimilar phoenixes. The phoenixes on the belly have multipronged crests and long, drooping tails. They look very splendid. Also, the phoenixes in different parts of the vessel are in different postures.

The vessel's loop-handle is attached to knobs in the shape of dragon heads with multipronged horns at the front and the back instead of at the two sides. The loop-handle is decorated with dragons with two heads looking at each other. There are flanges on each of the four sides of the vessel. The four flanges on the upper part jut out from the surface—which makes the *you* look very stately. Such flanges are rarely seen on bronzes of the Shang and Western Zhou Dynasties. This *you* belongs to the early Western Zhou Dynasty (11th–10th century B.C.).

76

Bronze *zheng* (percussion musical instrument) decorated with animal masks.
Height: 65.3 cm. Mouth: 30.8 × 44.2 cm. Western Zhou Dynasty

The *zheng,* a percussion musical instrument, has mostly been found singly. It was probably played as an accompaniment or served as a time beater for a group of players. Almost flat in form, with a hollow handle, it can be placed on a stand with its mouth upward to be struck. It produces two different tones, on the front panel and the side. The mouth rim is decorated with a double-tailed dragon and the body with stylized animal masks which have only symbolic eyes, the other parts being stylized into pure decorations.

This early Western Zhou (11th–10th century B.C.) bronze *zheng* is heavy and massive. Seldom has a huge *zheng* like this been handed down to posterity from generation to generation.

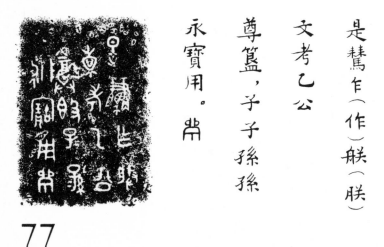

77

Bronze *gui* (food container) inscribed "Shi Lai."
Height: 29.7 cm. Diameter of mouth: 23.8 cm. Western Zhou Dynasty

This food vessel belongs to the middle Western Zhou Dynasty (10th–9th century B.C.). It has a flared mouth, two handles, a ring-foot, and a fretwork pedestal. *Gui* with square pedestals appeared at the beginning of the Western Zhou Dynasty. Before that, the pedestals were usually made out of wood or other materials; that is why none has been preserved. This *gui* is ornamented all over with vertical strips, simple yet graceful. An eighteen-character inscription on the inside bottom of the belly says that this is a sacrificial vessel made by a man named Shi Lai to dedicate to Lord Yi. Another vessel exists made by Shi Lai, the inscription on it slightly different.

78

Bronze *he* (wine-diluting or -warming vessel) decorated with animal masks and a dragon-shaped spout.
Height: 30.1 cm. Length: 39.2 cm. Western Zhou Dynasty. *Donated by Ding Yingrou*

The *he* was a vessel for diluting or warming wine. On the lid is a coiled dragon. The upraised dragon head forms the knob. The sides of the *he* are decorated with a band of trunked animals, and its neck is decorated with a band of dragons while the shoulder is decorated with spirals. Beneath the belly are three pouched legs each decorated with an animal mask. At the front is a dragon-shaped spout for pouring wine; at the rear is a handle in the shape of a dragon head. On the lid and neck are two open rings, which can be connected by a chain. The decorative animal masks and coiled dragons have parts in relief. This style is typical of the middle and late Western Zhou period. This *he* belongs to the middle Western Zhou (10th–9th century B.C.)

佳正月既生霸丁酉，
王才（在）周康宫（寢）卿（饗）醴。師
遽蔑厤者（侑）。王乎宰利
易（錫）師遽珪一，璋章（璋）
三（四）。師遽拜頴（稽）首，敢對
訊（揚）天子不（丕）顯休，用乍（作）
文且（祖）也公寶尊彝。用
匄萬年七（無）疆，世孫子永寶。

79 80

Bronze rectangular *yi* (wine container) inscribed "Shi Jiu."
Height: 16.4 cm. Mouth: 7.6 × 9.8 cm. Western Zhou Dynasty

This wine container has a roof-shaped lid. Ears with appendages are set on both sides of the vessel. Inside the vessel there is an inner partition dividing it into two chambers, which correspond to the two holes on the lid where small wine ladles could be inserted. The lid and belly of the vessel are decorated with stylized animal-mask designs.

The vessel and the lid each have an inscription of sixty-six characters, telling that at a feast given by King Gong (of the period 11th century–841 B.C.) of Zhou in the Kang Qin Palace, Shi Jiu presented gifts to him. Thereupon the king ordered Zai Li to bestow on him pieces of carved jade. As a token of his gratitude to the king and to publicize the king's good virtue, Shi Jiu had this ritual vessel made. The name Zai Li mentioned in the inscription is known to exist

in the period of King Gong. Therefore, this bronze rectangular *yi* provides very valuable material for studying the changed forms and patterns of bronze vessels during that king's reign.

81 82

Large bronze tripod *ding* (sacrificial vessel) inscribed "Ke."
Height: 93.1 cm. Diameter of mouth: 75.6 cm. Western Zhou Dynasty. *Donated by Pan Dayu*

This *ding* was unearthed in 1890 at Rencun Village, Famensi, Fufeng County, Shaanxi Province. Having been recorded in many reports and articles, the huge and important bronze vessel has become one of our nation's well-known treasures. It weighs 201.5 kilograms. Such a massive vessel has rarely been seen even among Western Zhou bronzes.

 The part beneath the mouth rim is decorated with animal masks and the belly with broad wave designs. The vessel's form is stately and formidable; the decorations, forceful and awesome. On the inner wall of the belly is a 290-character inscription recording that the nobleman Ke had held an important post in the court because of the merits of his master, Hua Fu. King Li (of the period c. 11th century–841 B.C.) of the Western Zhou conferred on him large tracts of land and many male and female slaves. This inscription has long been important material for studying the history of the Western Zhou Dynasty.

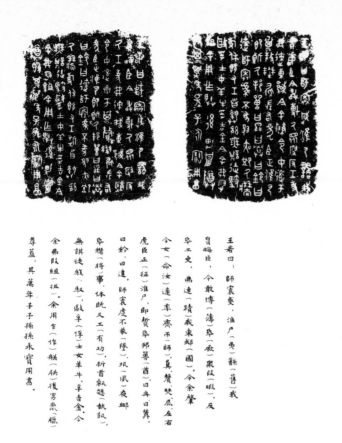

王若曰：師寰豎，淮尸（夷）繇（舊）我
負晦臣，今敢博（薄）氒（厥）眾叚（暇），反
氒工吏，弗速（蹟）我東邮（國），今余肇
令女（命汝）達（率）齊帀（師）、莫釐熒尻左右
虎臣正（征）淮尸，即質氒邦曑（酋）曰厈曰箕
曰鈴、曰達。師寰虔不墜（隆）、夙夜
氒揺（將）事、休既又工（有功）、折首執题（執訊），
無諆徒馭（馭）、歐孚（俘）士女羊牛、孚吉金，今
余弗嗀組（組）。余用乍（作）躲（朕）後男嬎（朕）
尊毃，其萬年子子孫孫永實用高。

83

Bronze *gui* (food container) inscribed "Shi Huan."
Height: 27 cm. Diameter of mouth: 22.5 cm. Western Zhou Dynasty

The *gui* was a food container. The edge of the lid and the mouth rim of this example are decorated with ragged curve patterns. The belly is decorated with horizontal grooves. An animal-shaped handle with appendage is set on either side of the body. The ring-foot is covered with scale patterns. There are three animal-type legs below. The design is simple, the form massive.

The lid and the vessel each have a 117-character inscription recording the fact that King Xuan (c. 827–782 B.C.) of the Western Zhou Dynasty ordered Shi Huan to lead an allied army of the State of Ji and others to go on an expedition against the Huai Yi tribes because they failed to pay tribute to the king. The expeditionary army smashed the several chiefs and returned triumphantly with captives and booty. This vessel was made to mark the victory. The inscription is evidence of the vassalage of the Huai Yi tribes to Western Zhou and the historical event of the expedition during the reign of King Xuan of the Western Zhou.

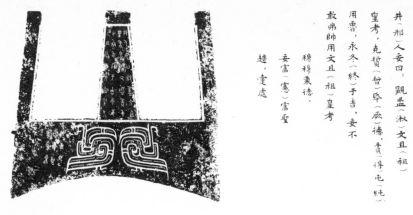

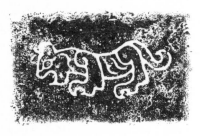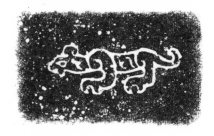

84

Bronze *zhong* (percussion musical instrument) inscribed "Xing Ren."
Height: 69.5 cm. Mouth: 29 × 38 cm. Western Zhou Dynasty

The *zhong* was a percussion musical instrument. As early as the middle Western Zhou Dynasty there appeared a set of three chime bells. This *zhong* is thick and heavy and huge in form. The shoulder is decorated with dragon designs while the lower side is decorated with symmetrical back-to-back *kui* dragons. There is a forty-three-character inscription which is only part of a text; another part of the text was later found on another *zhong* unearthed in 1971 at Qizheng Village, Fufeng County, Shaanxi Province. The whole text should have eighty-nine characters, revealing that Xing Ren had this *zhong* made to dedicate to his father. It dates back to the reign of King Xuan (c. 827–782 B.C.) of the Western Zhou.

85

Bronze *gui* (food container) inscribed "Hu."
Height: 34.7 cm. Diameter of mouth: 23.3 cm. Western Zhou Dynasty

This food container has been attributed to Fengxiang County, Shaanxi Province. It has a square pedestal and a lid with a knob in the shape of eight lotus petals. The lid can also be used as a bowl when put upside down. A dragon-head-shaped handle with appendage is set on each of the two sides of the vessel. They were cast beforehand and put in the clay molds for casting onto the body. Bands of broad wave patterns adorn the vessel and different forms of stylized animals adorn the mouth and foot rims. It looks simple and stately. Patination on it appears as green as emerald. It is an outstanding example of the late Western Zhou (9th century–771 B.C.) bronzes. Both on the lid and inside the belly is inscribed the character "Hu."

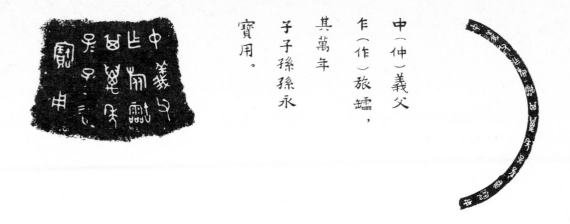

中（仲）義父
乍（作）旅鑘，
其萬年
子子孫孫永
寶用。

86

Bronze *ling* (wine vessel) inscribed "Zhong Yi Fu."
Height: 44.2 cm. Diameter of mouth: 15.5 cm. Western Zhou Dynasty

This lidded wine container was unearthed at Rencun Village, Famensi, Fufeng County, Shaanxi Province. Outside the flared mouth are four loop-handles which can be fastened with strings. It has a broad shoulder decorated with two dragon-shaped ears, a flat bottom, and a sham ring-foot. It is decorated with ragged curves at the neck, belt-of-scale patterns on the lid and upper and lower parts of the body, and overlaid scales over the remaining surface to give the impression of being the body of a dragon.

The *ling* has a sixteen-character inscription on the lid and the shoulder, saying that Zhong Yi Fu had this wine vessel made for use when traveling. The maker named the vessel a *ling,* having developed it from the *lei* wine vessel. This *ling* belongs to late Western Zhou (9th century–771 B.C.)

87 88

Bronze *li* (cooking vessel and food container) in the form of three turtledoves.
Height: 21.4 cm. Diameter of mouth: 14.3 cm. Western Zhou Dynasty

The *li* was used as a cooking vessel and also as a food container. It has a flared mouth and vertical handles. The neck is decorated with a band of scales. The belly and the legs are in the form of three turtledoves the heads of which are in relief; the breasts are ornamented with bands of spirals, looking like outstretched wings. Below are three pouched legs so designed as to give more surface for heating. The form is unique. To use the form of a turtledove as decoration for the *li* is a feature of the sculptural art of the Shang and Western Zhou Dynasties. This vessel is a fine specimen of applied art. It belongs to the late Western Zhou (9th century–771 B.C.).

89 90

Bronze *zun* (wine vessel) with dragon-shaped handles.
Height: 38.5 cm. Diameter of mouth: 35 cm. Western Zhou Dynasty

This wine container has a flared mouth, a broad shoulder, and a foot rim. The shoulder and foot rim are decorated with thunder patterns and the belly with horizontal grooves. These are patterns usually seen on late Western Zhou (9th century–771 B.C.) bronzes. The two dragon-shaped handles are as high as the vessel. The dragons are looking backward with open mouths, their curled tails drooping to the ground and their feet fixed to the belly of the vessel. Three-dimensional dragons as decoration on bronzes are very rare in the late Western Zhou period. The only *zun* of this shape seen, it was unearthed in Anhui Province.

91 92 93

Bronze *zun* (wine vessel) in the shape of an ox.
Height: 33.7 cm. Length: 58.7 cm. Spring and Autumn Annals Period

This *zun* (wine vessel) is one of the most exquisite bronzes unearthed in 1923 at Liyu Village, Hunyuan County, Shanxi Province. It belongs to the State of Jin of the late Spring and Autumn Annals Period (6th century–481 B.C.). It is in the shape of an ox, with three cavities on its back. The one at the center is to hold a wine pot while the other two are for filling the belly with water to warm the wine. The lids and wine pot are lost. Animal masks adorn various parts of the vessel. The neck and the mouth rim of the central cavity are adorned with small oxen, tigers, and leopards in relief. The ox has its ears pricked up and horns curled downward. A ring is attached to its nose. The ox looks lifelike. Bronze *zun* in the shape of an ox for warming wine are very rare.

94

Bronze *hu* (wine vessel) decorated with bird, animal, and dragon patterns.
Height: 44.2 cm. Diameter of mouth: 16.5 cm. Spring and Autumn Annals Period

This *hu* was one of a pair unearthed in 1923 at Liyu Village, Hunyuan County, Shanxi Province. It is a tall wine vessel with a fairly long neck and very exquisite decoration. Below the mouth rim are three bands of interlaced dragons entwined with mythical monsters having human faces, bird beaks, animal bodies, and bird tails. The belly is decorated with an animal mask holding a mythical monster like a coiled dragon in its mouth. In the space between the decorated bands are small lifelike oxen, rhinoceroses, tigers, and leopards. Under the belly is a circle of realistic-looking wild geese standing with raised heads and bent necks. The foot rim is decorated with cowries and twisted cord patterns. All the decorations bear features of the Jin area (present-day Shanxi Province) during the Spring and Autumn Annals Period. This meticulously made and profusely decorated vessel is probably the most remarkable bronze of the late Spring and Autumn Annals Period (6th century–481 B.C.).

95

Bronze *hu* (wine vessel) decorated with feather patterns.
Height: 47.5 cm. Diameter of mouth: 17 cm. Spring and Autumn Annals Period

This *hu* has a lid surmounted by four animals whose bodies form upright rings. The lid could be used as a *pan* (dish) when inverted. The two sides each have an animal mask with a ring as a handle. The body is decorated with five overlapping bands of feathers. This decor is a stylized animal pattern.

From the late Spring and Autumn Annals Period, bronze casters started to apply piece mold to the engraved model to get negative designs. In this way, people only had to engrave a single unit of the design on the model and use it repeatedly to obtain negative designs on many piece molds. From this vessel, we can see the amazing level attained in casting technique, the exquisiteness of the engraving, and the fineness of the clay used to make the molds. This wine vessel belongs to the late Spring and Autumn Annals Period (6th century–481 B.C.).

96

Bronze *dui* (food container) inlaid with geometric patterns.
Height: 25.6 cm. Diameter of mouth: 18.6 cm. Warring States Period

The whole vessel is in the shape of a ball, with the lid as one hemisphere and the body as another. The lid could be used as a bowl for food when inverted. On the belly is a band of triangles with alternating intaglio and relievo fillings. Above and below the belly are continuous and overlapping panels. Whorl patterns decorate the top and the bottom. The whole body of the vessel is inlaid with very fine silver and copper threads. The workmanship is exquisite; the designs are profuse yet very disciplined. Gold- and silver-thread inlays on bronzes are features of the Warring States Period (403–221 B.C.).

97

Bronze *ding* (sacrificial vessel) decorated with three ox forms.
Height: 33.2 cm. Diameter of mouth: 24.3 cm. Warring States Period

On the lid there are three squatting oxen and a ring at the center. Two handles are on the sides of the body and three long and flanged legs below. The whole vessel is plain except for three animal masks on the upper part of the legs. A *ding* with long legs is called a *jiao ding*. It belongs to the Chu Culture of the south during the Warring States Period (403–221 B.C.).

98

Bronze mirror decorated with a four-tiger design.
Diameter: 12.2 cm. Warring States Period

As proved by China's archaeological finds, mirrors were used as early as the Shang Dynasty. However, it was not until the Warring States Period that they became widely used. This mirror is said to have been unearthed in 1948 at Jincun Village, Luoyang County, Henan Province. The design on the reverse side, seen here, is divided into four zones; each has a tiger in relief. The tigers, which are gnawing at the knob, have hair on their necks and their bodies are decorated with thunder patterns. They are vivid and forceful.

The mirror is thick and heavy; its form is different from most mirrors of the Warring States Period. Its decorations are quite similar to those on bronzes unearthed at Hunyuan. The date of its manufacture cannot be later than the early Warring States Period (403–221 B.C.).

99

Bronze *hu* (wine vessel) in the shape of a fish.
Height: 31.8 cm. Diameter of mouth: 4.4 cm. Western Han Dynasty

This bronze *hu* in the shape of a fish is a wine container of the Western Han Dynasty (206 B.C.–A.D. 23). Its neck is in the form of a fish head. The belly is decorated all over with scales and the ring-foot suggests the tail. The entire vessel gives a soft, full, and rounded impression. The craftsman subtly devised this article, which combines the form of a fish to stir the viewer's imagination. The fish, symbolizing love and many descendants, was a favorite subject during the Han Dynasty.

100 101

Bronze lamp in the shape of a ram.
Height: 14.2 cm. Length: 17.1 cm. Western Han Dynasty

Making lamps in the shapes of animals was the vogue in the Han Dynasty. Lamps in the shape of a scarlet bird, a ram, an ox, and a goose leg are often seen. This lamp of the Western Han Dynasty (206 B.C.–A.D. 23) is in the form of a kneeling ram. Its back can be raised on a hinge to rest against the ram's head and form an oil reservoir. The lamp can also be used as an ornament when the back is closed. The people of Han times generally regarded the ram as a symbol of good luck because the two characters are homonymous, so that is probably why people cast lamps in the shapes of rams.

102

Gilt bronze tiger.
Height: 10.4 cm. Length: 17.2 cm. Western Han Dynasty

This tiger belongs to the Western Han Dynasty (206 B.C.–A.D. 23). It is lying down but looks ferocious and formidable. It embodies the simple and realistic style of the sculptural arts of the time. The body is gilded all over and engraved with hair patterns. A band of cowrie shells decorates the neck. In the Han Dynasty, the blue dragon, white tiger, scarlet bird, and the turtle and snake were regarded as four deities representing the four directions, *i.e.,* the east, west, south, and north. There is a hole on the underside of the tiger's belly. It is apparently for fixing onto a permanent stand. The purpose of this gilt bronze tiger is probably that mentioned in the inscription of a Han Dynasty mirror: "Dragon on the left and tiger on the right to ward off evils."

103

Bronze mirror decorated with figures of deities.
Diameter: 20.2 cm. Eastern Han Dynasty

Patterns on the backs of bronze mirrors during the Eastern Han Dynasty (A.D. 25–220) had changed to become representational art relief instead of the traditional ornamental art. This took place about the time when stone sculptural art became fashionable. The four scenes on the mirror represent the Eastern King Father and Western Queen Mother, attended by winged figurines. On one side are mythical monsters, which symbolize good luck, and on the other side, a chariot drawn by three galloping horses, representing the Han people's daily life.

104

Bronze mirror inscribed "Lin Shan Yun Bao."
Diameter: 17 cm. Sui Dynasty

The technique of casting bronze mirrors reached a remarkable level during the Sui and Tang Dynasties. This mirror inscribed "Lin Shan Yun Bao," of the Sui Dynasty (A.D. 581–618), was molded with extremely exquisite patterns. The ornamental pattern consists of six different equally spaced motifs of dancing birds and running animals. The remaining areas are decorated with delicate patterns of charming flowers and scrolls. An inscription along the edge of the mirror reads: "Impregnated by the sacred mountain; shiny as a lamp for the deities; round as a full moon; like a luminous pearl in the darkness; a rarity fixed on a jade stand, reflecting the images of well-dressed ladies; the forms of beauties shall be seen; bringing good luck and happiness." Around this inscription is a band of waving scrolls.

105

Bronze mirror decorated with peacocks and grapes.
Diameter: 20.9 cm. Tang Dynasty

This is a typical bronze mirror of the Tang Dynasty (A.D. 618–907) at its zenith. Along the edge of the mirror is a circle of interlocking grapevines and flying birds in various postures. In the center are peacocks and lions in relief, interspersed with interlocking grapevines which are elaborate and exquisite. Peacocks and lions are usually Buddhist art themes, but they are used here by Tang artists in a unique Chinese style quite free of religious connotations.

Paintings and Calligraphy

FOUR

Paintings and Calligraphy

Introduction by Zheng Wei

As early as 5000 B.C. the Chinese people used brushes of animal hair to paint flowing, elegant lines and a variety of patterns on pottery vessels. Historical records of more than 3,000 years ago say that King Wu Ding of the Shang Dynasty asked painters to draw a portrait of "A Faithful Officer," concerning whom he had dreamed. Centuries later, two silk scroll paintings, *Phoenix and Woman* and *Men on a Dragon Boat,* which date back to the 4th century B.C., were unearthed in Changsha. Archaeologists of the New China have discovered that even the walls of burial chambers in the tombs of the Western and Eastern Han Dynasties (3rd century B.C.–A.D. 3rd century) were painted with large murals. All this shows that magnificent Chinese paintings had long lent their splendor to China's ancient civilization and are an important component of China's national culture. Following is a selection of rare paintings and calligraphic works found in the Shanghai Museum collection.

Some of the calligraphic works of the Tang and Song Dynasties may help artlovers to understand the close relationship Chinese calligraphy and painting had with the development of the Chinese writing brush and ink. They are representative works of famous calligraphists in Chinese history. For example, *Ku Sun Tie* by Monk Huai Su of the Tang Dynasty (Fig. 106), *Reply to Xie Minshi on Literature* by Su Shi of the Song Dynasty (Figs. 109 and 110), and *Draft Script on a Stiff Fan* by the Song Emperor Hui Zhong, or Zhao Jie (Fig. 111), are exemplary models of calligraphy in elegant draft script and graceful regular script. By the time of the Tang and Song Dynasties, Chinese calligraphic art already had a history of nearly 3,000 years.

The works included in the painting section start from the Northern and Southern Song Dynasties (A.D. 10th–13th century). The main schools of painting at the time were the Academy of Painting, which had its beginnings in the Western Shu and Southern Tang Dynasties, and the School of Scholar-Painting, which first appeared in the late Tang and Five Dynasties Periods and reached maturity in the Song and Yuan Dynasties. This latter school was characterized by free ink sketches.

Representative works of the Academy of Painting school in this volume are: *Four-Sectioned Scroll* by Ma Yuan (Figs. 113 and 114), *Welcoming the Emperor* by an unknown Song Dynasty artist (Fig. 120), *Bird with Plum Blossoms and Bamboo in Winter* by Lin Chun (Fig. 112), and *Camellias and Butterfly* (Fig. 118) and *Quail* (Fig. 119) by anonymous Song Dynasty painters. The human figures, animals, flowers, and birds in these paintings are beautifully drawn, with exact delineation. The people are lifelike; and the flowers, birds, and animals have their unique natural characteristics. Works belonging to the Scholar-Painting school herein are: *Pine Tree Clad Mountains* by Ju-Ran (Fig. 107) and *Quiet Valley* by Guo Xi (Fig. 108). The painters used the wrinkle method to draw with ink wash that magnificent scenery of high mountains and forest which gives people a sense of nature's grandeur. As a matter of fact, there are signs showing that these two opposite schools of painting, besides developing independently along their own paths, also influenced each other.

By the Northern and Southern Song Periods, Buddhist ideas and Confucian themes, in particular, had permeated works of painting. For example, in his *Eight Eminent Monks* (Figs. 115 and 116) Liang Kai, a painter of the Southern Song Academy of Painting, departed from the established style of the Academy and used simple general strokes. In the Yuan Dynasty, when the Mongolian

nobles moved to settle in the Central Plain region of China, they carried out a brutal policy of oppressing the Han people. This caused the already evident contradictions between the two peoples to sharpen. Great changes took place in the style of the Scholar-Painting school on the basis of its achievements in the Northern and Southern Song Dynasties. Stress was placed now on portraying ideas which were to be simple yet elegant; brushstrokes were to be both plain and precise. There were comparatively fewer flowery works reflecting either themes of real life or imperial gardens. With the avowed intent of going back to ancient ways, the painters Zhao Mengfu and Qian Xuan took the lead to set up a style of their own. They were followed by such painters as Huang Gongwang, Wu Zheng, Ni Zeng, and Wang Meng, who claimed that nature was their teacher and used their brushes and ink to express their feelings by painting it. The scroll *Kicking Ball* by Qian Xuan (Fig. 121), although it is a tracing of an ancient work, is full of the simple and tranquil taste of scholars. In the scroll *Eastern Mountain by Dongting Lake* (Fig. 122) by Zhao Mengfu the whole scene is enveloped in mist and beauty. Most of the figure paintings were now simple sketches. In the *Scroll of the Nine Songs* by Zhang Wo (Figs. 123 and 124) the figures and their fluttering costumes reflect something of the works of Li Gonglin of the Northern Song Dynasty. The flower-and-bird works of the Song Academy of Painting are recalled, in the Yuan Period, by Ren Renfa's *Wild Ducks in an Autumn Creek* (Fig. 125). Looking at it, one can still discern its delicate character.

With the growth of capitalistic tendencies in the Ming and Qing Dynasties, painters came to congregate in a few major handicraft and commercial centers. Life in these different surroundings and circumstances gave rise to diverse styles of brushwork and schools of painting. For example, the Zhejiang School inherited the swift and vigorous brushwork style of Li Tang, Ma Yuan, and Xia Gui of the Southern Song Academy of Painting; *After Fishing in the Autumn River* (Fig. 130) by Wu Wei in this album is representative of this school's "thick-stroke" brushwork. The Wu School of the Suzhou region was an integration of the Song and Yuan Dynasties' Scholar-Painting school and Academy of Painting, and its brushwork was characterized by vigor and elegance. From the paintings *Wu Zhen Yuan Pavilion* (Fig. 129) by Shen Zhou, *Tall Tree in Late Spring* (Fig. 132) by Wen Zhenming, and *Admiring Chrysanthemums* (Fig. 131) by Tang Yin one can clearly see this integration of the two schools and its artistic achievement. The Songjiang School, headed by Dong Qichang, appeared toward the end of the Ming Dynasty and the beginning of the Qing Dynasty and its style was carried on by the Wang Family in Taichang and Yushan Counties. The painters of this school craved for an artistic appearance in brushwork and took such masters as Dong Qichang, Ju-Ran, and Yuan as their protagonists. *Clouds Shroud Mountains and a River* (Fig. 138) by Dong Qichang and *Blue-and-Green Landscape* (Fig. 140) by Wang Jian are paintings in this "ancient" style, achieving a measure of success in brushwork as well as in ink and color. In the same period there were the Eight Master Painters of Jingling in the Nanjing area, the Huangshan and Xinan Schools in Anhui Province, and the Ba Da–Lo Mu School in Jiangxi Province. Paintings such as *Touring Huayang Mountain* (Fig. 146) by Shi Tao (Yuan Ji) and *Wild Geese and Reeds* (Fig. 141) by Zhu Da (Bada Shanren) are works of these well-known painters of the Huangshan and Jiangxi Schools; their brushwork is natural, discarding the old and bringing forth the new—thus greatly influencing the development of the Yangzhou School, which appeared later. There were also many outstanding painters who specialized in flower-and-bird paintings in the Ming and Qing Dynasties. *Camellias and Silver Pheasants* (Fig. 128) by Lin Liang and *Peacocks* (Fig. 149) by Shen Quan represent the development of Academy Painting of that period. *Flowers and Birds* (Figs. 135 and 136) by Zhou Zhimian and *Flower Album* (Figs. 144 and 145) by Yun Shouping are lifelike sketches in elegant colors, expressing the traditional Academy Painting with scholars' interest.

The achievements of Chinese painting in the late Qing Dynasty and in modern times must not be neglected. The figure paintings by Su Liupeng and Ren Yi are comprehensive and lifelike in form, done with neat and simple brushstrokes. Flower paintings by Wu Changshuo are in thick brushstrokes, while fish and prawns painted by Qi Baishi are strikingly true to life. In the landscape paintings of Huang Binhong one feels the painter's breadth of mind in his high mountains and wild rivers. These were painters who carried on the traditional skills while creating styles of their own.

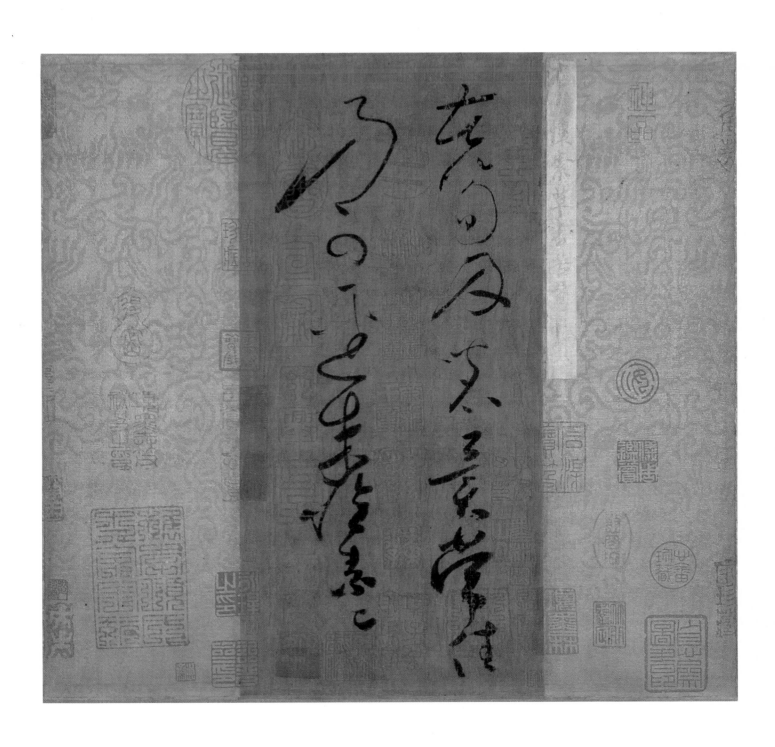

106 Huai Su. *Ku Sun Tie*.
Tang Dynasty

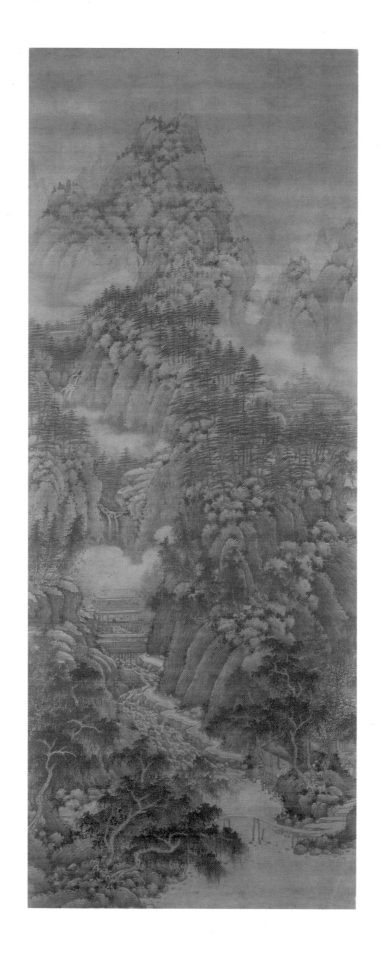

107 Ju-Ran. *Pine Tree-Clad Mountains.*
Five Dynasties Period

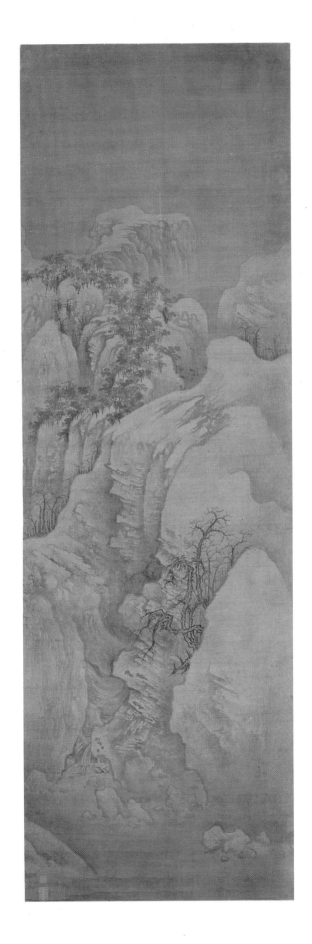

108 Guo Xi. *Quiet Valley.*
Northern Song Dynasty

妙如係風捕景能使是物了然
於心者蓋千萬人而不一遇也而況能
使了然於口與手者乎是之謂詞
達詞至於能達則文不可勝用
矣揚雄好為艱深之詞以文淺
易之說若正言之則人之知之此正
所謂雕蟲篆刻者其太玄法言
皆是物也而獨悔於賦何哉終
身雕蟲而獨變其音節便謂
之經可乎屈原作離騷蓋風
雅之再變者雖與日月爭光可也
可以其似賦而謂之雕蟲乎使賈
誼見孔子升堂有餘矣而乃以
賦鄙之至与司馬相如同科雄
之陋如此比者甚衆可与知者道

軾不
是文之意疑若不然求物之

難与俗人言也因論文偶及之耳
歐陽文忠公言文章如精金美
玉市有定價非人所能以口舌貴
賤也紛紛多言豈能有益於
左右悒悒不已
所須惠力法雨堂字軾本不善
作大字強作終不佳又舟中局迫
難寫未能如
教然則方過臨江當往遊寫數
僧有所欲記錄當為作數句留
院中慰
左右念
親之意今日已至峽山寺少留即
之金陵矣
以時自愛不宣 軾頓首再拜
民師帳勾推官閤下
十二月苔

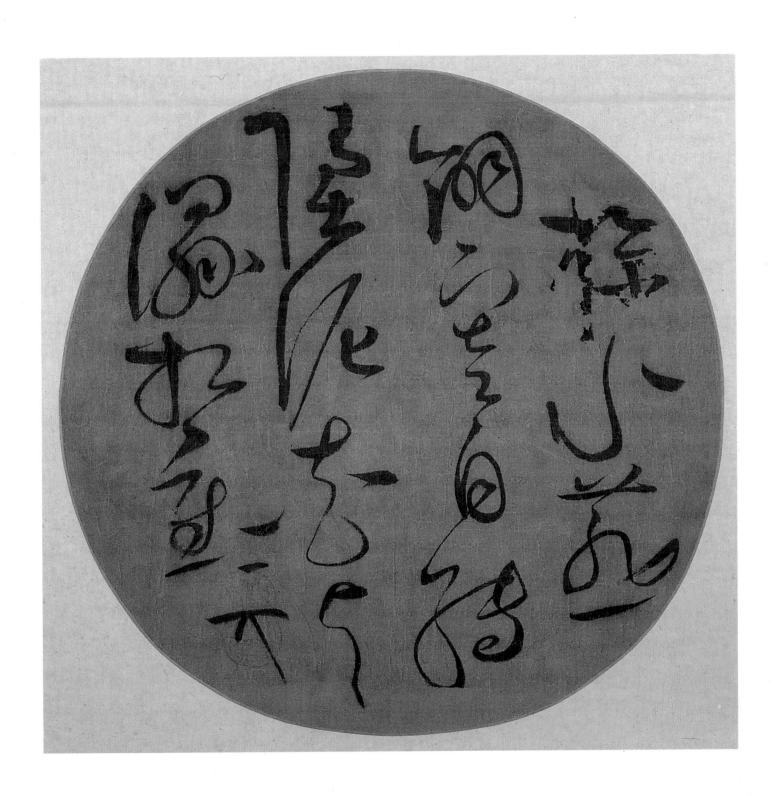

111 Zhao Jie. *Draft Script on a Stiff Fan.*
Northern Song Dynasty

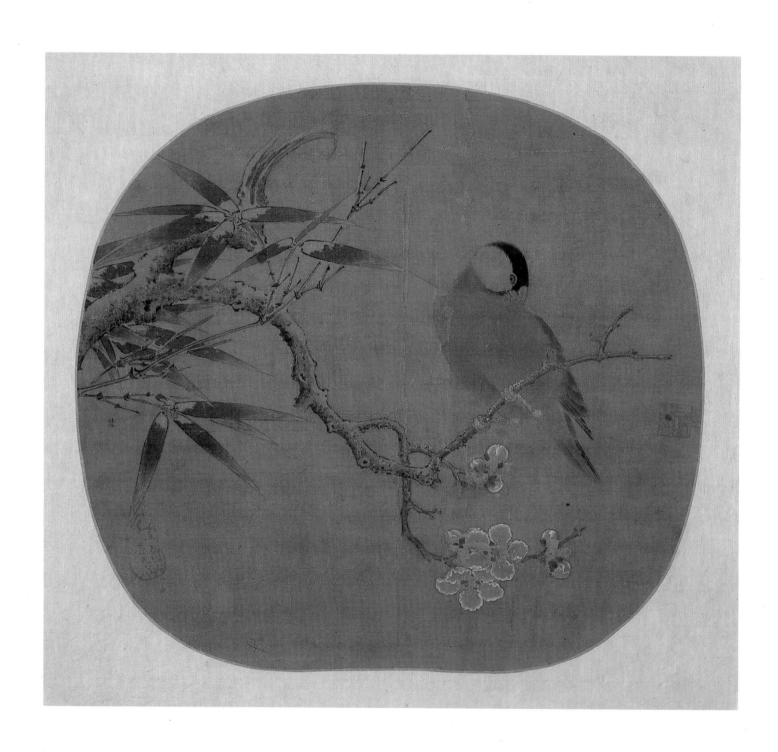

112 Lin Chun. *Bird with Plum Blossoms and Bamboo in Winter*.
Southern Song Dynasty

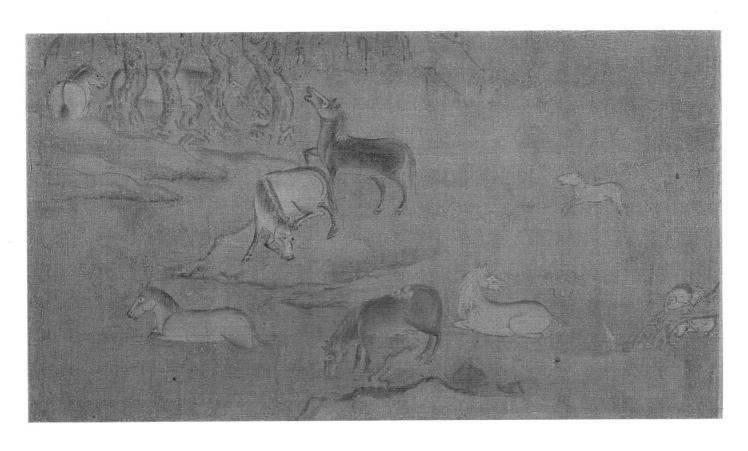

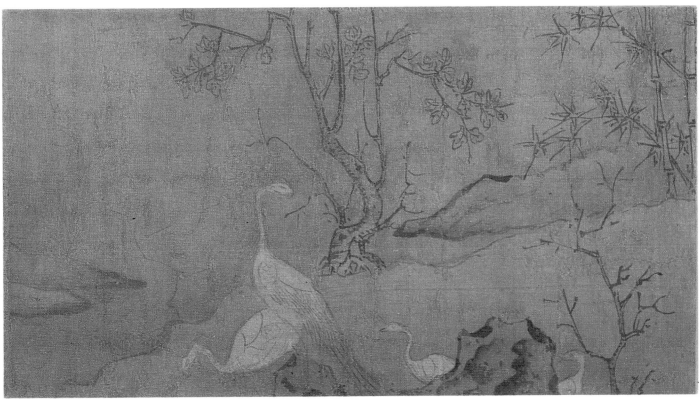

113 Ma Yuan. *Four-Sectioned Scroll:* (1) *Herding Horses.*
Southern Song Dynasty
114 Ma Yuan. *Four-Sectioned Scroll:* (2) *Phoenixes.*
Southern Song Dynasty

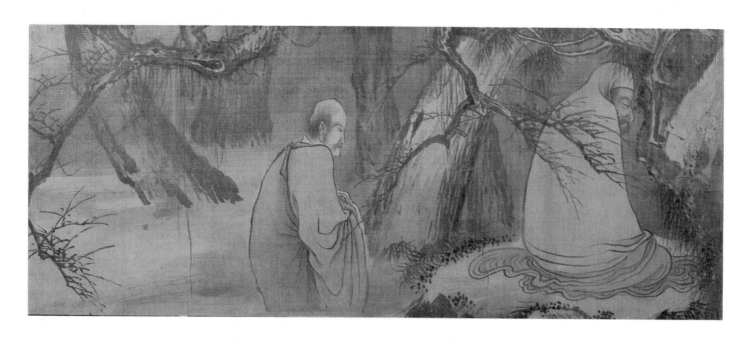

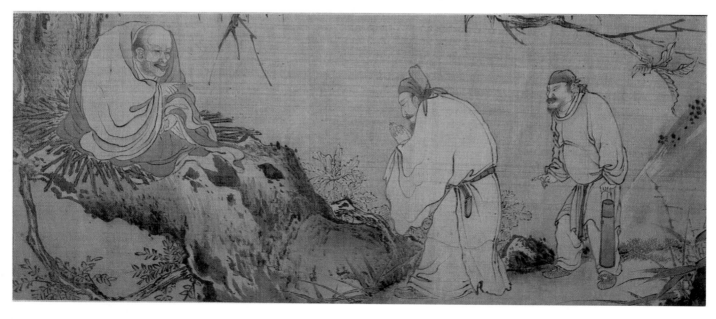

115 Liang Kai. *Eight Eminent Monks:* (1) *Bodhidharma Facing a Wall.*
Southern Song Dynasty
116 Liang Kai. *Eight Eminent Monks:* (2) *Bai Juyi Calling on Monk Niaoke.*
Southern Song Dynasty

117 Artist unknown. *Snow Scene.*
Song Dynasty

118 Artist unknown. *Camellias and Butterfly*.
 Song Dynasty
119 Artist unknown. *Quail*.
 Song Dynasty

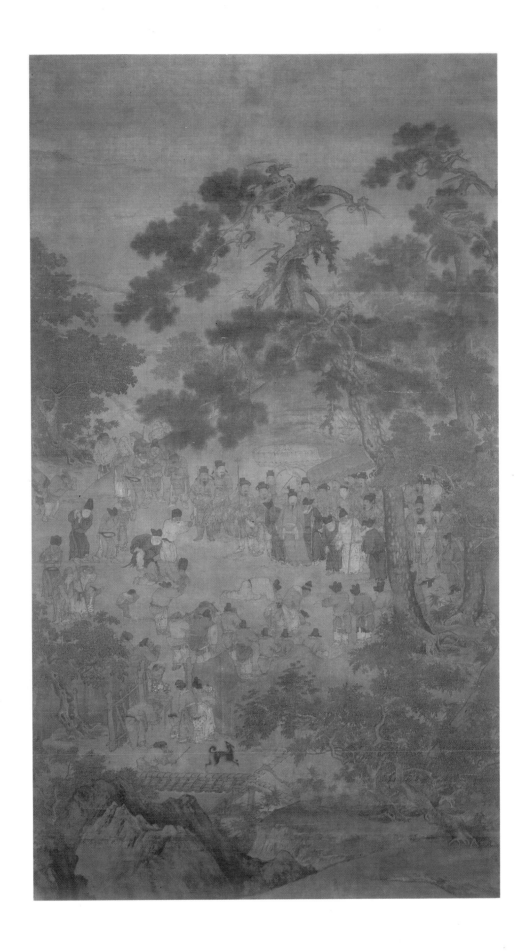

120 Artist unknown. *Welcoming the Emperor*.
Southern Song Dynasty

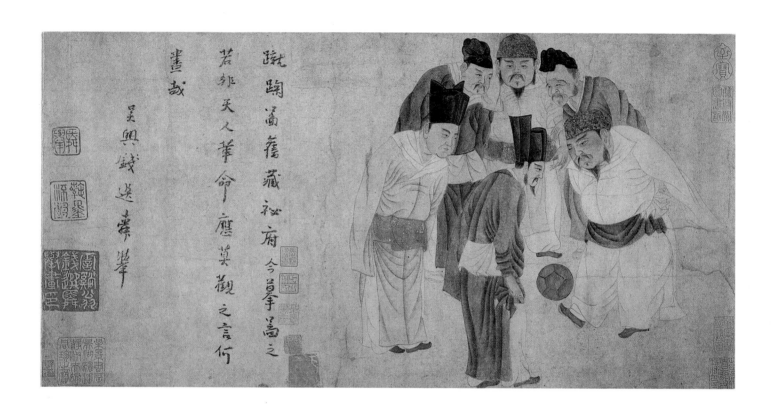

121 Qian Xuan. *Kicking Ball.*
Yuan Dynasty

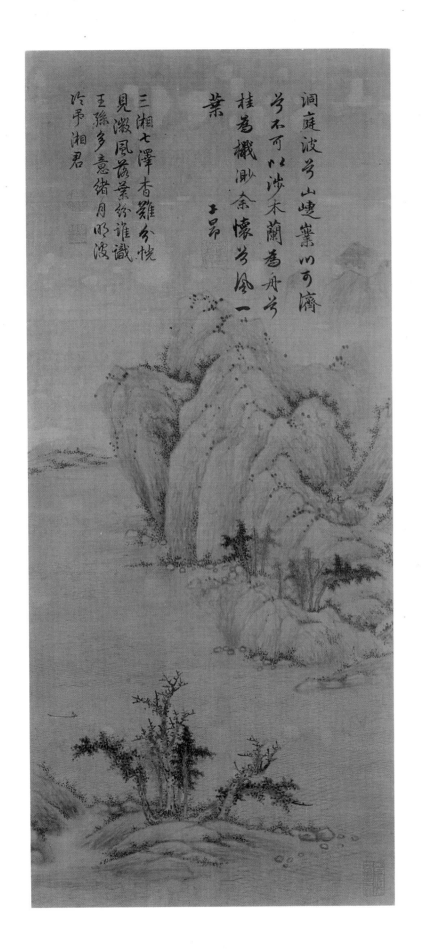

洞庭波兮山崒嵲業以可濟

兮不可以涉木蘭為舟兮

桂為檝渺余懷兮風一

葉　　王昂

三湘七澤杳難分兮悦

見瀲灔蕉葉於誰識

王孫多意緒月明波

吟弔湘君

122　Zhao Mengfu. *Eastern Mountain by Dongting Lake*.
Yuan Dynasty

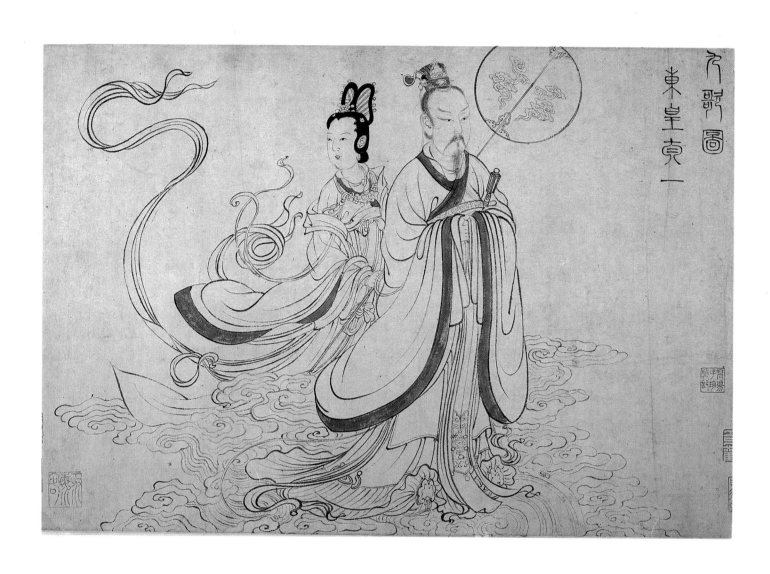

123 Zhang Wo. *Scroll of the Nine Songs:* (1) *Eastern Emperor Tai Yi.*
Yuan Dynasty

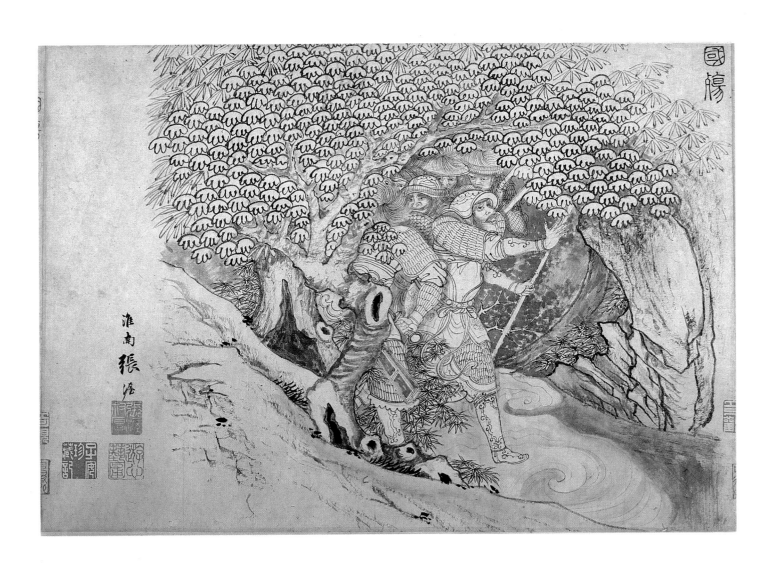

124 Zhang Wo. *Scroll of the Nine Songs:* (2) *Dying for the Motherland.*
Yuan Dynasty

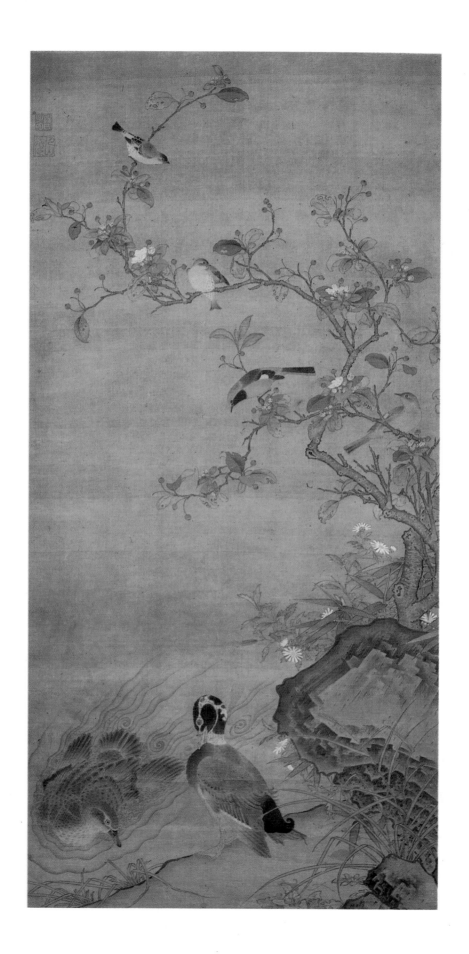

125 Ren Renfa. *Wild Ducks in an Autumn Creek.*
Yuan Dynasty

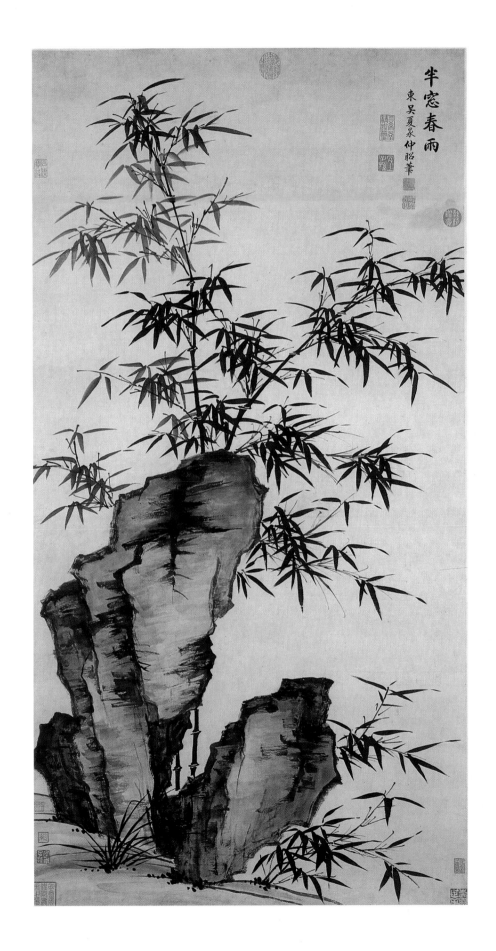

半窗春雨

東吳夏泉仲昭筆

126 Xia Chang. *Spring Shower by the Window.*
Ming Dynasty

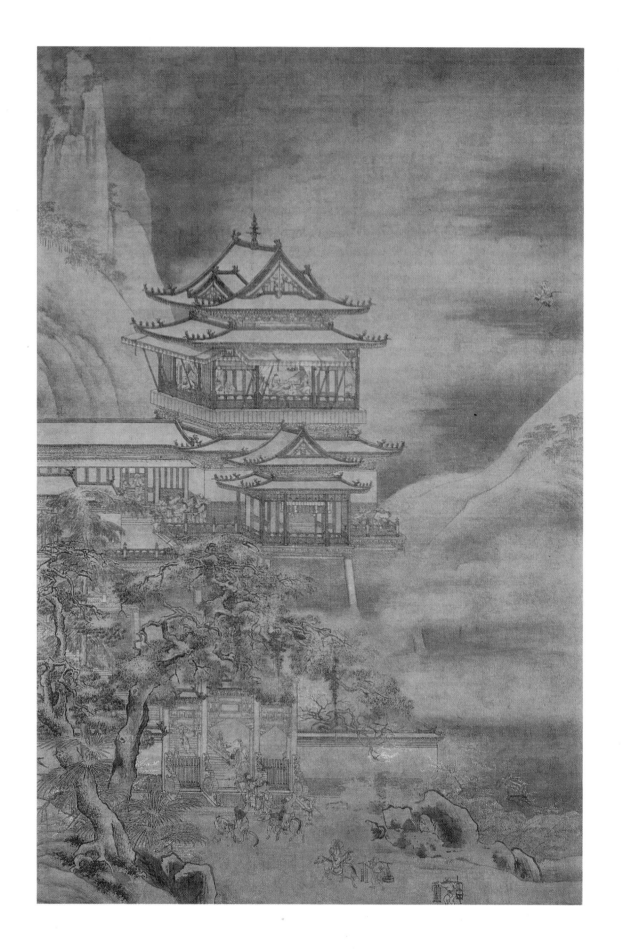

127　An Zhengwen. *Yellow-Crane Pavilion.*
Ming Dynasty

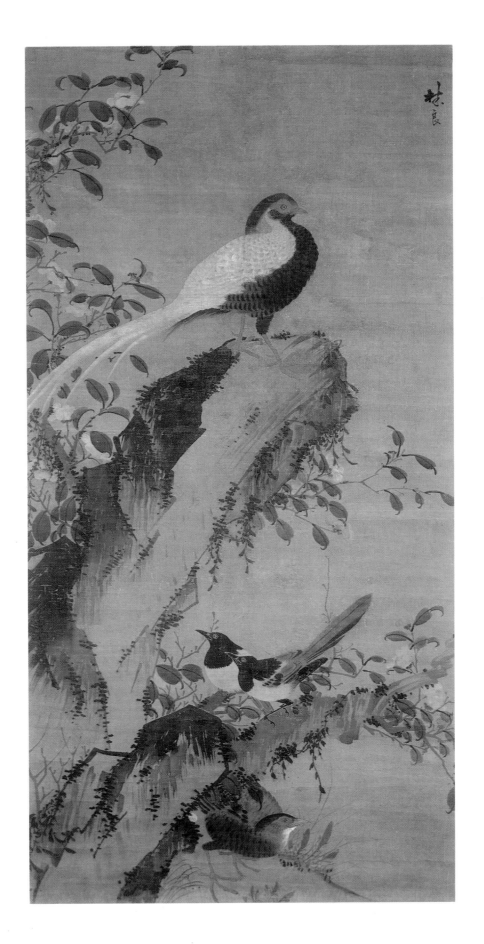

128 Lin Liang. *Camellias and Silver Pheasants.*
Ming Dynasty

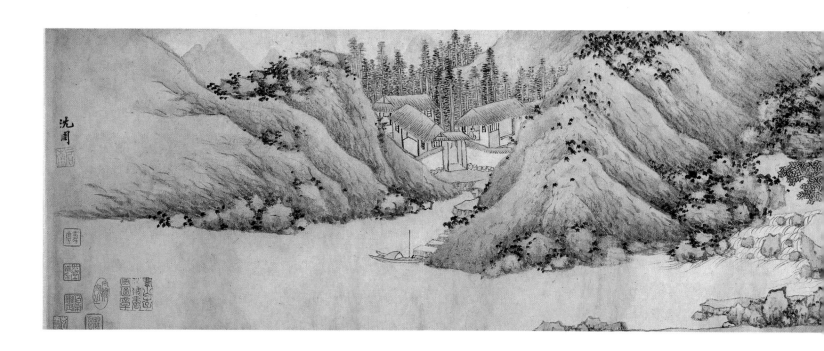

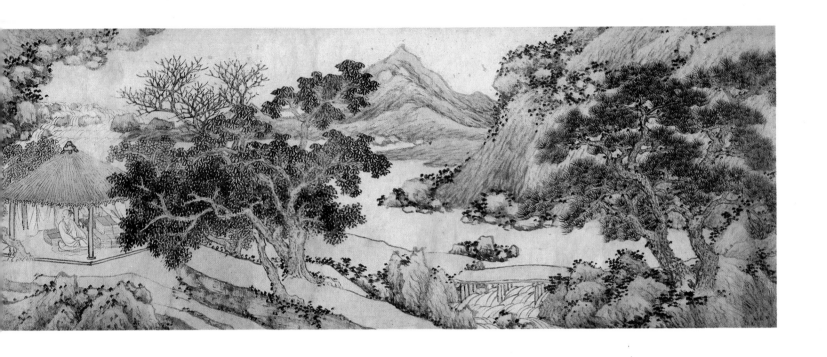

129 Shen Zhou. *Wu Zhen Yuan Pavilion.*
Ming Dynasty

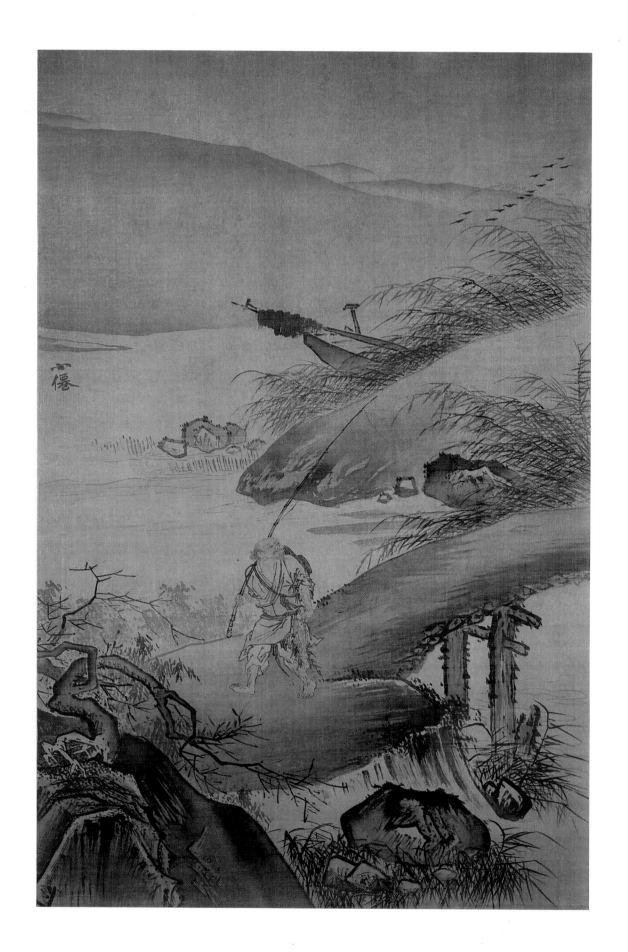

130 Wu Wei. *After Fishing in the Autumn River*.
Ming Dynasty

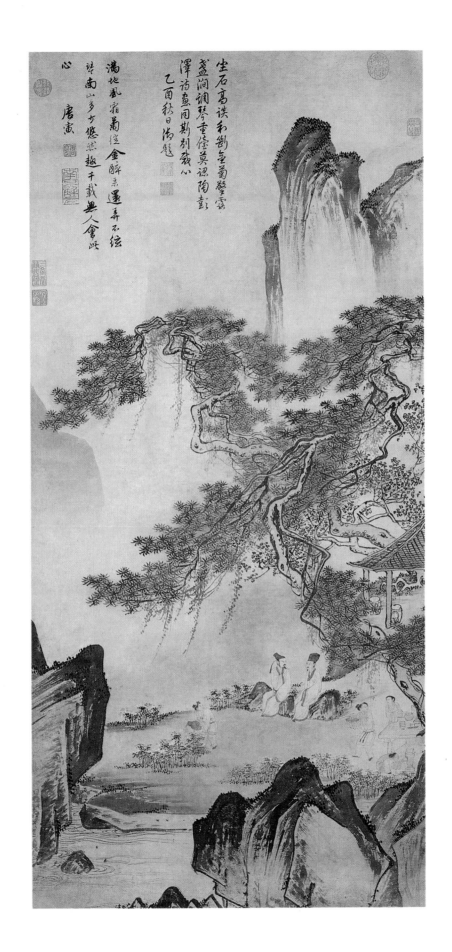

131 Tang Yin. *Admiring Chrysanthemums.*
Ming Dynasty

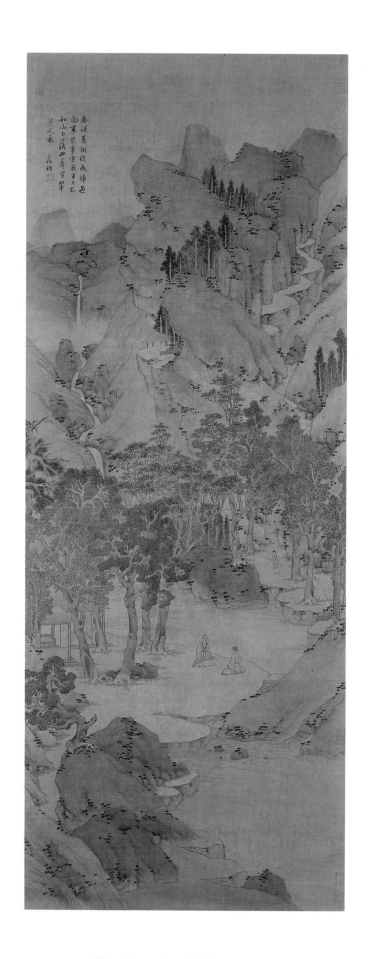

132 Wen Zhenming. *Tall Tree in Late Spring.*
Ming Dynasty

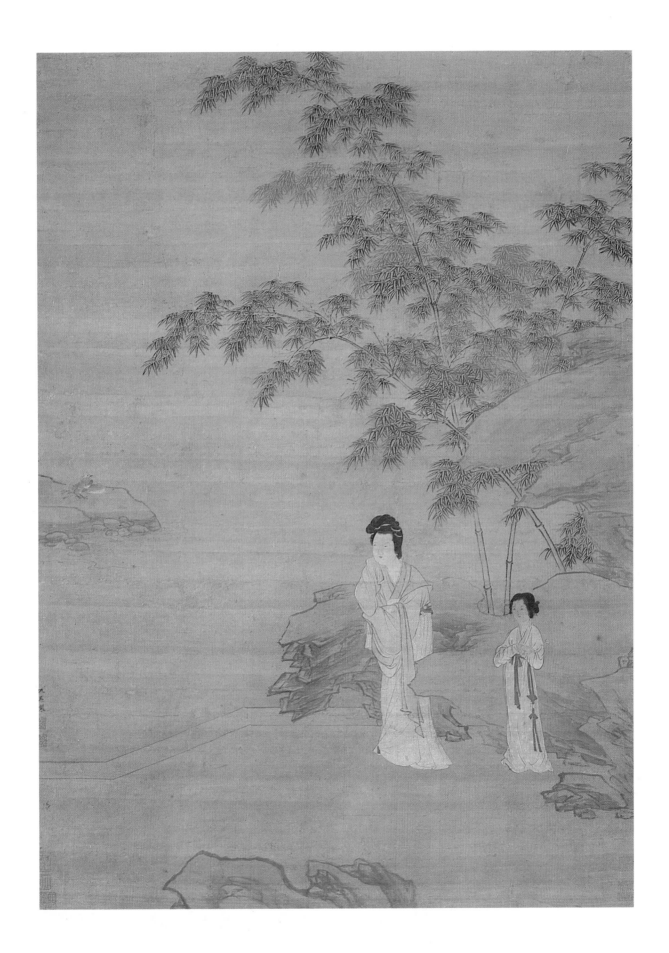

133 Jiu Ying. *Lady and Bamboo.*
Ming Dynasty

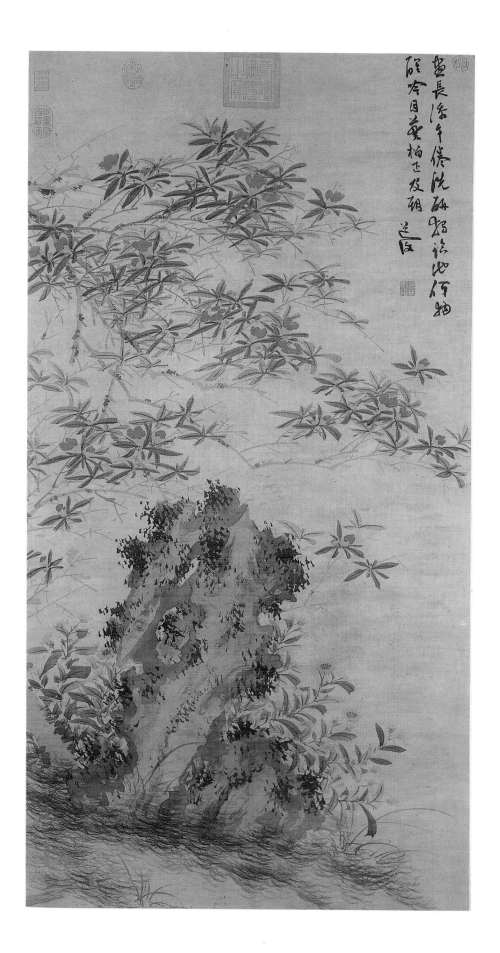

134　Chen Chun. *Pomegranate Blossoms.*
Ming Dynasty

135/136 Zhou Zhimian. *Flowers and Birds.*
Ming Dynasty

137 Ding Yunpeng. *Pouring the Wine.*
Ming Dynasty

山川出雲為
天下雨 玄宰書

138　Dong Qichang. *Clouds Shroud Mountains and a River.*
Ming Dynasty

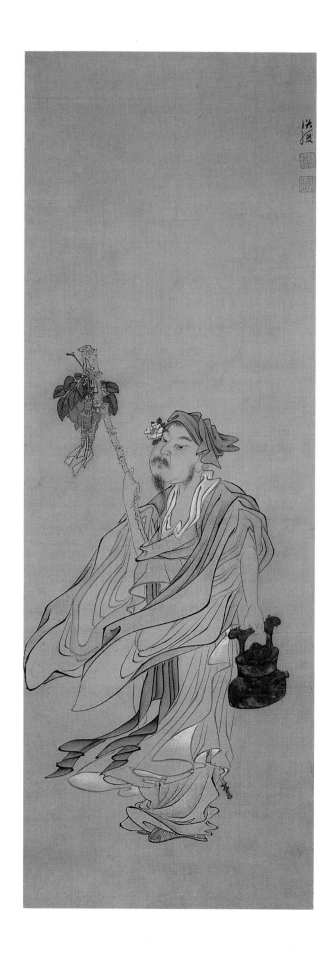

139 Chen Hongshou. *Ruan Xiu Buying Wine*.
Ming Dynasty

140　Wang Jian. *Blue-and-Green Landscape.*
Qing Dynasty

141 Zhu Da. *Wild Geese and Reeds.*
Qing Dynasty

142 Wang Wu. *Lotus Flowers and Mandarin Ducks.*
Qing Dynasty

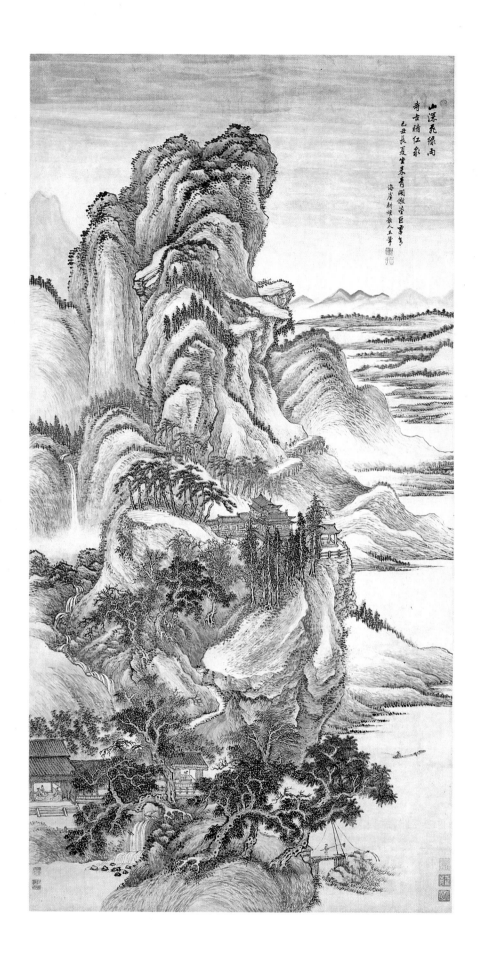

山深飛綠雨
奇古攤紅葉
己丑長夏堂朱青閣摹學巨畫意
海虞耕煙散人王翬

143　Wang Hui. *Old Temple in a Mountain Fastness.*
Qing Dynasty

144 Yun Shouping. *Flower Album:* (1) *Broad-Bean Flowers.*
Qing Dynasty

145 Yun Shouping. *Flower Album:* (2) *Cherries.*
Qing Dynasty

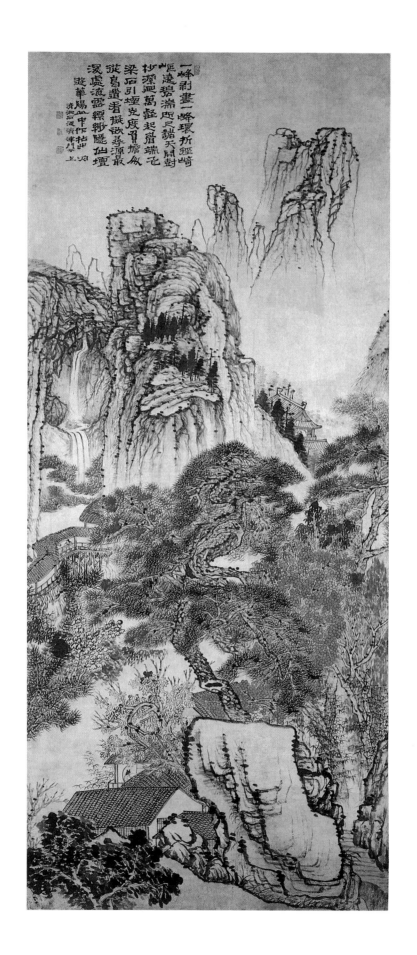

一峯初盡一峯環折經崎
嶇遠望碧湍惟尺齰天開封
秒漢洄萬聲起眉端飛
梁石引煙光度質據從
從鳥道看擬欲尋源最
溪處流露鏤鄉隱仙壇
越華陽山中作枯此田兒
清湘石濤濟上

146 Yuan Ji. *Touring Huayang Mountain.*
Qing Dynasty

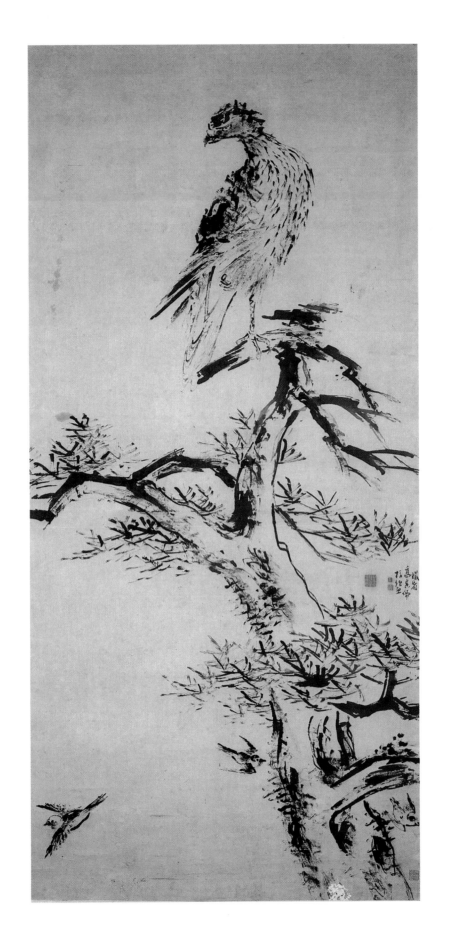

147 Gao Qipei. *Eagle on a Pine Tree.*
Qing Dynasty

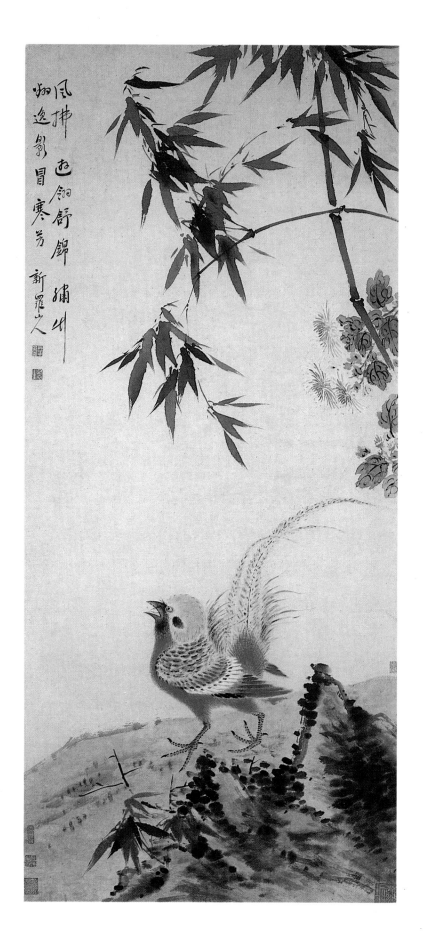

148　Hua Yan. *Pheasant, Bamboo, and Autumn Chrysanthemums.*
Qing Dynasty

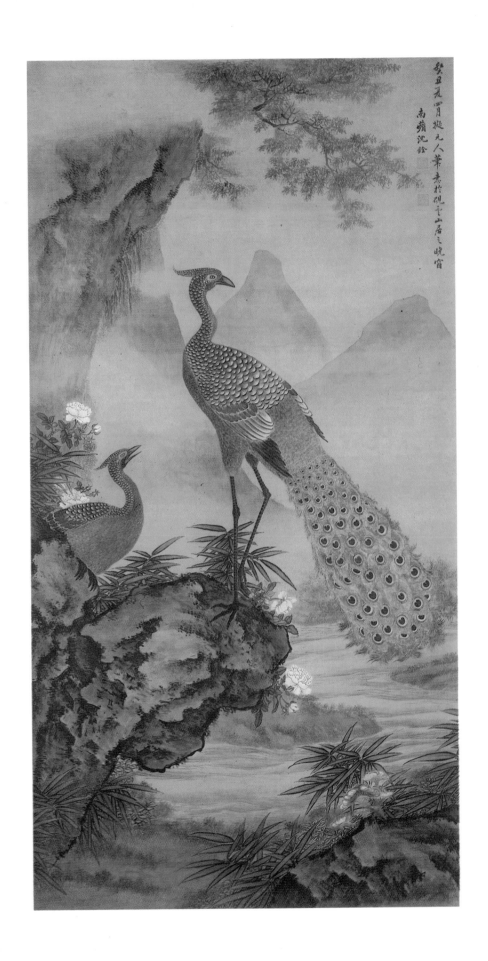

癸丑天罔擬元人筆
南蘋沈銓
春於西湖七峰山居之晚窗

149 Shen Quan. *Peacocks.*
 Qing Dynasty

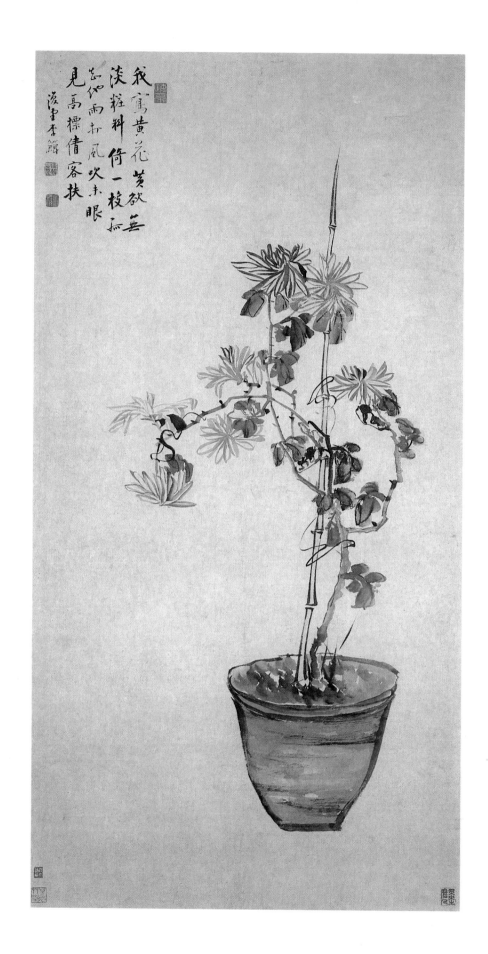

我寫黃花苦欲無
淡粧料倚一枝孤
苔仰雨和風吹未眼
見高標倩容扶

150　Li Shan. *A Pot of Chrysanthemums.*
Qing Dynasty

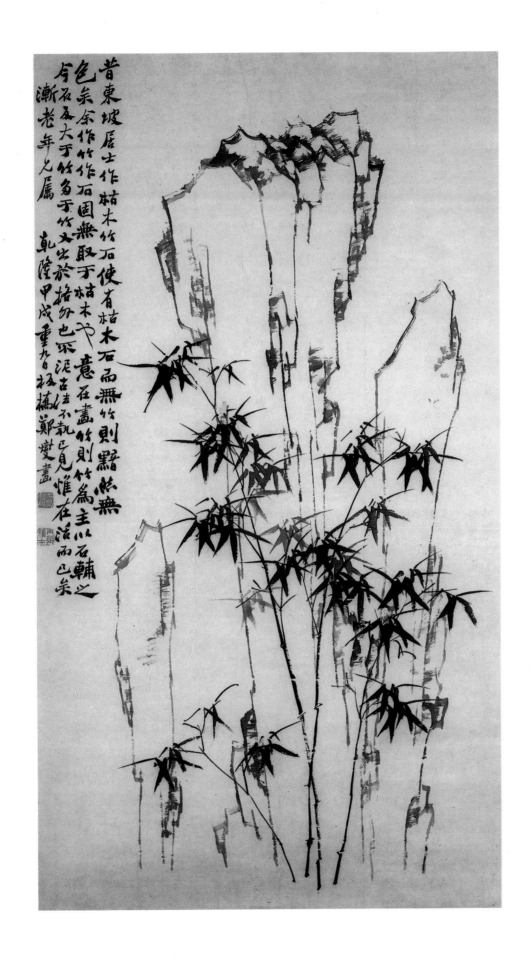

昔東坡居士作枯木竹石使有枯木石而無竹則黯然無
色矣余作竹作石固無取于枯木也意在畫竹則竹為主以石輔之
今石反大于竹多于竹又出於揩抑也不泥古法不執已見惟在活而已矣
漸老年凡兄屬乾隆甲戌重九日板橋鄭燮畫

151 Zheng Xie. *Bamboo and Rock.*
 Qing Dynasty

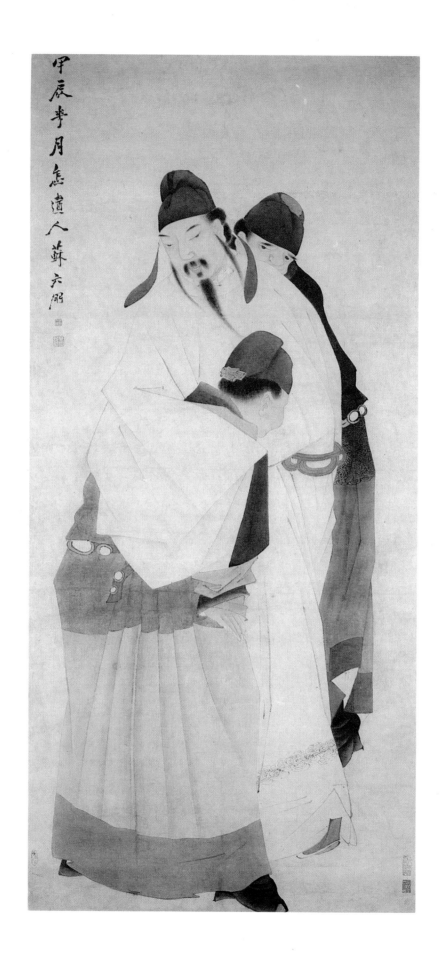

152 Su Liupeng. *Poet Tai Bai Drunk.*
Qing Dynasty

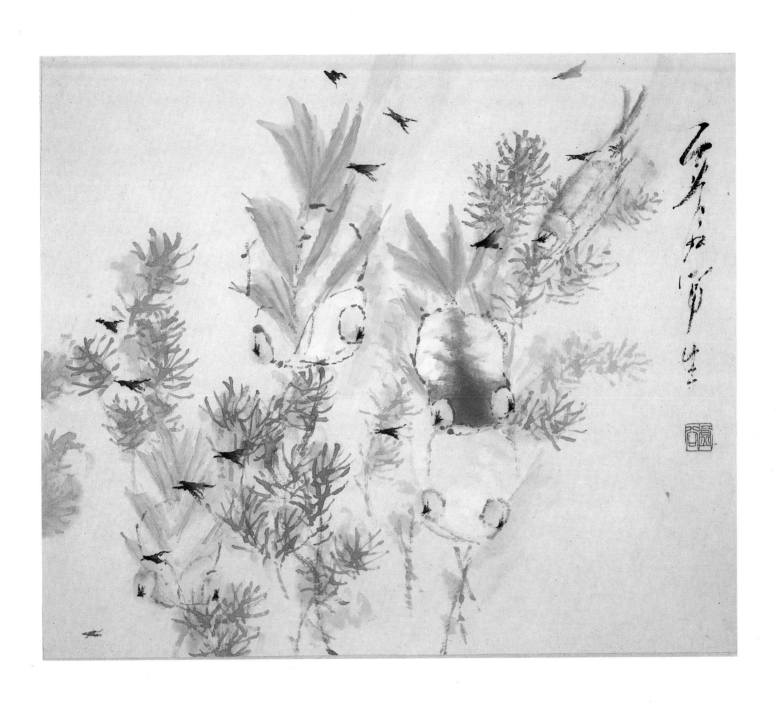

153 Xu Gu. *Painting Album:* (1) *Goldfish.*
Qing Dynasty

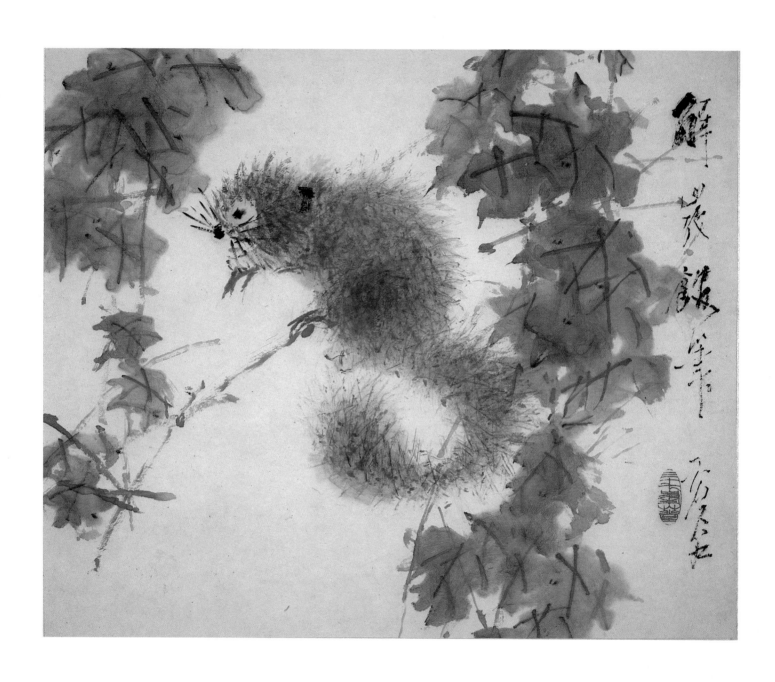

154 Xu Gu. *Painting Album:* (2) *Squirrel.*
Qing Dynasty

絨遊太世叔大人鈞鑒
同治己巳三月趙之謙繪

155　Zhao Zhiqian. *Oleander.*
Qing Dynasty

156　Ren Xun. *Sunflower and Cock.*
Qing Dynasty

157 Ren Yi. *The Fisherman.*
Qing Dynasty

158 Ren Yi. *Riding a Donkey.*
Qing Dynasty

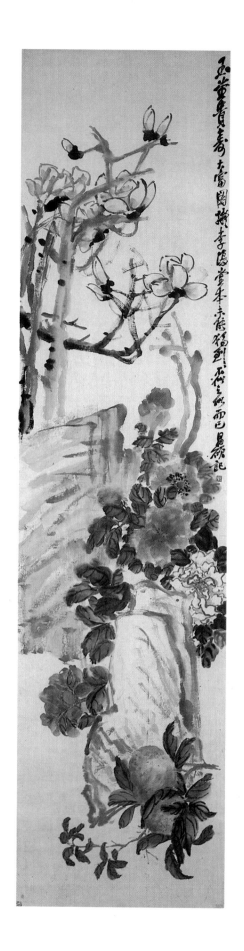

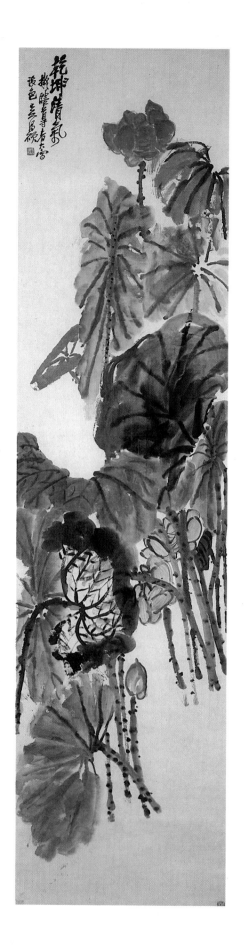

159 Wu Changshuo. *Flowers of the Four Seasons:*
(1) *Magnolia and Peony.*
Qing Dynasty

160 Wu Changshuo. *Flowers of the Four Seasons:*
(2) *Lotus.*
Qing Dynasty

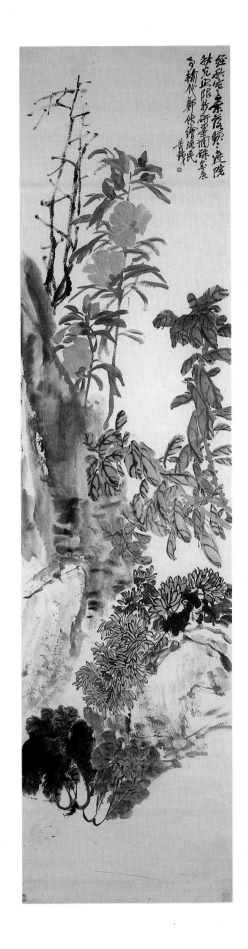

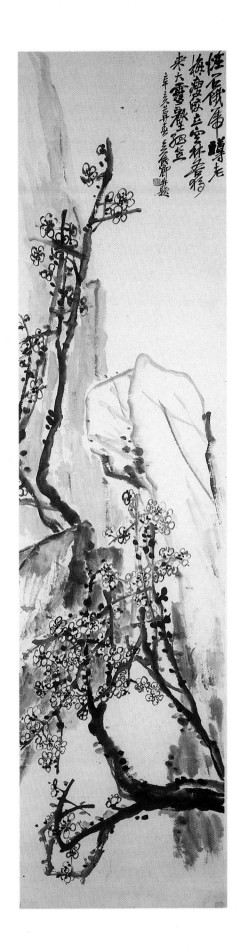

161 Wu Changshuo. *Flowers of the Four Seasons:*
 (3) *Chrysanthemums and Hollyhock.*
 Qing Dynasty

162 Wu Changshuo. *Flowers of the Four Seasons:*
 (4) *Plum Blossoms.*
 Qing Dynasty

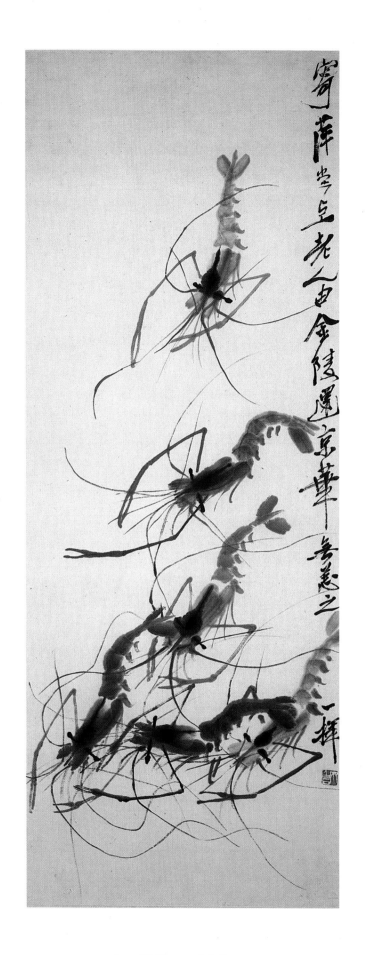

163 Qi Huang. *Ink Prawns.*
Modern Period

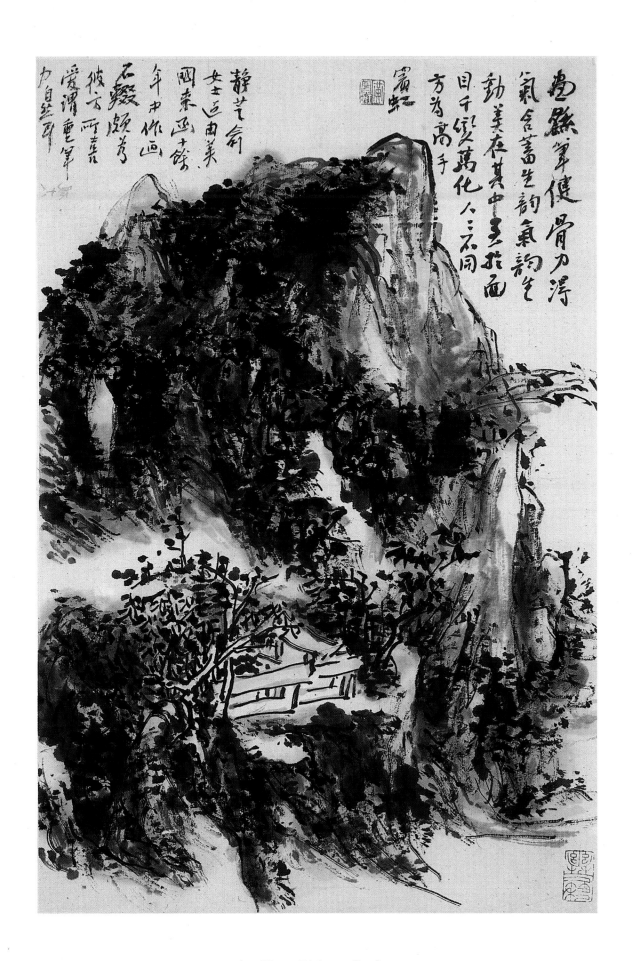

164 Huang Binhong. *Landscape*.
Modern Period

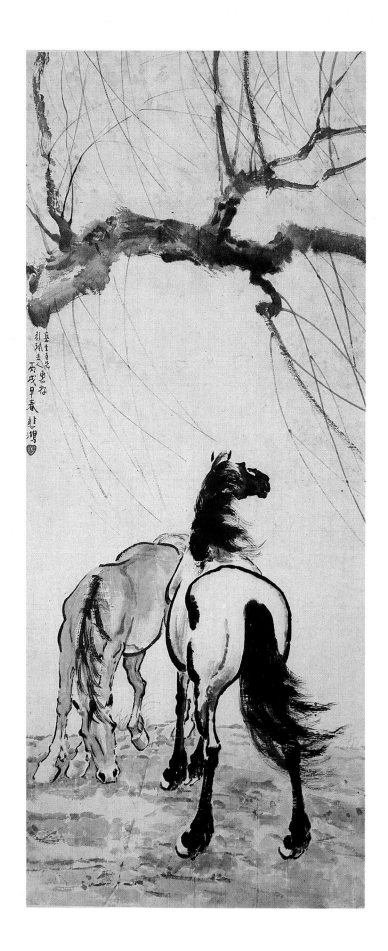

165 Xu Beihong. *Two Horses.*
Modern Period

106

Huai Su. *Ku Sun Tie.*
On silk. 25.1 × 12 cm. Tang Dynasty

Monk Huai Su (A.D. 725–785) styled himself Zang Zhen. His family name was Qian, and he was a native of Changsha, Hunan Province. A Tang Dynasty calligraphist famed for his draft script, he diligently studied and practiced calligraphy, following the draft script style of Zhang Xu and being guided by Yan Zhenqing. He claimed he had the "greatest inspiration for draft script." He greatly influenced later generations.

The meaning of the fourteen characters on the *tie* is: "Bitter bamboo shoot and fine tea are favorite things sought by people—written by Huai Su." They are written in a rounded, vigorous hand, which has the force of "a raging tornado." This is a specimen of Huai Su's famous handwriting which has come down to us.

107

Ju-Ran. *Pine Tree Clad Mountains.*
On silk. 200.1 × 77.6 cm. Five Dynasties Period

Monk Ju-Ran (A.D. 10th century) was a native of Zhongling. He was a famous landscape painter of the Five Dynasties and Northern Song Dynasty Period. He had lived in Kaiyuan Temple in Kaifeng city and was Dong Yuan's student. His paintings are done with faultless elegance and are full of power and grandeur. The mountaintops are painted like cobblestones in the broken-ink technique with burnt-black ink. This was his unique artistic characteristic.

This painting of verdant mountains and forest shows a winding valley, enshrouded by clouds, and a running creek. It is a picturesque scene with its green pine trees on the mountaintops and by the creek.

108

Guo Xi. *Quiet Valley.*
On silk. 167.7 × 53.6 cm. Northern Song Dynasty

Guo Xi (A.D. 11th century), who styled himself Chun Fu, was a native of Wenxian, Heyang (in present-day Henan Province). During the reign of Xi Ning (A.D. 1068–1077) he was a student at the Academy of Painting, and later became the head of the painters-in-attendance at the Hanlin Academy. He specialized in landscapes and was an outstanding successor of the Li Cheng school. His brushstrokes are rich and vigorous, with distinct ink tones. He was the author of *Lin Quan Gao Zhi (Essay on Forests and Fountains),* about landscape painting.

The painting shows a deep and secluded valley after snow. The peaks are precipitous and the valley deep. Guo Xi used shallow ink to outline the mountains and the wrinkle method to express light and shade. In painting old trees, he used strong ink to draw the crabbed branches. Though vigorous, his brushstrokes are elegant, showing an artistic conception of a mountain scene in a cold winter. This painting is a typical example of his works.

109 110

Su Shi. *Reply to Xie Minshi on Literature*.
On paper. 27 × 96.5 cm. Northern Song Dynasty

Su Shi (A.D. 1036–1101), who styled himself Zi Zhan, alias Dong Po Recluse, was born in Meishan, Sichuan Province. A famous writer and calligraphist of the Northern Song Dynasty, he was also an accomplished painter. His calligraphy followed the style of Yan Zhenqing of the Tang Dynasty, but had its own characteristics. Huang Tingjian, a famous calligraphist of Su Shi's day, placed him as the foremost of the Four Masters in the Song Dynasty—together with Cai Xiang, Huang Tingjian himself, and Mi Fei.

The scroll, written in a running script, has only thirty-three lines left; parts of the beginning have been lost and patched up. On comparing it with that in the *Collected Works of Su Dongpo,* we find it has altogether lost 148 characters. It was a letter written when he was sixty-five, in the third year of the reign of Yuan Fu (A.D. 1100). It was his reply to his friend Xie Qulian (Minshi) on literature. His calligraphy is fluent and lucid, giving a sense of "iron wrapped in cotton," and is representative of his works in his late years.

111

Zhao Jie. *Draft Script on a Stiff Fan*.
On silk. 28.4 × 28.4 cm. Northern Song Dynasty

Zhao Jie (A.D. 1082–1135) was Emperor Hui Zhong, the fatuous last emperor of the Northern Song Dynasty. He reigned for twenty-six years (A.D. 1100–1125), and excelled in calligraphy and painting. He studied the calligraphy of Xue Yao of the Tang Dynasty and created his own style of thin and strong brushstrokes which was known as "thin-gold characters." His running script was influenced by Monk Huai Su, and was both neat and powerful.

Draft Script on a Stiff Fan is a seven-character poem: "Swallows skim and touch the lake, sending ripples shimmering. Fallen petals on the mud pile up layer on layer." The brushstrokes are strong and elegant and show loftiness of spirit. The work bears his signature and a calabash-shaped vermilion seal with the characters "Emperor's script" on it. The composition is harmonious and gives a sense of freshness and complete beauty.

112

Lin Chun. *Bird with Plum Blossoms and Bamboo in Winter*.
On silk. 24.8 × 26.9 cm. Southern Song Dynasty

Lin Chun (A.D. 12th–13th century) is a famous flower-and-bird painter of the Southern Song Dynasty. A native of Qiantang, Zhejiang Province, he was a painter-in-attendance at the Academy of Painting during the reign of Zun Xi (A.D. 1174–1189). His flower-and-bird paintings followed the style of Zhao Chang, being light ink wash and full of the joy of life.

This painting is of snow thawing as red plum blossoms start to bloom. A bird, perched on a bough, has his head turned to preen himself. The scene is charmingly lively. A sprig of bamboo at one side adds to the atmosphere of freezing cold and beauty. The brushstrokes are executed with exquisite precision to depict nature's rejuvenation in early spring, and show an outstanding sketching talent.

I I 3

Ma Yuan. *Four-Sectioned Scroll:* (1) *Herding Horses.*
On silk. 9.3 × 16.6 cm. Southern Song Dynasty

Ma Yuan (A.D. 12th–13th century) styled himself Qin Shan. He was born in Hezhong (present-day Yongji County, Shanxi Province) but later moved to Qiantang (present-day Hangzhou). He was a painter-in-attendance at the Academy of Painting during the reigns of Guang Zong and Ning Zong of the Southern Song Dynasty (A.D. 1190–1224). Distinguished for painting landscapes, figures, and flowers-and-birds, he followed the style of Li Tang, though he had his own style and created a school of vigorous monochrome ink paintings.

 The painting shows seven horses and a pony, all in different postures: drinking, cropping, walking, standing, galloping, swimming, and neighing with head thrown high. The herdsman is dozing against a tree. The brushwork is simple and neat, with elegant colors that depict the tranquil rural surrounding and the strong and vigorous characters of the horses.

I I 4

Ma Yuan. *Four-Sectioned Scroll:* (2) *Phoenixes.*
On silk. 9.3 × 16.5 cm. Southern Song Dynasty

Phoenixes are mythical birds of ancient times; they symbolized good fortune. This painting shows two pairs of phoenixes, one of them singing with its head held high while another is pecking for food with head bent. The images of the birds are lively and well coordinated. The leaves of the Chinese parasol tree and bamboo on the hillock are sparse and scattered, giving a serene and beautiful artistic feeling. The painting was based on the lines of the *Shih Ching (Book of Odes):* "The phoenix will sing on the hilltop, while the parasol tree will grow facing the sun." This was an allusion to the timely discovery of Ma Yuan's talent by high officials. His brushstrokes are powerful, simple, and flowing.

I I 5

Liang Kai. *Eight Eminent Monks:* (1) *Bodhidharma Facing a Wall.*
On silk. 26.6 × 64.1 cm. Southern Song Dynasty

Liang Kai (A.D. 12th–13th century), nicknamed Liang the Lunatic, was born in Dongping, Shandong Province, and later settled in Hangzhou. He was painter-in-attendance at the Academy of Painting in the reign of Jia Tai (A.D. 1201–1204) and was accomplished in painting figures, landscapes, and flowers and birds. His brushstroke was comprehensive and free, and was known as "sketch stroke" in the annals of painting.

 Bodhidharma Facing a Wall is one of the eight serials of the *Eight Eminent Monks.* It depicts the Dhyana Buddhist Monk Bodhidharma at Sonshan, Henan Province, seated facing a wall in meditation. Standing behind him is his disciple Monk Zi Hui. The lineal brushstrokes are vigorous and neat. The expressions on the figures are serene and tranquil. The brushstrokes used to paint a number of old trees are also strong and forceful. This painting shows that economy of brushstrokes and treatment of light and shade had reached a mature level.

116

Liang Kai. *Eight Eminent Monks:* (2) *Bai Juyi Calling on Monk Niaoke.*
On silk. 26.6 × 64.7 cm. Southern Song Dynasty

Bai Juyi Calling on Monk Niaoke is one of the eight serials of the serial-story *Eight Eminent Monks*. It depicts the tale of the celebrated poet Bai Juyi (A.D. 722–846), who, when he was the prefect of Hangzhou, went with his servant to Qinwang Mountain in the southern outskirts of the city to call on Monk Niaoke (Bird's Nest).

The painting shows Bai Juyi (pale of face with a long beard) with the palms of his hands joined together, bowing to Monk Niaoke, who sits cross-legged on a sloping tree trunk. The monk is pointing with his right forefinger as he explains Buddhist scriptures. The expressions on the figures are vivid. This is one of Liang Kai's carefully executed works in exact delineation. His signature appears on the rock before the tree.

117

Artist unknown. *Snow Scene.*
On silk. 28.9 × 27.2 cm. Song Dynasty

This was painted in the "boneless" method, a style of painting using such colors as blue, green, vermilion, and brown to paint directly mountains, trees, and rocks without first outlining them in ink, and using golden lines for sketching the contours so as to create a colorful and dazzling artistic effect.

The background of the entire picture was done with gold dust, while white lead powder was used to paint the snow-capped mountains. The pine trees and forest on the mountains and valley were painted and dotted with such strong colors as vermilion, mineral-blue, and mineral-green. The whole picture is colorful and bright: it is one of the rare masterpieces of landscape painting in the Song Dynasty.

118

Artist unknown. *Camellias and Butterfly.*
On silk. 22 × 23 cm. Song Dynasty

This is an exquisite sketch on a stiff fan. The painting shows a sprig of white camellia on which one flower is in full bloom, another is half open, and the third one just beginning to blossom. The green leaves contrast and set out the small white flowers and make them look quite lovely. The fragrance of the flowers has attracted a butterfly, which flutters around to add to the feeling of liveliness in the picture. The brushstrokes are of precise line technique and the colors are elegant and harmonious. Though there is no signature of the painter, it is, in all probability, the work of a master painter of the Song Dynasty's Academy of Painting.

119

Artist unknown. *Quail.*
On silk. 23.5 × 23.1 cm. Song Dynasty

This is a painting in a Song Dynasty loose-leaf painting album. It shows barnyard grass waving in the autumn breeze. There are shepherd's-purse and reeds growing on the ground. On the slope a quail looks back with head turned. Though

there is no signature on the painting, its exact delineation and ability to capture the fleeting expression of the bird show that it is the work of a master painter of the Academy of Painting in the late Northern Song Dynasty.

120

Artist unknown. *Welcoming the Emperor.*
On silk. 195.1 × 109.5 cm. Southern Song Dynasty

This is a painting of a true story by an anonymous Southern Song Dynasty painter. During the fourteenth year of the reign of Tian Bao in the Tang Dynasty (A.D. 755), a border general, An Lushan, rose in rebellion and conquered Changan the following year. Emperor Xuan Zong (Li Longji) fled to Sichuan, while his son Li Heng was installed as Emperor Su Zong in Linwu. A year later, when the Tang army recaptured the capital, Emperor Su Zong welcomed his father's return.

The painting shows people at a post near the western suburb of the capital welcoming Li Longji on his way back to Changan. In the painting, Xuan Zong has a white beard and is wearing a yellow robe; Su Zong has a black beard and is dressed in a red robe. Burning incense, the people are on their knees welcoming the old emperor. It is a magnificent panorama with many people of different status and expression, depicted in a fine and lively way. This is a masterpiece of figure painting of the Southern Song Dynasty.

121

Qian Xuan. *Kicking Ball.*
On paper. 28.6 × 56.3 cm. Yuan Dynasty

Qian Xuan (A.D. 1235–after 1299) styled himself Shun Ju and also used the aliases Jade Lake, Lazy Old Man, and, in his old age, Snow Valley Old Man. He was born in Wuxing, Zhejiang Province, and was a famous painter of the late Song and early Yuan Dynasties. His forte was in landscape, figure, and flower painting. He turned his back on the Li Tang–Ma Yuan–Xia Gui school of painting which was very popular in the Southern Song Dynasty and followed the brushwork style of the earlier Northern Song Dynasty, thus to a certain extent influencing the development of the Schol-ar-Painting School and the formation of a new fashion in the Yuan Dynasty.

The painting shows Song emperors Tai Zhu (Zhao Kuangying) and Tai Zong (Zhao Guangyi) kicking ball with their ministers. Though it is a tracing, the lines of the figures are simple and faultless, the colors elegant, and the expressions lively—giving one much food for thought. It is clearly a specimen of the painter's exquisite precision and refined taste.

122

Zhao Mengfu. *Eastern Mountain by Dongting Lake.*
On silk. 60.8 × 26.6 cm. Yuan Dynasty

Zhao Mengfu (A.D. 1254–1322) styled himself Zi Ang and used the aliases Pine-and-Snow Daoist Priest and Crystal Palace Daoist Priest. He was a descendant of the royal house of the Song Dynasty and was born in Wuxin, Zhejiang Province. He was a master calligraphist and painter of the early Yuan Dynasty. He excelled not only in painting landscapes, but also in figures, flowers, trees, bamboos, and rocks. He advocated the brushwork of Tang and Northern Song days and transformed the style of the Academy of Painting of the Southern Song Dynasty, thus greatly influencing the formation of the brushwork of the Yuan Dynasty.

The brushwork in the painting is derived from Dong Yuan's "Code," to depict the scenery of the Eastern Mountain

by Dongting Lake. The lake is shrouded in mist; faraway mountains rise range upon range; ancient trees line the bank; and in the foreground are some crab trees. The mountains are painted in a pale blue-green to portray the expansive breathtaking beauty of this South China lakeside.

123

Zhang Wo. *Scroll of the Nine Songs:* (1) *Eastern Emperor Tai Yi.*
On paper. 28 × 41 cm. Yuan Dynasty. *Donated by Shen Tongyue and others*

Zhang Wo (A.D. 12th century) styled himself Shu Hou and used the name Zhen Qisheng. Born in Hangzhou, Zhejiang, he was a well-known Yuan Dynasty figure painter who specialized in sketching. This is his tracing of the Northern Song Dynasty painter Li Gonglin's work which took Qu Yuan's *The Song of Chu: The Nine Songs* as its theme. There are altogether ten serials to the *Nine Songs,* and this is the first of the serials. The legendary Eastern Emperor Tai Yi was a god and he is shown standing surrounded by clouds with a lady-in-waiting who is holding a stiff fan. Their expressions are solemn and respectful. With easy, fluent lines the artist depicts the swirling clouds and the flowing robe and ribbons of the lady-in-waiting, showing his skill in sketching images. This is one of the three extant paintings by the artist in which he took the *Nine Songs* as his theme.

124

Zhang Wo. *Scroll of the Nine Songs:* (2) *Dying for the Motherland.*
On paper. 28 × 40 cm. Yuan Dynasty. *Donated by Shen Tongyue and others*

Dying for the Motherland is the last of the *Nine Songs* serials. The painting shows a group of warriors, who have laid down their lives for their motherland, coming out of a forest. Wearing coats of mail and with weapons in hand, their angry eyes glare about. This is to show that even in death their heroic spirits are still brave and unconquerable. The brushwork is comprehensive, reaching to the height of imparting life to the images. Very few genuine works of Zhang Wo have survived, but the *Nine Songs* sketches are representative of his artistic achievements.

125

Ren Renfa. *Wild Ducks in an Autumn Creek.*
On silk. 114.3 × 57.2 cm. Yuan Dynasty

Ren Renfa (A.D. 1254–1327), who styled himself Zi Ming and used the name Yue Shan, was born in Chingpu County, Jiangsu Province. He was a famous Yuan Dynasty water-conservancy expert and was accomplished in painting, specializing in painting flowers, birds, figures, and especially horses.

The painting shows two wild ducks, one swimming and the other preening itself by the creek. Along the bank is a flowering Chinese crab-apple tree in full bloom. Two pairs of sparrows with different postures are perched on the bough, showing rich imagery in a real-life sketch. The painting, done with exquisite precision and in strong colors, is in the tradition of sketching from real life of the Academy of Painting in the Southern Song Dynasty. There are very few of Ren Renfa's works extant. This is one of his masterpieces.

126

Xia Chang. *Spring Shower by the Window.*
On paper. 131.6 × 67.4 cm. Ming Dynasty

Xia Chang (A.D. 1388–1470), who styled himself Zong Zhao, alias Carefree Man or Jade Precipice, was born in Kunshan, Jiangsu Province. His family name was originally Zhu, but later it was changed to Xia. A well-known painter of the early Ming Dynasty who specialized in painting ink bamboos, he learned his art from Wang Fu. His brushwork is done with meticulous care, keeping strictly to set principles. He retained the best from his forebears while creating a style of his own.

The painting shows his use of bold and simple brushstrokes in painting bamboos and rocks, and his integration of strong and light ink with distinct shades to present the bamboo in a variety of positions and vividnesses.

127

An Zhengwen. *Yellow-Crane Pavilion.*
On silk. 162.5 × 105.5 cm. Ming Dynasty

An Zhengwen (c. first half of A.D. 15th century) has no record of being a painter in his biography. However, it is known that he was one of the lowest military officers in the Academy of Painting in the early Ming Dynasty. From his paintings, now scattered among the people, he seems to have specialized in "ruled paintings" and in painting figures, landscapes, flowers, and birds. He basically followed the style of the Academy of Painting of the Southern Song Dynasty.

The original site of Yellow-Crane Pavilion was on Snake Mountain in Wuhan, Hubei Province. The building of it began in A.D. 3rd century, but it was totally destroyed in the early Southern Song Dynasty. Since then, it has been repeatedly rebuilt and destroyed. The painting shows the bustling scene of travelers at Yellow-Crane Pavilion during heavy snow in a cold winter. It shows the artist's skill in drawing with square and ruler the building and the accuracy of its structure. The distant mountains and nearby trees and rocks harmonize closely. The expressions of the figures are vivid. They are absorbed in looking at the fairy passing overhead on a flying crane and thus giving life to such a drawing of a building.

128

Lin Liang. *Camellias and Silver Pheasants.*
On silk. 152.3 × 77.2 cm. Ming Dynasty

Lin Liang (c. A.D. 1416–1480), who styled himself Yi Shan, was born in Guangdong Province. He was a painter at the imperial court during the reign of Tian Shun in the Ming Dynasty. He specialized in flower-and-bird paintings. His brushstrokes are unrestrained and easy, and he is representative of the monochrome free-sketch style for flower-and-bird paintings of the Ming Dynasty Academy of Painting.

This painting shows camellias in full bloom near a rock on which a male silver pheasant idly stands. There are a pair of magpies below him with their heads cocked, while a female silver pheasant is searching for food among the grass. All the birds are lifelike and very spirited. The painting is full of the atmosphere of spring, when flowers bloom and birds twitter. This is one of Lin Liang's works done with meticulous care and beauty.

129

Shen Zhou. *Wu Zhen Yuan Pavilion*
On paper. 27.6 × 146.5 cm. Ming Dynasty

Shen Zhou (A.D. 1427–1509), who styled himself Qinan, alias Rock Field and, later, White-Rock Old Man, was born in Changzhou (present-day Suzhou). He specialized in landscape painting. He first learned from Du Qiong but later turned to embrace the style of the Four Masters of the Yuan Dynasty. His brushstrokes are thick and vigorous, with his own peculiar characteristics. He also drew flowers and birds, and most of his paintings were in monochrome. Tang Yin and Wen Zhenming learned painting from him. He ranked as the doyen of the Four Masters of the Ming Dynasty.

This painting shows the reposeful serenity surrounding Wu Zhen Yuan Pavilion, in which an old man sits cross-legged with a book and listens to the trickling waters. The mountains and forest are green and flourishing. The wrinkle method of painting is done meticulously and easily, with strong ink-dotting of leaves, showing the great skill of the artist and the care he has taken in this work.

130

Wu Wei. *After Fishing in the Autumn River.*
On silk. 164 × 106.2 cm. Ming Dynasty

Wu Wei (A.D. 1459–1508), who styled himself Shi Ying or Zi Weng and used the aliases Small Fairy and Man from Lu, was born in Jiangxia (present-day Wuchang), Hubei Province. He was a painter at the imperial court during the reigns of Cheng Hua and Hong Shi and was adept in painting landscapes and figures. He was acclaimed as the "Great Master of Painting."

The painting shows a fisherman returning from fishing at day's end. A flock of wild geese is flying low, faraway, as if they were seeking a place to rest for the night. The stern of a boat is protruding from the reeds and in it is a fishing net wound around an oar. Carrying his catch, the fisherman, barefooted and with sleeves rolled up, has crossed the bridge and is striding along while looking up at the sky. The painting depicts the elation of the fisherman as he returns home.

131

Tang Yin. *Admiring Chrysanthemums.*
On paper. 134.6 × 62.6 cm. Ming Dynasty

Tang Yin (A.D. 1470–1523), who styled himself Bo Hu and Zi Wei, alias Man of Liu Ru, was born in Wuxian (present-day Suzhou), Jiangsu Province. He was an accomplished poet, calligraphist, and painter, especially of landscapes, figures, and flowers. His brushstrokes were elegant and vigorous and done with a great deal of thought. Together with Shen Zhou, Wen Zhenming, and Jiu Ying, he was one of the Four Masters of the Ming Dynasty.

The painting shows precipitous hills at the back and an old gnarled pine tree and a winding creek near the pavilion. The scenery is tranquil and beautiful. Two scholars are sitting on a rock chatting and enjoying the autumn chrysanthemums in a carefree manner. A boy servant is watering the plants, which are vivid and lifelike. The painting shows the influence of the style of Li Tang of the Southern Song Dynasty.

132

Wen Zhenming. *Tall Tree in Late Spring.*
On silk. 169.8 × 65.7 cm. Ming Dynasty

Wen Zhenming (A.D. 1470–1559), originally named Bi, styled himself Zhenming; later he began using Xing and then Zhenzhong, alias Man of Hengshan. He was born in Changzhou (present-day Suzhou). He learned painting from Shen Zhou and excelled in painting landscapes, being also good at flower and figure paintings. He was one of the Four Masters of the Ming Dynasty. His brushwork can be divided into two types: one, thin-stroke, which was elegant and meticulous; the other, thick-stroke, which was thick and vigorous. He had many pupils, and greatly influenced later generations.

The painting shows a forest scene in late spring. Two scholars sitting face-to-face on the bank are chatting together while a boy servant is bringing a harp across the creek. The zigzag path and the cascading waterfall depict the quiet life in the valley. The rocks and hills are painted in strong mineral-blue and mineral-green with forceful dots. The entire painting is both decorative and highly realistic. It is a masterpiece of the painter's meticulous work.

133

Jiu Ying. *Lady and Bamboo.*
On silk. 88.3 × 62.2 cm. Ming Dynasty. *Donated by Yang Dimian*

Jiu Ying (c. A.D. 16th century), who styled himself Shi Fu, as well as Shizhou, was born in Taicang, Jiangsu Province, and later lived in Suzhou. He was adept in figure and landscape painting and also good at painting flowers, birds, and animals. He excelled in tracing ancient paintings. His brushwork was easy and fluent. He was one of the Four Masters of the Ming Dynasty, together with Shen Zhou, Wen Zhenming, and Tang Yin.

The painting shows an imperial concubine in a palace garden. On the neat and tidy lakeside, tall bamboos wave in the breeze, while a pair of mandarin ducks nestle on a rock on the opposite bank. It is a garden scene in early summer. The woman is leaning against a rock, her chin resting on her hand, in deep thought; a maid stands behind her holding a whisk. The painting shows the quiet monotony of life at the imperial palace.

134

Chen Chun. *Pomegranate Blossoms.*
On paper. 118 × 62 cm. Ming Dynasty

Chen Chun (A.D. 1483–1544) had styled himself Dao Fu, but when he later adopted it as his name, he restyled himself Fo Pu, alias Man of White-Sun Mountain. He was born in Changzhou (present-day Suzhou) in Jiangsu Province, and was a pupil of Wen Zhenming. He was accomplished in painting landscapes, particularly in sketching flowers from real life.

The painting shows a pomegranate in full bloom in early summer. The bright red blossoms are well set off by the verdant leaves. Beneath the tree is a Taihu rock covered with moss. On the ground is a carpet of green grass with a riot of wildflowers. The painter uses sparse, elegant brushstrokes and bright colors to depict the beauty of a garden in summer.

135 136

Zhou Zhimian. *Flowers and Birds.*
On paper. 29.1 × 408.6 cm. Ming Dynasty

Zhou Zhimian, who styled himself Fu Qing, alias Small Valley, was born in Changzhou (present-day Suzhou), in Jiangsu Province. He was a flower-and-bird painter who was active from the reign of Jia Jing to the reign of Wan Li (A.D. 16th century) in the Ming Dynasty. He specialized in painting birds and, because he was a careful observer of them when they drank, pecked, flew, and perched, he painted them true to life.

This long scroll is painted with flowers and birds of the four seasons. Of the two sections chosen here, the first is crape myrtle and a starling, and the second is camellia and a hawfinch. The brushwork is sparse and elegant. The colors are quiet and refined. The painting was done in the twenty-ninth year of the reign of Wan Li (A.D. 1601), during the painter's late years.

137

Ding Yunpeng. *Pouring the Wine.*
On paper. 137.4 × 56.8 cm. Ming Dynasty

Ding Yunpeng (A.D. 1547–1628), who styled himself Nan Yu, alias Man of Shenhua, was born in Xiuning, Anhui Province. He was a Ming Dynasty painter who specialized in sketching figures and Buddhist images, but he also did landscapes and flowers. The painting shows an old Daoist priest with two servants straining wine in a garden beneath shady autumn willow trees with chrysanthemums growing on the ground. Scattered on a stone table are a musical instrument, a book, and other objects which impart an aesthetic mood to the painting. The painter's signature is on a rock at bottom left.

138

Dong Qichang. *Clouds Shroud Mountains and a River.*
On silk. 124.1 × 50.4 cm. Ming Dynasty

Dong Qichang (A.D. 1555–1636), who styled himself Xuan Zai, also called Si Pei, was born in Huating (present-day Songjiang County, Shanghai). He was a master calligraphist and a strong advocate of scholar-painting in the late Ming Dynasty. He was an accomplished painter of landscapes, with his own unique style which had great influence.

The painting shows blue and green mountains and a river shrouded in mist at the beginning of summer. The faraway peaks are sharp and clear and the trees of the green forest in the foreground sway in the gentle breeze. The low summer twilight lights up the mountain peaks. The use of color is exactly the same way here as for ink—the "splash-ink" method with mineral-green color to give a lush green feeling. This is one of Dong Qichang's works of his late years.

139

Chen Hongshou. *Ruan Xiu Buying Wine.*
On silk. 78.3 × 27.1 cm. Ming Dynasty

Chen Hongshou (A.D. 1598–1652), who styled himself Zhang Hou, alias Old Lily, was born in Zhuji, Zhejiang Province. He was a famous painter of the late Ming Dynasty, accomplished in painting figures, flowers, birds, and also landscapes—all with his own style.

The picture depicts the famous scholar Ruan Xiu of the Western Jin Dynasty (A.D. 3rd and 4th century), who refused to serve the powerful nobles and became a recluse in a forest. He bought and drank wine for his own enjoyment. The painting shows Ruan Xiu in a loose flowing robe, walking with the aid of a bamboo stick from which hang money and medicinal herbs, and carrying a wine pot in his hand. With head held high and glancing aside, he looks as if he had just bought some wine and was on his way home. The painter used round and forceful brushstrokes to depict the scholar's unrestrained character.

140

Wang Jian. *Blue-and-Green Landscape*.
On paper. 175.1 × 87.7 cm. Qing Dynasty

Wang Jian (A.D. 1598–1677), who styled himself Xuan Zhao and later Yuan Zhao, alias Fragrant Master and also called Xiang Bi, was born in Taicang, Jiangsu Province. He was a famous painter in the early Qing Dynasty. Together with Wang Shimin, Wang Hui, and Wang Yuanqi he was one of the Four Wangs. His landscape painting was influenced by Dong Qichang. He loved tracing the technique of ancient paintings and had a great mastery of brushstrokes.

The painting shows ranges of green mountains receding into the clouds and mist in the distance. Villages in valleys are scattered here and there. The trees and rocks are painted in patches of green and reddish-brown, with a grand but dark atmosphere. This is a masterpiece by the painter in his seventy-eighth year.

141

Zhu Da. *Wild Geese and Reeds*.
On paper. 146.6 × 73.8 cm. Qing Dynasty

Zhu Da (A.D. 1626–1705), who styled himself Ren Wu, alias A Mountain and also called Bada Shanren, was born in Nanchang, Jiangxi Province. He was a descendant of the Ming royal family. After the overthrow of the Ming Dynasty, he became a monk and later a Daoist priest. In Nanchang he built a Daoist temple called Azure Cloud Temple. He was an accomplished painter of landscapes, flowers-and-birds, and also excelled in calligraphy. He was one of the four great monk-painters of the early Qing Dynasty.

The picture shows reeds and hibiscus blossoms dangling from a cliff. Two wild geese are on a rock, one nestling and another looking up with head turned. Strong and shallow ink dottings on the backs of the wild geese give a fluffy feeling to the feathers. The brushstrokes are comprehensive and lively. It is a masterpiece of Zhu Da's works in his late years.

142

Wang Wu. *Lotus Flowers and Mandarin Ducks*.
On paper. 164.7 × 71.4 cm. Qing Dynasty

Wang Wu (A.D. 1632–1690), who styled himself Qin Zhong, also called Wang An and Xue Dian Daoist Priest, was born in Wuxian (present-day Suzhou), Jiangsu Province. He was accomplished in painting flowers and birds, and absorbed the style of the great masters of the Song, Yuan, and Ming Dynasties. His brushwork is easy and flowing and vividly expressive.

The painting shows the style of the "boneless" method and the method of exact delineation; it is elegant in color and in artistic conception. In the pond, the lotus flowers are in full bloom and the green leaves drift in the breeze. A pair of mandarin ducks swim about among the duckweed. It is a portrayal of nature's idleness.

143

Wang Hui. *Old Temple in a Mountain Fastness.*
On paper. 182.3 × 91.5 cm. Qing Dynasty

Wang Hui (A.D. 1632–1717), who styled himself Shi Gu, alias Man Who Cultivates Smoke, Man from Wumu Mountain, and Master of Bright Ray, was born in Changshu, Jiangsu Province. He was a famous landscape painter in the early Qing Dynasty, and was one of the Four Wangs, together with Wang Shimin, Wang Jian, and Wang Yuanqi. He had been instructed by Wang Jian and Wang Shimin. His brushstrokes are rich, thin, and elegant, combining the advantages of the various schools in the Song and Yuan Dynasties, which had great influence in the Qing Dynasty.

 The painting shows high precipices with green forests. A corner of a temple can be seen in the deep valley. Host and guests are sitting in a hall in the valley. There are a waterfall and a man fishing from a boat drifting in the river. This is a serene and beautiful mountain scene. It is a masterpiece of the painter's seventy-eighth year.

144

Yun Shouping. *Flower Album:* (1) *Broad-Bean Flowers.*
On silk. 29.9 × 22.2 cm. Qing Dynasty

Yun Shouping (A.D. 1633–1690), originally named Ge, who styled himself Zheng Shu, alias South Field, Man from Cloud Creek, and Hermit of Fragrance, was born in Wujin, Jiangsu Province. He was accomplished in poetry, calligraphy, and painting, and specialized in painting flowers in the "boneless" style. He brought about a new phase in flower painting in the Qing Dynasty, and exerted great influence in later generations. He was one of the Six Masters of the Early Qing Dynasty, together with Wang Shimin, Wang Jian, Wang Hui, Wang Yuanqi, and Wu Li.

 This is one of the eight paintings in *Flower Album*. The painting shows a branch of a broad-bean plant. The flowers are starting to bloom. The white petals and black stigmas are painted in the "sketch method," while the stalk and leaves are painted in the "boneless" style showing their obverse and reverse sides in different positions. Broad-bean flowers generally were not used as models by artists in paintings, but the brushwork in this painting is simple and soft, with bright and elegant colors. It is a meticulous work of sketching by the painter.

145

Yun Shouping. *Flower Album:* (2) *Cherries.*
On silk. 29.9 × 22.2 cm. Qing Dynasty

This is another of the eight paintings in *Flower Album*. The branch of cherries is painted in the "boneless" style. The leaves are proportionate to the cherries. The brushwork is accurate and elegant, with clear and strong colors, giving a lifelike appearance to the cherries.

146

Yuan Ji. *Touring Huayang Mountain.*
On paper. 239.6 × 102.3 cm. Qing Dynasty

Monk Yuan Ji (A.D. 1641–?) was born to a family named Zhu in Quanzhou, Guangxi, and was named Ruoji. He was a descendant of the Ming royal family. After the overthrow of the Ming Dynasty, he became a monk and took the name Yuan Ji, styling himself Shi Tao, alias Bitter Gourd Monk and Man from Qingxiang, and he was also called Da Di Zi. He advocated natural themes, declaring: "I make my own style," and opposed sticking to conventional methods. His brushwork in painting landscapes or flowers was unique in style and fresh in composition, displaying a strong creative spirit and exerting great influence on the future development of Chinese painting.

This painting shows a unique composition. There are old pine trees and bamboo beside a rock and on precipices. At the bottom of the waterfall is a winding path surrounded by mountains. The scene was painted with lofty inspiration. Yuan Ji's brushwork is delicate and meticulous, soft but powerful. The colors are clear and elegant. This is a masterpiece of Yuan Ji's landscape painting.

147

Gao Qipei. *Eagle on a Pine Tree.*
On paper. 161.1 × 74.7 cm. Qing Dynasty

Gao Qipei (A.D. 1660–1734), who styled himself Weizi and was also called Qie Yuan, was born in Tieling, Liaoning Province. He was a painter in the early Qing Dynasty and was accomplished in poetry and in the painting of landscapes, figures, flowers, and birds. He specialized in painting with his fingers instead of a brush.

This is a finger painting showing an eagle standing on a pine tree and looking at a frightened bird. The eagle's talons on one foot are opening in readiness for action. The branches of the pine tree are old and dried up and the bark is stripping off. The pine needles are sticking out and full of substance, displaying fully the characteristics of the finger-painting technique.

148

Hua Yan. *Pheasant, Bamboo, and Autumn Chrysanthemums*
On paper. 106.8 × 47.2 cm. Qing Dynasty

Hua Yan (A.D. 1682–1756) styled himself Qiu Yue, alias Man from Xingluo Mountain, East Garden Scholar, Plain Scholar, and Clean Hermit; he was born in Shanghang, Fujian Province, and later lived in Hangzhou and Yangzhou. He was accomplished in painting figures and landscapes and excelled in painting flowers, birds, and insects. His brushstrokes are strong and generalized, with elegant style and creativeness. Hua Yan influenced the development of flower-and-bird painting after the mid-Qing Dynasty.

The painting shows a pheasant on a rocky slope crowing with head raised and tail erect. Its pose is strikingly vivid and the tones bright and colorful. The autumn chrysanthemums and bamboo bending in the breeze provide a harmonious unity to the painting.

149

Shen Quan. *Peacocks.*
On silk. 146.2 × 75.5 cm. Qing Dynasty

Shen Quan (A.D. 1682–c. 1760), who styled himself Nan Ping and was also called Heng Zai, was born in Wuxing, Zhe-jiang Province. A Qing Dynasty painter whose forte was in painting flowers, birds, and animals, he used bright colors and belonged to the meticulous-delineation method school of the Academy of Painting in the Song Dynasty. In the seventh year of the reign of Yong Zheng (A.D. 1729) he was invited to teach painting in Japan, and had many students there.

The painting shows a pair of peacocks standing on a rock by a shallow creek against a background of distant mountains. The male, with a colorful pattern of gold and green dots on its tail, is standing upright before the breeze, while the peahen is crouching beside it with head raised and mouth opened, showing its reluctance to depart. The Chinese roses are in full bloom in the valley and the bamboos bend in the breeze to present a serene and beautiful picture. The painter has written that this painting was done in the year of Kuei Zou; that is, in the eleventh year of the reign of Yong Zheng (A.D. 1733). It was painted when Shen Quan was fifty-two years old.

150

Li Shan. *A Pot of Chrysanthemums.*
On paper. 106.7 × 56.3 cm. Qing Dynasty

Li Shan (A.D. 1686–1762), who styled himself Zhong Yang, alias Regretful Daoist Priest and also called Fu Tang, was born in Xinghua, Jiangsu Province. A famous Qing Dynasty painter, and one of the Eight Eccentric Painters of Yang-zhou, he first learned painting from Jiang Tingxi; later he changed from meticulous delineation to the "thick-brush-stroke" style. He followed the techniques of Lin Liang, Xu Wei, and Shi Tao, but created his own unique artistic style.

The painting shows a pot of pale yellow autumn chrysanthemums in full bloom supported by a bamboo stick. The painter has painted with high artistic skill and in an unrestrained and free spirit while, at the same time, showing a gift for capturing impromptu models and scenes.

151

Zheng Xie. *Bamboo and Rock.*
On paper. 217.4 × 120.6 cm. Qing Dynasty

Zheng Xie (A.D. 1693–1765) styled himself Ke Rou, alias Timber Bridge; he was born in Xinghua, Jiangsu Province. One of the Eight Eccentric Painters of Yangzhou in the Qing Dynasty, he was adept in painting orchids and bamboos. On the basis of having mastered the traditional techniques, he laid stress on real-life sketching and was good at using the art of calligraphy in his pantings to express the meanings of his various works in a clear-cut manner.

The painting shows tall, thin bamboos before high, craggy rocks. This was his masterpiece, painted when he was sixty-two years old. On the left he wrote: "Don't stick to traditional methods and your own ideas, just make it vivid." The stress on "vividness" shows Zheng Xie's artistic principle of painting to capture the vivid impression gained.

152

Su Liupeng. *Poet Tai Bai Drunk.*
On paper. 204.8 × 93.0 cm. Qing Dynasty

Su Liupeng, who styled himself Zhenqin, alias Daoist Priest Why and Daoist Priest Lofu, was born in Shunde, Guang-dong Province. He was a painter of the late Qing Dynasty Period, from the reign of Dao Guang to that of Xian Feng (A.D. 1821–1861), was accomplished in figure painting, and was influenced by the painters Huang Shen and Shang Guan-zhou of the mid-Qing. His brushwork is of two kinds: delicate and elegant or "thick-brushstroke" in a free style. The people of his period loved his paintings, whose themes were mostly taken from historical stories and the life and customs of the local people.

The painting shows Tai Bai drunk. Legend has it that the famous Tang Dynasty poet Li Bai loved drinking wine and, under its influence, would wax eloquent and write his magnificent poems. The painter uses thin but vigorous and generalized lines to depict the bold and carefree image of the tipsy poet, in contrast to the wretched appearance of the eunuchs. Their expressions are vivid and true-to-life. This is a masterpiece of the painter's meticulous style.

153

Xu Gu. *Painting Album: (1) Goldfish.*
On paper. 34.7 × 40.6 cm. Qing Dynasty

Monk Xu Gu (A.D. 1823–1896), alias Man from Purple-Sun Mountain, was born to a family named Zhu in Jixian County, Anhui Province. he later lived in Yangzhou but often traveled about between Suzhou and Shanghai, and earned his living by painting. He was an outstanding painter, accomplished in painting landscapes, flowers, fruits and vegetables, birds, fowls, and fish.

The painting shows four goldfish of different colors and a silver carp swimming among the green water weeds. The brushwork is strong and vigorous, using bright colors. The lifelike eyes of the fish and the realistic way they chase each other show the high level of artistic maturity attained by the painter.

154

Xu Gu. *Painting Album: (2) Squirrel.*
On paper. 34.7 × 40.6 cm. Qing Dynasty

The squirrel was a subject Xu Gu often painted. The painting shows the lively nature of a squirrel jumping among the grapevines, the leaves of which are depicted by light green ink wash with strong ink for venation. His brushwork looks disorderly but regular. He uses strokes to express the squirrel's fluffy fur, making it look realistic.

155

Zhao Zhiqian. *Oleander.*
On paper. 91 × 40.5 cm. Qing Dynasty

Zhao Zhiqian (A.D. 1829–1884), who styled himself Yi Fu, alias Cold Man, later restyled himself Wei Suo, and was also called Bei An and Wu Men. Born in Huiji (present-day Shaoxing), Zhejiang Province, he excelled in engraving seal script

and writing running script in the Wei style. He was also accomplished in painting flowers, vegetables, and fruits with unrestrained brushwork.

The painting shows a spray of oleander, which is thin and long. The green leaves are painted in the "boneless" method. The bright red flowers are of various heights. Two orchids on the lower right add to the painting's tranquil beauty.

156

Ren Xun. *Sunflower and Cock.*
On paper. 135.6 × 60.8 cm. Qing Dynasty. *Donated by Sun Yufeng*

Ren Xun (A.D. 1835–1893), who styled himself Fuchang, was born in Xiaoshan, Zhejiang Province. He was a well-known painter, specializing in painting figures, flowers, and birds. He followed the style of Chen Hongshou in figure-painting and used the "double-curved" method in painting flowers and birds.

The painting shows the natural scenery of a garden. There is a well-plumed cock standing on a rock; beside him is a sunflower, supported by a bamboo fence. Ren Xun's brushwork is free and neat, employing brilliant colors. The composition is unique. It is a striking piece of work.

157

Ren Yi. *The Fisherman.*
On paper. 157.8 × 47.2 cm. Qing Dynasty. *Donated by Sun Yufeng*

Ren Yi (A.D. 1840–1896), originally named Run, who styled himself Xiao Lou and later Bo Nian, was born in Shanyin (present-day Shaoxing), Zhejiang Province. He lived by painting in Shanghai for a long time and was good at painting everything—including figures, portraits, flowers, birds, and landscapes. He had all-round skill and often used the methods of outline, dotting, and splashing together, thus creating a unique and unrestrained new style which still has a great influence today.

This painting by Ren Yi shows a fisherman on his way home from fishing on a snowy day. With basket in hand, the fisherman is looking back into the distance. The brushwork is simple and neat. A few easy and powerful strokes give a vivid portrayal of a fur-clad fisherman. The way the bamboo basket, hat, and fishing rod are drawn shows the painter's skill in sketching and in the masterly use of lines.

158

Ren Yi. *Riding a Donkey.*
On paper. 106.6 × 33.8 cm. Qing Dynasty. *Donated by Sun Yufeng*

This painting shows an old man with a bamboo hat riding a donkey. The donkey is painted in strong and watery ink wash while the old man's cloak is done in a vermilion color splash, which gives it a feeling of substance. Light ink is used to paint the ominous sky and snowy slope. One can see the high skill of the artist in using ink and color.

159

Wu Changshuo. *Flowers of the Four Seasons:* (1) *Magnolia and Peony.*
On paper. 250.7 × 62.4 cm. Qing Dynasty

Wu Changshuo (A.D. 1844–1927), originally named Jun and Jun Ching, styled himself Chang Shuo and Cang Shi; he was also known as Fou Lu and Ku Tie. He was born in Anji, Zhejiang Province, and lived in Shanghai for a long time. A famous seal-script engraver, calligraphist, and painter, he began to paint at the age of thirty and used the style of seal script and running script in rhapsodic style. He painted flowers, fruits, and vegetables in a strong and vigorous way. The paintings are strong in color and full of spirit, and they exerted quite an influence on art circles.

This painting shows a white magnolia matched with a red peony in full bloom, to depict a thriving spring scene. According to Chinese folk tradition, a pair of peaches symbolized longevity, while the peony symbolized richness. People usually painted these objects to express their good wishes and hopes.

160

Wu Changshuo. *Flowers of the Four Seasons:* (2) *Lotus.*
On paper. 250.7 × 62.4 cm. Qing Dynasty

The painting, done in neat and easy brushwork, shows an entrancing summer scene of lotus flowers in a variety of positions which reveal the obverse and reverse sides of their leaves. The whole picture was painted with such easy, unrestrained strokes that the leaves become one integrated unit. The painting seems to exude an intoxicating fragrance. It most certainly shows the painter's unusual artistic skill.

161

Wu Changshuo. *Flowers of the Four Seasons:* (3) *Chrysanthemums and Hollyhock.*
On paper. 250.7 × 62.4 cm. Qing Dynasty

By use of different techniques and colors, the painting vividly shows various flowers in an autumn garden. The hollyhock and tricolor amaranth were painted in the "boneless" style while the orange chrysanthemums were painted in ink with outlines. The two Chinese cabbages were painted in the "ink splashing" method. With ink and color together, the whole picture gives a sense of colorful freshness.

162

Wu Changshuo. *Flowers of the Four Seasons:* (4) *Plum Blossoms.*
On paper. 250.7 × 62.4 cm. Qing Dynasty

The painting shows an old plum tree growing out of a rock, its trunk and branches rising crookedly upward. The plum blossoms, in full bloom, and the strange rocky cliffs rising steeply show not only the painter's vigorous brushwork skill, but also the unyielding character of plum blossoms in a severe frost.

163

Qi Huang. *Ink Prawns.*
On paper. 95.8 × 35.8 cm. Modern Period

Qi Huang (A.D. 1863–1957), called A Zhi in his childhood, styled himself Ping Sheng, and was also called Baishi; he was born in Xiangtan, Hunan Province. An outstanding painter of modern times, he was also highly successful in poetry, seal-script engraving, and calligraphy. He excelled in painting flowers, fruits, insects, and birds, and was very accomplished in figure and landscape painting. Qi Huang was able to absorb the good qualities of earlier masters and create his own style. He laid stress on true-to-life feelings in daily life. His style was simple and fresh, healthy and powerful.

The painting is of one of the themes he often painted. A number of prawns are swimming and diving in the water. With a few strokes, the artist has created living images of them. This clean brushwork of painting transparent prawns was also Qi Huang's unique technique.

164

Huang Binhong. *Landscape.*
On paper. 38.3 × 27.3 cm. Modern Period. *Donated by Zhu Yanyin*

Huang Binhong (A.D. 1864–1955) was named Zhi and styled himself Bucun; he was also known as Binhong, as well as Yuxiang, Honglu, and Hongsou. He was born in Jixian, Anhui Province. A famous master painter of modern times, he did a great deal of research work on poetry, calligraphy, seal carving, inscriptions on bronzes and stone, and on the theory of painting.

He laid stress on real-life sketching—painting landscapes with intricate compositions and strong ink—and obtained space through substance by employing different lights and shades. In his late years, he particularly stressed using ink, and was adept in using strong ink, splash ink, and burnt-black ink to depict the grand scenes of mountains and rivers and the magnificent clouds at dawn and dusk, thus creating his own unique style. From the painting, one can see the characteristics of his art.

165

Xu Beihong. *Two Horses.*
On paper. 95.6 × 38.6 cm. Modern Period. *Donated by Sun Yufeng*

Xu Beihong (A.D. 1895–1953) was born in Yixing, Jiangsu Province. This contemporary painter and teacher of fine arts studied in France and was accomplished in traditional Chinese painting and oil painting. He was also remarkable in sketching. In painting figures, he was good at portraying their expressions and spirit. When painting flowers, birds, animals, and landscapes, he painted them full of life. He was especially renowned for painting horses. His style is free and unrestrained, and he combined traditional and Western techniques to create a new feature in painting.

This painting was done in 1946. There are two lifelike horses under a willow tree, whose wands are swaying in the breeze. One horse is standing with head raised, while another is cropping at the grass with its head lowered. With its rich brushstrokes, the painting shows a grazing scene in spring.

Carvings
and Other Handicrafts

FIVE

Carvings and Other Handicrafts

Introduction by Zhu Shuyi

The history of applied arts in China dates back thousands of years. During this lengthy span many kinds of handicrafts, of multifarious forms and exquisite in workmanship, have been created which have both traditional national characteristics and local styles. Among them are jade, stone, bamboo, wood, lacquer, ivory, and rhinoceros-horn carvings, enamelware, tapestry, embroidery, etc. They are in effect a cluster of brilliant gems in the treasure-house of the Chinese nation's art.

Applied arts originated with man's labor. They emerged and developed with the production of instruments and tools. Men who lived some 20,000 years ago in China had already mastered the skill of grinding down stones and drilling holes in them. Their tools, therefore, generally had sharp edges and polished butts and were well proportioned and symmetrical. About 5,000 years B.C., during the Neolithic Period, there appeared jade, ivory, and bone pendants. Jade carving was particularly outstanding among the handicrafts. The jade *huang* (Fig. 2), or pendant, unearthed at Songze in Qingpu County, Shanghai, and seen in the first section of this volume, is an exquisite piece of the time.

Jade carving is one of the oldest handicrafts in China. Owing to its hardness, mellow quality, and pretty colors, jade has been regarded as a precious stone since the Shang and Zhou Dynasties. Different kinds of jade were carved into various types of ritual vessels and ornaments. Jade carving as a handicraft was greatly developed during the Han Dynasty; it was carved with intaglio or relievo patterns, sculptured, or was decorated with openwork carving. In this volume, the jade ax (Fig. 183) and jade *ge,* or halberd (Fig. 182), are polished flat slabs with intaglio patterns; the jade figurine of a man (Fig. 180) is a sculpture which was executed as representational art with some exaggeration; the openwork jade disc of double rings and with grain decoration (Fig. 187) and the jade pendants (Fig. 181) in the shapes of different animals are simple yet vivid examples. All these objects represent the remarkable craftsmanship of the time. In the Han Dynasty jade carvings became even more delicate and are mostly of regular forms. The openwork jade rhomboid decorated with four deities and inscribed "Chang Yi Zi Sun" (Fig. 192) included herein is a piece of translucent, well-polished jade and is also a neatly cut artistic work.

In addition, the crafting of lacquerware also made great progress in the Han Dynasty, in which there was already a strict division of labor for its production: the *sui gong* was the workman who prepared the priming, the *xiu gong* was the lacquerer, the *shang gong* was the lacquerer of the outermost layer, and the *diao gong* was the engraver. Lacquerware had wood, bamboo, and cloth or hemp cloth as its matrix. Most lacquerware pieces of the Han Dynasty were fabricated by a method called *jia zu* (lined with hemp cloth). They were decorated with either carvings or paintings. Carved lacquerware was executed by cutting, carving, or engraving, according to the quality and the form of the ware, while decorated lacquerware was usually painted with bright colors and fine and flowing lines, often red patterns on a black ground, or vice versa. Lacquerware was widely used in everyday life at the time. The lacquer *zhi* (wine vessel) decorated with spirals and rhombs (Fig. 189) and the lacquer dish decorated with cloud designs (Fig. 190) were articles of daily use.

During the period of the Wei and Jin Dynasties and the Southern and Northern Dynasties, Bud-

dhism was widely propagated in China. The hewing of caves in cliffs and the building of large numbers of monasteries and temples ushered in an unprecedented development of Buddhist art. Both the form and the style of Buddhist art combined those of Chinese traditional art and the Gandharan art of India. Most of these Buddhist images were sculpted slender and graceful. The decorations on the images were rich and resplendent. The later Buddhist images of the Sui and Tang Dynasties inclined to be representational, with their forms rounded, massive, and well proportioned; they show strong Chinese national style. The bronze and stone Buddhist images in this volume are typical of those of the Northern Wei, Sui, and Tang Dynasties.

Handicrafts in these dynasties grew in variety and their products increased accordingly, decorations on handicrafts being enriched by foreign artistic influences. This was especially so beginning with the Tang and Song Dynasties, when frequent cultural interflow between China and the West resulted in her artistic works' showing influences from both her minority nationalities and the foreign countries and thus enriching China's national style. The tapestry of the Song Dynasty is quite important in China's textile history; Zhu Kerou was a capable tapestry maker and her tapestry of ducks in a lotus pond (Fig. 196) is her masterpiece. The gold and silver wares and ivory and jade carvings presented here are all executed with liveliness and vividness, and show varied styles. The incised lines on the openwork Tang Dynasty jade ornament, depicting phoenixes (Fig. 195), are flowing and vivid.

China was in the late period of feudal society during the Yuan, Ming, and Qing Dynasties, which lasted some 600 years. In the late Ming Period, European imperialists invaded China, with the result that capitalism emerged and the commodity economy developed. Owing to the demand of the market at home and abroad, applied arts reached a new height in China. Artistic works were made by the imperial workshops in the Ming and Qing courts as well as in the provinces. Those for the imperial palace were usually made of high-quality materials and by skillful artisans. Apart from the articles of daily use for the palace, most of these were ornaments. Those made by the folk workshops were full of varying local characteristics. There appeared many artists who became famous both at home and abroad, such as the jade carver Lu Zigang, the rhino-horn carver Bao Tiancheng, the lacquerer Lu Kuisheng, the craftsman for mother-of-pearl inlaying Jiang Qianli, and the bamboo carvers Pu Zhongjian and Zhu Xiaosong.

Toward the end of the Ming Dynasty there also emerged a number of skilled embroiderers. They belonged to different schools in embroidering. The Gu School was the most famous in the Ming Dynasty; from it four other schools—the Su, Yue, Xiang, and Shu—originated. The embroidery *Rock, Flowers, and Butterflies* (Fig. 211) is an outstanding work by Han Ximeng, a famous embroiderer of the Gu Family in the Shanghai area.

During the Ming and Qing Dynasties, the bamboo, wood, ivory, rhinoceros-horn, and jade carvings each had their own characteristics.

Bamboo carving is a special handicraft of China. It began in the Ming Dynasty and flourished in the Qing. Jiading County in the Shanghai area became the center of this art during the two dynasties. The bamboo censer decorated with carved figures (Fig. 198) by Zhu Xiaosong, the carbed bamboo armrest decorated with the figure of an old man beneath a pine tree (Fig. 212) by Wu Zhifan, and the bamboo carving of Tao Yuanming, an ancient poet (Fig. 213), by Deng Fujia are all remarkable works by famous masters of Jiading County. From the different parts of bamboo, artists have made different articles. For instance, bamboo roots were often carved with openwork or carved into figures, flowers, fruits, birds, or other animals, while split bamboo was carved into armrests, fans, etc. The decorations on these last were often in relief—engravings or gougings out of part of the skin to form various patterns.

Wood carving was usually used to decorate buildings and furniture. The craftsmen used red sandalwood, mahogany, and boxwood to carve many excellent artistic works. They were carved with either bold or fine lines. The carved boxwood ornament of Dong Fansu, an ancient humorist (Figs. 214 and 215), is deftly executed and is a unique piece of wood carving. Bamboo and wood carvers were often also skillful at ivory and rhino-horn carving.

Ivory carving reached a peak in the reign of Qian Long in the Qing Dynasty. Ivory works of that period are usually neat, regular, and delicate, and full of ornamental interest. Some of the works were even dyed or painted, and Beijing and Guangdong Province were famed for such carving. Having gone through the complicated processes of splitting, weaving, carving, dyeing, and inlaying, the ivory woven and engraved fan decorated with flowers and birds (Fig. 226) is a masterpiece of the Qian Long Period (A.D. 1736–1795).

Rhino-horn carving appeared in the Ming Dynasty and continued through the Qing Dynasty. As rhinoceros horns have the medicinal effects of allaying fever and being an antidote—apart from their semi-translucent and soft, fine-grained quality—they were often made into cups during the Ming Period. The carvers made use of the flat bottom and pointed tip of the horn to produce the rhino-horn goblet in the shape of a lotus (Fig. 205) and the rhino-horn goblet in the shape of a floating raft (Fig. 206).

During this period, jade carving became fine and meticulous. Craftsmen designed jade articles in accordance with the shape and color of the material, and many excellent jade works of art were thus made.

After thousands of years of experience, the making of lacquerware became even more refined. The cities of Beijing, Fuzhou, Guangchou, Chengdu, Yangzhou, and Suzhou were known for their exquisite lacquerwares, which were decorated by carving, filling, gold-painting and -inlaying, as well as their bodiless wares. The carved lacquer box decorated with a chrysanthemum-picking scene (Fig. 197), lacquer box carved with cloud patterns (Fig. 200), lacquer box with carved and filled-in qi lin (unicorn) pattern (Fig. 203), lacquer tray decorated with figures edged with gold on a bright red ground (Fig. 204), and black lacquer plates inlaid with mother-of-pearl landscapes (Fig. 222) are representative of the various lacquer-work skills of the Yuan, Ming, and Qing Dynasties.

Cloisonné, which was applying filigree work on a brass body and filling the fretwork with enamel colors, was a metal handicraft of the Ming Dynasty, famous at home and abroad. Since this craft reached its height during the Ming, in the reign of Jing Tai, it is known as the "blue of Jing Tai." The Qing Dynasty, on the other hand, was known for its painted-enamel works. Painted-enamel works would mellow and become resplendent and the colors would not fade for a long time. Presented herein are painted-enamel works and cloisonné of the Ming and Qing Dynasties, their brilliant colors still as fresh as new.

After the reign of Qian Long in the Qing Dynasty, China's applied arts industry gradually declined, particularly after the Opium War in 1840, when China became a semi-colonial and semifeudal country. Some of the art industries collapsed and others were ruined. However, jade, stone, bamboo, wood, and ivory carving, and embroidery and lacquer work practiced by folk handicraftsmen, still retained Chinese national traditions. Since the founding of the People's Republic of China, the applied arts industries have flourished again. Craftsmen have carried on the national traditions and at the same time created many new varieties to enrich these art forms. The pieces of modern handicraft works in this book—such as the white-jade carved flask decorated with bird and floral patterns and interlinked chains (Fig. 241), the green-jade vase decorated with openwork birds and flowers (Fig. 244), and the lacquer screen inlaid with ivory and semi-precious stones (Fig. 246)—were made since the liberation. They each show perfectness of skill and add to the magnificence of China's applied arts.

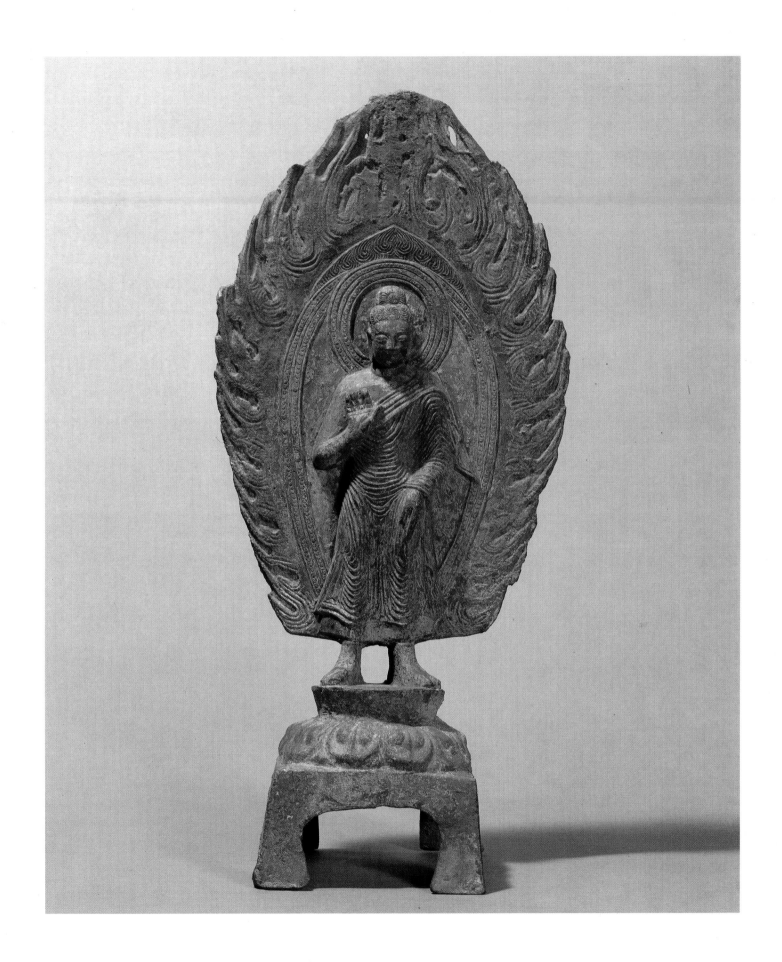

166 Bronze image of the Buddha.
Northern Wei Dynasty

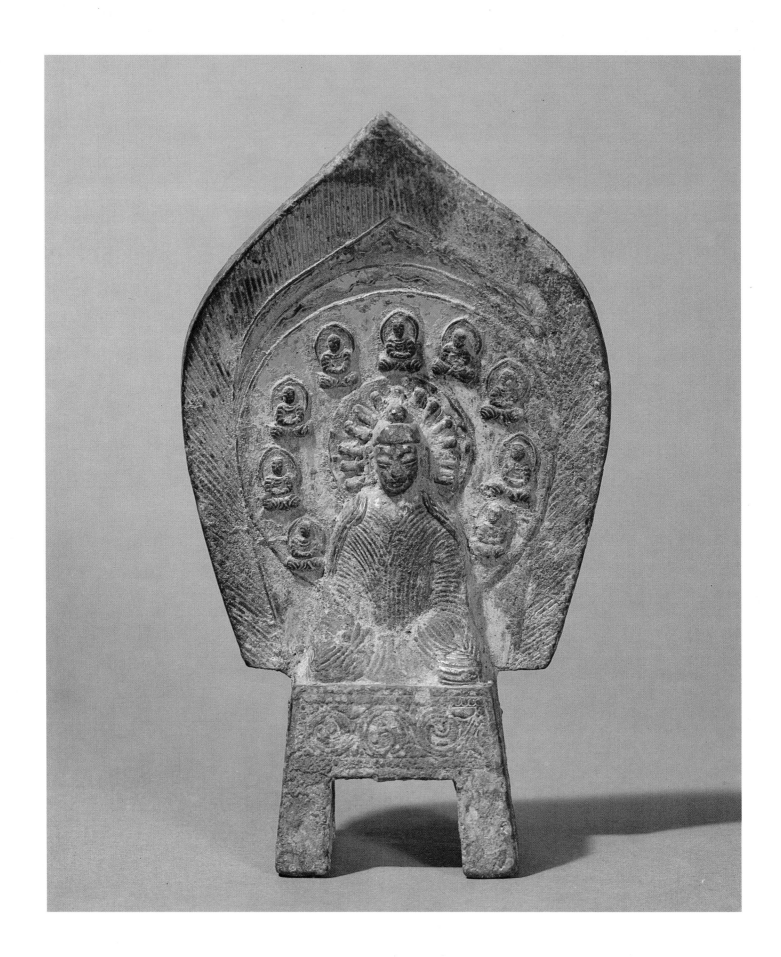

167/168 Gilded bronze image of the Buddha.
Northern Wei Dynasty

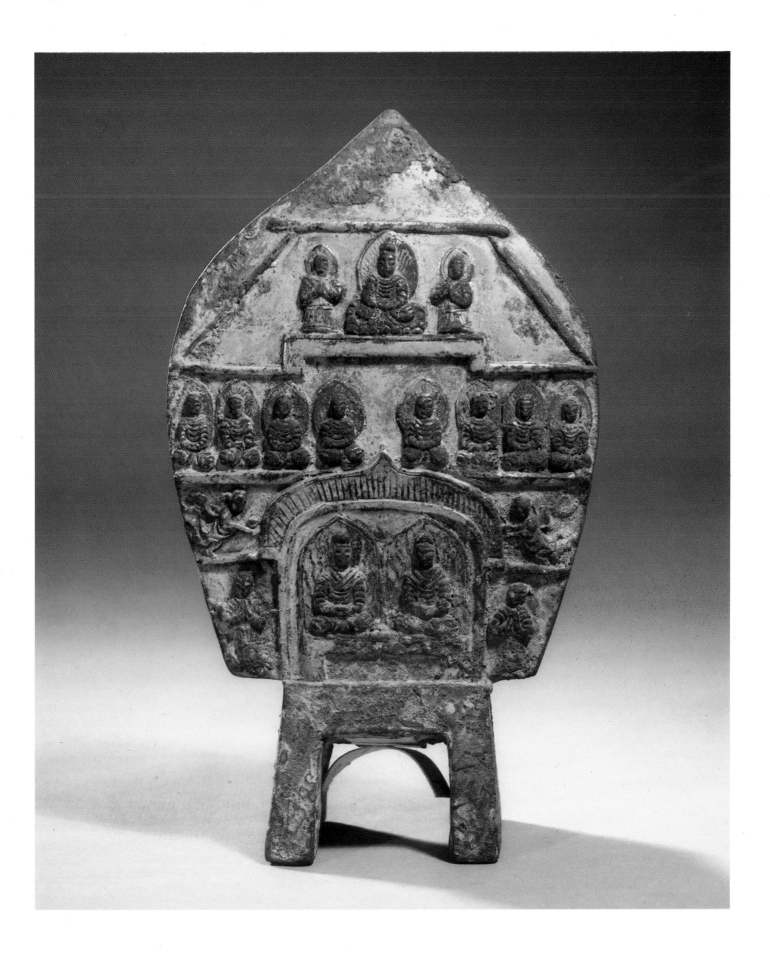

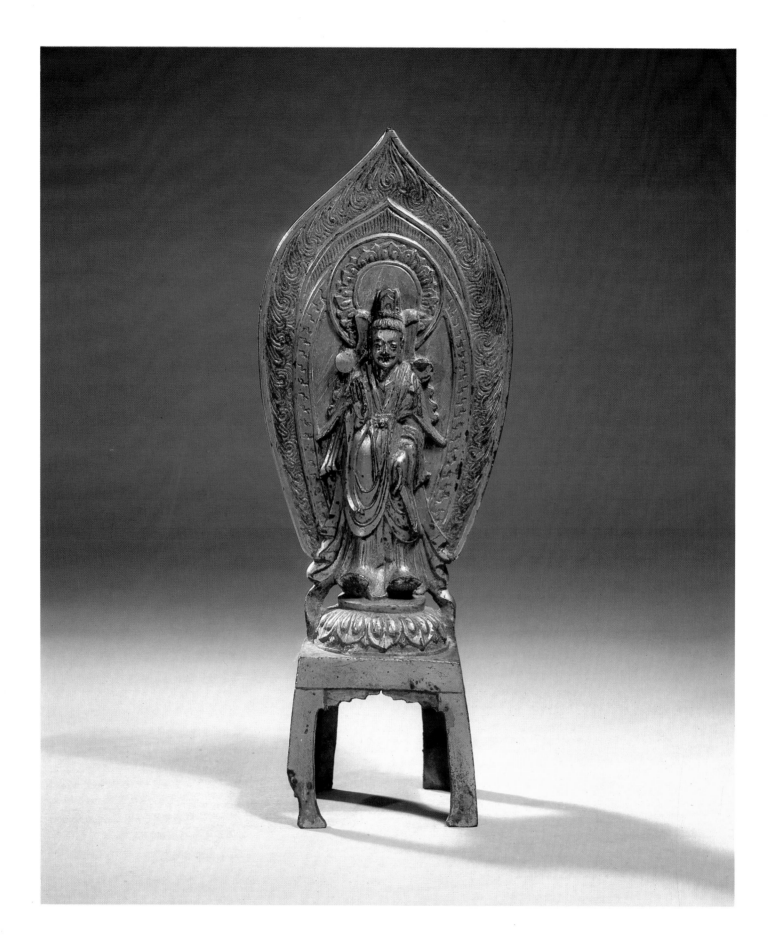

169 Gilded bronze image of Avalokitesvara.
Northern Wei Dynasty

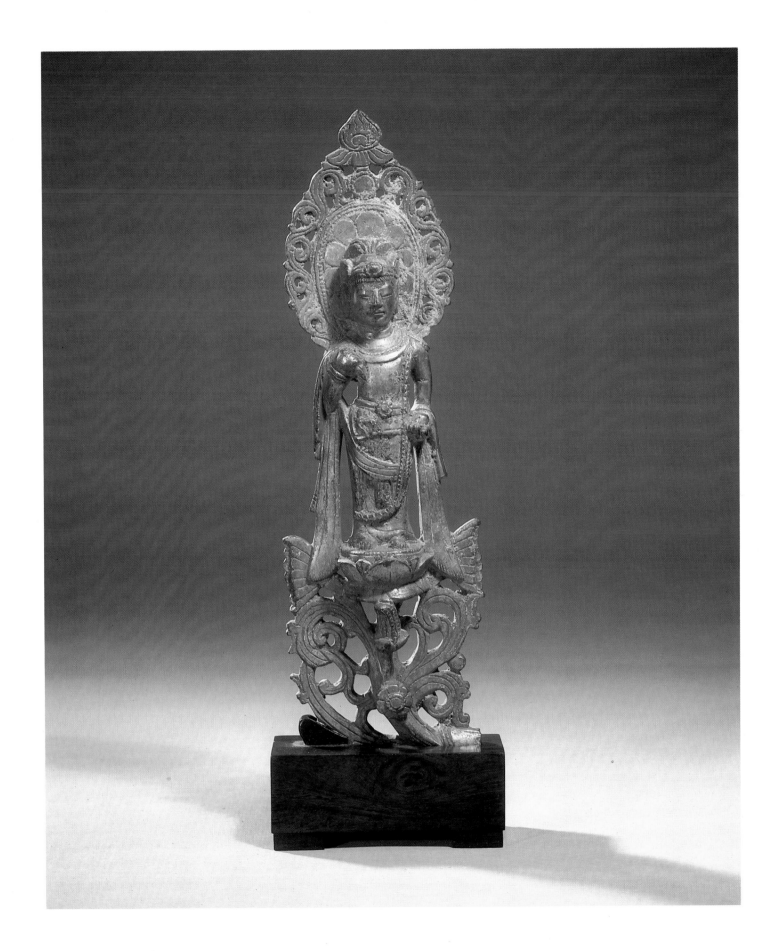

170 Gilded image of a bodhisattva.
Sui Dynasty

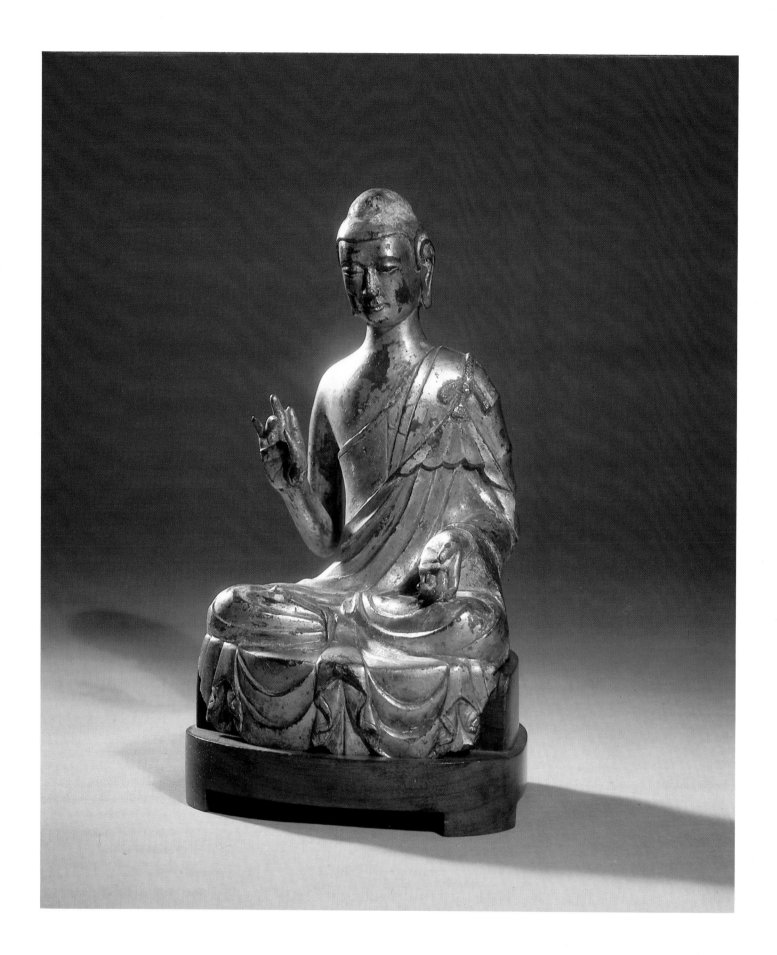

171 Gilded image of the Buddha.
Tang Dynasty

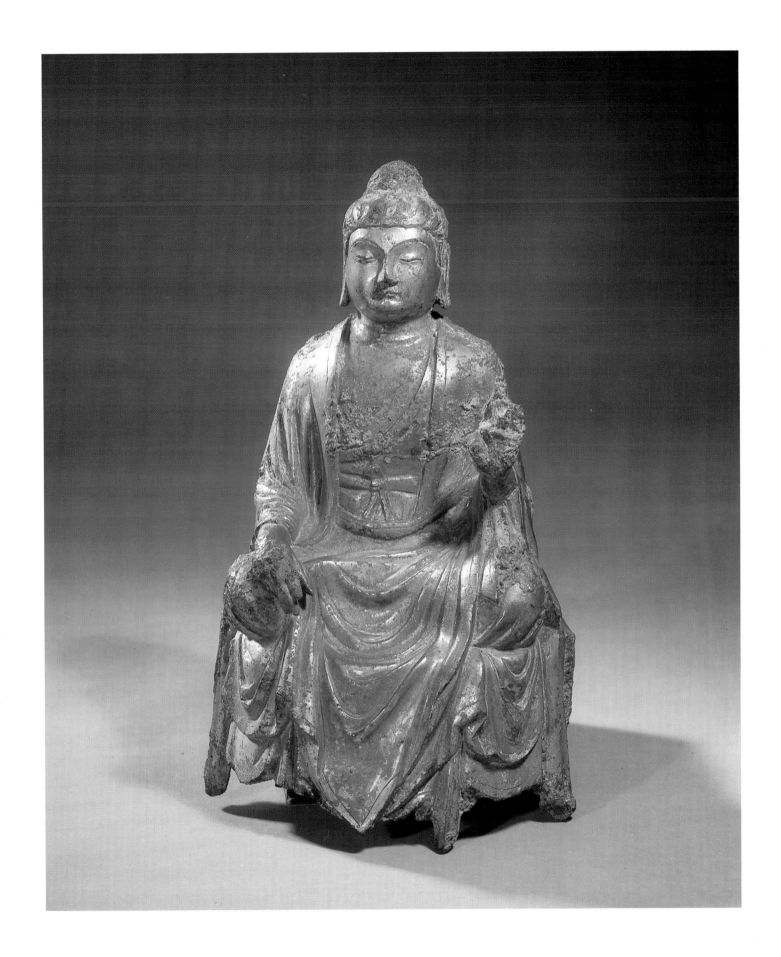

172 Gilded bronze image of the Buddha.
Tang Dynasty

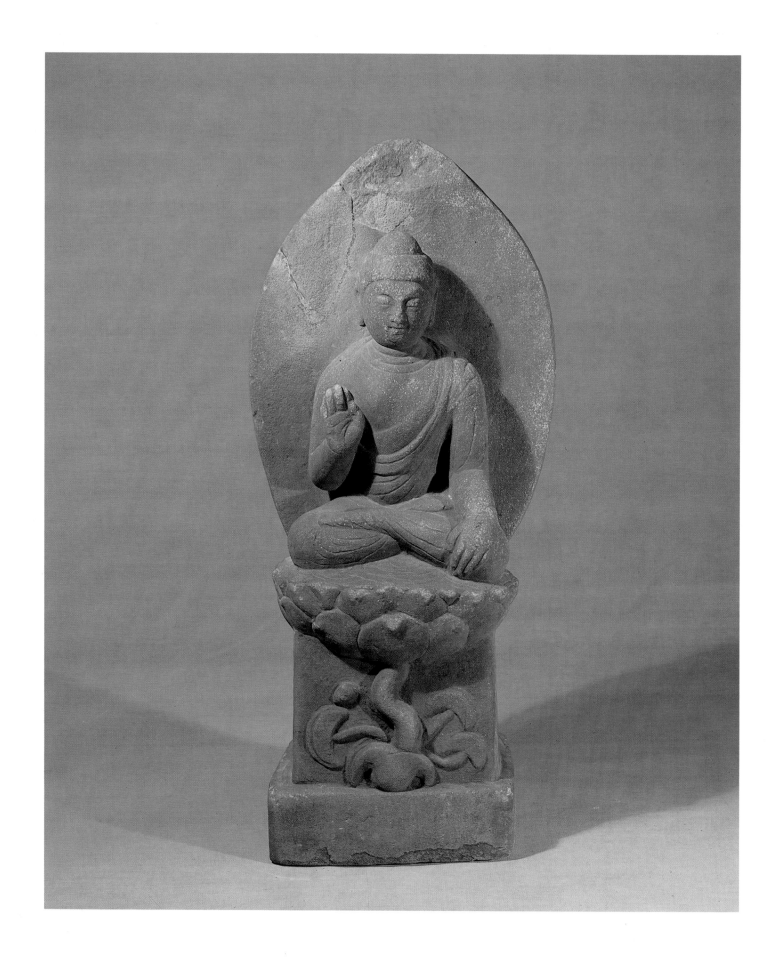

173 Stone image of the Buddha.
Eastern Wei Dynasty

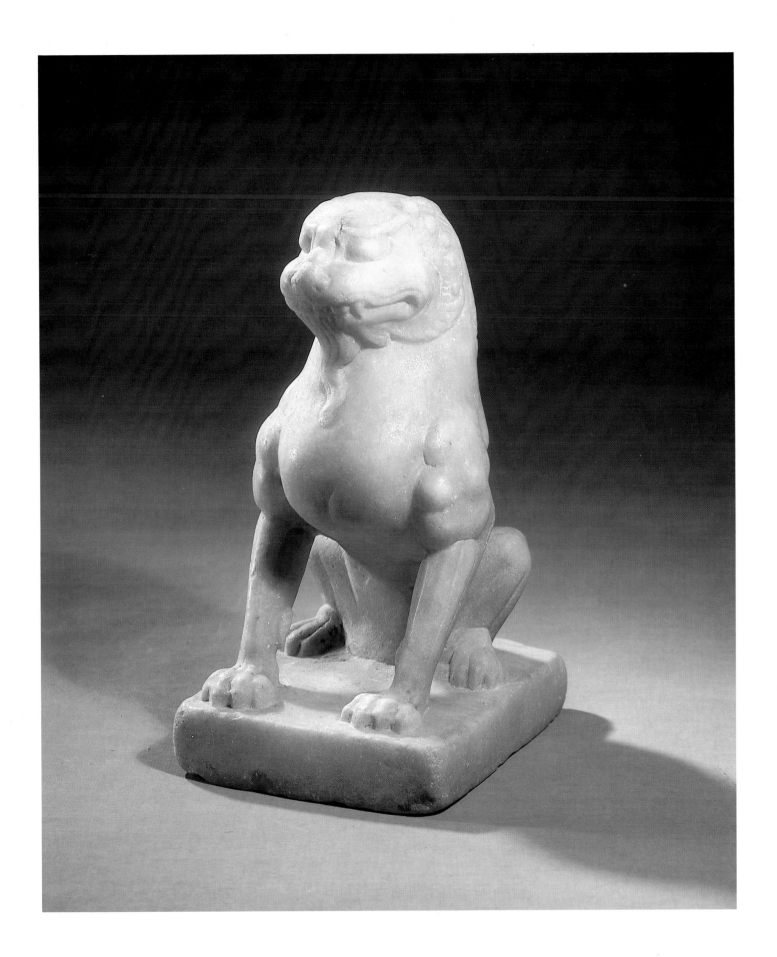

174 Stone lion.
Tang Dynasty

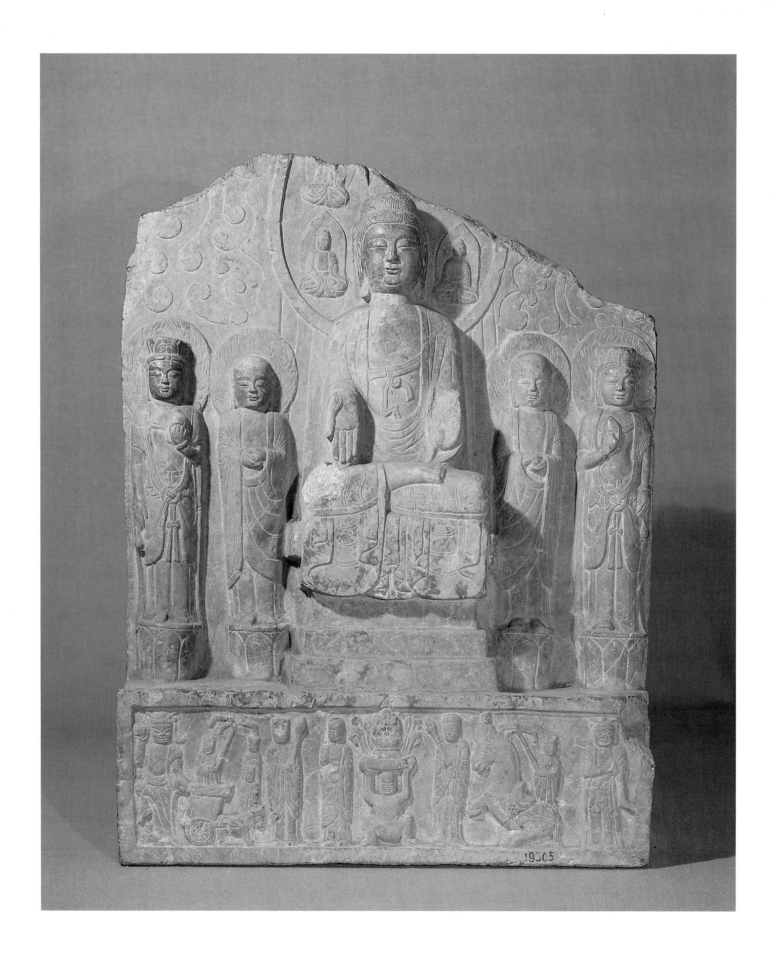

175/176 Stone stele of the Buddha and bodhisattvas.
Sui Dynasty

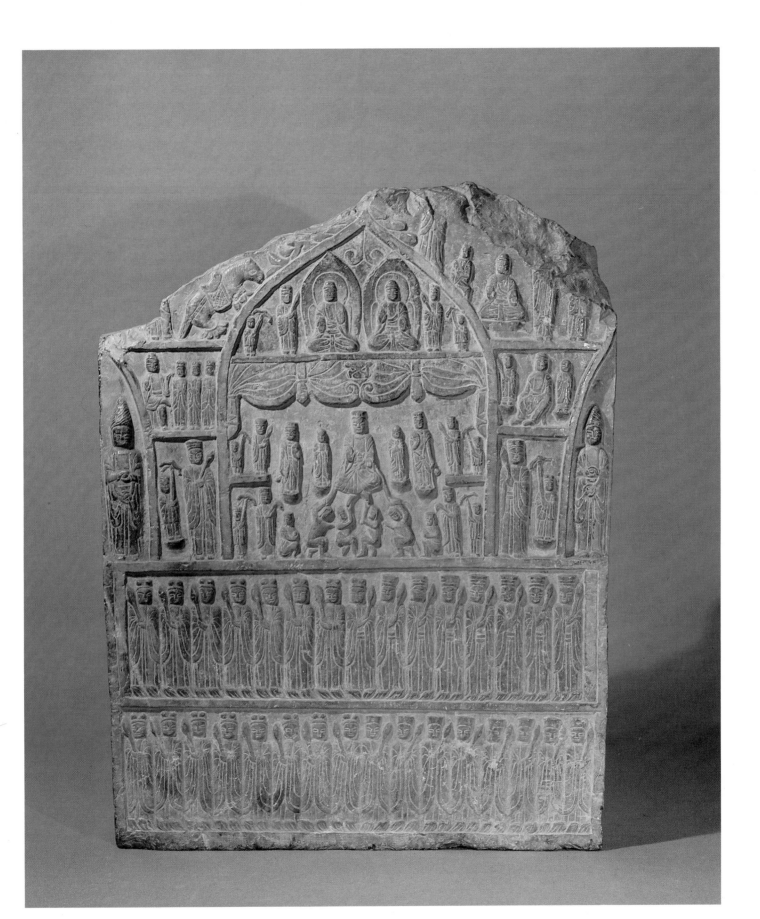

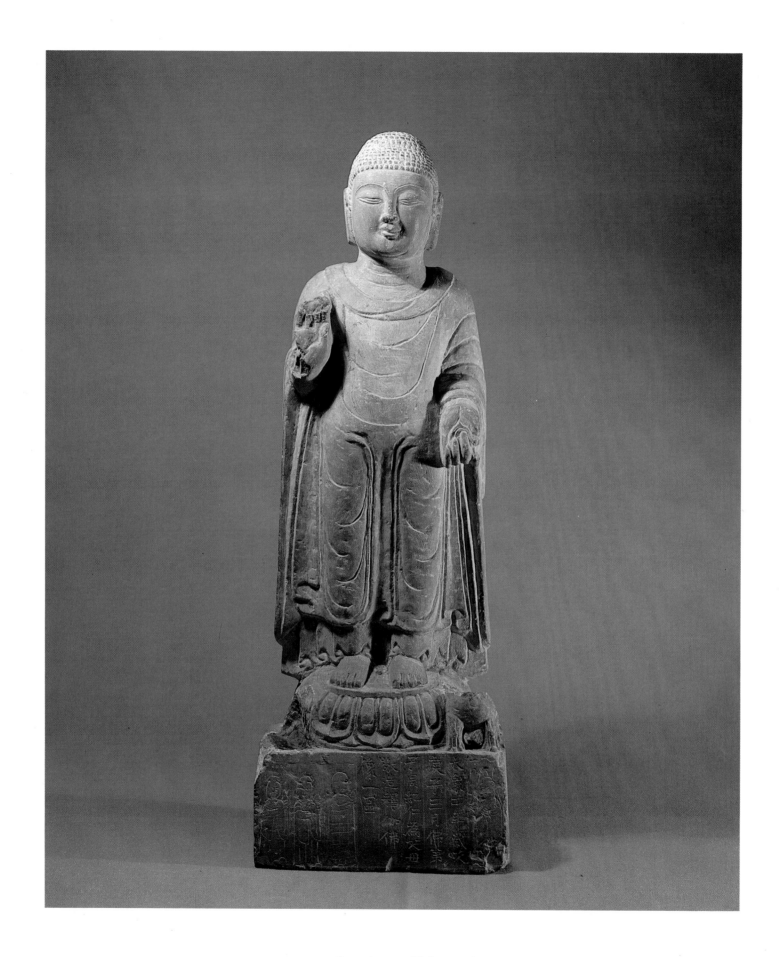

177 Stone image of Sakyamuni.
Northern Zhou Dynasty

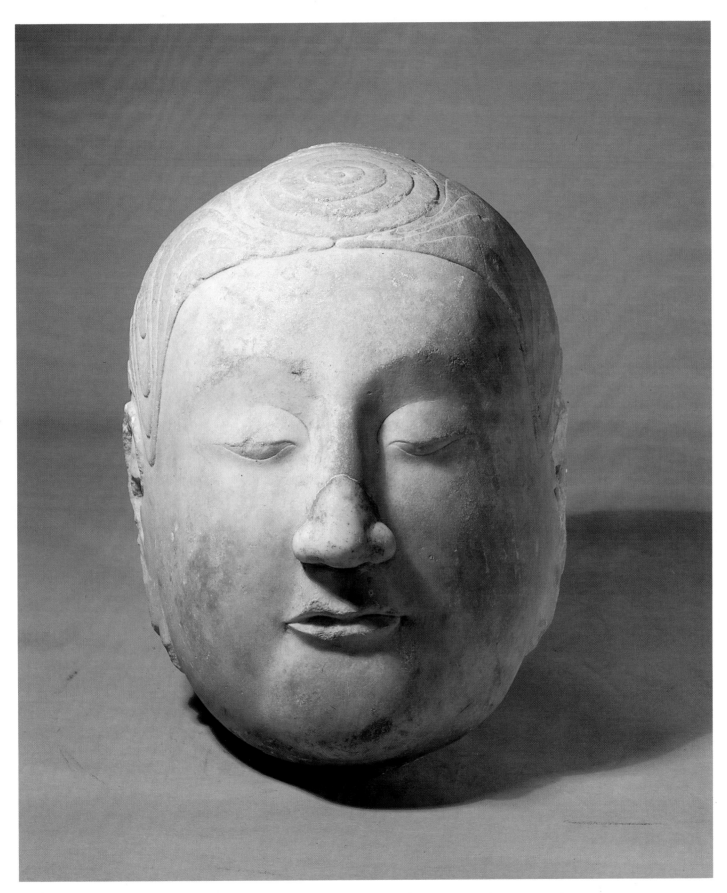

178 Stone Buddha's head.
Tang Dynasty
179 Musicians in stone relief.
Five Dynasties Period

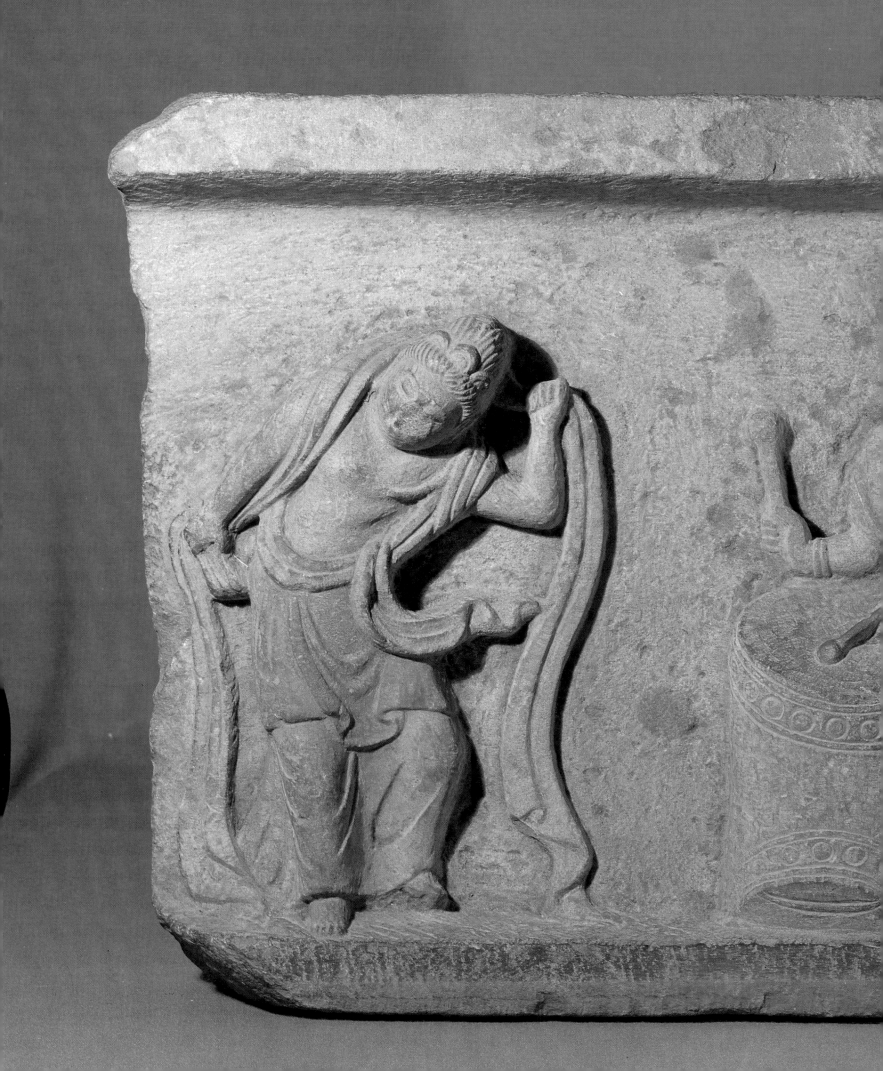

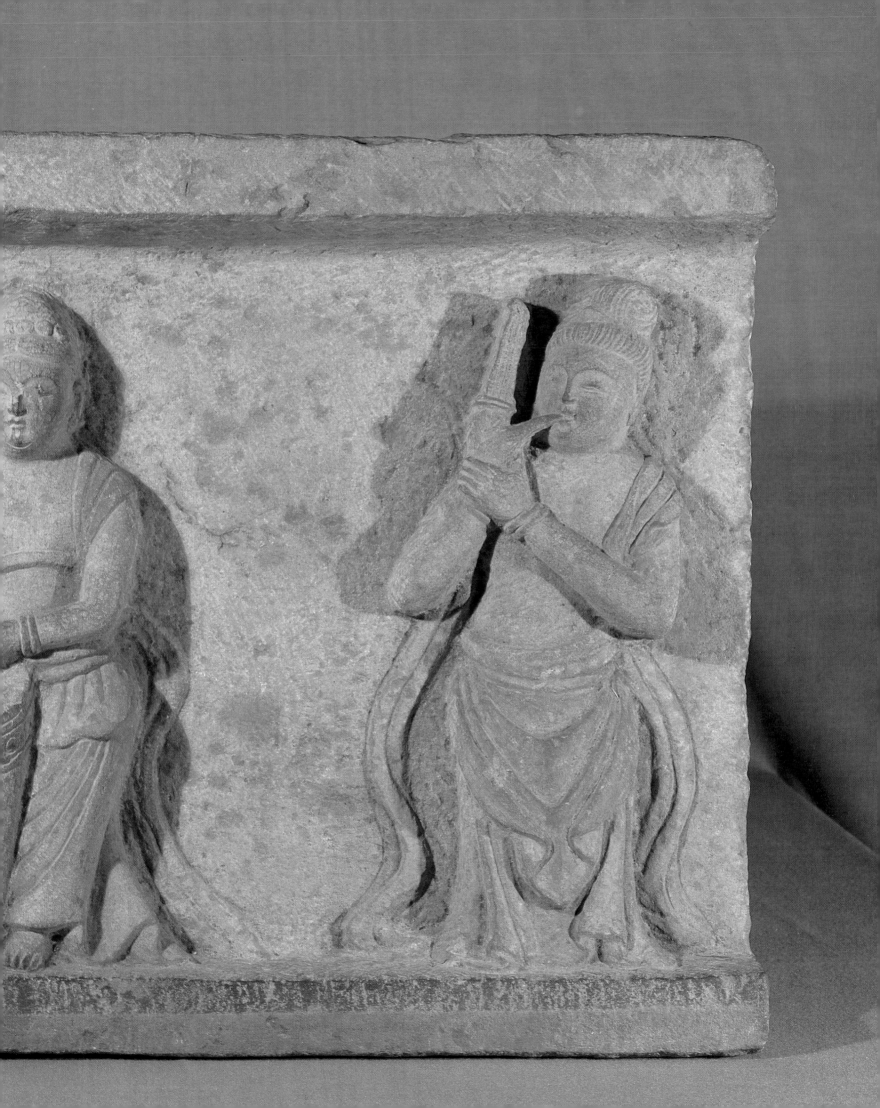

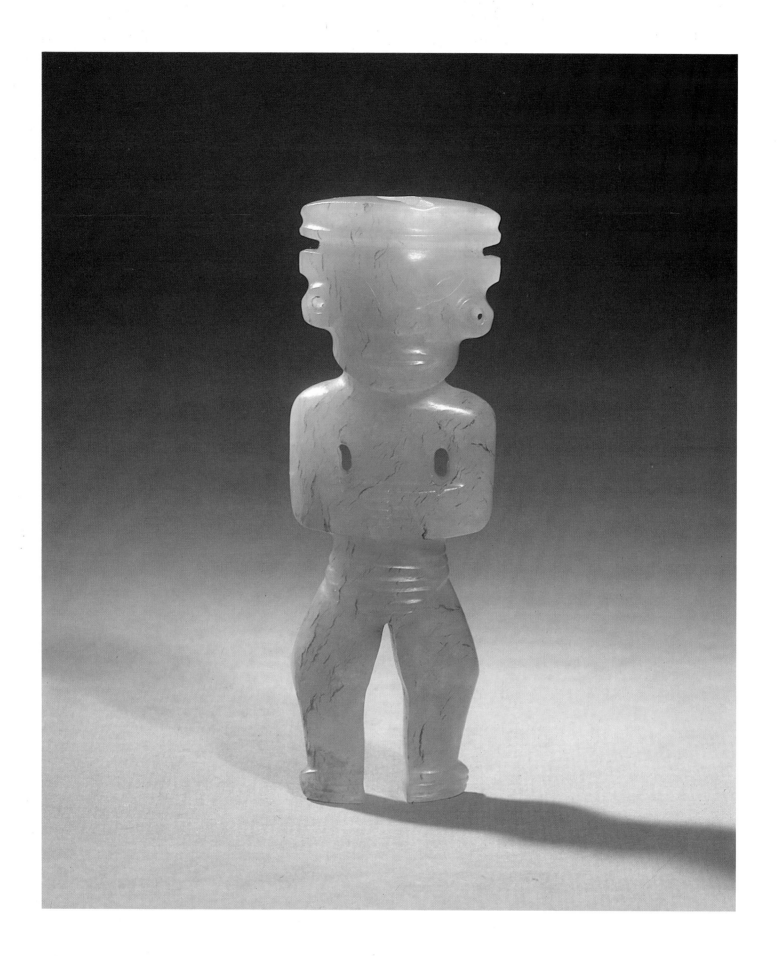

180 Jade figurine.
Shang Dynasty

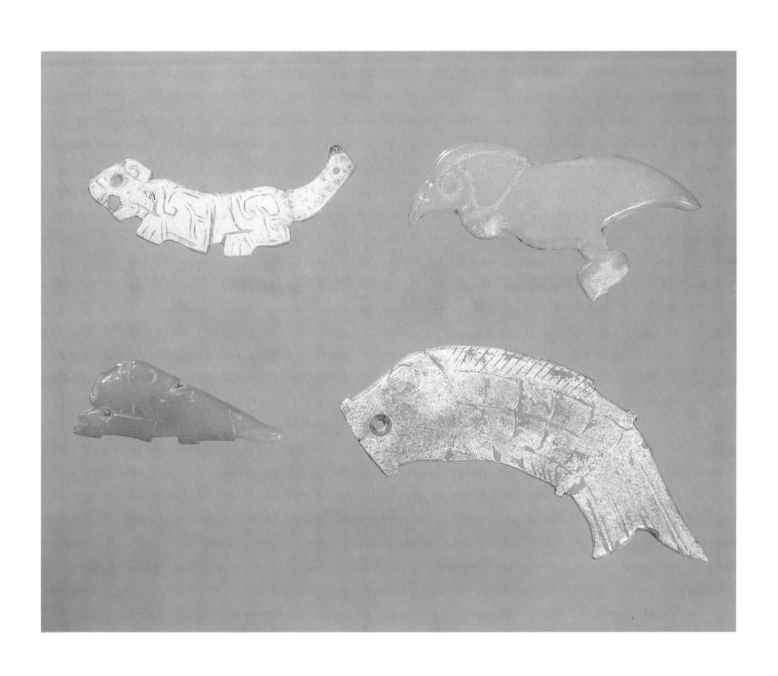

181 Jade pendants.
Shang Dynasty

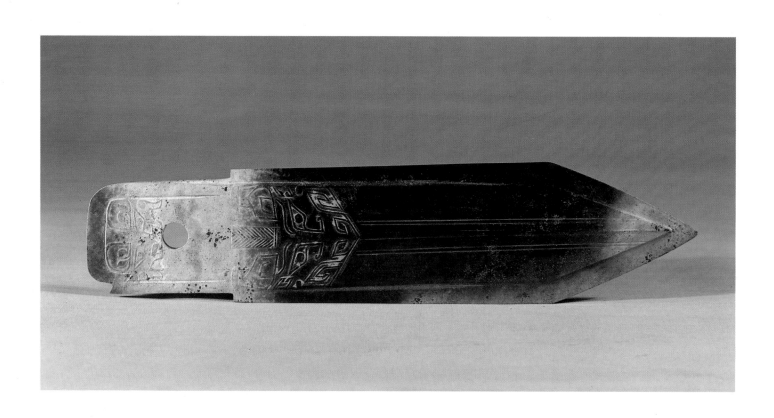

182 Jade *ge* (halberd) with animal-mask designs.
Western Zhou Dynasty

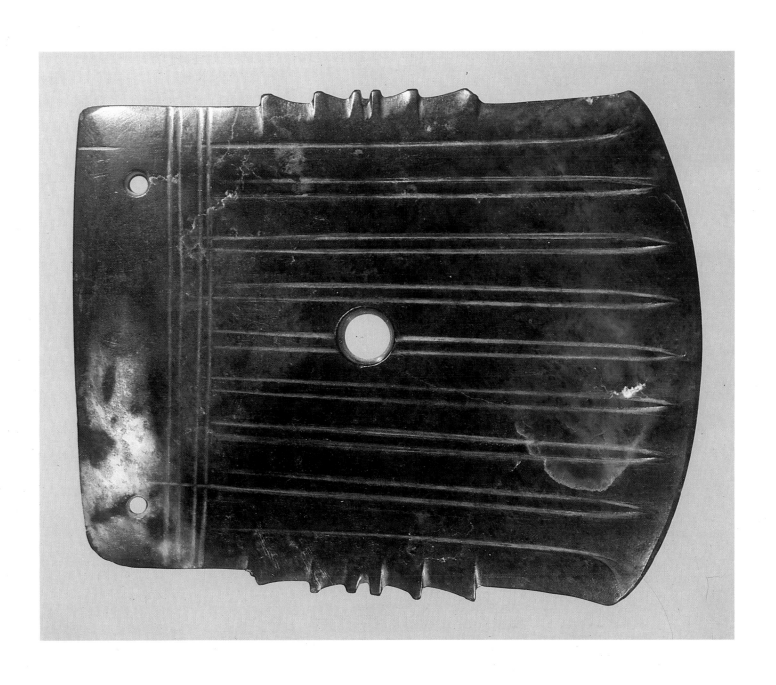

183 Jade ax decorated with vertical lines.
Shang Dynasty

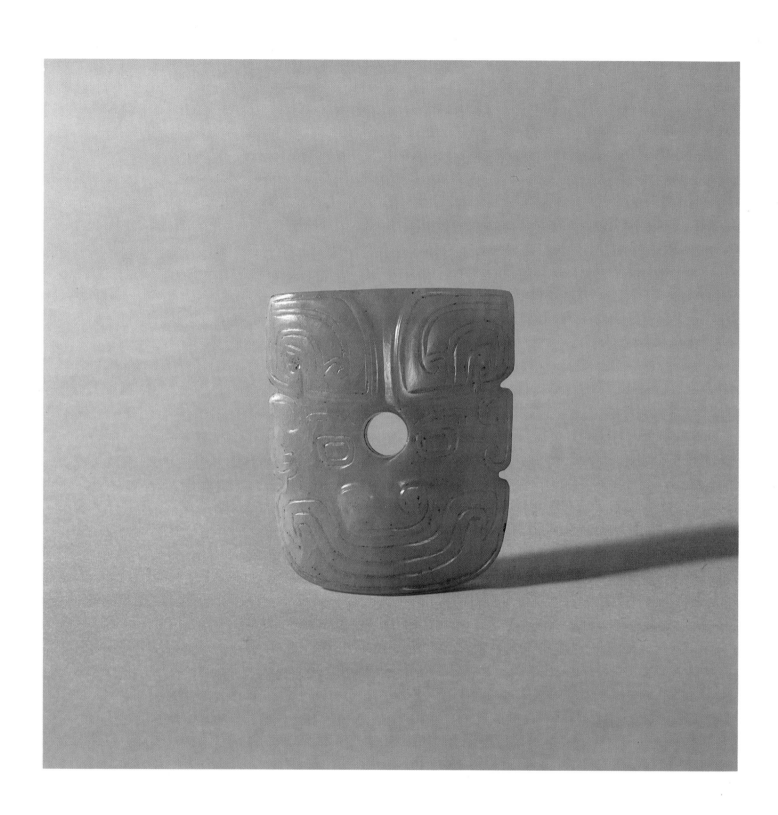

184 Nephrite pendant in the shape of an animal mask.
Western Zhou Dynasty

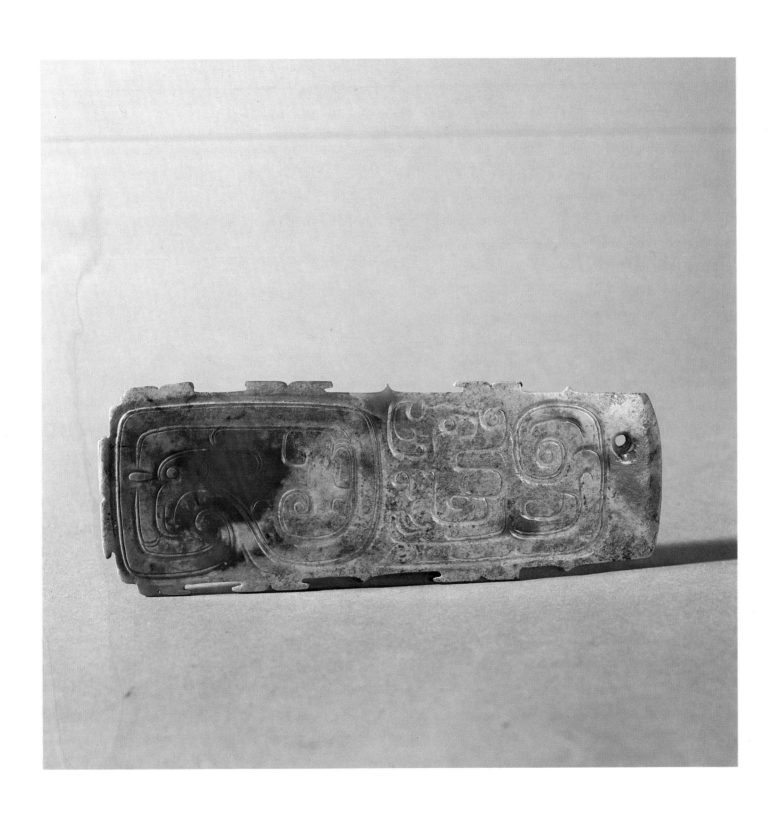

185 Nephrite pendant decorated with bird patterns.
Western Zhou Dynasty

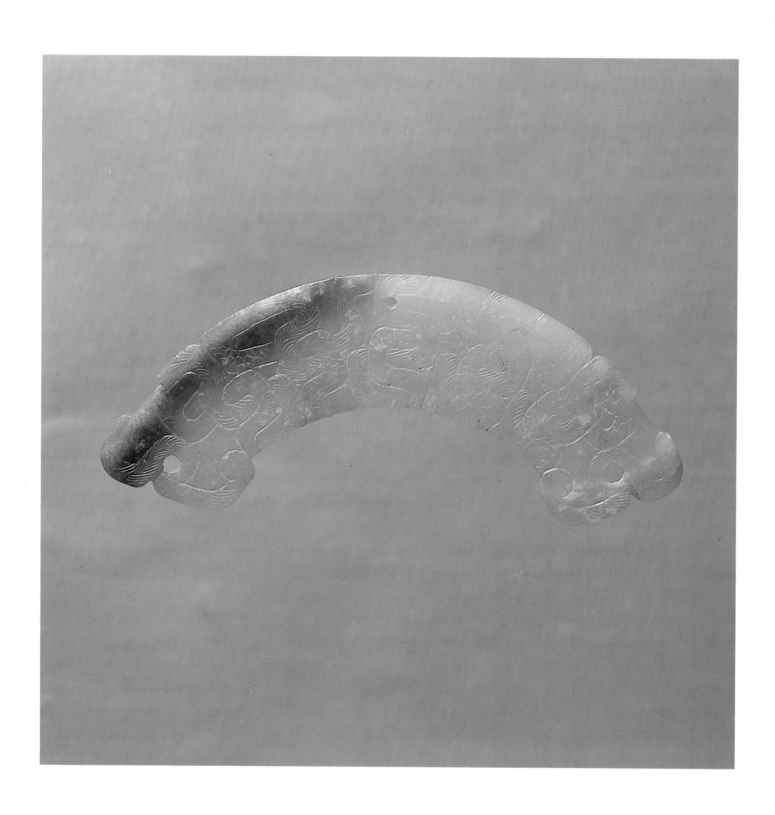

186 Jade *huang* (pendant) decorated with dragon patterns.
Warring States Period

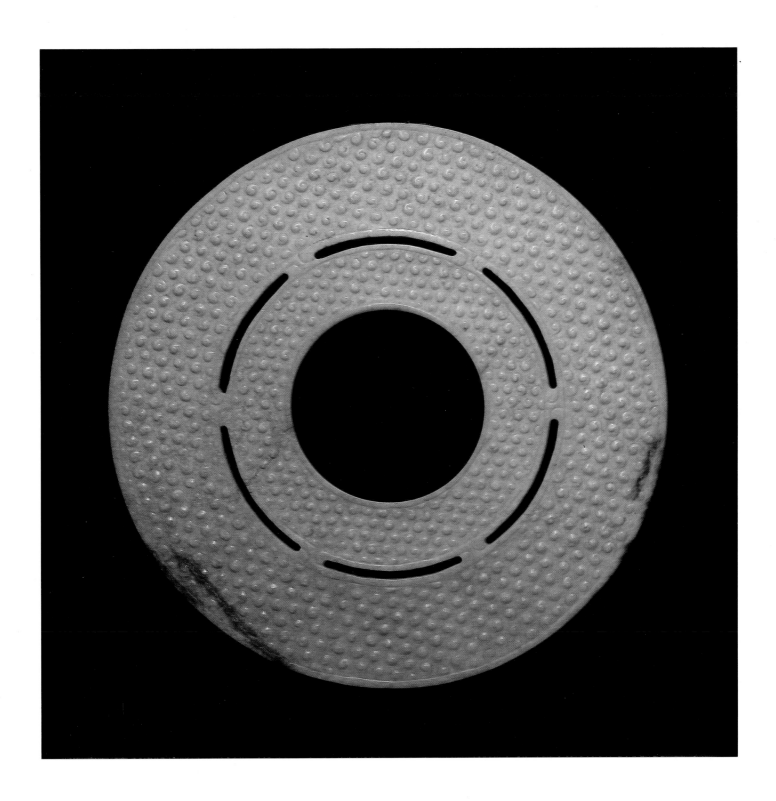

187 Jade disc in the shape of double rings and decorated with grain patterns.
Warring States Period

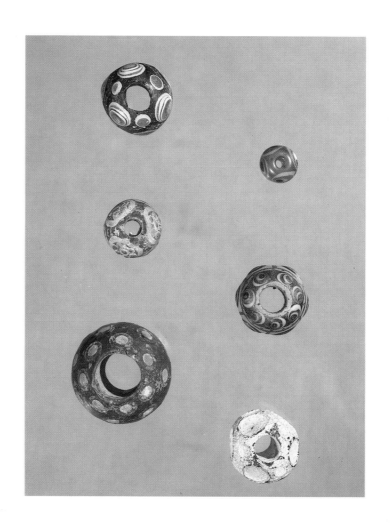

188 Glass beads.
Warring States Period

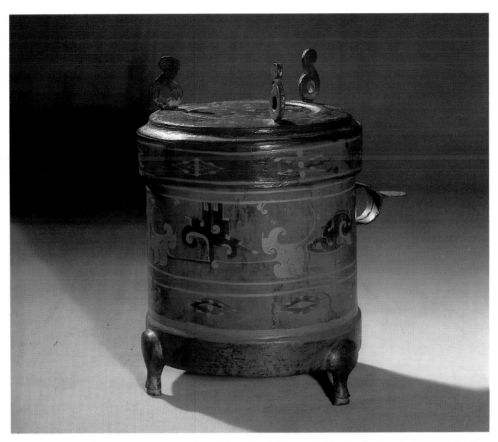

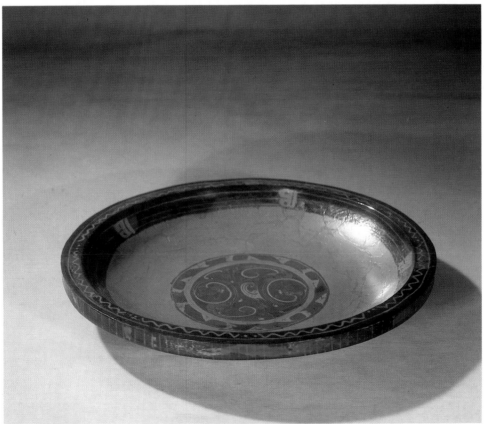

189 Lacquer *zhi* (wine vessel) decorated with spirals and rhombs.
Warring States Period
190 Lacquer dish decorated with cloud designs.
Han Dynasty

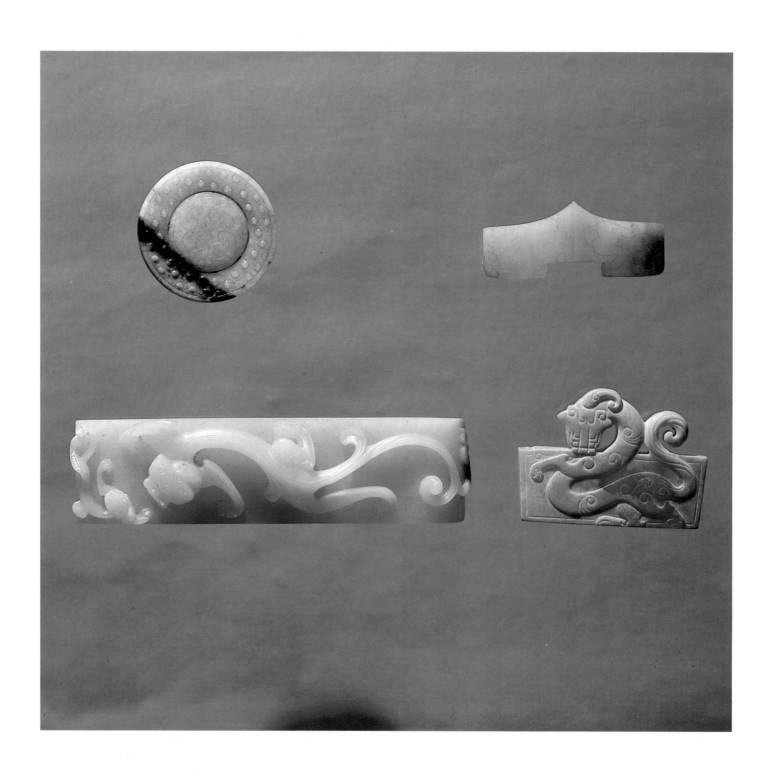

191 Jade ornaments of a sword.
Han Dynasty

192 Openwork jade rhomboid decorated with four deities and inscribed "Chang Yi Zi Sun."
Han Dynasty
193 Jade belt hook decorated with an openwork dragon.
Southern and Northern Dynasties Period

194 Musicians in relief on jade belt ornaments.
Tang Dynasty
195 Jade ornament decorated with openwork phoenixes.
Tang Dynasty

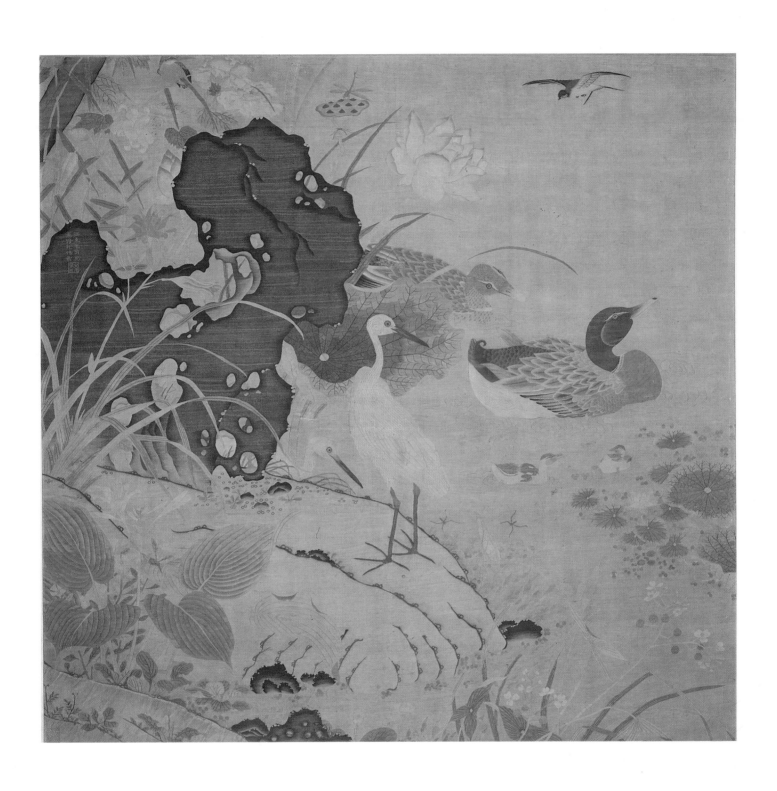

196 Zhu Kerou. Tapestry of ducks in a lotus pond.
Song Dynasty

197 Carved lacquer box decorated with a chrysanthemum-picking scene.
Yuan Dynasty

198 Zhu Xiaosong. Bamboo censer decorated with carved figures.
Ming Dynasty

199 Carved bamboo brush-holder decorated with figures of girls.
Ming Dynasty

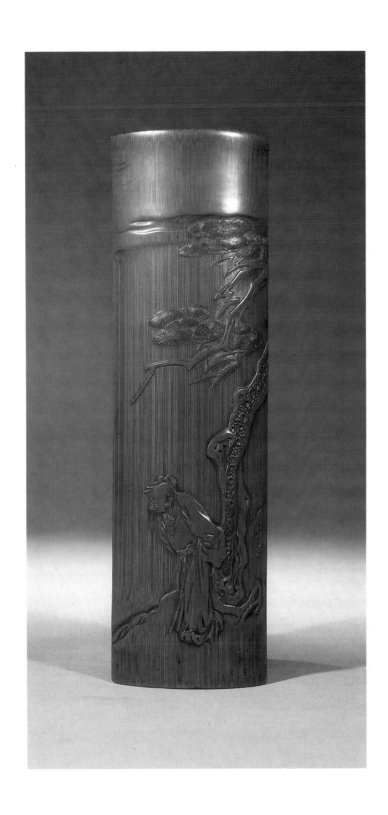

212 Wu Zhifan. Carved bamboo armrest decorated with figure of an old man below a pine tree.
Qing Dynasty

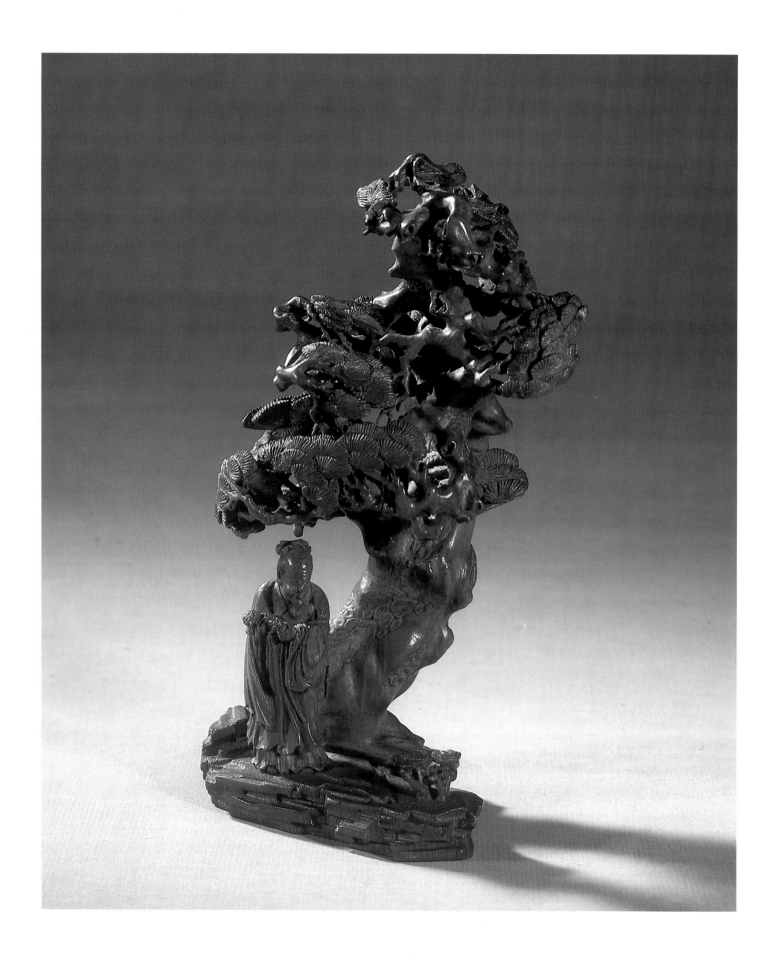

213 Deng Fujia. Bamboo carving of Tao Yuanming, an ancient poet.
Qing Dynasty

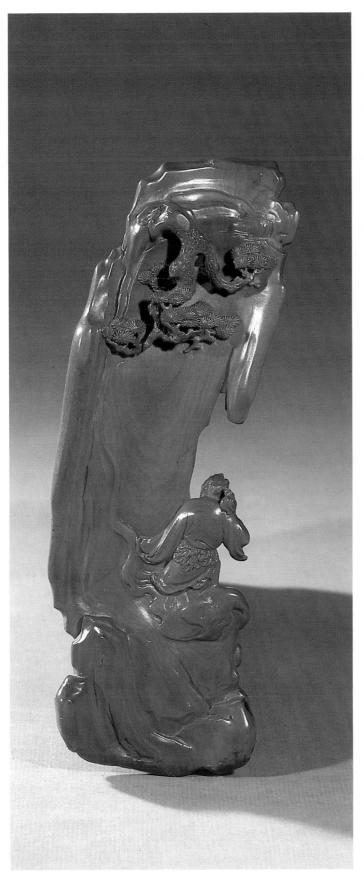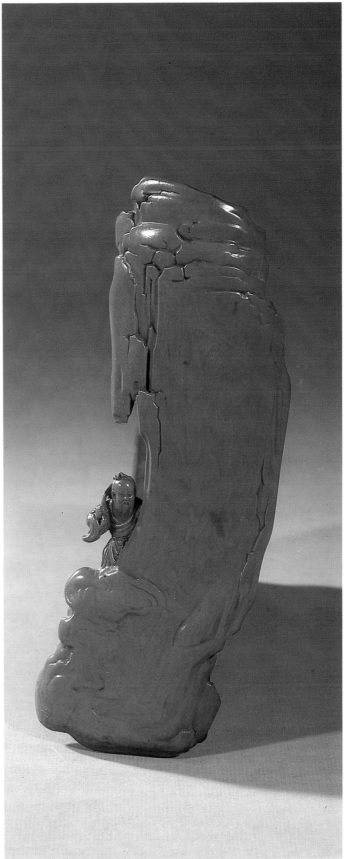

214/215 Carved boxwood ornament of Dong Fangsu, an ancient humorist.
Qing Dynasty

216 Carved red sandalwood brush-holder inlaid with jade and precious stones.
Qing Dynasty

217 Carved lacquer two-storied house.
Qing Dynasty

218/219 Carved lacquer box in the shape of a peach decorated with clouds-and-dragon patterns.
Qing Dynasty

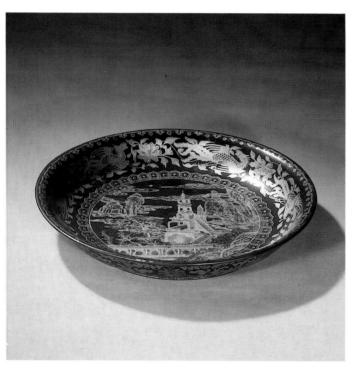 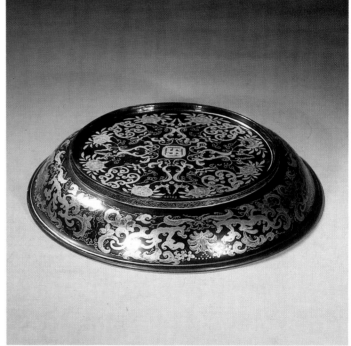

220/221 Black lacquer tray decorated with gold-traced cloud scrolls, mountains, and pavilions.
Qing Dynasty

222 Black lacquer plates inlaid with mother-of-pearl landscapes.
Qing Dynasty

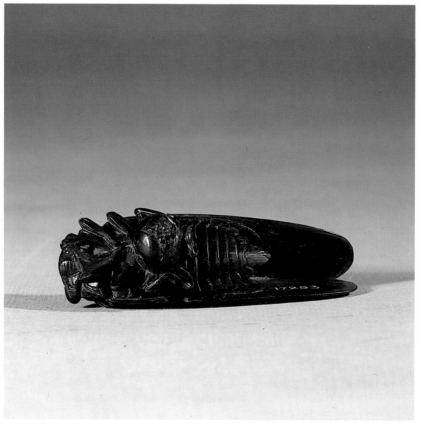

223/224 Rhino-horn pendant in the shape of a cicada.
Qing Dynasty

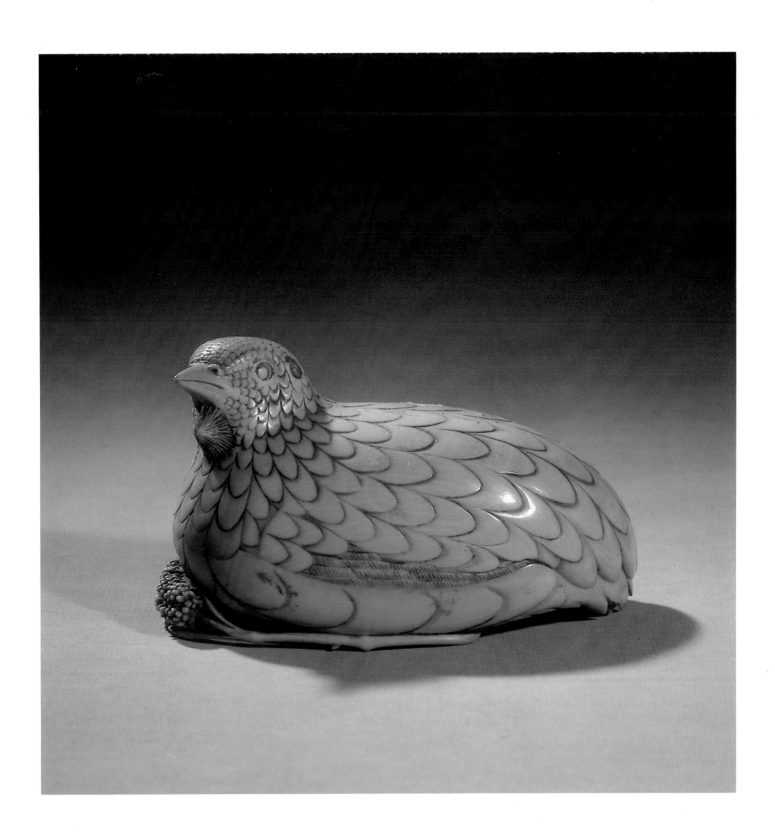

225 Carved ivory box in the shape of a quail.
Qing Dynasty

226 Ivory woven and engraved fan decorated with flowers and birds.
Qing Dynasty

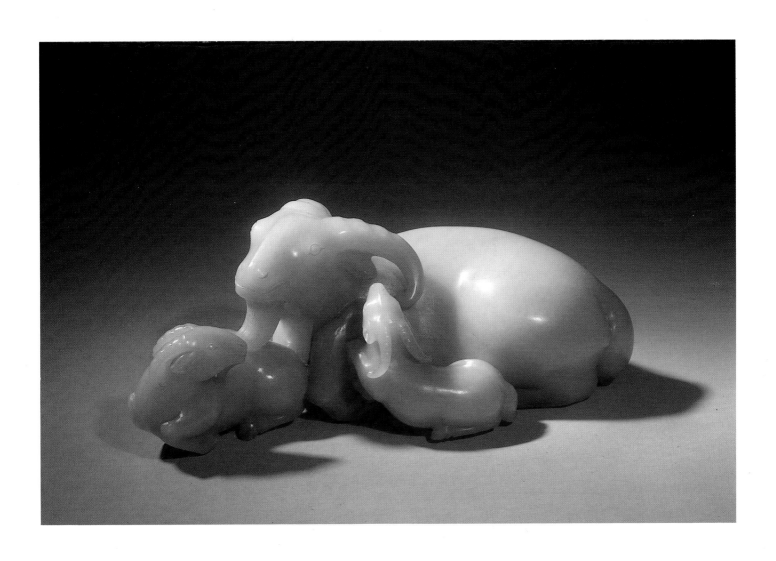

227 White jade carved into the shape of three goats.
Qing Dynasty

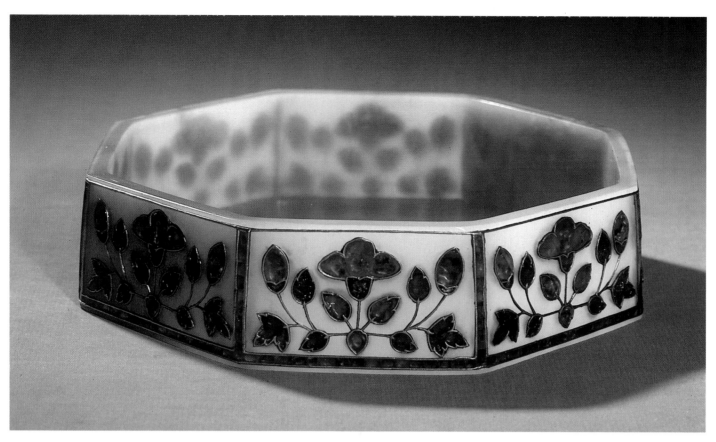

228/229 White-jade octagonal box inlaid with gems.
Qing Dynasty

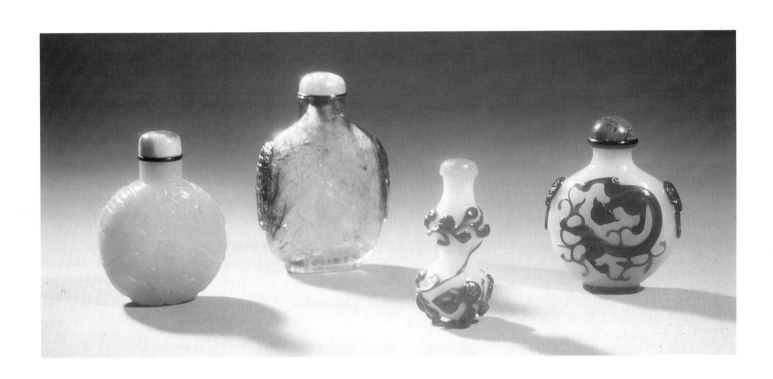

230 Glass and hair-crystal snuff bottles.
Qing Dynasty

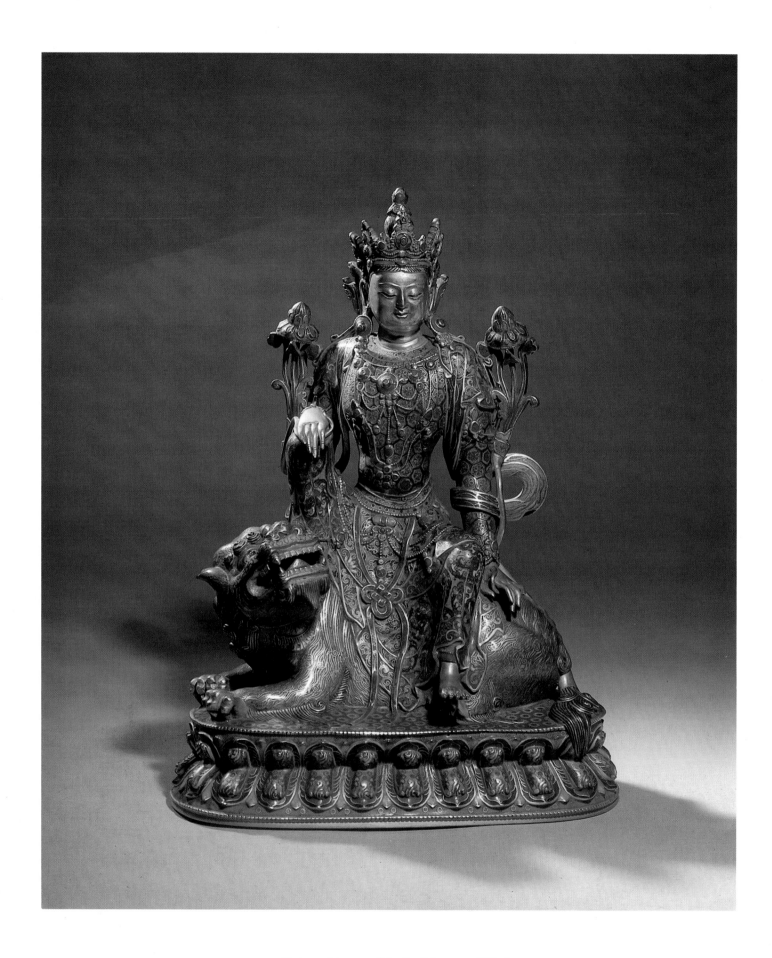

231 Cloisonné image of the Bodhisattva of Wisdom.
Qing Dynasty

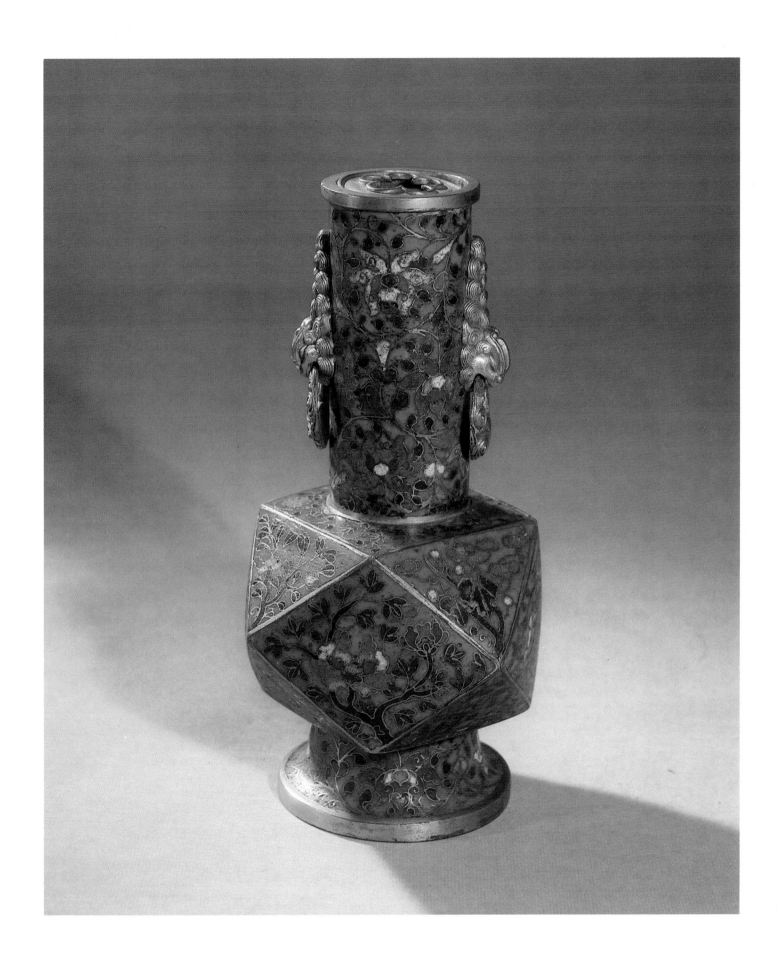

232 Cloisonné vase decorated with lion masks with ring-handles.
Qing Dynasty

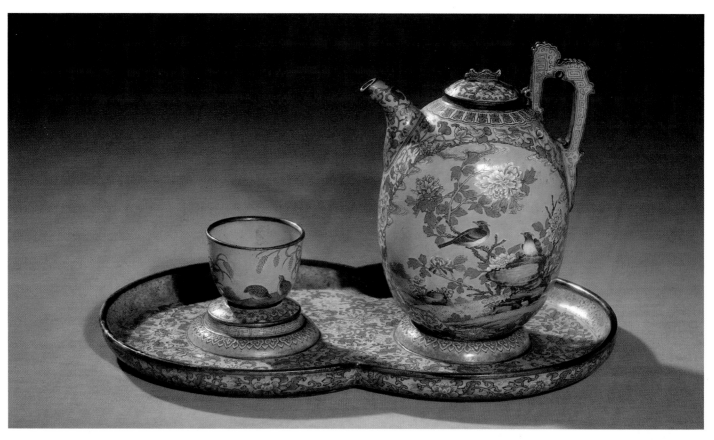

233/234 Enamel tea set painted with flowers and birds.
Qing Dynasty

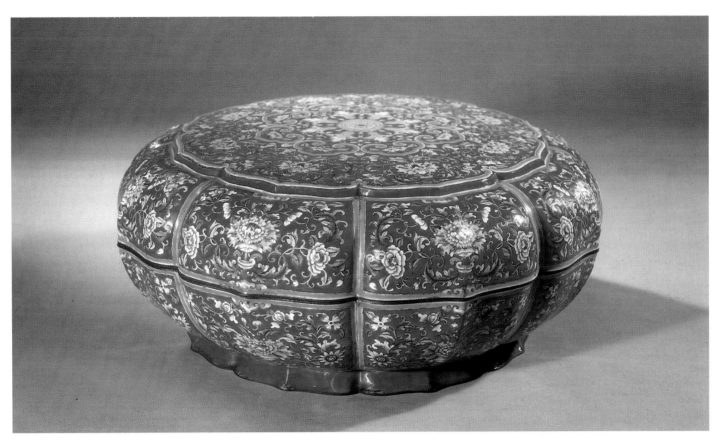

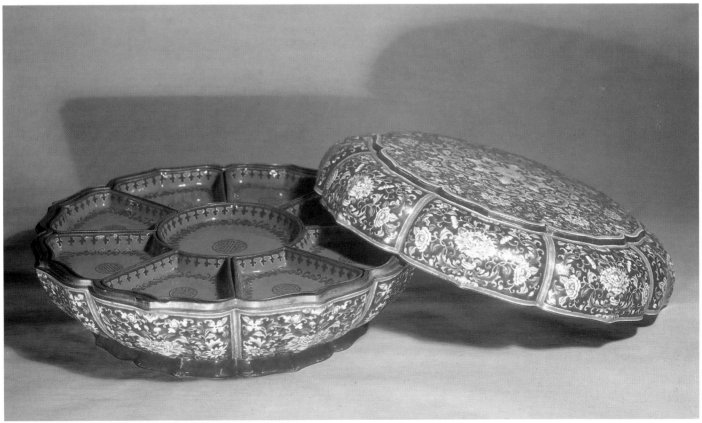

235/236 Enamel box painted with Indian lotuses.
Qing Dynasty

237　Tapestry fan decorated with a cicada and lotuses.
Qing Dynasty

238 Zhu Zichang. Carved boxwood figures of boys playing with crickets.
Modern Period

239 Carved ivory cabbage with insects.
Modern Period

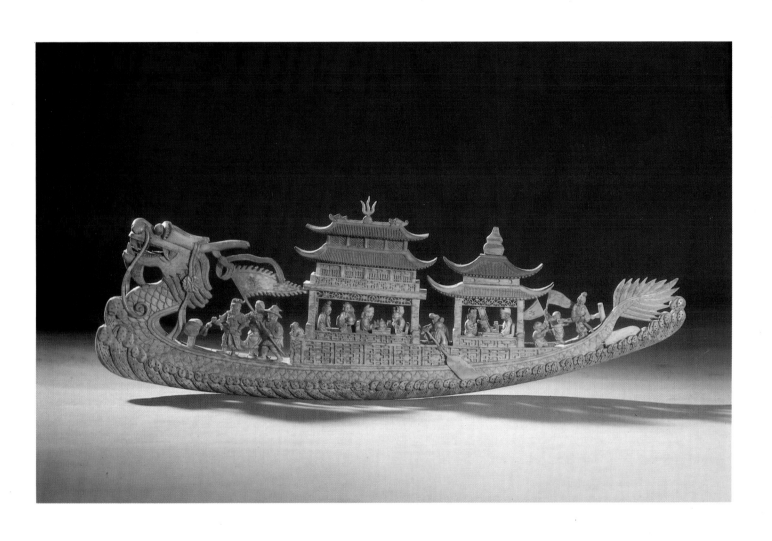

240 Carved ivory dragon boat.
Modern Period

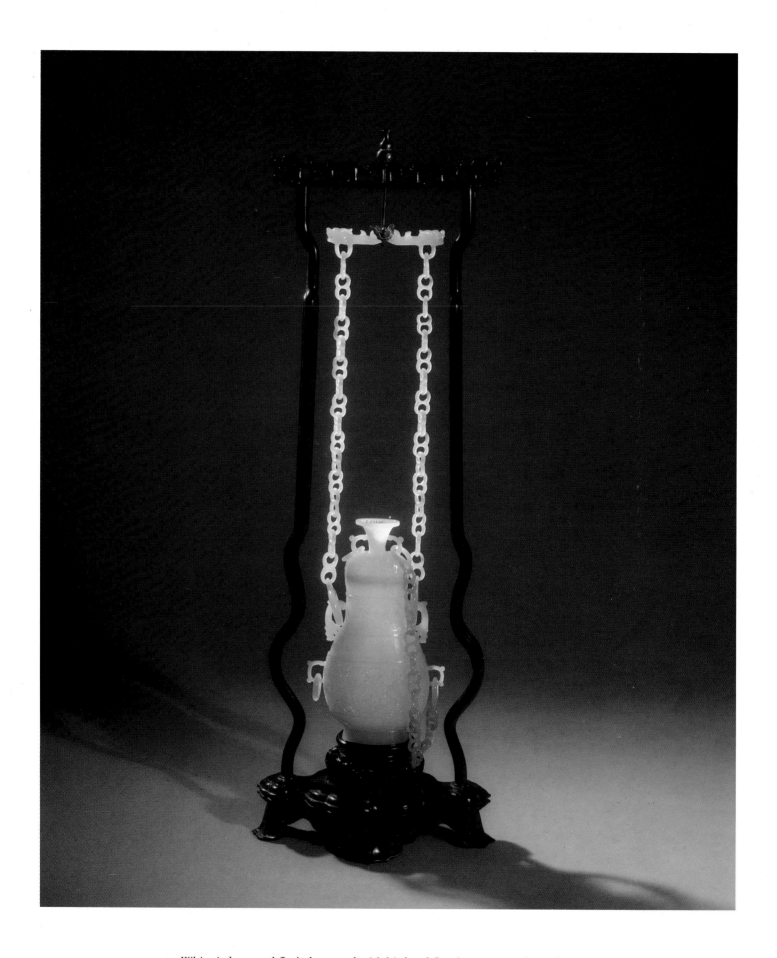

241　White-jade carved flask decorated with bird and floral patterns and interlinked chains.
Modern Period

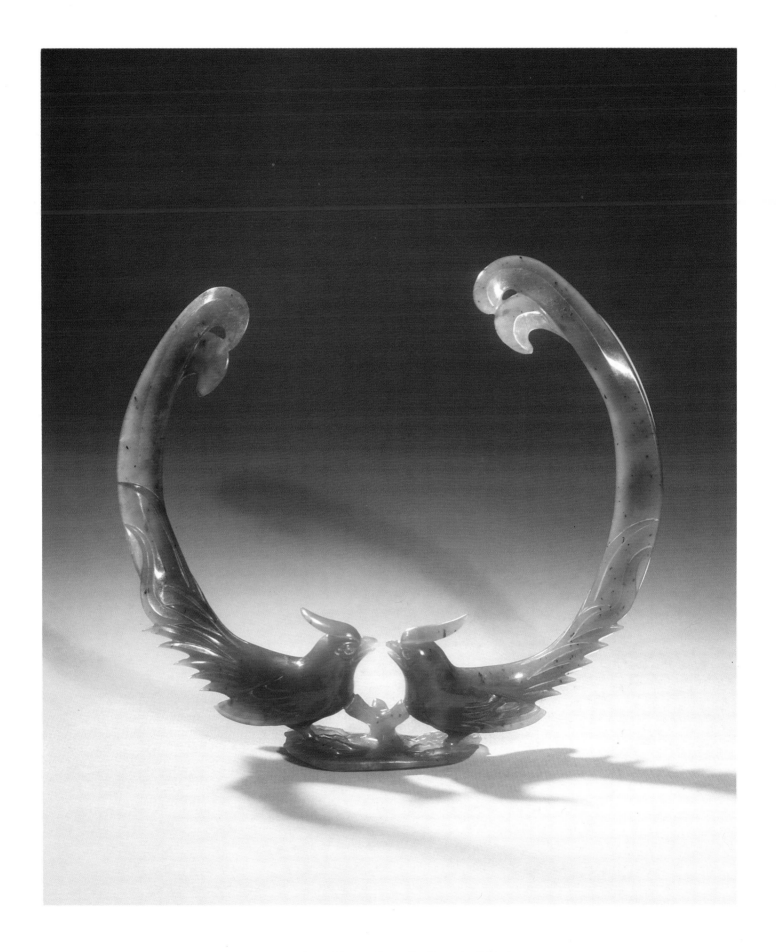

242 Carved jasper "paradise flycatcher" birds.
Modern Period

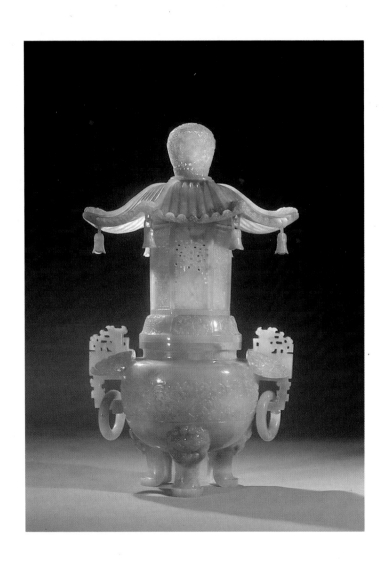

243 Green-jade openwork censer.
Modern Period

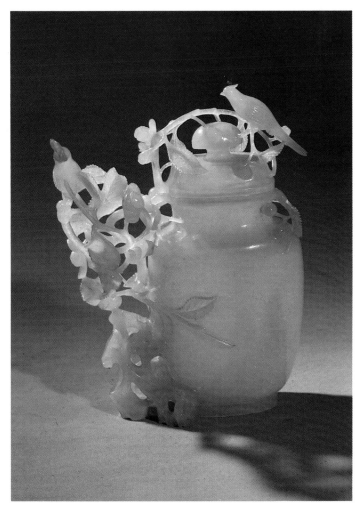

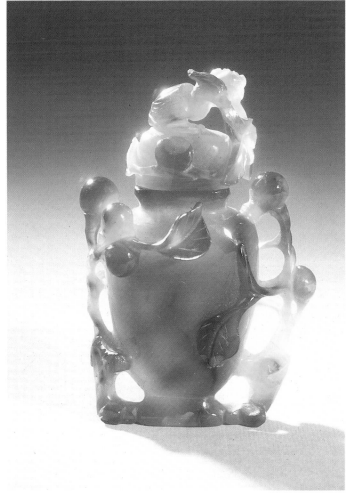

244 Green-jade vase decorated with
openwork birds and flowers.
Modern Period

245 Agate vase decorated with
openwork cherries and a bird on its lid.
Modern Period

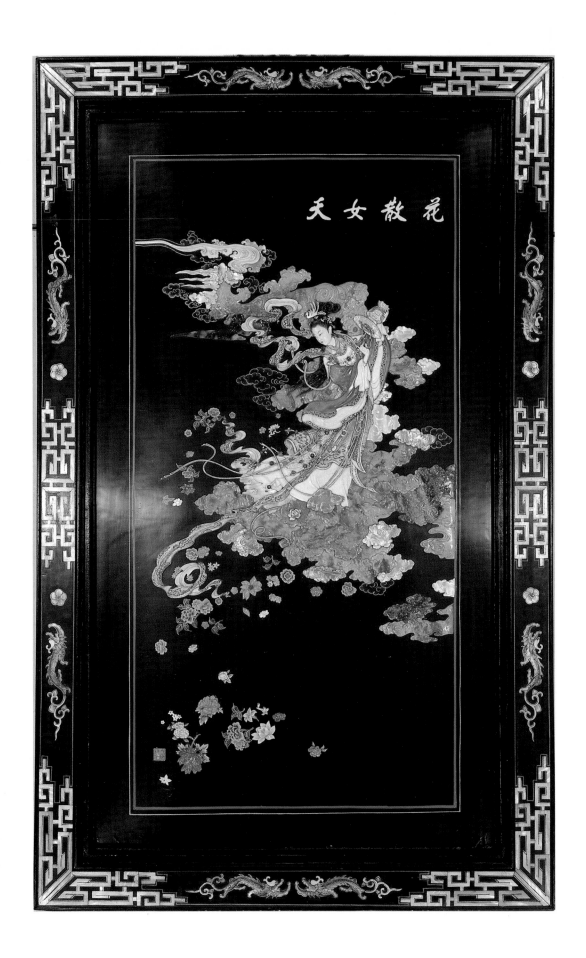

天女散花

246 Lacquer screen inlaid with ivory and semi-precious stones.
Modern Period

166

Bronze image of the Buddha.
Height: 35.5 cm. Northern Wei Dynasty

This gilded bronze image of the Buddha, with hands in *abhaya* and *vara,* has a smile on his plump face and his wavy hair done up in a chignon. His right shoulder is bare. His diaphanous robe has clear and regular pleats. He stands barefooted on a lotus pedestal. At his back is a magnificent yet refined lotus-petal aureole whose outer edge is decorated with incised and engraved flames (some of the tips are missing), its middle band with finely incised flames, and the inner band with five concentric circles—the two thicker ones decorated with a string of beads. The image's halo is in the form of a lustrous pearl. Judging by its style, this statuette belongs to the Northern Wei Dynasty.

167 168

Gilded bronze image of the Buddha.
Height: 15 cm. Northern Wei Dynasty

This image was cast during the Northern Wei Dynasty. On the front is a seated Buddha with hands joined, palms together. He has a thin and graceful face and his robe drapes down in rounded folds. At his back is a lotus-petal aureole which is decorated on the outer edge with radiant rays and on the inner band with nine seated Buddhas. The halo is round and decorated with long and narrow lotus petals in bas-relief.

The back is divided into four registers with a pointed niche at the center. In the niche are Sakyamuni and Prabhutaratna seated together, while on either side of the niche are attendants, each with an apsaras; attendants with lotus flower in hand are on the right and left above. On the top panel is Maitreya, flanked by two attendant bodhisattvas; eight seated Buddhas occupy the panel below.

169

Gilded bronze image of Avalokitesvara.
Height: 18.8 cm. Northern Wei Dynasty, first year of reign of Sheng Gui

Cast in A.D. 518, this gilded image of Avalokitesvara has a high chignon and diadem. He has a thin and graceful face. His right hand is in *abhaya* and his left hand is pointing downward. His garment drapes down while his long skirt covers his feet. He stands on a lotus pedestal. Slender and graceful, he is made in the style of the Southern and Northern Dynasties. At his back is a lotus aureole in three bands. The outer band is decorated with flames, the middle band with tips of lotus petals and radiant rays, and the inner band with geometric patterns. The halo looks like a pearl edged with lotus petals.

The inscription on the pedestal says that on the eighth day of the fourth month Buddha's disciple Lu Bienzhi had been saved from drowning and that he had this image of Avalokitesvara made in the hope that Buddha and the bodhisattvas will not forsake his family whenever they encouter calamity.

170

Gilded image of a bodhisattva.
Height: 17.4 cm. Sui Dynasty

This image of a bodhisattva has a diadem and a piled-up chignon. His chest and arms are bared. A scarf drapes over his arms and hangs down to both sides of the pedestal. A necklace hangs from his left shoulder. A long skirt sweeps the ground. He is standing on a lotus throne. The pedestal is of openwork plant patterns. Beside him are two exotically designed lotus flowers. The halo is an openwork leaf scroll; on the tip is a pearl surrounded by flames.

 This is an attendant bodhisattva broken off from a stele. Judging by its style, it belongs to the Sui Dynasty.

171

Gilded image of the Buddha.
Height: 18 cm. Tang Dynasty

Cast in the Tang Dynasty, the gilt on this Buddha has flaked off in some places. He has a well-proportioned face and his chignon is smooth and blends with his two ears. He looks down with a kind expression. The flowing folds of his robe show the contour of his body and his right shoulder is bared. The Buddha's right hand is in a posture of preaching and the left hand is slightly raised, with palm up and fingers slightly bent. He sits crossed-legged on a lotus throne.

172

Gilded bronze image of the Budkdha.
Height: 19.4 cm. Tang Dynasty

This gilded image of Buddha sits crossed-legged on a lotus throne. He has wavy hair and a chignon. His high nose-bridge joins with the eyebrows. He has a small mouth and thin lips. He is in meditation with eyes closed. His left hand is upraised in the posture of preaching and his right hand is resting on his right knee. He looks plump and dignified. His outer garment covers his whole body and the skirt reaches down over the throne; the folds are treated with flowing lines, to give the impression that it is made of silk. Its style shows that it belongs to the Tang Dynasty.

173

Stone image of the Buddha.
Height: 41 cm. Eastern Wei Dynasty, seventh year of reign of Wu Ding

This stone image of the Buddha was carved in A.D. 549. Plump and with hair piled up in a twisted knot, his eyes are half open and his long earlobes hang down close to his face. His robe hangs down from his left shoulder close to the surface of his body. The folds are treated with flowing lines. His right hand is upraised in *abhaya* while his left hand is on his knee. He sits crossed-legged on a lotus throne. He has a plain lotus-petal aureole at his back (the tips are damaged).

 The square pedestal is in two layers. On the front of the pedestal are lotus leaves and stalks going up to connect with the lotus throne. On the sides are inscribed "On the hour of *yi chou,* the day of *yi ji,* in the sixth month of the year *yi ji,* the seventh year of the reign of Wu Ding, the disciple of Buddha Li Bainu had this stone image made and prays that he'll get his wishes."

174

Stone lion.
Height: 19.2 cm. Tang Dynasty

The shape of this stone lion is simple. With staring eyes, it squats on a square pedestal. The carving is executed with rounded and forceful cuts, brief yet expressive. Except for the curled hairs on the head, the carver did not use any incised lines. It is made by a deft hand and is of the style of the Tang Dynasty at its zenith.

175 176

Stone stele of the Buddha and bodhisattvas.
Height: 62.6 cm. Length: 47 cm. Sui Dynasty

In the center of the stele is a seated Buddha with his wavy hair done up in a chignon. His shoulders are covered by his robe and his right hand is in the posture of *vara;* his left hand is missing. He sits crossed-legged on a throne covered by hs garment. Within the halo around his head are smaller Buddhas. His disciples Kasyapa, Ananda, and two bodhisattvas holding lotus buds flank the Buddha. In the center of the front of the pedestal is a Boshan censer supported by a warrior; around the censer are worshippers followed by their attendants and chariots.

On the back of the stele are statues in relief. Within the niche are seated Sakyamuni and Prabhutaratna. Below the canopy are four warriors holding up the Buddha, and also attendants. Outside the niche are Buddhas, bodhisattvas, worshippers, and horses. In the lower registers are two rows of worshippers holding lotus flowers. The style of this piece of work places it in the Sui Dynasty.

177

Stone image of Sakyamuni.
Height: 56 cm. Northern Zhou Dynasty, second year of reign of Da Xiang

This stone image stands on a lotus pedestal. He has a twisted hair knot and his eyebrows are fine and long. He looks down with half-opened eyes and a smile on his lips. His right hand is held up in *abhaya* and his left hand is hanging down (one finger is missing). His garment fits tightly on his torso and the hanging drapery is represented by parallel folds. Flanking the lotus throne are two guardian animals (the one on the left is missing and the right one's head is damaged). On three sides of the square pedestal are incised images of worshippers, and an inscription saying: "In the third month of the year of Geng Ze, the second year of the reign of Da Xiang of the Northern Zhou Dynasty (A.D. 580), Zhou Jiren, a disciple of the Buddha, had the image of Sakyamuni made to dedicate to his parents."

178

Stone Buddha's head.
Height: 32.2 cm. Tang Dynasty

The Buddha is plump and graceful. The wavy hair is carved in bas-relief with a coiled knot on top. His long earlobes are close to the cheeks. He has long and slender eyes, a high nose-bridge, a small mouth, and thin lips. With eyes half opened, he looks kind, serene, and dignified. This stone carving is attributed to the Tang Dynasty by its style.

179

Musicians in stone relief.
Height: 40.5 cm. Length: 70.5 cm. Five Dynasties Period

Three musicians carved in relief are well fleshed out, with their upper torsos bared. Their shoulders are raised up slightly and their hair knots are piled up high. The one on the left is dancing, with his scarf flying, to the music of the other two. The one in the middle is beating a drum and the one on the right is blowing a *sheng* musical instrument; both of them are looking at the dancer. The three, in their different postures, look very lively. Judging from its style, the stone relief should belong to the Five Dynasties Period.

180

Jade figurine.
Height: 10.3 cm. Shang Dynasty

The figurine was made out of white jade with a tinge of green. It has a crownlike object on its head and small holes on its earlobes. The face was executed with exaggeration, the eyes being represented with incised lines. The figurine is standing upright with folded hands. He looks quiet and stately. There is a hole from top to bottom for threading.

A jade figurine of a man, which was among a group of jade figurines unearthed in 1976 from the tomb of Fu Hao at the Yin Ruins in Anyang, Henan Province, is similar to this one but the carving is finer. Therefore, this figurine should date earlier than the one from Fu Hao's tomb.

181

Jade pendants.
Lengths: 5.3 cm., 5.9 cm., 4.1 cm., and 8.1 cm. Shang Dynasty

The pendants are in the shapes of a bird, a tiger, a hare, and a fish. They are all simply carved yet produce a blending and rounded effect. The tiger was carved in bold lines to show its powerful muscles, while the fish, with incised scales and fins, is full of ornamental interest. The bird is pretty in form and the hare looks as if it is running. The small holes on the pendants are for threading. These carvings show the maturity of the Shang carvers' skill.

182

Jade *ge* (halberd) with animal-mask designs.
Length: 25.3 cm. Width: 5.8 cm. Western Zhou Dynasty

The dark green jade *ge* has a sharp blade. On both sides of the cheeks are neatly cut animal-mask designs of ornamental interest. A ridge along the middle of the blade has three vertical raised lines. Such ritual jade weapons were symbols of the ruler's power.

183

Jade ax decorated with vertical lines.
Length: 11.3 cm. Width: 9 cm. Shang Dynasty. *Donated by Gu Kaishi and Cheng Yanjia*

The jade ax is not a tool but a ritual implement in imitation of the practical stone ax. The jade is black and lustrous. The ax is of regular shape with symmetrical zigzags on its two sides. There are three round perforations in different sizes on the tip and the center of the ax for fastening the head onto a handle. The blade is arch-shaped. The cheeks of the ax are decorated with forceful and well-spaced vertical lines.

184

Nephrite pendant in the shape of an animal mask.
Length: 4.7 cm. Width: 4 cm. Western Zhou Dynasty

The *tao tie* animal mask, made out of a piece of nephrite, is well polished and pretty. It was carved on the flat slab with incised details. It looks simple yet dignified. The two carved horns on the top and the big nose and wide mouth give the mask a very vivid appearance. There is a hole between the eyebrows for threading.

185

Nephrite pendant decorated with bird patterns.
Length: 12.6 cm. Width: 4.7 cm. Western Zhou Dynasty

This flat pendant has bird patterns on both sides incised in flowing and forceful lines. The birds look lifelike. A hole on the upper-right corner is for threading. On both upper and lower sides there are flange decorations.

186

Jade *huang* (pendant) decorated with dragon patterns.
Length: 8.3 cm. Warring States Period

The *huang* is a type of ancient pendant. This one is made out of a piece of white jade. It is decorated with fine dragon patterns, with a small hole for threading. According to Guo Morue, a famous archaeologist, *huang* together with *hang* and *chong* are pendants.

187

Jade disc in the shape of double rings and decorated with grain patterns.
Diameter: 21.2 cm. Warring States Period

The double-ring-shaped disc was carved out of a single piece of jade, with one smaller ring within the other. The face of the disc is studded with grains in an orderly arrangement. The six holes could be used for threading.

This disc is regular in shape but unique in form. It is rarely seen among the jade discs handed down from generation to generation. The jade itself is fine—pure and luminous. It is a very valuable cultural relic.

188

Glass beads.
Diameters: (1) 2.2 cm., (2) 1.1 cm., (3) 1.8 cm., (4) 2.15 cm., (5) 3 cm., (6) 2.1 cm. Warring States Period

This kind of glass was fired with lead and niter as catalyst and has been found in Western Zhou Dynasty tombs in the Luoyang area. These glass beads, however, belong to the Warring States Period. The beads are semi-transparent, with white dots or painted designs on green, blue, and black grounds. They look very pretty and were used as ornaments in ancient times.

189

Lacquer *zhi* (wine vessel) decorated with spirals and rhombs.
Height: 12.5 cm. Diameter of mouth: 11.3 cm. Warring States Period

China had many kinds of bronze wine vessels in Shang Dynasty times, and beginning in the Warring States Period some of them were made of lacquer as great quantities of lacquerware were produced. The lacquer *zhi* is a kind of wine container whose form has never been seen among bronze vessels. In recent years, the complete sets of lacquer wine containers and food vessels unearthed from ancient tombs have provided us with a large amount of valuable material by which to study the ancient craft of lacquerware making.

This *zhi* is on a lacquer-coated wooden base. Its pedestal, handle, and ornaments on the lid are all made of bronze. The lid ornaments can also serve as the legs when the lid is inverted. The outer rim of the lid, the top, and the lower body are decorated with painted interlocking rhombs and the middle section is decorated with stylized bird and animal patterns and whorl patterns. The ornamental designs are clear and bright. It is a typical piece of lacquerware of the Warring States Period, attributed to a Warring States tomb at Changsha, Hunan Province.

190

Lacquer dish decorated with cloud designs.
Height: 3.5 cm. Diameter of mouth: 22.1 cm. Han Dynasty

Lacquer dishes were ancient food containers usually found as one of a set of food vessels; they were used widely in the Western Han Dynasty. This dish has a wooden base coated with lacquer. Along the edge of the plate is a band of wave patterns with small studs; inside the mouth rim are three raised lines and geometric patterns which were fashionable during the Western Han Dynasty. The dish's center is decorated with a band of vermilion wedge-shaped designs on

a purplish-brown ground. Within the circle at the center of the dish are vermilion cloud scrolls and whorls on a purplish-brown ground.

Meticulously made and lavishly decorated, this dish is a valuable piece of Han Dynasty lacquerware. It is attributed to a Han Dynasty tomb at Changsha.

191

Jade ornaments of a sword.
(1) Diameter: 3.3 cm., (2) length: 4.9 cm., (3) length: 10.9 cm., (4) length: 5.15 cm. Han Dynasty. *Donated by Li Yinxuan*

This is a set of jade ornaments which decorated a sword. The jade *beng,* inlaid at the hilt-guard, is round with a convex center and is decorated with a band of grain patterns on the bent outer circle and cloud patterns within the band; the jade *er,* a rectangular piece decorated with engraved dragon patterns on both sides, has a hole in the center for inserting the sword blade's haft; the jade *chih,* a rectangular piece decorated with an openwork dragon affixed to the scabbard, has a square perforation at the lower section for tying the scabbard onto a sword belt; the jade *bi,* decorated with a dragon in relief on one side and stylized clouds on the other, has a cavity at one end for fitting onto the tip of the scabbard. This set of jade ornaments is lustrous and meticulously worked. The incised designs look most appealing.

192

Openwork jade rhomboid decorated with four deities and inscribed "Chang Yi Zi Sun."
Height: 3.2 cm. Length: 5.5 cm. Han Dynasty

Jade rhomboid pendants were widely used during the Han Dynasty. It was believed that they could ward off evil. This meticulously carved rhomboid must have belonged to a high-ranking official. It is made of mutton-fat white jade, and inscribed on both front and back with eight characters, all in seal script, meaning: "Having many descendants and longevity." The characters were carved with very fine and forceful lines. The four sides of the rhomboid are decorated with figures of the blue dragon, white tiger, scarlet bird, and a turtle-and-snake figure; these were regarded as four deities, each representing the lunar mansions in one of the four directions. (Ancient astronomers in China divided the heavens into three constellation areas and twenty-eight lunar mansions.)

This jade rhomboid was skillfully carved with openwork, and is regular in form and lively with the decorative animals. It is invaluable as its finely inscribed seal-script characters have preserved Han Dynasty calligraphy.

193

Jade belt hook decorated with an openwork dragon.
6.5 × 9.5 cm. Southern and Northern Dynasties Period

This belt hook is made of white jade and decorated with an openwork dragon with engraved scales. The inlays are missing. There are four small holes on its four corners for threading it onto a belt. An inscription in two lines on the back says: "White jade *xian pi* [belt hook] made at the imperial workshop in the year of Gen Wu…" According to the *Han Shu (History of the Han Dynasty),* belt hooks have been called *xian pi* since ancient times. This is a valuable artifact for, apart from its exquisite workmanship, its inscription testifies to the accuracy of historical records.

194

Musicians in relief on jade belt ornaments.
(1) 3.8 × 3.6 cm., (2) 3.2 × 3 cm. Tang Dynasty

These jade ornaments were attached to a belt. Carved in relief on their obverse sides are two musicians, both seated upright on a carpet. One is looking down and concentratedly playing a flute; behind him are fluttering ribbons. The other musician is playing cymbals with his shoulders raised high, his face covered with a broad smile, and looking very joyful. The figures are lively, executed with simple, rounded lines. There is a small hole on each of the four corners of the two pieces for threading.

195

Jade ornament decorated with openwork phoenixes.
7.8 × 16.2 cm. Tang Dynasty

This rectangular jade ornament is carved with openwork phoenixes in cloud scrolls. The two phoenixes, with finely engraved feather patterns, are turned to face each other. Their swirling tails and open mouths indicate that they are singing and dancing. They are of rich imagery. This ornament's incised patterns and carving technique are similar to those on the gold and silver ware of the Tang Dynasty. It is a very rare treasure, which has been handed down through the generations.

196

Zhu Kerou. Tapestry of ducks in a lotus pond.
107.5 × 108.8 cm. Song Dynasty. *Donated by Pang Bingli*

This tapestry is of plain woven textile. But since it was woven in sections, there are traces of broken wefts and warps as though cut, so it is also known as "cut silk." It has a unique artistic style.

During the Song Dynasty, the tapestry industry was highly developed, with such well-known artisans as Zhu Kerou, Shen Zifan, and Wu Xu. This was made by Zhu Kerou. On the tapestry are pink lotus flowers, white egrets, green duckweed, a bluebird, and two ducks and ducklings swimming in the pond. Dragonflies and other insects weave through the lively scene. An inscription on the left on the rock reads: "The tapestry of ducks in a lotus pond made by Zhu Gang of Jiangdong." Beneath it is the seal of Kerou. Fairly large in size, the tapestry is fine and closely woven with a variety of colors. It is a masterpiece of extant Song Dynasty tapestries.

197

Carved lacquer box decorated with a chrysanthemum-picking scene.
Diameter: 11.8 cm. Yuan Dynasty

During the Song and Yuan Dynasties, lacquer carving was highly developed. Lacquerware was made by coating a matrix with layer after layer of lacquer. Generally, a piece required dozens of coatings, and sometimes even hundreds, before it was finely carved. This box was thickly coated with bright red lacquer and the carving was done in a rounded, flowing hand. Carved on the lid is a scene of the Eastern Jin Dynasty poet Tao Qian with his boy attendant picking chrysanthe-

mums beneath a pine tree close to a bamboo fence. It is a rare piece of artwork, unearthed in 1954 at Qingpu County, Shanghai, from a Yuan Dynasty tomb of the Ren family.

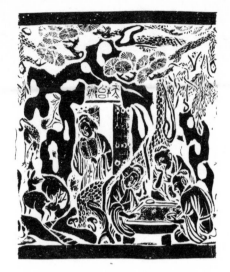

198

Zhu Xiaosong. Bamboo censer decorated with carved figures.
Height: 16.5 cm. Diameter: 3.7 cm. Ming Dynasty

The censer was unearthed in 1966 from a Ming Dynasty tomb of the Zhu family at Gucun Village, Baoshan County, Shanghai. It was made by the famous Ming Dynasty carver Zhu Xiaosong of the Jiading region. The carved scene represents a fairy tale which tells of Liu Chen and Ruan Zhao of the late Han Dynasty (A.D. 3rd century), who went to gather medicinal herbs. They lost their way in the mountains of Tiantai and had to stay at a deity's cave for several days. When they returned from the mountains, to their great consternation they found seven generations had passed in the world of man. The scene of the censer depicts Liu and Ruan with the deity, playing chess beneath a pine tree outside the Tiantai cave.

In order to exaggerate the enchanted atmosphere, deers and storks, symbolizing respectively good fortune and longevity, were added. On the lintel of the cave are inscribed "Zhu Ying" and also the seal "Xiaosong." The base and the cover of the censer are carved out of red sandalwood and decorated with a stylized tiger. It is an art treasure, intelligently designed and skillfully fabricated.

199

Carved bamboo brush-holder decorated with figures of girls.
Height: 14.9 cm. Diameter: 15.5 cm. Ming Dynasty

The brush-holder is oval with a low foot rim. The decoration consists of the usual garden landscape: within a moon gate are an old pine tree with interlocking rugged branches, a plantain, a Chinese parasol tree with lush sprays and leaves, balusters, long benches, and a small table with incense burner, stationery, etc., on it. Below the parasol tree are two girls reading a book; one is seated and the other is standing. The entire picture is meticulously arranged and the carving skillfully executed. It is an outstanding piece of Ming Dynasty bamboo carving.

200

Lacquer box carved with cloud patterns.
Height: 4 cm. Diameter: 7.7 cm. Ming Dynasty. *Donated by Gu Lijiang*

The box has been coated with thick layers of black-, yellow-, and vermilion-colored lacquer and then carved and gouged to show the different colors in the patterns formed. On the cover and the sides are three units of cloud patterns. The bottom is a plain dark purple. The cloud patterns are simple and archaic and the carving is done in a rounded, broad hand. Such carved lacquerware pieces are as glossy as rhinoceros horns, so they were called "gouged rhino horns."

201 202

Lacquer box carved with peony patterns.
Height: 9.7 cm. Diameter: 21.8 cm. Ming Dynasty, reign of Xuan De (A.D. 1426–1435)

This box of thick layers of lacquer has a bright red lacquer surface and a cover decorated all over with carved peonies, camellias, chrysanthemums, etc. It was carved with a graphic hand and polished by a skillful handicraftsman. The sides of both the cover and the body are also decorated with peonies, lotus flowers, camellias, sunflowers, etc. The bottom is coated with dark brown lacquer and on the edge is inscribed: "Made in the Reign of Xuan De of the Great Ming Empire"—which is filled in with gold dust.

 During the reign of Yong Le (A.D. 1403–1424) of the Ming Dynasty the Guoyuanchang workshop was set up in Beijing to manufacture lacquerware exclusively for the court. The wares fabricated in the reigns of Yong Le and Xuan De are similar to those made in the Yuan Dynasty. They have the common feature of "distinctly hiding the tip of the knife and gradually letting the suaveness appear," and are quite different from those manufactured later, which have thin coats of lacquer and finely and densely executed designs.

203

Lacquer box with carved and filled-in *qi lin* (unicorn) pattern.
Height: 3.7 cm. Diameter: 11.9 cm. Ming Dynasty, reign of Jia Jing (A.D. 1522–1566)

The lacquerware pieces decorated by the carving and filling-in method were rather fashionable during the Ming Dynasty. They were made by carving the surface of the lacquerware in intaglio patterns and then filling these in with colored lacquer. This box is buff-colored. On its cover is a carved running *qi lin* with its head turned back. Red- and green-colored lacquer were used to fill in the pattern, which was outlined again with golden lacquer to make it stand out more. Around the head of the *qi lin* is a halo of red flames. The edge of the cover is decorated with floral patterns.

 The sides of the box are decorated with wave patterns and the eight auspicious Buddhist emblems (including the wheel of the law, the conch, the umbrella, the canopy, the lotus, the jar, the fish, and the mystic endless knot). The carvings are shallow but the carved lines are flowing. The inscription on the bottom reads: "Made in the Reign of Jia Jing of the Great Ming Empire."

204

Lacquer tray decorated with figures edged with gold on a bright red ground.
4.7 × 30.6 × 44.7 cm. Ming Dynasty. *Donated by Gu Lijiang*

The matrix was first polished, then coated with black or bright red lacquer. After being dried, it was again burnished and the designs were outlined in bright red and painted with colored lacquer on the surface. Gold powder was then applied to the outlines.

In the center of the tray is an official in Ming Dynasty costume. Around him are four attendants carrying a musical instrument, a casket, a fan, and a load on a shoulder pole. They all seem to be accompanying the official on his way to take office. The picture is very vividly executed.

On the reverse side of the tray are imitations of bamboo weaving. This is a characteristic decoration of the Ming Dynasty.

205

Rhino-horn goblet in the shape of a lotus.
Height: 10.5 cm. Diameter of mouth 19.5 cm. Ming Dynasty

As rhino horns can be used as medicine, having the effect of allaying fever, it was fashionable in the Ming Dynasty to carve them into wine cups. This goblet is in the shape of a lotus leaf. The leaf is curved slightly upward to make a flared mouth cup. The stalk of the lotus entwines with a reed and reaches up to the edge of the leaf to form the handle. The stalk, the veins on the leaf, and the reed are all rendered very lifelike. Outside the cup is a full lotus seedpod. The whole article shows the remarkable handicraftsmanship in rhino-horn carving.

206

Rhino-horn goblet in the shape of a floating raft.
Height: 9.7 cm. Length: 25.5 cm. Ming Dynasty

This is a carved ornamental goblet in the shape of a floating raft. On top of the raft are magic mountains, rugged rocks, and fruit trees. Sitting upright on the raft with his back against the mountains is an old man with a long beard who is holding a book. On one side of the raft are a lotus leaf and seedpod; on the other, a gourd. On the bottom of the raft are wave patterns to make the raft seem floating.

207

Rhino-horn image of the Maitreya Buddha.
Height: 8.8 cm. Ming Dynasty

This statuette of the Maitreya Buddha was carved out of a rhinoceros horn, using its broad base for the figure's base and the horn's narrow upper portion for the image's head. The fat figure is barefooted and seated with a flowing robe draping over his body but leaving his chest and belly bare. His right hand is clutching his robe on his knee while his left hand is counting his beads. There are five boys climbing up and playing on him. This piece of work looks natural and the figures' expressions are lively.

208

Stone image of an Arhat.
Height: 11 cm. Ming Dynasty. *Donated by Hu Ruichi*

This seated Arhat was carved out of Shoushan stone of Fujian Province. He wears a robe, leaving his breast bared, and sits crossed-legged. The lapels and the cuffs of the sleeve are all carved and filled in with gold interlaced flower patterns. His left hand is lightly clenched on his knee; his right hand is placed across his chest. His head is slightly inclined to the left, and he looks very realistic.

209

Jade belt ornament with openwork dragon decoration.
6 × 15.4 cm. Ming Dynasty. *Donated by Gu Lijiang*

This white-jade belt ornament has two layers of openwork decoration: the ground and upper areas. The latter consists of a dragon flanked by cloud designs while below are wave patterns. The exquisite jade dragon is further surrounded by skylarks and rhomboid patterns. The openwork ground, of reversed swastikas inside small squares, brings out the delicate exquisiteness of the dragon decoration.

210

Cloisonné tripod censer with a pair of handles and decorated with interlocking lotus flowers.
Height: 10.9 cm. Diameter of mouth: 11.5 cm. Ming Dynasty

Cloisonné is made by soldering very fine metal wire onto the surface of the metal matrix in a design and filling in the filigree work with different-colored enamel agents before the article is fired, polished, and plated with gold.

This piece of cloisonné is an imitation of the brass censers made in the reign of Xuan De (A.D. 1426–1435). It has a blue ground and its Indian lotus patterns are filled in with red, yellow, white, and green colors. Therefore, though the flower patterns are quite the same, the different colors and the interspersed interlocking small flowers and green leaves make the decoration appear variegated and resplendent. The decoration is similar to Ming Dynasty brocade patterns.

211

Han Ximeng (of the Gu Family). Embroidery of rock, flowers, and butterflies.
30.3 × 23.9 cm. Ming Dynasty

Gu School embroidery was started by a person named Gu Mingshi of Shanghai during the reign of Jia Jing (A.D. 1522–1566) of the Ming Dynasty. Many of Gu Mingshi's descendants were known to be skilled at embroidering. Their works were known as "Gu embroidery." Since they lived in a garden house, called Luxiangyuan, their embroidery was also called "Luxiangyuan embroidery."

Han Ximeng (the granddaughter-in-law of Gu Mingshi) was an outstanding embroiderer of the Gu School and, at the same time, talented in Chinese painting. Therefore, the flowers embroidered by her show great spirit. She styled herself "Embroiderer of Wu Ling." This *Rock, Flowers, and Butterflies* is a masterpiece of her work. She "painted" with

her needlework and used small and fine stitches to imitate brushstrokes and thread color-matching to produce the effect of the washing and shading used in Chinese painting. On the lower left corner is a bright red embroidered seal which reads: "Work Done by Han." It was done in the fourteenth year of the reign of Chong Zhen (A.D. 1641).

212

Wu Zhifan. Carved bamboo armrest decorated with figure of an old man below a pine tree.
Height: 24.5 cm. Width: 7 cm. Qing Dynasty

Wu Zhifan, who styled himself Lu Zhen, alias Daoist of Donghai, was a well-known bamboo carver in the early Qing Dynasty in the Jiading area. He was especially skilled in relief work. The bamboos carved with figure, flower, and bird patterns in relief by him are interesting and lively.

Carved on this armrest is an old gnarled pine tree with a rugged exposed root and interlocking branches. Beneath its shade stands an old man with a long beard and wearing a robe with wide sleeves. His hands are clasped behind his back and he is leaning slightly forward as if in meditation. The old man is very lifelike and the folds of his clothes are carved in flowing lines. The picture is calm and serene. On the lower-right corner is an inscription in running script which reads: "Made by Zhi Fang."

213

Deng Fujia. Bamboo carving of Tao Yuanming, an ancient poet.
Height: 14.4 cm. Qing Dynasty

Deng Fujia, who styled himself Yong Ji, lived in the reign of Qian Long (A.D. 1736–1795). He was born in Fujian Province but lived in Jiading. Talented in landscape painting, he was also skilled in bamboo carving. The bamboo carving of Tao Yuanming was made out of a bamboo root to depict the hermit life of that Eastern Jin Dynasty poet. The figure and his dress are in flowing lines and he appears quiet at leisure. The pine tree is old and rugged. The entire piece is of a high artistic level. On the bottom is an inscription in seal script which reads: "Yong Ji."

214 215

Carved boxwood ornament of Dong Fangsu, an ancient humorist.
Height: 15.3 cm. Qing Dynasty

The subject matter of the carved boxwood ornament of Dong Fangsu is based on a fairy tale. On one side an old man carrying a load of peaches on his shoulder is coming down the cliff on a patch of floating cloud. On the other side the old man's appearance is carved to show jubilance and joy and at the same time indicate that he is a bit nervous because his peaches are stolen.

Owing to the carver's clever perspective and skillful technique, as well as because of its fine-grained and smooth wood, this piece has attained an extreme suavity and delicacy. Not only is the figure lifelike, but the whole conception is new and unique. It is a rare piece of wood carving.

216

Carved red sandalwood brush-holder inlaid with jade and precious stones.
Height: 11.9 cm. Diameter of mouth: 9.3 cm. Qing Dynasty. *Donated by Hu Ruizhi*

The brush-holder is made of red sandalwood. Around the mouth rim are silver-wire-inlaid patterns of spirals. On the surface of the brush-holder are jade, coral, agate, lapis lazuli, turquoise, ivory, and mother-of-pearl inlays which with their natural colors form the patterns of wolfberry, chrysanthemum, and rocks. The inlays give an effect of "reliefs." Such a technique was known as "inlaid with a hundred precious things." The piece is unusually pretty.

217

Carved lacquer two-storied house.
Height: 49 cm. Length: 53 cm. Qing Dynasty

The two-storied house is in ancient Chinese architectural style. The house has double eaves, and a ridge with a *xiao wei* (ridge ornament) on each end and a gourdlike flame in the middle. Hanging from the upturned eave corners are bells. The tiles on the roof are arranged in lotus-flower patterns. The partition walls, the eave side-appendages, and the balustrade are all decorated with exquisite openwork patterns. The whole building looks grand and luxurious.

218 219

Carved lacquer box in the shape of a peach decorated with clouds-and-dragon patterns.
Height: 15.3 cm. Width: 44.5 cm. Qing Dynasty. *Donated by Hu Ruizhi*

Carved lacquer of the Qing Dynasty inherited the Ming Dynasty style, but the lacquer colors were brighter, the carving clearer, and the decorations more elaborate.

This box in the shape of a peach has eight small peach-shaped boxes within. It is elegant in form and of exquisite workmanship. On the surface of the box is carved a magic basin which emits radiant flames. Above the radiant jewelries is the character *"chun,"* and beside them are clouds-and-dragon patterns; within the character are a deer (symbol of success in career) and an old man (symbol of longevity). The outer sides of the cover are carved panels. The partitions within the box are decorated with gold peaches and green leaves and the covers of the smaller boxes are carved with themes from fairy tales. The entire decoration is symbolic of good luck, traditional in the Ming Dynasty. Many of the carved lacquerware pieces of the reigns of Jia Jing and Wan Li are similarly decorated.

220 221

Black lacquer tray decorated with gold-traced cloud scrolls, mountains, and pavilions.
Height: 3.7 cm. Diameter of mouth: 22.3 cm. Qing Dynasty

Black lacquerware is made by polishing the wooden base, coating it with black lacquer, then polishing it smooth again, painting it with different patterns, and finally applying gold powder to the patterns.

The black lacquer tray is painted with a beautiful landscape with a pavilion at the center. Around the pavilion are covered walks and cloud scrolls, mountains, trees, streams, and a bright moon in the sky. Along the inner side of the tray is a border of phoenixes with interlocking peonies, while on the outer side are stylized tiger patterns, face to face.

The center of the bottom is decorated with a reverse-swastika symbol surrounded by symmetrical pomegranate flowers.

The gold paintings on this tray are all outlined in vermilion in order to make them stand out more distinctly. The tray is of neat and regular form, the decorations variegated, and the colors brilliant on both inside and outside surfaces.

222

Black lacquer plates inlaid with mother-of-pearl landscapes.
1.4 × 10.9 × 11.1 cm. Qing Dynasty

These rectangular plates have wooden bases coated with black lacquer and decorated with mother-of-pearl-inlaid landscape and figures. Gold foils were also used to enhance the brilliance of the decoration. Around the edges of the plates are four flying dragons with fine, hair-thin whiskers. On the outer side of the plates are lines from Tang Dynasty poems. One is: "Who's to join me to enjoy the moon?" (from the poem "Reminiscences at the River Pavilion" by Zhao Gu). The other is: "No passage can be found in an old forest; the tolling bell is heard in deep mountains" (from the poem "Passing Xiangji Temple" by Wang Wei). Taking these lines as subject matter, the pictures are well arranged and are carved and inlaid with remarkable skill.

It is claimed that these plates were made by Jiang Qianli, a talented artisan who was very good at mother-of-pearl inlays toward the end of the Ming and the beginning of the Qing Dynasty.

223 224

Rhino-horn pendant in the shape of a cicada.
Length: 6.5 cm. Qing Dynasty. *Donated by Gu Lijiang*

This pendant carved out of a rhinoceros horn is in the shape and size of a cicada. Its eyes bulge out, the thorax and abdomen segments are distinct, and the wings are transparent. One of the legs grasps a small pomegranate. Its tongue is inserted into the branch to suck the sap. It is very lifelike.

225

Carved ivory box in the shape of a quail.
Height: 5.6 cm. Length: 9.7 cm. Qing Dynasty

Ivory carving was a flourishing handicraft in the Qing Dynasty, particularly during the reign of Qian Long (A.D. 1736–1795), when many small and very exquisite ivory carvings were made. This ivory box is sculptured and engraved into the form of a roosting quail with head raised, eyes staring, and a slightly curved-down beak which is pointed and strong. It is covered with close feathers and its rounded wings have fine pinion feathers. The knife cuts over the entire quail are rounded and show versatility. This lifelike quail box is a masterpiece of ivory carving.

226

Ivory woven and engraved fan decorated with flowers and birds.
Height: 49 cm. Width: 32.7 cm. Qing Dynasty, reign of Qian Long (A.D. 1736–1795)

This fan was used at the imperial palace in the Qing Dynasty. It was made by weaving ivory slips into a fine mesh in the fan's shape, attaching colored ivory flowers, birds, and butterflies onto the mesh, framing the fan with tortoiseshell, and then fixing on the fan a decorated rib and an engraved ivory handle. Meticulously made and elaborately decorated, it is an outstanding piece of ivory-ware handicraftsmanship.

227

White jade carved into the shape of three goats.
Height: 8.7 cm. Length: 21.5 cm. Qing Dynasty

This piece of jade was carved into the shape of three goats lying quietly on the ground. The three-goat theme was very popular among the people, for the word for "goat" is homonymous with that for "good luck." The jade as mellow as mutton fat, and showing the simple yet deft skill in producing the vivid form, this is an excellent piece of jade carving.

228 229

White-jade octagonal box inlaid with gems.
Height: 3.1 cm. Diameter of mouth: 12.4 cm. Qing Dynasty

This white-jade octagonal box of regular form is exquisitely made. Each side is framed with inlaid gold wire, and inside the panels are symmetrical floral patterns of gold-wire inlay. Green jade is set for the leaves and ruby for the flowers and buds. The decorations are pretty and brilliant.

Inscribed in weal script on the bottom are six characters reading: "Emperor Qian Long of the Great Qing Empire" and eight characters in clerical script meaning: "To be used forever by sons and grandsons." It is a piece of palace ware.

230

Glass and hair-crystal snuff bottles.
Heights: (1) 7.1 cm., (2) 9.1 cm., (3) 6.6 cm., (4) 7.6 cm. Qing Dynasty. *Numbers 2, 3, and 4 donated by Gu Lijiang*

The first of the four snuff bottles is of yellow glass decorated with *ru-yi* ("as you wish") and *ji xiang* (a symbol of good luck) in relief. On the two sides of the bottle are stylized symmetrical dragons; on top of it is a green-jade cover. The second bottle is one of hair crystal decorated on two sides with animal masks, and on top is a jade cover. The third bottle is of white glass, in the shape of a gourd decorated with dark red gourds and interlocking vines, on top of which is a green-jade cover. The fourth of the snuff bottles is of white glass decorated with a blue-glass stylized dragon and animal masks on two sides in relief; it has a malachite cover.

The four snuff bottles are all beautiful in color, delicate in form, and have practical use while also being artistic works.

231

Cloisonné image of the Bodhisattva of Wisdom.
Height: 31.4 cm. Width: 23.4 cm. Qing Dynasty

The statuette is plump-looking, with a piled-up hair knot, and wears a diadem, a necklace, and a flowing robe. He is seated on a lion and two lotus flowers rise up by his arms. He appears calm and dignified. This image was made out of pure brass; the matrix is thick and heavy. The filigree work, the inlaying, and the gilding were all done with skill and perfect workmanship.

232

Cloisonné vase decorated with lion masks with ring-handles.
Height: 20 cm. Diameter of mouth: 4.7 cm. Qing Dynasty

The vase has a multi-angular body, long vertical neck, and ring-handles. The mouth rim, ring-handles, and foot rim are all gilded. The neck is decorated with interlocking lotus flowers and the angular surfaces with peony, camellia, pomegranate, plum-blossom, and other floral patterns. The decorations are in bright colors, the workmanship is exquisite, and the form of the vase is unique.

233 234

Enamel tea set painted with flowers and birds.
Height: 14 cm. Length: 23.2 cm. Qing Dynasty, reign of Qian Long (A.D. 1736–1795)

Painted enamelware pieces are produced by making the brass matrix, painting on it with different-colored enamel agents, and then firing the painted matrix. The tray of this tea set has a yellow ground decorated with interlocking lotus flowers. The cup is decorated with quails, trees, and rocks. The teapot is decorated all over with interlocking lotus flowers, leaving a panel on either side which is painted with flowers, birds, and rocks. On the shoulder of the pot is a frieze pattern made up of the characters for "longevity." The decorations on the tea set are orderly arranged and the colors are very well matched. On the bottoms of the tray, cup, and pot are inscriptions which read: "Made in the Reign of Qian Long."

235 236

Enamel box painted with Indian lotuses.
Height: 15 cm. Diameter of mouth: 33.5 cm. Qing Dynasty

This box in the shape of a rhomboid has a blue ground. The eight-lobed cover is painted with Indian lotus patterns bordered by interlocking lotus flowers and flower scrolls. It has bright contrasting colors, such as yellow, green, and red. The box is partitioned into eight petal-shaped compartments with a ninth, rounded compartment in the center. The partition walls are decorated with bats and the characters for "longevity." The whole form is balanced and lovely.

237

Tapestry fan decorated with a cicada and lotuses.
Diameter: 27 cm. Qing Dynasty, reign of Kang Xi (A.D. 1662–1722)

In tapestry, the Qing Dynasty artisans carried on the tradition of the Song and Yuan Dynasties, but the workmanship was more meticulous and methods for shading and adding brushstrokes were applied. The picture shows an autumn scene at a lotus pond. Between the lotus leaves and flowers stretches a full lotus seedpod on which perches a cicada. On the water surface is half of a dead lotus leaf, with distinct stem and veins. The workmanship is outstanding. On the right side of the fan are vermilion seal marks reading: "Lan Xuan."

238

Zhu Zichang. Carved boxwood figures of boys playing with crickets.
Height: 11 cm. Width: 13.5 cm. Modern Period

The carved boxwood figures of boys playing with crickets were made by the famous wood carver Zhu Zichang of Wenzhou, Zhejiang Province. They are a group of five boys dressed in Qing Dynasty style. Two in the front are busy making the crickets fight, another two are standing with the arms of one on the other's shoulders, and the last one is sitting on the ground with crossed arms, watching. The boys' innocence and liveliness are very vividly portrayed. Their clothes are rendered with flowing lines. This is a masterpiece of Zhu Zichang's works. On the back of each boy is inscribed "Zhu Zichang" in intaglio.

239

Carved ivory cabbage with insects.
Length: 25 cm. Modern Period

Ivory dyeing and carving is a traditional Beijing handicraft. The artisan carved a cabbage out of white, fine-grained ivory so that the cabbage looks real, with distinct leaves and veins. On the top and sides of the cabbage are lively insects and myriopods such as a wasp, a mantis, a centipede, etc. On the leaves are worm-eaten holes which make the cabbage look even more real.

240

Carved ivory dragon boat.
Length: 32.5 cm. Modern Period

The dragon boat is carved out of a single tusk. The dragon looks ferocious, with head held high and tail slightly raised. On the boat are a building and a pavilion. Within the buildings are feudal officials, some drinking at a table. Standing at the front of the boat are three imposing guards in full armor and wearing swords; one of them is holding up a banner. At the stern, two boys wave flags bearing the characters "Lin Ze," which are emblems of authority. The rowers are all women.

 The boat is meticulously carved and exquisitely decorated. All the doors, windows, balusters, and eaves are decorated with very fine patterns. Below the boat are carved waves and spray.

241

White-jade carved flask decorated with bird and floral patterns and interlinked chains.
Height: 14.9 cm. Diameter of mouth: 4.3 cm. Modern Period

The flask and chains are made out of a single piece of pure, mellow jade. The flask is engraved with birds and floral patterns. Both the chain-bar and loop-handles are in the shape of dragons. The lid and the ears are linked with further delicate chains. The form and the decorations are of traditional style.

242

Carved jasper "paradise flycatcher" birds.
Height: 13.1 cm. Modern Period

This is a pair of jasper "paradise flycatchers," with long, curved-up tails. The two birds facing each other are blithely singing on a branch. Symbolizing longevity, the "paradise flycatcher" is a popular folk subject. The jasper is a lush green. The workmanship is excellent.

243

Green-jade openwork censer.
Height: 33.5 cm. Modern Period

This green-jade censer is composed of a pagoda-like lid, a hexagonal barrel, and a censer. The knob on the lid, as well as the barrel, are carved with openwork patterns. Bells hang from the lid's corners. The censer is decorated with floral patterns in relief; the ring-handles are in animal-mask ears which were carved in openwork. The jade is luminous and the form is unique. It is an exquisite piece.

244

Green-jade vase decorated with openwork birds and flowers.
Height: 15.8 cm. Modern Period

The vase was carved out of green jade. An openwork cherry tree and rock decorate one side. On the tree are two small birds looking at each other from afar. The head of one of the birds was carved out of a part of the jade which had a tinge of different color; this makes this piece of carving even more charming. The jade vase is a mellow, luminous green. The carving is exquisite.

245

Agate vase decorated with openwork cherries and a bird on its lid.
Height: 8 cm. Modern Period

The vase is carved out of a piece of agate having different colors. Purple and dark red cherries, branches, and leaves surround the small vase. A tiny bird perched on the lid serves as the knob. The vase is of unique form, resplendent color, and mellow texture.

246

Lacquer screen inlaid with ivory and semi-precious stones.
103 × 62.5 cm. Modern Period

The subject of this screen is a heavenly maid scattering flowers. The screen has a black lacquer ground inlaid with carved openwork ivory, jade, stone, and mother-of-pearl figures and flowers.

 In the picture portrayed we see a heavenly maid standing on a patch of cloud in the sky as she looks at the beautiful fairies below and scatters heavenly flowers down to them. The picture is framed with mother-of-pearl inlays of dragon and other ornamental patterns. The screen is of fine workmanship and its scene is delightful.

TABLE OF CHINA'S DYNASTIES

Name of Dynasty		Period
Xia		21st–16th century B.C.
Shang		16th–11th century B.C.
Zhou	Western Zhou	1027–771 B.C.
	Eastern Zhou	771–256 B.C.
	Spring and Autumn Annals Period	722–481 B.C.
	Warring States Period	403–221 B.C.
Qin		221–206 B.C.
Han	Western Han	206 B.C.–A.D. 23
	Eastern Han	A.D. 25–220
Three Kingdoms	Wei	A.D. 220–265
	Shu	A.D. 221–263
	Wu	A.D. 222–280
Jin	Western Jin	A.D. 265–316
	Eastern Jin	A.D. 317–420
Sixteen Kingdoms		A.D. 304–439
Southern Dynasties	Song	A.D. 420–479
	Qi	A.D. 479–502
	Liang	A.D. 502–557
	Chen	A.D. 557–589
Northern Dynasties	Northern Wei	A.D. 386–534
	Eastern Wei	A.D. 534–550
	Northern Qi	A.D. 550–577
	Western Wei	A.D. 537–557
	Northern Zhou	A.D. 557–581
Sui		A.D. 581–618
Tang		A.D. 618–907
Five Dynasties		A.D. 907–960
Ten Kingdoms		A.D. 902–979
Song	Northern Song	A.D. 960–1127
	Southern Song	A.D. 1127–1279
Liao		A.D. 907–1125
Western Xia		A.D. 1032–1227
Jin		A.D. 1115–1234
Yuan		A.D. 1279–1368
Ming		A.D. 1368–1644
Qing		A.D. 1644–1911

LIST OF ILLUSTRATIONS

Archaeological Work in the Shanghai Region

1 Red pottery *fu* (cooking vessel) with a broad ring and square handles. Neolithic Period.
2 Jade *huang* (pendants), – Neolithic Period
3 Red pottery *ding* (cooking vessel) with flat legs and incised designs. Neolithic Period
4/5 Pig-shaped gray pottery *yi* (ewer). Neolithic Period
6 Painted black pottery jar. Neolithic Period
7 Stone plow. Neolithic Period
8 Red pottery *gui* (vessel for heating liquids). Neolithic Period
9 Black pottery *hu* (drinking vessel) with wide handles and a lid. Neolithic Period
10 Black pottery *he* (vessel for heating liquid). Neolithic Period
11 Gray pottery *gui* (food vessel) with circle-and-dot design. Shang Dynasty
12 Impressed geometric-design pottery *hu* (wine vessel) in the shape of a duck. Shang Dynasty
13 Impressed-design pottery *guan* (jar) with handle and stud feet. Warring States Period
14 Yue ware lotus-flower porcelain *guan* (jar). Five Dynasties Period
15 Brick screen panel carved with figures. Song Dynasty
16 Gold phoenix hairpin. Song Dynasty
17 through 23 Carved wooden ceremonial figurines. Ming Dynasty

Ceramics

24 Painted pottery pot with four circles of netlike designs. Neolithic Period
25 Black pottery cup with openwork high stem. Neolithic Period
26 Green-glaze proto-porcelain *zun* (wine vessel) with raised-line decoration. Shang Dynasty
27 Green-glaze proto-porcelain *ding* (cooking vessel) decorated with a dragon head. Warring States Period
28 Green-glaze pottery duck. Han Dynasty
29 Green-glaze pottery watchtower. Han Dynasty
30 Green-glaze proto-porcelain jar crowned with a building and figurines. Western Jin Dynasty
31 Green-glaze proto-porcelain tiger. Western Jin Dynasty
32 Color-glaze pottery *hu* (wine vessel) decorated with embossed floral patterns and dragon heads. Tang Dynasty
33 Tricolored pottery *zun* (wine vessel) decorated with two dragens. Tang Dynasty
34 Tricolored pottery tomb-guardian. Tang Dynasty

35 Tricolored pottery figurine of a mounted woman. Tang Dynasty
36 Tricolored pottery figurine of a seated woman. Tang Dynasty
37 Tricolored pottery camel. Tang Dynasty
38 Yue ware begonia-shaped porcelain bowl. Tang Dynasty
39 Changsha ware brown-green glaze porcelain *hu* (ewer) with molded floral decoration. Tang Dynasty
40 White porcelain pillow with openwork hall-building and figurine. Five Dynasties Period
41 Ge ware porcelain vase with nipple-like studs and cylindrical ears. Song Dynasty
42 Jun ware porcelain basin in the shape of a begonia. Song Dynasty
43 Ding ware porcelain dish with impressed clouds-and-dragon design and a silver-mounted rim. Song Dynasty
44 Longquan ware covered jar in the shape of a lotus flower with molded coiled dragon. Southern Song Dynasty
45 Bacun ware porcelain prunus vase with black floral designs on a white ground. Song Dynasty
46 Bacun ware painted porcelain figurine of a seated woman. Song Dynasty
47 Color-glaze porcelain pillow engraved with flower-and-bird design. Song Dynasty
48 Jingde ware blue-and-white porcelain vase decorated with interlaced sprigs of peonies. Yuan Dynasty
49 Jingde ware blue-and-white flat flask with two ears and decorated with Indian lotus motif. Ming Dynasty
50 Jingde ware porcelain flask with contrasting-color designs of plant tendrils. Ming Dynasty
51 Jingde ware polychrome covered porcelain jar with clouds-and-dragon designs. Ming Dynasty
52 Painted-enamel porcelain bowl decorated with interlaced sprigs of peony. Qing Dynasty
53 Jingde ware polychrome porcelain vase decorated with figures. Qing Dynasty
54 Jingde ware lobed porcelain vase decorated with famille-rose flowers and birds. Qing Dynasty
55 Porcelain vase with enamel-color figurines. Qing Dynasty
56 Coral-red porcelain vase with two ears decorated with designs in gold (belonging to the House of Shende). Qing Dynasty
57 Thin-wall porcelain vase decorated with famille-rose flowers. Modern Period
58 Thin-wall porcelain bowl decorated with famille-rose flowers and birds. Modern Period
59 Porcelain jar painted with underglaze colors. Modern Period

Bronzes

60 Bronze *jue* (wine goblet) with animal-mask design. Shang Dynasty

61 Bronze *jia* (wine container and warmer) with animal-mask design. Shang Dynasty

62 Bronze *ding* (food container) with animal-mask design. Shang Dynasty

63/64 Bronze *lei* (wine container) ornamented with four ram heads. Shang Dynasty

65 Bronze *gui* (food vessel) "You Fu Kui." Shang Dynasty

66 Bronze *zun* (wine container) inscribed "Jia Fu Kui," Shang Dynasty

67/68 Bronze *you* (sacrificial wine container) inscribed "Gu Fu Ji." Shang Dynasty

69/70 Bronze *gong* (wine container) inscribed "Fu Yi." Shang Dynasty

71 Bronze rectangular *ding* (sacrificial vessel) inscribed "Tian Gao Fu Ding." Western Zhou Dynasty

72 Bronze *ding* (sacrificial vessel) inscribed "Jiao." Western Zhou Dynasty

73 Bronze *hu* (wine container) inscribed "Chu Fu Geng." Western Zhou Dynasty

74 Bronze rectangular *zun* (wine container) inscribed "Kuei Gu." Western Zhou Dynasty

75 Bronze *you* (sacrificial wine container) decorated with phounixes. Western Zhou Dynasty

76 Bronze *zheng* (percussion musical instrument) decorated with animal masks. Western Zhou Dynasty

77 Bronze *gui* (food container) inscribed "Shi Lai." Western Zhou Dynasty

78 Bronze *he* (wine-diluting or-warming vessel) decorated with animal masks and a dragon-shaped spout. Western Zhou Dynasty

79/80 Bronze rectangular *yi* (wine container) inscribed "Shi Jiu." Western Zhou Dynasty

81/82 Large bronze tripod *ding* (sacrificial vessel) inscribed "Ke." Western Zhou Dynasty

83 Bronze *gui* (food container) inscribed "Shi Huan." Western Zhou Dynasty

84 Bronze *zhong* (percussion musical instrument) inscribed "Xing Ren." Western Zhou Dynasty

85 Bronze *gui* (food container) inscribed "Hu," Western Zhou Dynasty

86 Bronze *ling* (wine vessel) inscribed "Zhong Yi Fu." Western Zhou Dynasty

87/88 Bronze *li* (cooking vessel and food container) in the form of three turtledoves. Western Zhou Dynasty

89/90 Bronze *zun* (wine vessel) with dragon-shaped handles. Western Zhou Dynasty

91/92/93 Bronze *zun* (wine vessel) in the shape of an ox. Spring and Autumn Annals Period

94 Bronze *hu* (wine vessel) decorated with bird, animal, and dragon patterns. Spring and Autumn Annals Period

95 Bronze *hu* (wine vessel) decorated with feather patterns. Spring and Autumn Annals Period

96 Bronze *dui* (food container) inlaid with geometric patterns. Warring States Period

97 Bronze *ding* (sacrificial vessel) decorated with three od forms. Warring States Period

98 Bronze mirror decorated with a four-tiger design. Warring States Period

99 Bronze *hu* (wine vessel) in the shape of a fish. Western Han Dynasty

100/101 Bronze lamp in the shape of a ram. Western Han Dynasty

102 Gilt bronze tiger. Western Han Dynasty

103 Bronze mirror decorated with figures of deities. Eastern Han Dynasty

104 Bronze mirror inscribed "Lin Shan Yun Bao." Sui Dynasty

105 Bronze mirror decorated with peacocks and grapes. Tang Dynasty

Paintings and Calligraphy

106 Huai Su. *Ku Sun Tie*. Tang Dynasty

107 Ju-Ran. *Pine Tree-Clad Mountains*. Five Dynasties Period

108 Guo Xi. *Quiet Valley*. Northern Song Dynasty

109/110 Su Shi. *Reply to Xie Minshi on Literature*. Northern Song Dynasty

111 Zhao Jie. *Draft Script on a Stiff Fan*. Northern Song Dynasty

112 Lin Chun. *Bird with Plum Blossoms and Bamboo in Winter*. Southern Song Dynasty

113 Ma Yuan. *Four-Sectioned Scroll: (1) Herding Horses*. Southern Song Dynasty

114 Ma Yuan. *Four-Sectioned Scroll: (2) Phounixes*. Southern Song Dynasty

115 Liang Kai. *Eight Eminent Monks: (1) Bodhidharma Facing a Wall*. Southern Song Dynasty

116 Liang Kai. *Eight Eminent Monks: (2) Bai Juyi Calling on Monk Niaoke*. Southern Song Dynasty

117 Artist unknown. *Snow Scene*. Song Dynasty

118 Artist unknown. *Camellias and Butterfly*. Song Dynasty

119 Artist unknown. *Quail*. Song Dynasty

120 Artist unknown. *Welcoming the Emperor*. Southern Song Dynasty

121 Qian Xuan. *Kicking Ball*. Yuan Dynasty

122 Zhao Mengfu. *Eastern Mountain by Dongting Lake*. Yuan Dynasty

123 Zhang Wo. *Scroll of the Nine Songs: (1) Eastern Emperor Tai Yi*. Yuan Dynasty

124 Zhang Wo. *Scroll of the Nine Songs: (2) Dying for the Motherland*. Yuan Dynasty

125 Ren Renfa. *Wild Ducks in an Autumn Creek*. Yuan Dynasty

126 Xia Chang. *Spring Shower by the Window*. Ming Dynasty

127 An Zhengwen. *Yellow-Crane Pavilion*. Ming Dynasty

128 Lin Liang. *Camellias and Silver Pheasants*. Ming Dynasty

129 Shen Zhou. *Wu Zhen Yuan Pavilion*. Ming Dynasty

130 Wu Wei. *After Fishing in the Autumn River*. Ming Dynasty

131 Tang Yin. *Admiring Chrysanthemums*. Ming Dynasty

132 Wen Zhenming. *Tall Tree in Late Spring*. Ming Dynasty

133 Jiu Ying. *Lady and Bamboo*. Ming Dynasty

134 Chen Chun. *Pomegranate Blossoms*. Ming Dynasty

216 Carved red sandalwood brush-holder inlaid with jade and precious stones. Qing Dynasty

217 Carved lacquer two-storied house. Qing Dynasty

218/219 Carved lacquer box in the shape of a peach decorated with clouds-and-dragon patterns. Qing Dynasty

220/221 Black lacquer tray decorated with gold-traced cloud scrolls, mountains, and pavilions. Qing Dynasty

222 Black lacquer plates inlaid with mother-of-pearl landscapes. Qing Dynasty

223/224 Rhino-horn pendant in the shape of a cicada. Qing Dynasty

225 Carved ivory box in the shape of a quail. Qing Dynasty

226 Ivory woven and engraved fan decorated with flowers and birds. Qing Dynasty

227 White jade carved into the shape of three goats. Qing Dynasty

228/229 White-jade octagonal box inlaid with gems. Qing Dynasty

230 Glass and hair-crystal snuff bottles. Qing Dynasty

231 Cloisonné image of the Bodhisattva of Wisdom. Qing Dynasty

232 Cloisonné vase decorated with lion masks with ring-handles. Qing Dynasty

233/234 Enamel tea set painted with flowers and birds. Qing Dynasty

235/236 Enamel box painted with Indian lotuses. Qing Dynasty

237 Tapestry fan decorated with a cicada and lotuses. Qing Dynasty

238 Zhu Zichang. Carved boxwood figures of boys playing with crickets. Modern Period

239 Carved ivory cabbage with insects. Modern Period

240 Carved ivory dragon boat. Modern Period

241 White-jade carved flask decorated with bird and floral patterns and interlinked chains. Modern Period

242 Carved jasper "paradise flycatcher" birds. Modern Period

243 Green-jade openwork censer. Modern Period

244 Green-jade vase decorated with openwork birds and flowers. Modern Period

245 Agate vase decorated with openwork cherries and a bird on its lid. Modern Period

246 Lacquer screen inlaid with ivory and semi-precious stones. Modern Period